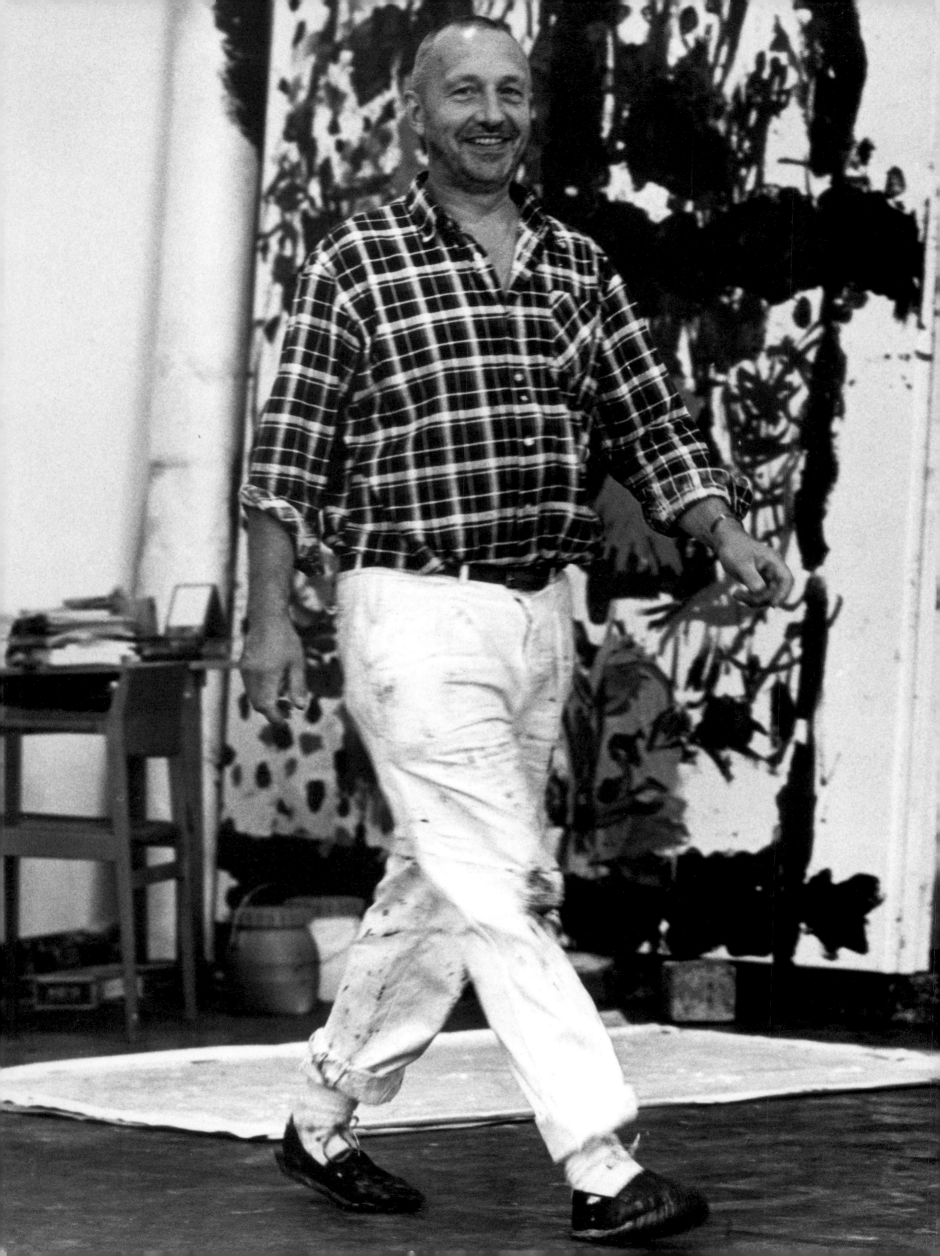

GEORG BASELITZ

COLLEGE L[?]

by Diane Waldman

GUGGENHEIM MUSEUM

English translation of
Georg Baselitz's writings
© 1995 Joachim Neugroschel.

ISBN 0–8109–6885–1 (hardcover)
ISBN 0–89207–144–3 (softcover)

Guggenheim Museum Publications
1071 Fifth Avenue
New York, New York 10128

Hardcover edition distributed by
Harry N. Abrams, Inc.
100 Fifth Avenue
New York, New York 10011

Printed in Germany by Cantz

Front cover:
Flaschentrinker (*Bottle Drinker*),
August 1981 (cat. no. 126)

Frontispiece:
Georg Baselitz, Atelier Derneburg,
1992

Georg Baselitz
Curated by Diane Waldman

Solomon R. Guggenheim Museum,
New York
May 26–September 17, 1995

Los Angeles County Museum of Art
October 15, 1995–January 7, 1996

Hirshhorn Museum and Sculpture
Garden, Smithsonian Institution,
Washington, D.C.
February 15–May 5, 1996

Nationalgalerie, Staatliche Museen
zu Berlin, Preußischer Kulturbesitz
May–July 1996

CONTENTS

Hartmut and Silvia Ackermeier,
Berlin
Bayerische Staatsgemäldesammlungen,
Staatsgalerie Moderner Kunst,
Munich
Berlinische Galerie, Berlin,
Landesmuseum für Moderne
Kunst, Photographie und
Architektur
The Carnegie Museum of Art,
Pittsburgh
Phoebe and Herbert Chason
Crex Collection, Hallen für Neue
Kunst, Schaffhausen
Elaine and Werner Dannheisser
Ellyn and Saul Dennison,
Bernardsville, New Jersey
Deutsche Bank AG, Frankfurt
Deutsche Bank Luxembourg S.A.
Anthony d'Offay Gallery, London
Stefan T. Edlis Collection
Froehlich Collection, Stuttgart
Fundació "La Caixa," Barcelona
The Arthur and Carol Goldberg
Collection
Solomon R. Guggenheim Museum,
New York
Galerie Michael Haas, Berlin
L. C. Heppener, The Netherlands
Hess Collection, Napa, California
Ronnie and Samuel Heyman,
New York
Hirshhorn Museum and Sculpture
Garden, Smithsonian Institution,
Washington, D.C.

Collection IFIDA Investments,
Philadelphia
Kleihues Collection
Kunsthaus Zürich
Kunstmuseum Bonn
Thomas H. Lee and
Ann Tenenbaum
Jeanne and Richard Levitt,
Des Moines
Louisiana Museum of Modern Art,
Humlebaek, Denmark
Ludwig Forum für Internationale
Kunst
Le Musée d'Art Moderne et
Contemporain de Strasbourg
Musée de l'Abbaye Sainte-Croix,
les Sables-d'Olonne
Musée National d'Art Moderne,
Centre Georges Pompidou. Paris
Museum Ludwig, Cologne
The Museum of Modern Art,
New York
Michael and Judy Ovitz,
Los Angeles
PaceWildenstein, New York
Darwin and Geri Reedy
Phil Schrager. Omaha
Pippa Scott
Scottish National Gallery of Modern
Art, Edinburgh
Emily and Jerry Spiegel
Staatsgalerie Stuttgart
Stedelijk Museum Amsterdam
Stedelijk Van Abbemuseum,
Eindhoven

Katharina and Wilfrid Steib, Basel
Dr. Michael and Dr. Eleonore Stoffel
Tate Gallery, London
Judith and Mark Taylor
Jamileh Weber Gallery, Zurich
Galerie Michael Werner, Cologne
and New York
Ealan Wingate, New York
Patricia Withofs, London

Private collectors who wish to
remain anonymous

THE SOLOMON R. GUGGENHEIM FOUNDATION

This exhibition is sponsored by

HUGO BOSS

Significant additional support has been provided by
Deutsche Bank AG.

Beck's; The Ministry of Foreign Affairs of the Federal Republic of Germany,
through the German Consulate General in New York; the National Endowment
for the Arts; The Owen Cheatham Foundation; and the New York State Council
on the Arts have also provided generous funding for the exhibition.

SPONSOR STATEMENT

With this exhibition and monograph devoted to the work of Georg Baselitz, Hugo Boss AG continues its remarkable long-term collaboration with the Solomon R. Guggenheim Foundation.

Baselitz is a German artist of international importance. This exhibition is especially significant because his work underscores the conflict between abstraction and figuration, an intellectual debate that has become acutely topical in Germany since reunification. Fifty years after the end of World War II and the division of the country, this debate has flared up as the evolution of abstract art in western Germany clashes with the unbroken tradition of figurative art in eastern Germany.

The Guggenheim Museum and Hugo Boss AG are engaged in promoting innovative artists who question traditional values. We are very glad, therefore, to have a part in the making of this expertly selected and organized exhibition, which will be seen again in Berlin in 1996. From our involvement with this and other Guggenheim programs, we hope to create a positive stimulus for society at large and for our corporate culture.

Peter Littmann
President and CEO,
Hugo Boss AG

In our 125th-anniversary year, Deutsche Bank AG is proud to support this exhibition, which recognizes Georg Baselitz as one of Germany's finest living artists. With the goal of bringing contemporary art to a wider audience, Deutsche Bank AG has a long tradition of supporting the world's leading art museums and artists. We are especially pleased that the exhibition will travel from New York to Los Angeles, Washington, D.C., and Berlin.

In addition to helping museums in their endeavors to bring art to their communities, we believe in creating a daily dialogue with contemporary art. Through our "Art at the Workplace" program, which originated more than fifteen years ago, Deutsche Bank AG has been a significant collector of contemporary art for its branches around the world. By bringing the outstanding work of German and local artists into the workplace, we have provided opportunities for employees and customers to interact with contemporary art and have created a dynamic work environment that fosters excellence and innovation.

This exhibition will provide a stimulating encounter with the work of an artist who, like Deutsche Bank AG, belongs as much to the international community as to Germany.

Hilmar Kopper
Spokesman of the Board of Managing
Directors, Deutsche Bank AG

John A. Rolls
President and CEO,
Deutsche Bank North America

PREFACE

For the last thirty years, Georg Baselitz has produced a body of work that places central emphasis on the figure. His engagement with figurative painting began at a time when representation and its operating principles were under increasing assault. Baselitz has emerged over the past several decades as one of the most compelling artists to revitalize painting and powerfully reinvest realist idioms with a new sense of purpose. His accomplishments have been acclaimed within Europe, most notably in Germany, where he continues to live and work. But it became clear in 1989, following the Guggenheim Museum's *Refigured Painting: The German Image 1960–88,* which was devoted to the proliferation of figurative painting in Germany, that the full range of Baselitz's achievement deserved a thorough examination for an American audience unaccustomed to his radical brand of figuration. *Georg Baselitz* is the first comprehensive survey of the artist's major paintings and sculptures to be mounted in the United States.

Had it not been for the support of Baselitz as well as the dedication and skills of numerous individuals this undertaking might have remained an ideal. I am most grateful to the artist, who over the years since we first worked together has shared his insights into the nature of painting and his developments as an artist. My sincere gratitude also goes to Diane Waldman, Deputy Director and Senior Curator, who undertook the exhibition with great acumen and whose expertise has enlivened and

added immeasurably to our understanding of Baselitz's work, and to Clare Bell, Assistant Curator, who has worked with her so ably.

The Guggenheim has been extremely fortunate to have had the opportunity to work with Hugo Boss AG to realize this project. Our joint efforts serve as a reflection of their strong commitment to innovation and excellence in the arts, and signal a collaboration between a museum and corporation that is unparalleled in its goals and scope of ideas. I am indebted to Peter Littmann, President and CEO, for his enlightened generosity. Dr. Littmann and his colleagues have shown extraordinary creativity and dedication in support of our ongoing landmark partnership and this exhibition in particular.

My thanks are also due to Deutsche Bank AG, in particular to Hilmar Kopper, Spokesman of the Board of Managing Directors; John A. Rolls, President and CEO, Deutsche Bank North America; Herbert Zapp, Member of the Board of Managing Directors (retired); and Michael Rassmann, Executive Vice President and General Manager. Their long-standing relationship with Baselitz is reflected in the bank's collection and its important financial support. Critical resources were also made available by the Ministry of Foreign Affairs of the Federal Republic of Germany through the German Consulate General in New York. My sincere gratitude goes to Dr. Erhard Holtermann, Consul General, and to Thomas Meister, Consul, who were crucial advocates and supporters from the project's inception. In addition, my appreciation extends to Beck's and its Managing Director, Josef Hattig.

The Owen Cheatham Foundation has over a period of many years helped the museum realize major exhibitions. I am deeply indebted for this continued support and for the contributions of the Mnuchin Foundation, and the Merrill G. and Emita E. Hastings Foundation. Critical funding was provided by the National Endowment for the Arts and the New York State Council on the Arts, whose help made this project's research possible. My thanks also go to Michael Werner of Galerie Michael Werner, New York and Cologne, Arne Glimcher of PaceWildenstein, and Anthony d'Offay of Anthony d'Offay Gallery, London, for their help in sustaining every phase of implementation.

Finally, the cooperation and good will of the participating venues and, especially, the lenders to the exhibition deserve special recognition. Their willingness to share their spaces and, above all, their works in an effort to facilitate an awareness and understanding of Baselitz's achievements is abundantly evident and greatly appreciated.

Thomas Krens
Director

ACKNOWLEDGMENTS

The ideas behind this exhibition and publication were enriched and developed by an ongoing dialogue that I have shared with Georg Baselitz over the course of several years. A prolific artist and writer, Baselitz is also an engaging and knowledgeable conversationalist. Often, our talks have moved back and forth through the annals of art history, while the artist generously shared his insights and inspirations. At other times, we have taken up his personal reflections and experiences as an artist and as a German. Each time we sit down to talk, I witness the intensity of his vision and his abounding energy. He and his wife, Elke, have treated me with the warmest of hospitality. Without their personal support and assistance, this undertaking would never have been realized.

This project was aided by many individuals. Detlev Gretenkort, the artist's assistant, gave generously of his time and expertise to help oversee many of the details involving the selection and installation of the exhibition and the production of this monograph. Clare Bell, Assistant Curator, and Tracey Bashkoff, Curatorial Assistant, coordinated every phase of the exhibition and publication. To them, I owe my deep gratitude.

Michael Werner, Baselitz's first dealer, continues to be an avid patron and friend of the artist. He has provided critical support, as have the staffs of his galleries in Cologne and New York, in particular, Gordon VeneKlasen, Director, Justine Birbil, and Blair Wrinkle. I am also indebted to Benjamin Katz, who, like Werner, shared his account of

Baselitz's early years. I am grateful to Arne Glimcher, Douglas Baxter, Executive Director, and Marc Glimcher, Director, of PaceWildenstein for sharing their insights and expertise, and to Linda Ashkraft, Registrar, for her help with several loans. I also extend my sincere appreciation to Anthony d'Offay for his important contributions.

I thank the members of the Guggenheim Museum's staff for their assistance and professional commitment. Most especially, I am grateful to Thomas Krens, Director, with whom I began this project and whose admiration for the artist's work is long standing. His encouragement and support have been essential. My deep appreciation goes to Maryann Jordan, Director of External Affairs, and Barbara Steffen, Executive Assistant to the Director, for their unwavering efforts in raising the funds to mount an exhibition of this magnitude. My sincere thanks go as well to Judith Cox, General Counsel, and Amy Husten, Manager of Budget and Planning, for overseeing many of the important details involved with the exhibition's development and its itinerary. To Catherine Vare, Director of Communications, I also convey my gratitude.

My heartfelt appreciation is extended to Anthony Calnek, Director of Publications, for managing every aspect of the catalogue and for his vital edits to my text. The publication would not have been possible without the expert participation of Elizabeth Levy, Production Editor, Laura Morris, Associate Editor, Edward Weisberger, Assistant Managing Editor, Jennifer Knox, Assistant Editor, and Carol Fitzgerald, Editorial and Production Assistant. A special debt of thanks goes to Takaaki Matsumoto of Matsumoto, Inc. for his perceptive design of the catalogue and to his talented assistants, John Rodrigues and Amy Wilkins.

My thanks are also due to Katharina Katz for her indispensable assistance during the project's initial phases in helping to gather and discern critical materials. I also extend my gratitude to Anne Jones for her expertise during the project's final phases. The many interns who gave enthusiastically of their time include Karrie Adamany, Poly Colovos, Pilar Del Valle de Lersundi, Blythe Kingston, Elizabeth Koerner, Josette Lamoureux, Raphaele Rivier, Sandra Rothenberg, Susan Joan Schenk, Amy Stern, Gerhard Straube, Elena Urizar, and Jacqueline van Rhyn.

The enormous and challenging task of transporting Baselitz's work has been expertly coordinated by Linda Thacher, Exhibitions Registrar, Pamela Myers, Administrator for Exhibitions and Programming, and Scott Wixon, Manager of Installation Services, Joseph Adams, Senior Museum Technician, Peter Read, Jr., Manager of Fabrication Services, Cara Galowitz, Manager of Graphic Design Services, Michelle Martino, Graphic Designer, Adrienne Schulman and Wendy Cooney, Lighting Technicians, and

Kelly Parr, Project Assistant, among many others, were chiefly responsible for all aspects of the installation, thoughtfully reconciling the complexities the works posed in the spaces of the Frank Lloyd Wright building. I also extend my thanks to Julie Barten, NEA Fellow in Conservation, for her contributions in the planning phases of the installation.

I am genuinely indebted to the exhibition's sponsors It is through their generosity and support of the artist that the Guggenheim Museum has the opportunity to mount this exhibition. Finally, my thanks go to the lenders who magnanimously agreed to share their works. It is because of them that we are able to present Baselitz's vision to an American public that until now has not had the opportunity to become familiar with the breadth of his extraordinary achievements.

Diane Waldman
Deputy Director and Senior Curator

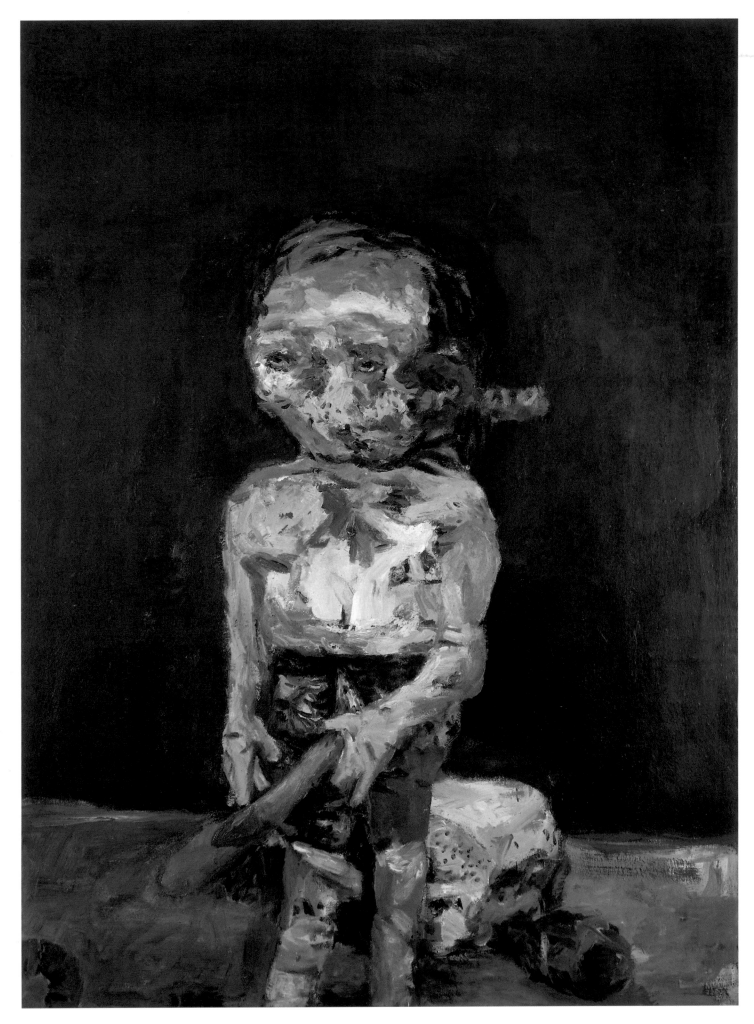

1. Georg Baselitz, *Die grosse Nacht im Eimer* (*The Big Night Down the Drain*),

1962–63. Oil on canvas, 250 x 180 cm (98 3/8 x 70 7/8 inches). Museum Ludwig,

Cologne, Ludwig Donation.

GEORG BASELITZ: ART ON THE EDGE

I look on my past as a stranger would. All that I have done in my life I can use as a stranger would.[1]

Biological Beginnings

Georg Baselitz recalls that the opening day of his first solo exhibition was uneventful. Held in West Berlin on October 1, 1963, it marked the debut of both the twenty-five-year-old artist and a new gallery founded by two young dealers, Michael Werner and Benjamin Katz. Perhaps because it coincided with the Berlin Festival, the opening drew a large crowd, which included a well-known literary critic and Berlin's Senator for Science and Art. While the critic was heard to comment, "in rage and despair," that "he had never seen anything so frightful and repulsive in his life," the senator, in a letter written some time after the exhibition came to be viewed as a scandal, wrote that "I saw no sign . . . that the pictures on display were causing offence."[2]

The day after the opening, the German Press Agency issued a report on the exhibition that put a sensationalist spin on it: "Alarmed, horrified and shocked, the invited guests, among them Berlin's Senator for Science and Art, Arndt, stood before the scandalous oil-paintings of Georg Baselitz. . . . Whispering groups of smartly dressed people jostled past the fifty-two obscene oil-paintings, watercolours and drawings . . . bewildered or

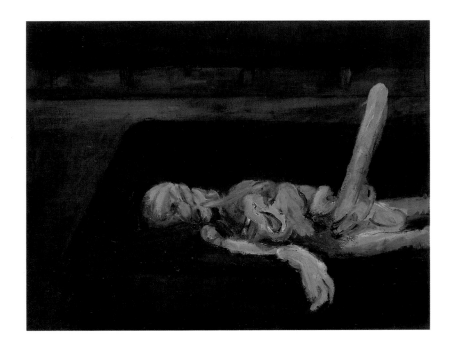

disgusted by so many horrors."[3] On October 3, the Berlin newspaper *Der Tagesspiegel* ran a review by critic Heinz Ohff that encapsulates the intense reaction the show provoked in the press. Although "Baselitz is considered an up-and-coming man in Berlin," wrote Ohff, "his work would best be kept out of the public eye. . . . Baselitz's paintings appear to have risen from the gutter and not above it." While Ohff conceded that art and morality should have nothing to do with one another, he concluded that Baselitz's aim was to shock the bourgeoisie. As for Werner and Katz's decision to launch their gallery with a show of works by Baselitz, he stated dismissively: "This is the kind of stuff you finish with."[4]

On October 4, the story moved to *Der Tagesspiegel*'s editorial page, where Ohff reported that the district attorney's office had confiscated two paintings—*Die grosse Nacht im Eimer* (*The Big Night Down the Drain*, 1962–63, no. 1) and *Der nackte Mann* (*The Naked Man*, 1962, no. 2)—for their "lewd," "pornographic," "revolting," "phallic," and "obscene" nature. In Ohff's account, and in a related editorial-page article, the newspaper cited Article 5 of the Grundgesetz (the West German constitution), which guarantees freedom of speech, and Paragraph 184 of the Strafgesetzbuch (the penal code), which provides definitions of "lewd" and "erotic" matter as well as of "the infringement of public morality," to express its disagreement

with the district attorney's confiscation of the paintings. Ohff reiterated his judgment that the paintings were "revolting," but denied that they had any "erotic" content.[5]

In fact, the two paintings had *not* been seized by the authorities on October 3, yet all told, nineteen German newspapers joined in to further ignite—or help to create—the controversy. The press stories created a self-fulfilling prophesy, and on October 9 the show was actually raided by the police.[6] For its part, the politically conservative West German government maintained that the threat to public morality in this case outweighed the loss of an individual's right to freedom of expression.[7]

Born in Germany on the brink of World War II, and raised in the Soviet-dominated portion of a divided nation, Baselitz was all too familiar with the political complexities of his native country. Baselitz's exhibition came just two years after the erection of the Berlin Wall, the culmination of deep-seated tensions between the Soviet Union and its former allies that stretched back to their common victory over Nazism. Soon after Berlin fell to Russian troops on May 2, 1945, the city, administered by the four Allied powers, became the staging area of what would become the Cold War. A decisive event occurred in June 1948, when the American, British, and French, who controlled West Berlin, introduced the West German mark as the city's official currency; the Soviets, fearing

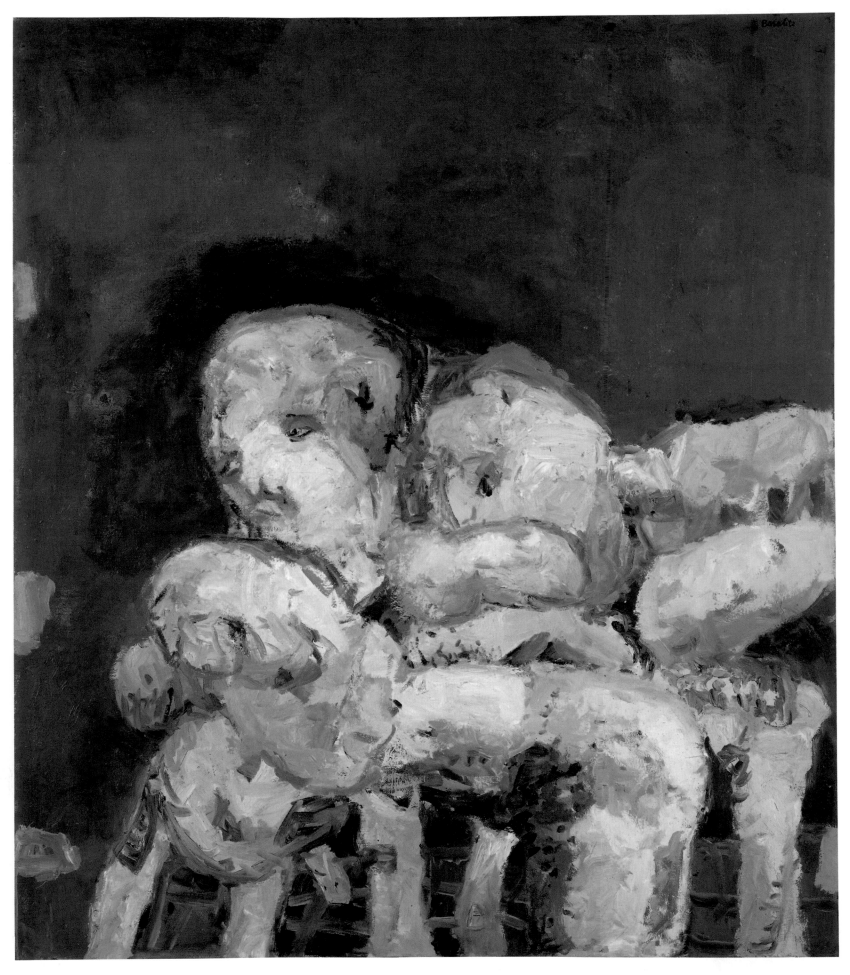

3. Georg Baselitz, *Geschlecht mit Klössen* (***Sex with Dumplings***), 1963. Oil on canvas,

190 x 165 cm (74 ³/₄ x 65 inches). Private collection, Germany.

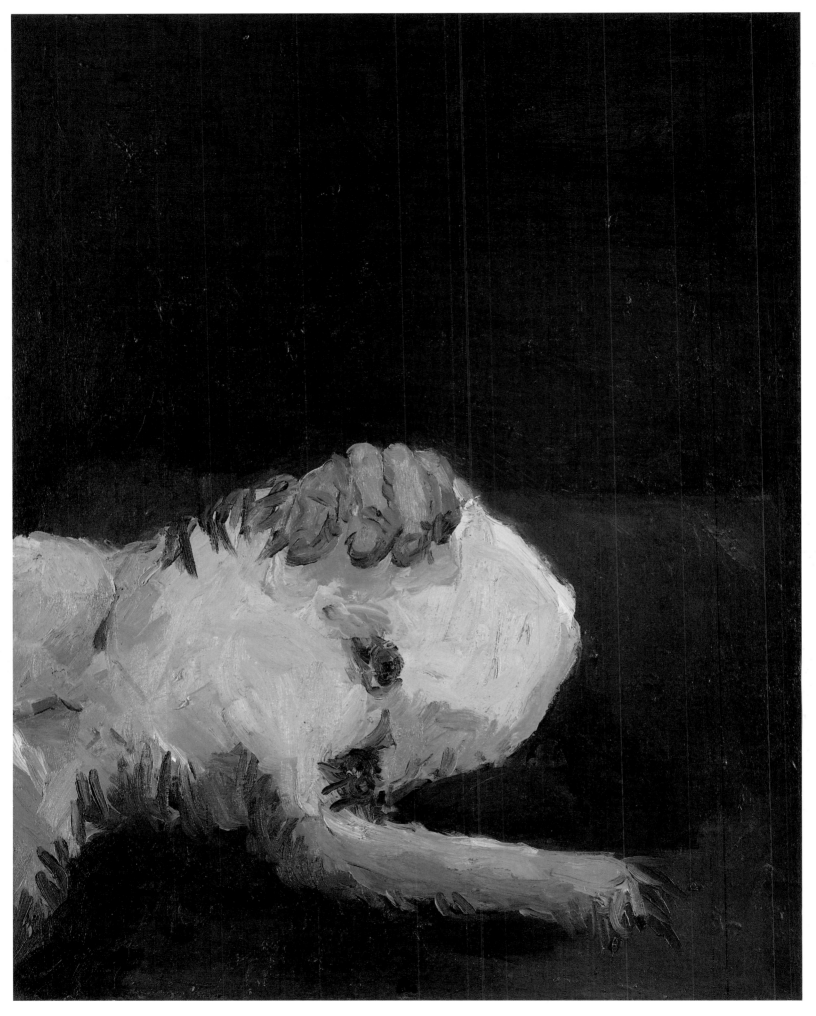

4. Georg Baselitz, *Tränenbeutel* (*Tear-Sac*), 1963. Oil on canvas, 100 x 80 cm
(39 3/8 x 31 1/2 inches). Collection of Pippa Scott.

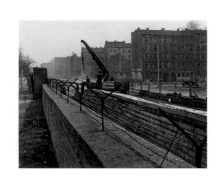

5. The Berlin Wall under construction.

that West Berlin would soon be fully absorbed into the West, retaliated by imposing a blockade around the city. Shortly thereafter, Western forces began a massive airlift, transporting supplies into beleaguered areas of the city. In May 1949, the blockade was lifted. That October, the German Democratic Republic was created from the Soviet Occupied Zone and East Berlin was named its capital. In 1950, West Berlin was made a state of the Federal Republic of Germany.

During the 1950s, West Berlin became a showcase of western values, boasting consumerism, a free press, and open elections (although West Berlin citizens were not afforded representation in the national parliament). The border between East and West remained open, and over the course of the decade more than three million citizens of East Germany defected to the West, half of them by crossing into West Berlin. To halt the exodus, which was crippling the nation's economy, the East German government erected the Berlin Wall on August 13, 1961. A devastating solution, the wall severed the lifelines of Germany's most active city.

A city divided into two political camps, one fiercely anti-Fascist, the other capitalist, Berlin was also divided into two distinct artistic milieus, each informed by recent history. The Third Reich had brutally terminated a long and distinguished painting tradition in Germany. Hitler's regime mounted a virulent attack against Modernism and its major

proponents, among them Willi Baumeister, Max Beckmann, Otto Dix, Ernst Ludwig Kirchner, Franz Marc, and Emil Nolde, labeling their extraordinary achievements "degenerate art" and auctioning off and even burning scores of their works.[8] The Nazis supplanted Modernism with an art designed to serve the regime's political agenda. Stalin's approach to art in the Soviet Union had been similar, and so it was only natural that the Soviet-backed East German government would view art as a tool of the state.

West Berlin, no longer subject to Nazi subjugation of the arts but isolated from Western Europe, produced a generation of disenfranchised artists. For fifteen years after the war, there were no German role models for younger artists like Baselitz. Baselitz speaks of this period as a time of immense wariness. "Among the postwar generation of artists," he says, "the distrust against everything that had been shown, against everything that was around, was very pronounced."[9] During the 1950s, the prevailing aesthetics in West Berlin were Art Informel and Tachisme,[10] and Existentialism was the motivating philosophy among artists and writers. Baselitz experimented with Art Informel and Tachisme, and was influenced by writers like the Surrealist poet and dramatist Antonin Artaud (theorist of the "theater of cruelty"), whose utter disregard for convention, bouts of madness, and savage commentary on invention corresponded to the mental anguish of a young artist caught up in the war and its aftereffects. Baselitz

saw himself as an outsider and was drawn to artists and writers who were also marginal figures. In this respect, he differed significantly from other East German artists of roughly the same generation, like Sigmar Polke and Gerhard Richter, painters who moved to Düsseldorf to complete their studies in 1953 and 1960 respectively, and subsequently settled in West Germany. Polke and Richter eagerly embraced American pop culture in the early 1960s, and, along with Konrad [Lueg] Fischer, in 1963 invented a movement they dubbed Capitalist Realism. Their works utilized specific sources from the media and highlighted the burgeoning awareness of American capitalism and its blatant appeal.

Baselitz and others of his generation were attracted to a more personally expressive art that centered around the figure. Their activity was concentrated around West Berlin's Staatliche Hochschule für Bildende Künste (state academy for fine arts), where Baselitz studied from 1957 to 1962. Paintings like *The Naked Man* and *The Big Night Down the Drain,*[11] with their oversized phalli, were a form of youthful rebellion against all forms of "official" art, be it the Socialist Realism sanctioned by East Germany or the abstract Art Informel and Tachisme favored in Western Europe.

The confiscation of the works shown at Werner and Katz led to a lengthy legal battle. On June 30, 1964, a Berlin court convicted Baselitz and his dealers of "jointly exhibiting

6. The schoolhouse in Deutschbaselitz in which the Kerns lived.

obscene pictures," and each was fined DM400. They appealed the case to Federal Court, and on March 23, 1965, the original sentence was thrown out and a new trial ordered. A conclusion was finally reached on October 20 of that year, when another court dismissed the case because of its "triviality," while maintaining, nonetheless, that the accused were "obviously guilty of the offence."[12] Although a watercolor and a painting were sold at the time of the exhibition—the painting, *P. D. Stengel* (1963),[13] was bought by the noted Berlin dealer Rudolph Springer—the show was not critically reviewed by the art-world press and, once the furor surrounding the seizure of the paintings died down, it attracted little attention from the public at large. From Baselitz's point of view, however, the exhibition was important because, as he puts it, "these paintings are, so to speak, the biological beginning."

Baselitz's true beginning occurred on January 23, 1938, in Grossbaselitz, in Upper Lausitz, Saxony, a country village located a short distance from Dresden.[14] Born Hans-Georg Kern to Johannes and Lieselotte Kern, he was the second of four children, who included his elder sister, Rosemarie, and two younger brothers, Günter and Andreas. The village, originally called Deutschbaselitz, had been renamed Grossbaselitz by the Nazis to incorporate the neighboring village of Wendischbaselitz, where an enclave of

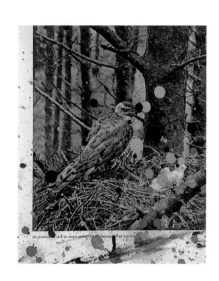

7. Nature photograph from a book by Emil Sonnemann and Kurt Gentz, *Mit Kajak und Kamera – Streifzüge zweier Vogelfreunde durch Sumpf, Moor und Heide* (Dresden: Sachsenverlag, 1949). Baselitz used this photograph as the source for no. 74.

Sorbs and Wends, Slavic peoples, still live. Following the war, the village reverted to its original name. Baselitz was born in its schoolhouse, where the family lived. The school consisted of two classrooms in which his father and an assistant taught; because the village was small, four primary grades were instructed at one time. As the head of a school, Johannes was conscripted into the NSDAP (National Socialist German Workers Party). A soldier during World War II, he lost an eye in battle; after being held prisoner by the British army for a time, he was interned for six months in a Russian prison. Because of his NSDAP affiliation, after the war, he was forbidden to teach for many years, and Baselitz's mother, a housewife, became a teacher instead. The village had no church, but a pastor from Kamenz, the capital of the region, came to preach in the schoolhouse. (Baselitz recalls that his father played the harmonium during Sunday sermons.) Baselitz's uncle, Wilhelm Kern, a pastor from Dresden whom the artist credits with possessing erudite knowledge and an interest in art, often visited.

The young Baselitz began to browse among the books in the schoolhouse library (inherited from the local castle, which, as an unwelcome reminder of Germany's feudal past, was destroyed by the East German government) and discovered numerous nineteenth-century albums of pencil drawings recording the travels of a member of the von Zechwitz family. The drawings in these diaries were Baselitz's first encounter with

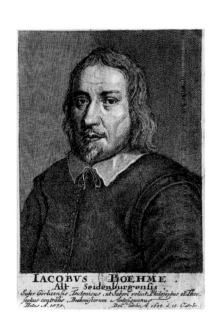

8. Anonymous engraving, *Portrait of Jakob Böhme*, seventeenth century. Bibliothèque Nationale de France, Paris.

art. Other inspirational events of his childhood include the time his uncle showed him a book about the nineteenth-century Saxon artist Louis Ferdinand von Rayski, who painted in the style of Gustave Courbet, and when he assisted the naturalist photographer Helmut Drechsler in finding material for his photographs. His contact with Drechsler ignited a longstanding interest in nature photography, and Baselitz based some of his later paintings of birds (no. 74, for example) on such works.

In 1950, the family moved to Kamenz, where Baselitz completed his primary- and secondary-school education. In the school auditorium, he saw a lithograph of von Rayski's painting *Wermsdorfer Wald* (*Wermsdorf Wood*, 1859, no. 70); the image would become the model for his first fully executed upside-down painting, *Der Wald auf dem Kopf* (*The Wood on Its Head*, 1969, no. 69). Baselitz was also an avid reader. He was particularly impressed by the writings of Jakob Böhme, a seventeenth-century mystic and theologian whose portrait hung in the Kamenz city hall. Böhme had attempted to reconcile the positive and negative sides of existence—good and evil, light and dark—which he saw as stemming from the same source. He was a major influence on nineteenth-century philosophers such as Georg W. Hegel, Friedrich Nietzsche, and Arthur Schopenhauer. Baselitz investigated the land around the village and was impressed by urns he found in a Slavic graveyard and by ancient stone

crosses; crosses would become an important motif in his paintings of the mid-1960s (no. 71, for example).

Although Baselitz began making fantasy drawings and watercolors as a youngster, he was inspired to paint by one Herr Lachmann, a teacher from Kamenz who worked in a Neue Sachlichkeit style.[15] Baselitz found, however, that painting forms from nature in the Neue Sachlichkeit style did not appeal to him. His parents, moreover, objected to his interest in becoming an artist, primarily because they thought he could not make a living at it. They urged him to consider a career as a drawing teacher or as a porcelain painter. Baselitz refused, and applied to the Kunstakademie (art academy) in Dresden in 1955, but was rejected. In 1956, he applied to the Staatliche Forstschule (state forestry school) in Taranth. Although he was accepted, he applied and was admitted to the Hochschule für Bildende und Angewandte Künste (academy for fine and applied arts) in East Berlin, where the conservative curriculum was dictated by Communist theory and Socialist Realism. Baselitz was aware that the majority of the students were well schooled in drawing from the nude and in studies from nature; his own experience was limited primarily to his imagination. Two professors, Walter Womaka and Herbert Behrens-Hangler, taught painting technique, and Behrens-Hangler was especially important to the young student because he was more informed about Modern art.

It was at this time that Baselitz became friendly with Peter Graf and A. R. Penck (who then went by his given name, Ralf Winkler). Graf was from Dresden and was knowledgeable about twentieth-century art. They formed a circle around Behrens-Hangler. who in his own work rebelled (albeit secretly) against official doctrine by painting in a Futurist style. Baselitz and Graf also frequented jazz clubs and listened to recordings by Bix Beiderbecke, Johnny Dodds, and Baselitz's favorite, Charlie Parker. With Graf, he traveled to West Berlin by train and saw what the West had to offer in the way of Modern art—Cubism, for example, which meant more to them than anything they had seen in East Berlin, so much so that they stole postcards of works by Pablo Picasso to bring back to the East because they had no money. Baselitz recalls:

> At the school in East Berlin, while there was no information on art during the Third Reich, there was no information on art before that time either. There was no information on the Bauhaus or the like. It simply was omitted. The bridge backward went as far as Adolph von Menzel . . . and perhaps some [Lovis] Corinth. . . . [Max] Liebermann also. but not so much, because his subjects were too bourgeois. [In West Berlin, on the other hand,] there was an abundance of information, exhibitions and pictures and discussions, such an immense profusion of them that at the beginning I was totally confused.

9. Georg Baselitz, *Ohne Titel (Onkel Bernhard)* (*Untitled [Uncle Bernhard]*), 1958. Watercolor, india ink, and wash on paper, 30.9 x 21.4 cm (12 1/8 x 8 3/8 inches). Private collection, Germany.

10. Ernst Wilhelm Nay, *Orbit*, 1963. Oil on canvas, 139.7 x 169.6 cm (55 x 66 3/4 inches). Estate of the artist.

During school break, most students were expected to do industrial work in Rostock, on the Baltic, but Baselitz remained at school, where he painted fifty new canvases. Because these works were thought "incomprehensible," he was expelled from the academy after two semesters for "socio-political immaturity."[16] Graf, who was also expelled, returned to Dresden. Baselitz wanted to stay in East Berlin, but since he had no money and no chance of making a living, he had no choice but to leave.

In 1957, he applied for admission to the Staatliche Hochschule für Bildende Künste in West Berlin to study with Hann Trier, and he received a scholarship that enabled him to support himself. He became friends with fellow students Eugen Schönebeck and Benjamin Katz and studied the theories of Vasily Kandinsky and Kazimir Malevich, two early twentieth-century pioneers of abstract art, and those of Ernst Wilhelm Nay, a German practitioner of Art Informel. Baselitz made small studies in the style of Kandinsky (see, for example, *Ohne Titel [Onkel Bernhard]* [*Untitled (Uncle Bernhard)*], 1958, no. 9), but for most of his first year he was preoccupied with following the color theories Nay described in his 1955 book *Vom Gestaltwert der Farbe, Fläsche, Zahl und Rhythmus*, making small-scale works on paper. Nay developed a system of color based on disk forms covering the canvas:

I disregarded the optical theories of color as well as the theory of

11. Hann Trier, *Soledad II (Solitude II),*
1958. Oil on canvas, 149 x 97 cm
(58 5/8 x 38 1/8 inches). Kunstmuseum Bonn.

complementary colors derived from them. What I invented was a pointwise
system, the disk system. . . . The system of color set technique, the pointwise
disk system, made it possible to cover the surface almost choreographically.
Disks, several disks of the same color, ran over the surface, with each color
group of disks constituting an unobjective figuration. The disk groups taken
together—in three different colors, for example—constituted a constellation
on the surface.[17]

Baselitz studied with Trier from 1957 through 1962, taking his 1961–62 master
class, but disagreements eventually arose between them. Trier stated that West German
postwar society was organized in such a way that everyone could do what he liked, that
it was a free society where all doors were open. Baselitz soon realized, however, that
ideas that did not fit into Trier's vision met with resistance. Trier was a dedicated
abstract painter and the alternative that Baselitz followed—a commitment to the
figure—was one that Trier had rejected.

From September 1 through October 1, 1958, the academy hosted the historic
exhibition *The New American Painting*. Selected by Alfred H. Barr, Jr. and circulated by
the International Council of the Museum of Modern Art in New York, it included the
works of Philip Guston, Franz Kline, Willem de Kooning, Robert Motherwell, Barnett

12. Philip Guston, *Beggar's Joy*, 1954–55. Oil on canvas, 182.9 x 172.7 cm (72 x 68 inches). Collection of Boris and Sophie Leavitt, on loan to the National Gallery of Art, Washington, D.C.

Newman, Jackson Pollock, Mark Rothko, and Clyfford Still, among others.[18] Simultaneously, the academy also showed a related exhibition, *Jackson Pollock: 1912–1956*, organized by the same museum. Baselitz remembers being especially impressed by the work of Pollock and Guston.[19] He was particularly struck by the large-scale format of many of the paintings of the New York School (Guston, who worked on easel-sized canvases, was an exception), because "in Europe there was a lot of blasting and deformation with regard to content, and very new paintings were conceived, but the format was always maintained." Although he found Pollock's work impressive, there was nothing in his process of pouring and dripping paint that was of use to Baselitz at that time. In Guston's method, on the other hand (for example the way in which he overlapped brushstrokes and clustered areas of color together), there was a directness and even an ungainliness that was refreshingly different from Art Informel. At the same time, Baselitz was aware of how pervasive American influence was in postwar Europe, especially in Germany. As he remarks:

> *Every citizen ate American food, dressed in an American way, drove a car, which looked American, but was smaller, and so on. . . . In brief, it was opportune to take on American habits. . . . Only the intellectuals and also the artists had trouble [with this position].*

16

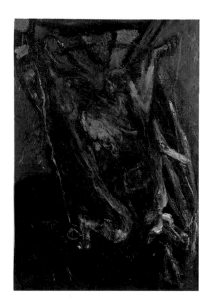

13. Chaim Soutine, *Le Boeuf écorché*
(*The Skinned Ox*), 1926. Oil on canvas,
166 x 115 cm (65 ³/₈ x 45 ¹/₄ inches). Stedelijk
Museum, Amsterdam.

In 1958, Baselitz took up permanent residence in West Berlin, where he met his future wife, Elke Kretzschmar. The next year, he hitchhiked to Amsterdam, where, at the Stedelijk Museum, he particularly recalls seeing Chaim Soutine's painting *Le Boeuf écorché* (*The Skinned Ox*, 1926, no. 13), based on a 1669 work by Rembrandt. On the way home, he stopped in Kassel to see *Documenta 2*. The *Documenta* exhibitions, initiated in 1955 by Arnold Bode, director of the academy in Kassel, became the most important showcase in postwar Germany for advanced international art, rivalled only by the Venice *Biennale* in scope and significance. Held in the city of Kassel, near the border between East and West Germany, the first *Documenta* had been a survey of twentieth-century art, intended "to clos[e] the gap in Germany's knowledge of art events of the preceding twenty-five years."[20] *Documenta 2*, organized by the German dealer Rudolph Zwirner, was devoted to "presenting the development of the art of the last fifteen years in Europe and Europe-oriented countries."[21] It included paintings by many of the Americans Baselitz had seen the year before in Berlin, among them de Kooning, Guston, and Pollock, as well as work by Joan Mitchell. Robert Rauschenberg's *Combine* paintings, such as *Bed* (1955), were also exhibited. Europeans represented included Francis Bacon, Jean Dubuffet, Jean Fautrier (a leading figure of Art Informel), and Asger Jorn. Baselitz's professor, Trier, whose paintings bear a curious resemblance to

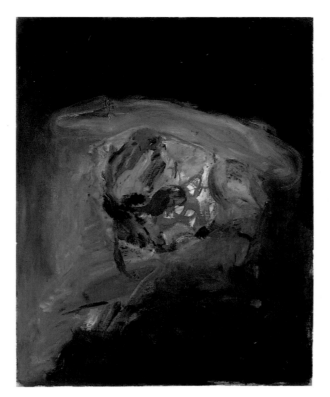

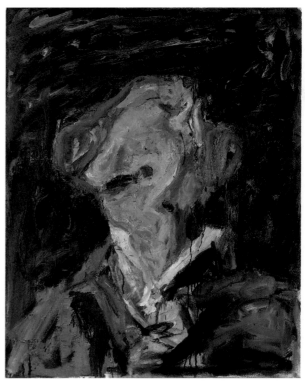

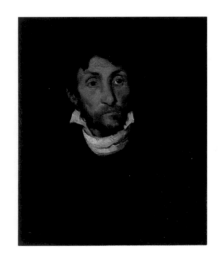

16. Théodore Géricault, *Monomanie du vol*
(*Portrait of a Kleptomaniac*), ca. 1822.
Oil on canvas, 61.2 x 50.2 cm (24 x
19 ¾ inches). Museum voor Schone Kunsten,
Ghent.

those of Mitchell, was also included. While influenced by Guston's mid-1950s work and the way in which the American both grouped and isolated his brushstrokes, Baselitz's paintings of the late 1950s and early 1960s also reflect the influence of the French artist Fautrier, whose emphasis on matter and encrusted surfaces were of vital importance to Baselitz's development at this time.

Baselitz recognized that the models offered by the Bauhaus and the School of Paris—much admired by Trier and his circle—had little connection to him. He sought more personal models in his first attempts at finding his own voice:

> *I remembered what my uncle, the pastor, had shown and told me. And then I started to paint so-called imaginary Rayski portraits. Because Rayski had a concept, a conventional concept in painting, where everything important is placed in the middle. And most important, because they were mostly portraits, was the nose in the middle. And this nose was always very prominent. This is why my first paintings to be taken seriously show these imaginary Rayski heads with the nose in the center. Everything around it, around the head and the face, so to speak, was very vague, very opaque, and actually unimportant, but the nose in the middle was always very important for these paintings.*

17. Georg Baselitz, *Kopf* (*Head*), 1960. Oil on canvas. 100 x 80.5 cm (39 3/8 x 31 5/8 inches). Staatsgalerie Moderner Kunst, Munich. On loan from a private collection.

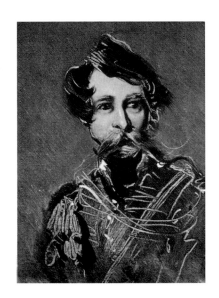

13. Ferdinand von Rayski, *Selbstbildnis in der Schnürenjacke* (*Self-Portrait in Fleece Jacket*), ca. 1839. Stadtmuseum, Bautzen.

Trier called the resulting paintings anachronistic; like most artists of the time, he perceived that art was progressive and of necessity abstract. Baselitz was not, at that time, concerned with the notion of progression, but was taken up with the possibility of making original paintings.

The *Rayski-Kopf* (*Rayski Head*) series (nos. 14, 15, and 17, for example) occupied Baselitz on and off until 1960. He based it on several self-portraits by von Rayski, including one of ca. 1839 (no. 18) in which the artist appears to have used Théodore Géricault's *Monomanie du vol* (*Portrait of a Kleptomaniac*, ca. 1822, no. 16) as his model, and another of 1849 that is relatively straightforward and more typical of his style of portraiture.[22] In Baselitz's portraits of von Rayski, he fused an imaginary portrait of the artist with a painterly abstract style in canvases that owe some of their surface treatment to Art Informel and some of their impetuous brushwork to the canvases of the New York School artists. The notable feature of the paintings, however, is the autonomous role of color, color that does not define the face or its features but exists in and of itself.

Other paintings of the period also reflect the influence of Géricault, whose *Etudes de pieds et de mains* (*Studies of Feet and Hands*, 1818–19, no. 25), sketches for *The Raft of the Medusa* (1819), was undoubtedly a basis for Baselitz's grotesque series *P. D. Füße*

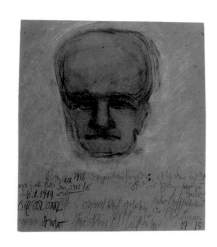

(*P. D. Feet*, 1960–63, nos. 23 and 24, for example).[23] Matthias Grünewald's rendering of diseased skin in the *Isenheim Altarpiece* (ca. 1510–15, no. 41) served as another basis for the series,[24] while the brutal but painterly impact of Soutine's depiction of flayed flesh also played a role. An impressive series of ten paintings in which Baselitz dissects a part of the body and paints it as though it were a whole, the *P.D. Feet* works speak of ugliness and beauty, decay and life. By focusing on parts of the body, and by distorting portions of the figure into amorphous organisms with sensual attributes, Baselitz identifies not only with the writings of Artaud but also in general with the art of the "insane" and their obsessions with religion, sex, and death.

In 1960, Baselitz devoted time to the study of anamorphosis (the distortion of images) and read Jurgis Baltrusaitis's book *Anamorphoses ou perspectives curieuses* (1955). Using Baltrusaitis as his source, he painted works like *Russische Frauenliebe* (*Russian Woman's Love*, 1960, no. 19). Baselitz also became fascinated by the hallucinatory art of the mentally ill, which he saw reproduced in Hans Prinzhorn's *Bildnerei der Geisteskranken* (1923).[25] Early in 1961, he painted *G. – Kopf* (*G. – Head*, no. 21),[26] derived from the work, illustrated in Prinzhorn, made by a mental patient.

That same year, Baselitz made the first of many trips to Paris, and was especially impressed with Gustave Moreau's work, which he saw at the Musée Moreau. In spring

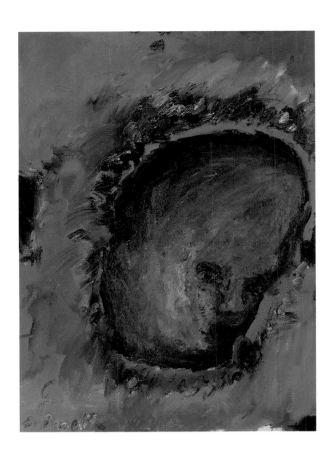

21. Georg Baselitz, *G. – Kopf* (*G. – Head*), 1961. Oil on canvas, 135 x 100 cm (53 ¼ x 39 ⅜ inches). Private collection, Germany.

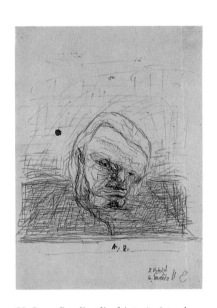

22. Georg Baselitz, *Kopf Antonin Artaud* (*Head of Antonin Artaud*), 1962. Ink on paper, 29.7 x 21.1 cm (11 ⅝ x 8 ⅜ inches). Froehlich Collection, Stuttgart.

1961, he once again visited Amsterdam, where he saw the exhibition *Bewogen Beweging* (*Art of Motion*) at the Stedelijk Museum. The show included a replica (the first of its kind) of Marcel Duchamp's *The Bride Stripped Bare by Her Bachelors, Even* (1915–23; also known as *The Large Glass*). On another excursion to Paris, in fall 1964, he visited the Galerie Furstenberg and saw a large exhibition of late work by Francis Picabia. Baselitz had been impressed by the conceptual premises of the Dada movement, as exemplified by Duchamp, Picabia, and Kurt Schwitters. The movement's antic performances, iconoclastic approach to art, and antibourgeois sentiment undoubtedly appealed to the young artist. So, too, did Picabia's late work, with its blatant vulgarity and ungainly drawings, which suggest a radical departure in the treatment of the figure. Baselitz especially admired Picabia's freedom to change styles.

By this time, Baselitz had assimilated many literary influences, chief among them the poetry of the Comte de Lautréamont (the pseudonym of Isidore Ducasse), a nineteenth-century precursor of the Surrealists, and the writings of the Symbolist poet Charles Baudelaire. His drawings, paintings, and writings reflect their stream-of-consciousness style, evoking both human and anthropomorphic forms strewn about an amorphous landscape. He also dedicated some early drawings to Artaud (no. 22, for example). In his first manifesto, written in 1961, Baselitz paid tribute to his French models:

left: **23. Georg Baselitz,** *2. P.D. Fuß – Alte Heimat* **(Second P.D. Foot – The Old Native Country),** 1960–63. Oil on canvas, 120 x 90 cm (47 1/4 x 35 1/2 inches). Crex Collection, Hallen für Neue Kunst, Schaffhausen.

right: **24. Georg Baselitz,** *Fünfter P.D. Fuß – Russischer Fuß* **(Fifth P.D. Foot – Russian Foot),** 1963. Oil on canvas, 130.5 x 81.5 cm (51 3/8 x 32 inches). Crex Collection, Hallen für Neue Kunst, Schaffhausen.

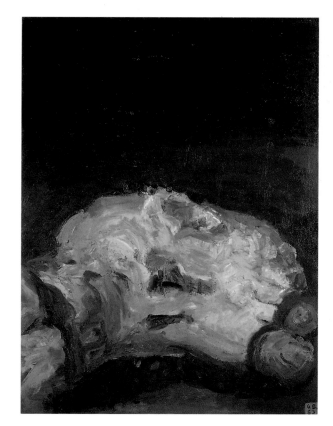 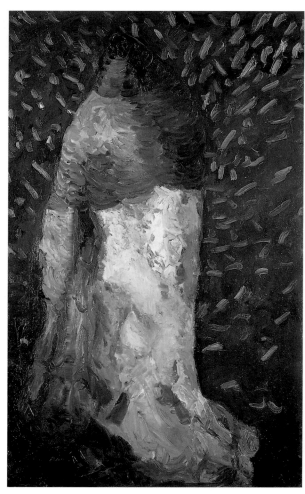

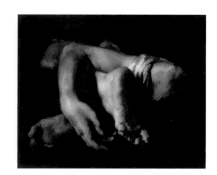

25. Théodore Géricault, *Etudes de pieds et de mains* **(Studies of Feet and Hands),** 1818–19. Oil on canvas, 52 x 64 cm (20 1/2 x 25 1/8 inches). Musée Fabre, Montpellier.

We have blasphemy on our side. . . . In my eyes can be seen the altar of Nature, the sacrifice of flesh, bits of food in the drain, evaporation from the bedclothes, bleeding from stumps and aerial roots, oriental light on the pearly teeth of lovely women, gristle, negative shapes, spots of shadow, drops of wax, parades of epileptics, orchestrations of the flatulent, warty, mushy and jellyfishy beings, bodily members, braided erectile tissue, mouldy dough, gristly growths in a desert landscape.[27]

As a self-imposed outcast who distanced himself from the dominant mode of abstract painting in West Berlin, Baselitz was attracted to other outsiders, past artists like Gaston Chaissac, Carl Fredrik Hill, Charles Meryon, Moreau, and Mikhail Vrubel, and writer August Strindberg. *Hommage à Wrubel – Michail Wrubel – 1911 – Alte Heimat – Scheide der Existenz* (*Homage to Vrubel – Mikhail Vrubel – 1911 – The Old Country – Border of Existence,* 1963, no. 26) pays tribute to the Russian Symbolist, a follower of the Wanderers, a group that denounced the St. Petersburg academic tradition of "art for art's sake" in favor of an art based on reality.[28] Vrubel, who led a life of abject poverty and mental anguish, eventually disavowed the Wanderers' use of art as social propaganda, declaiming, "The artist should not become a slave of the public: he himself is the best judge of his works. . . . To steal that delight which differentiates a spiritual

26. Georg Baselitz, *Hommage à Wrubel – Michail Wrubel – 1911 – Alte Heimat – Scheide der Existenz (Homage to Vrubel – Mikhail Vrubel – 1911 – The Old Country – Border of Existence)*, 1963. Oil on canvas, 162 x 146 cm (63 3/4 x 57 1/2 inches). Froehlich Collection, Stuttgart.

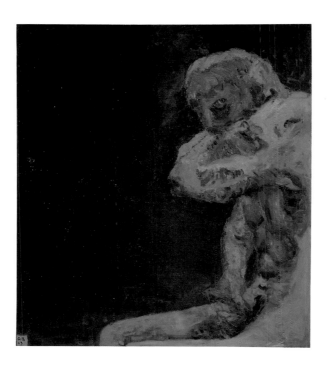

27. Mikhail Vrubel, *The Dance of Tamara*, 1890–91. Watercolor and whiting on paper, mounted on cardboard, 50 x 34 cm (19 7/8 x 13 3/8 inches). State Tretiakov Gallery, Moscow.

approach to a work of art . . . is to deprive man of the best part of his life."[29] Baselitz's painting shows a strongly independent spirit, just the quality that he admired in the Russian artist. The demoniac nature of Baselitz's figure may be an allusion to Vrubel's *Sitting Demon* (1890)[30], one of a series of watercolors he made to illustrate Mikhail Lermontov's poem *The Demon* (1829–41), but it also incorporates imagery related to Auguste Rodin's *The Thinker* (1880) in the pose of the seated figure and in its sense of volume. (Baselitz also looked at the work of Russian artists when he created his *Idols* and *Oberon* paintings of 1964.)

Baselitz and Schönebeck jointly organized an exhibition of their works, which they presented from November 10 through 30, 1961 at an abandoned house at 22 Schaperstraße in West Berlin. The exhibition consisted of thirty paintings and drawings by Baselitz and thirty drawings by Schönebeck. Critic Martin Buttig later wrote that "in order to show his work, Baselitz rented a wreck of a house and the only thing that was missing was anyone to see it."[31] Baselitz and Schönebeck collaborated on two manifestos, which they subsequently referred to as *Pandämonia*. The first manifesto (no. 28), written for the show, includes separate handwritten texts by Baselitz and Schönebeck along with drawings by each. It was made in response to a 1959 manifesto in poster form written by Arnulf Rainer, Friedensreich Hundertwasser,

28. Georg Baselitz and Eugen Schönebeck, *Pandämonisches Manifest I, 1. Version* (*First Pandemonium Manifesto, First Version*), October 1961. Blueprint, 62.5 x 103.9 cm (24 5/8 x 40 1/2 inches). Private collection.

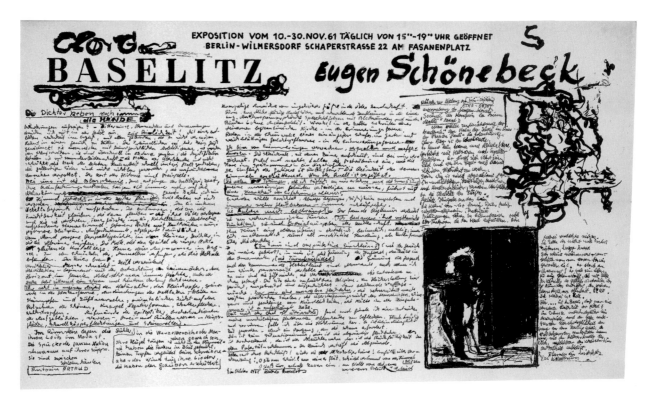

29. Carl Fredrik Hill, *August Strindberg*, n.d. Charcoal and pencil on paper, 41.5 x 34 cm (16 3/8 x 13 3/8 inches). Malmö Museer.

and Ernst Fuchs, a group of Viennese artists using the name Pintorarium. Paying homage to the works of Vrubel, the French Symbolist painter Odilon Redon, Milanese artist Giuseppe Archimboldi, and Artaud, *Pandämonium I* is an angry declaration of support for an art of recollection, mysticism, ecstasy, and fantasy. Comprised of absurd and grandiose phrases conjuring up loathsome images, the manifesto employs a language of apocalyptic proportions. Having aroused very little attention with the first version of their manifesto, Baselitz and Schönebeck published a second, abridged version during the course of the exhibition. It is similar in content but omits references to the artists and writers cited above. Like the exhibition itself, it generated little public attention. The two then collaborated on a second manifesto in West Berlin in early 1962 (no. 30). This manifesto was written in response to one published the previous January by Spur, a Munich-based group linked to COBRA and the Situationists.

Spur, formed by artists Lothar Fischer, Heimrad Prem, Helmut Sturm, and Hans-Peter Zimmer, aimed their cultural criticism at the political parties in the German government devoted to reconstructing the conservative society that existed before the war. In their view, the open-ended society that had existed for a time after the destruction and chaos of World War II had quickly given way to complacency and conformity. The Spur artists banded together with writers, filmmakers, and intellectuals

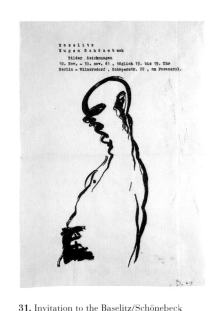

to protest the status quo, which both officially and unofficially sanctioned
constructivism and Art Informel. Spur based its activities on a synthesis of Dada and
Surrealism, using irony as a weapon with which to mount an assault on the
establishment. They pronounced themselves "against the truth, against luck, against
contentment, against a good conscience, against the fat belly, against harmony. . . .
Instead of an abstract idealism we claim a sincere nihilism."[32] The Spur artists painted
expressively and searched for an emotion-filled art form that reflected their time.[33]
Baselitz's and Schönebeck's response consisted of two parts, the first with typewritten
text and drawings by Baselitz and the second with the same by Schönebeck. As
volatile as their first treatise, this manifesto addresses the notions of paranoia, "the
discharges of the flesh, the sexual fantasticality. . . . Pandemonic entrenchment
that leaves no more hope."[34]

To support himself during these years, Baselitz took a series of odd jobs, working as a
driver for a brewery, in a plant nursery, and in a metal factory. Considering Kern too
common a name, in 1961 he adopted the surname Baselitz. In this, he was following a
time-honored tradition of artists who have assumed other names, often that of the town
of their origin (an especially common practice during the Renaissance). In 1962, he
married Kretzschmar. Their first son, Daniel, was born that year.

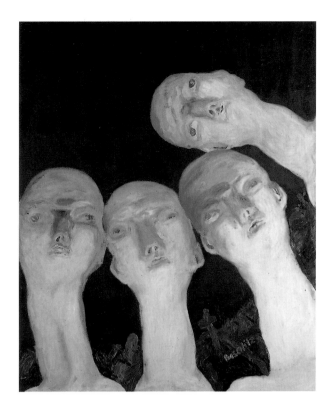

Around the time he finished his studies, Baselitz met Michael Werner, who was working as an assistant at Galerie Springer. The dealer remembers that Baselitz visited the gallery with Schönebeck, both looking rather disheveled, dressed in long coats, with long hair, and smoking cigarettes. They were interested in placing a copy of the *Pandämonium* manifesto in the gallery window. Werner recalls that he finally consented because Baselitz was very stubborn.[35] Some months later, Werner was invited to a party at Baselitz's home and studio on Joachim-Friedrich-Straße by a student from the academy. The studio itself was closed off, but Werner succeeded in getting Baselitz to show him some work and was taken with a series of small drawings and watercolors. A dispute followed about the cost of the drawings, because the price of student work was fixed by the academy at DM30 and Baselitz wanted DM300 per drawing. Soon, an agreement was reached, and Werner began visiting Baselitz's studio frequently. He recalls that Baselitz, like many artists, was poor and to save money often scraped paint from his canvases and reused it as the ground for a new painting. In his student years, he even used paint left over by his classmates. The dark ground became a characteristic feature of such paintings as *Geschlecht mit Klössen* (*Sex with Dumplings*, 1963, no. 3) and *Tränenbeutel* (*Tear-Sac*, 1963, no. 4). When Werner left Springer and formed a partnership with Katz to open their own gallery, they offered the young artist his first

solo exhibition. It was in this exhibition that Baselitz publicly declared his intention to forge a new figurative style, one based on collective history and personal memory.

Heroes

When Baselitz first came to West Berlin from East Germany, he thought of himself as a revolutionary. But his manifestos made little impact and his first solo gallery show raised more controversy than interest in his work. In short, his efforts to prove himself as an artist were unsuccessful, and he found himself in a rather precarious position. In 1965, he won a six-month scholarship to study in Florence. The scholarship, funded by a German bank, consisted of a stipend and the opportunity to live at the Villa Romana. It was Baselitz's first encounter of life in Southern Europe and, as he noted, "I found it infectious."[36] In contrast to the rather grim world he knew in Germany, Italy was a land full of lively cafés, delectable cuisine, sunny weather, and a vital art tradition. Life existed in the most pleasurable of ways.

Italy offered Baselitz a chance to begin anew and provided a treasure of great museums with an unparalleled depth in painting. In his first *Pandämonium* manifesto, Baselitz had confessed his attraction to the Mannerists and their "addiction to excess."[37] In Italy, he sought out their work: the art of Agnolo Bronzino, Rosso Fiorentino, Jacopo

33. Georg Baselitz, *Der Dichter* (*The Poet*), 1965. Oil on canvas, 162 x 130 cm

(63 ³/₄ x 51 ¹/₈ inches). Private collection, Hamburg.

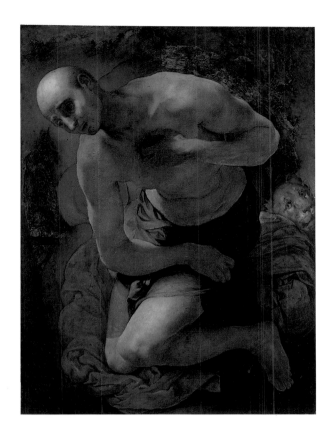

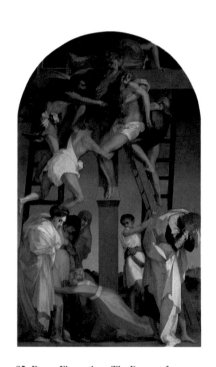

35. Rosso Fiorentino, *The Descent from the Cross*, 1521. Oil on panel, 335.3 x 196.9 cm (132 x 77 ¹/₂ inches). Pinaccteca Comunale, Volterra.

Pontormo, and Parmigianino was especially instrumental in the formation of his imagery. In Mannerist painting, a profoundly disquieting, introspective vision replaced the serene and ordered view of the world described by the art of the High Renaissance, and, stylistically, distortion played a new and major role. Baselitz found in Rosso, the most extreme of the Mannerists, a notable precursor. In Rosso's paintings, such as the monumental *The Descent from the Cross* (1521, no. 35), the forms are angular, the colors nacreous, the mood profoundly disturbing. Baselitz also points to Pontormo's *St. Jerome as a Penitent* (ca. 1527–28, no. 34), at the Landesmuseum in Hannover, as a work he greatly admires.

While he was struck by the Mannerists' work, Baselitz may also have been attracted to them because their lives resembled those of the painters and poets he had admired as a student. Giorgio Vasari's sixteenth-century classic *Lives of the Artists*, which Baselitz read from time to time, indicates that the Mannerists led desolate lives, that Rosso committed suicide, Pontormo was shy and withdrawn, and Parmigianino was a bearded, long-haired, "almost savage or wild man."[38] Vasari's descriptions of many Renaissance and Mannerist painters anticipated the Romantic conception of the artist as someone ill suited for life. *Lives of the Artists* was also read by one of Baselitz's heroes, Artaud, who identified with Vasari's accounts of Renaissance figures like the painter

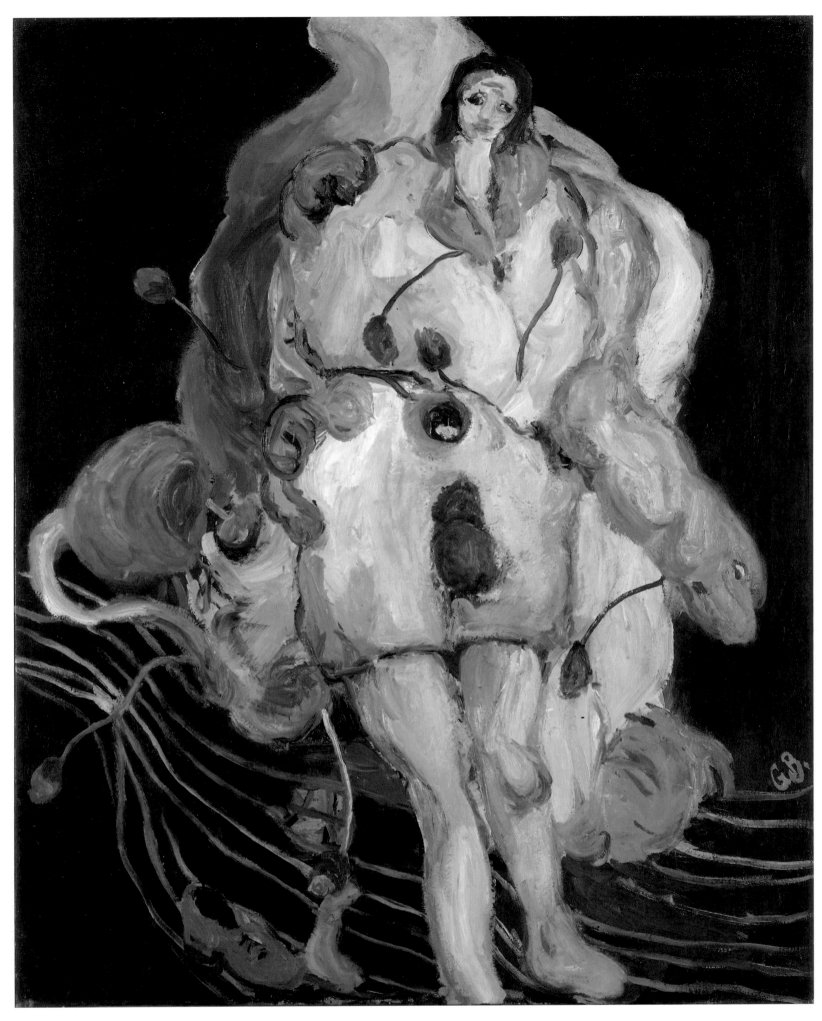

36. Georg Baselitz, *Mann im Mond – Franz Pforr (Man in the Moon – Franz Pforr)*,

1965. Oil on canvas, 162 x 130 cm (63 ³/₄ x 51 ¹/₈ inches). Private collection.

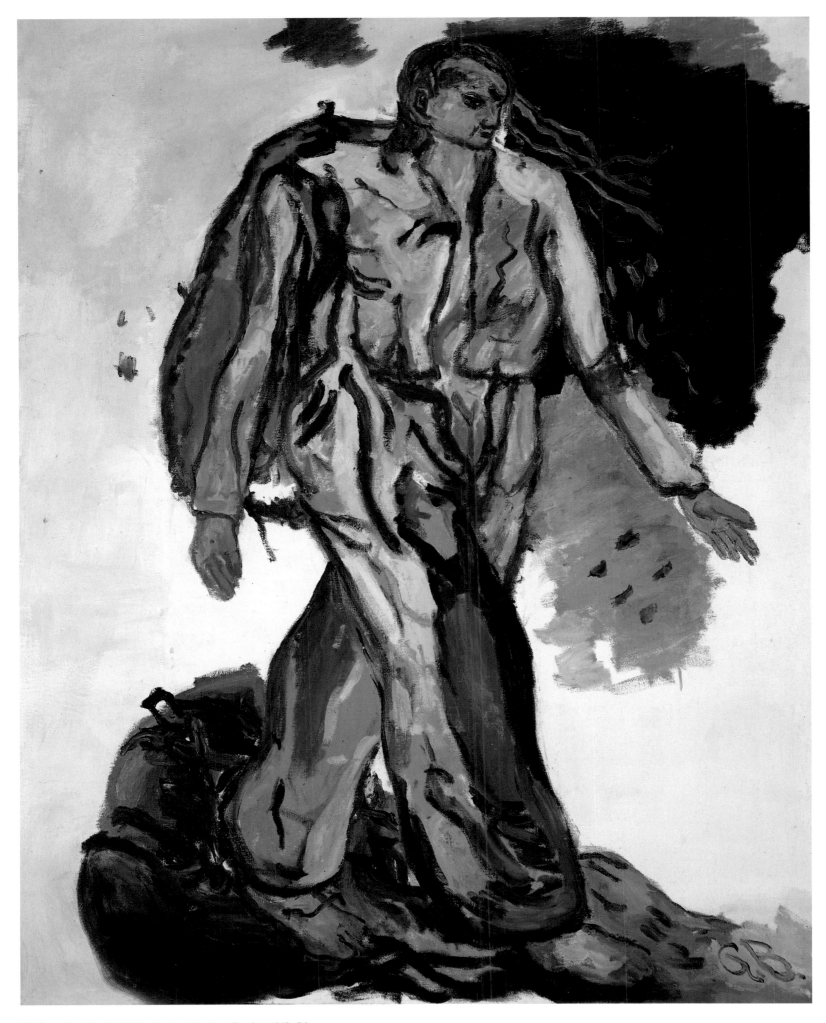

37. Georg Baselitz, *B.j.M.C. – Bonjour Monsieur Courbet*, 1965. Oil on canvas,

162 x 130 cm (63 ³/₄ x 51 ¹/₈ inches). Private collection. Cologne.

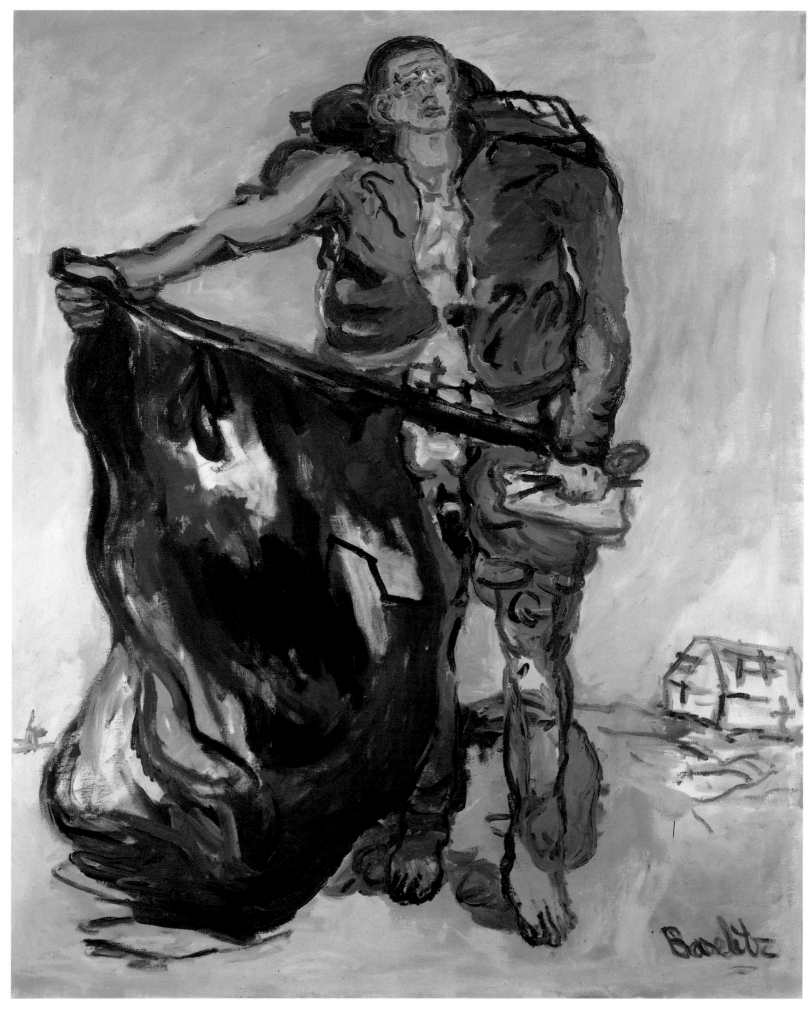

38. Georg Baselitz, *Mit roter Fahne* (*With a Red Flag*), 1965. Oil on canvas, 162 x 130 cm

(63 ³/₄ x 51 ¹/₈ inches). Private collection.

Paolo Uccello, whom Vasari described as "solitary, eccentric, melancholy, and poor."[39]

The attenuated forms, atypical color, and use of distortion characteristic of Mannerism held great appeal for Baselitz. In Italy, he was especially attracted to Mannerist graphics, which reinforced his interest in printmaking (he had produced his first etchings in 1964) and awakened his admiration for the school of Fontainebleau, whose work he found to be "revolutionary" in comparison with German art of the same time.[40] At Fontainebleau, Rosso created some of his most compelling compositions. Because time has ravaged many of the paintings, stucco decorations, and drawings of the Fontainebleau artists, Baselitz believes that the best way to understand their style is by studying their prints. He has written:

> *If you're looking for an immediate image, then there's a lot to be said for prints. This is more obvious in the prints of, say, the Fontainebleau school than in other prints. . . . On the one hand, this makes these works interesting in terms of reconstructing the style and the specific quality of the images invented in Fontainebleau; and on the other hand, these works are more authentic in documenting the new form that was found here.[41]*

Baselitz has also been attracted to work by artists related to the Fontainebleau school, among them the Flemish artist Jan Massys. At the Hamburger Kunsthalle, Baselitz saw

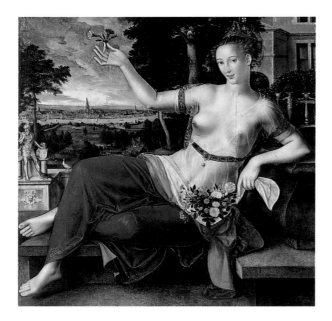

Massys's painting *Flora* (1559, no. 39), a depiction of the ancient Roman goddess of
flowers. Her recumbent, tapered figure, right arm outstretched, fingers holding a few
delicate carnations, is the essence of female beauty; with ivory skin tones and draped in
rich red cloth, she is placed in a courtly setting with Antwerp as a backdrop. Flora was
a familiar subject in art, painted by Titian and Botticelli. An object of beauty, her
artificiality eventually made her a stereotype, an abstraction whose forms Baselitz could
well appreciate, even if he did not choose to directly emulate them in his art.

In Florence, Baselitz worked on a series of canvases that he had brought with him
from Berlin. *Der Dichter* (*The Poet*, 1965, no. 33) and *Mann im Mond – Franz Pforr*
(*Man in the Moon – Franz Pforr*, 1965, no. 36) were the first in the series, which is
known as *Helden* (*Heroes*), *Neue Typs* (*New Types*), or *Partisans*. Baselitz employed
many aspects of Mannerism in the *Heroes*, chiefly the distortion of the figure: the heads
are often notably small in relation to the bodies, while the hands are often exaggeratedly
large. In paintings like *Partisan* (1965, no. 43), for example, the hands are such a
pronounced feature of the figures that they become the focus of the painting. The figures
appear at their most vulnerable when the hands are turned palm outward. In Baselitz's
paintings of this period, the heads and hands are the figures' most expressive features
and endow the images with a sense of poignancy and pathos.

40. Georg Baselitz, *Die Hand – Die Hand Gottes* (*The Hand – The Hand of God*), 1964–65.
Oil on canvas, 140 x 99 cm (55 ⅛ x 39 inches). Kunstmuseum Bonn. On permanent loan from
the Kunststiftung Sparkasse Bonn.

In a related pair of canvases that Baselitz painted prior to beginning the *Heroes*—*Die Hand – Das brennende Haus* (*The Hand – The Burning House*, 1964–65, no. 51) and *Die Hand – Die Hand Gottes* (*The Hand – The Hand of God*, 1964–65, no. 40)—he isolated the hand as he had the foot in the *P. D. Feet* paintings. Each hand is a universe in miniature: in the former painting, it holds a burning house signifying the destruction of a nation, in the latter a house and farmer's tools, which suggest a rebuilding of the land, a theme underscored by birds, the symbol of hope, flying off in the distance.

Art historian Siegfried Gohr claims that Baselitz identified with the vision of the Suprematists and their belief in a new world order, stating that the *Heroes* derive "from the literature of the Russian revolution."[42] Baselitz himself has noted that the figures in the series are based in part on his readings on Russia's reconstruction following the victory of the Red Army over the Whites (the counter-revolutionary forces), which marked the establishment of the USSR. The flag at the feet of the hero in *Mit roter Fahne* (*With a Red Flag*, 1965, no. 38) may symbolize that episode from Russian history. But although Baselitz makes explicit reference to political turmoil in this painting, the figure holding the flag appears passive and disengaged. Indeed, the hero is armed with the emblems of the painter—palette and brush—and is merely a witness.

The *Heroes* paintings demonstrate Baselitz's affinity with German Romanticism, also

representing, he has said, the defeated German soldiers who returned to the wreckage of their homeland after World War II. The subjects of this series are young men—fighters and partisans, poets and painters—with whom Baselitz identified. They are heroes and anti-heroes, existentialist figures from the world of Samuel Beckett, survivors of a world in chaos.

Begun just two years after Richter, Polke, and Fischer created the German version of Pop art and named it, somewhat sardonically, Capitalist Realism, Baselitz's *Heroes* consciously distanced him from this aesthetic, concerned as it was with mass culture and the media. Instead, he deliberately chose as his subject workers and artisans; his "heroes" represented the postwar bourgeois ideal that Americans and Europeans craved and that affected a range of international art movements, including Neo-Dada, Pop, and Nouveau Réalisme. In creating a figure that was the antithesis of the bourgeoisie, Baselitz appeared to be rejecting, through his paintings, the capitalist system of the West. But he was not expressing an advocacy of Communism or of older systems, such as aristocracy or feudalism.

What differentiates Baselitz's work from that of many of his German colleagues is his attachment to the art of the past and to the reality of a world that lies tattered around him. In many of his paintings, the hero is seen in worn, baggy clothing, surrounded by

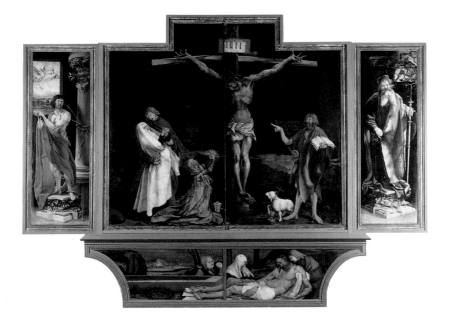

scorched earth, burning houses, crosses, or rusting farm equipment. Destruction appears everywhere, but the figure, a phoenix rising from the ashes, is a survivor. Into this image of a Romantic, melancholy spirit, one may project the artist himself, as wanderer, poet, and painter attached to his bit of earth.

If a comparison is to be made between Baselitz and artists who worked with Pop imagery, it is perhaps not with Baselitz's German peers, but with their American precursors, especially Andy Warhol. It is fair to say that both Warhol and Baselitz were working with archetypes: Warhol with celebrities like Elvis Presley and Marilyn Monroe, heroes of American culture who died tragic deaths, Baselitz with rebels—the partisan, the painter, and the poet, who were outsiders like himself. The comparison ends there, for while Warhol took advantage of technological methods of reproduction, Baselitz honed his imagery with the means of the painter.

Many of the figures in the *Heroes* are single forms rendered frontally and occupying a good portion of the center of the canvas. While this is an unusual format in European painting, precursors do exist, for example in Byzantine painting, medieval manuscript illumination, and Russian icons. But it was the figure of Christ on the Cross in such Northern Renaissance panel paintings as Grünewald's *Isenheim Altarpiece* (no. 41) that suggests a model for Baselitz. The figure of the shepherd, the smallish heads, the

exaggerated hands, and other Christian motifs in Grünewald's painting recur from time to time in Baselitz's paintings of 1965 and 1966. Baselitz often preferred a low horizon line in the *Heroes* series too, a device common in this and other Renaissance paintings.

The youthful figures in the *Heroes* are seated or standing, and each is delineated by a light or dark ground. The figure may refer to a painter Baselitz admires, as in *B. j. M. C. – Bonjour Monsieur Courbet* (1965, no. 37)—in which the younger artist was evidently acclaiming Courbet's Realism—or *Ludwig Richter auf dem Weg zur Arbeit* (*Ludwig Richter on His Way to Work*, 1965, no. 45), an homage to the nineteenth-century German Romantic landscape painter. Other works in the *Heroes* series refer to historical and current events in Germany. These paintings fuse a knowledge of European history with an awareness of postwar abstract painting. But they must also be seen as the self-portrait of an artist who was conscious of his origins and ambitious enough to create a new conception of the painter and a new type of painting in Germany. Baselitz resolved the conflict between past and present styles by recognizing that among his German precursors—Lucas Cranach, Albrecht Dürer, Caspar David Friedrich, and Emil Nolde—were models who had dealt with both beauty and ugliness. He has spoken of Dürer as "the master of the ugly" and of Cranach's "ability to make dwarfs of people and porcelain elves of women"; "of the landscape," he continues, Cranach "made a

42. Georg Baselitz, *Die grossen Freunde* (*The Great Friends*), 1965. Oil on canvas, 250 x 300 cm (98 ³/₈ x 118 ¹/₈ inches). Museum Ludwig, Cologne, Ludwig donation.

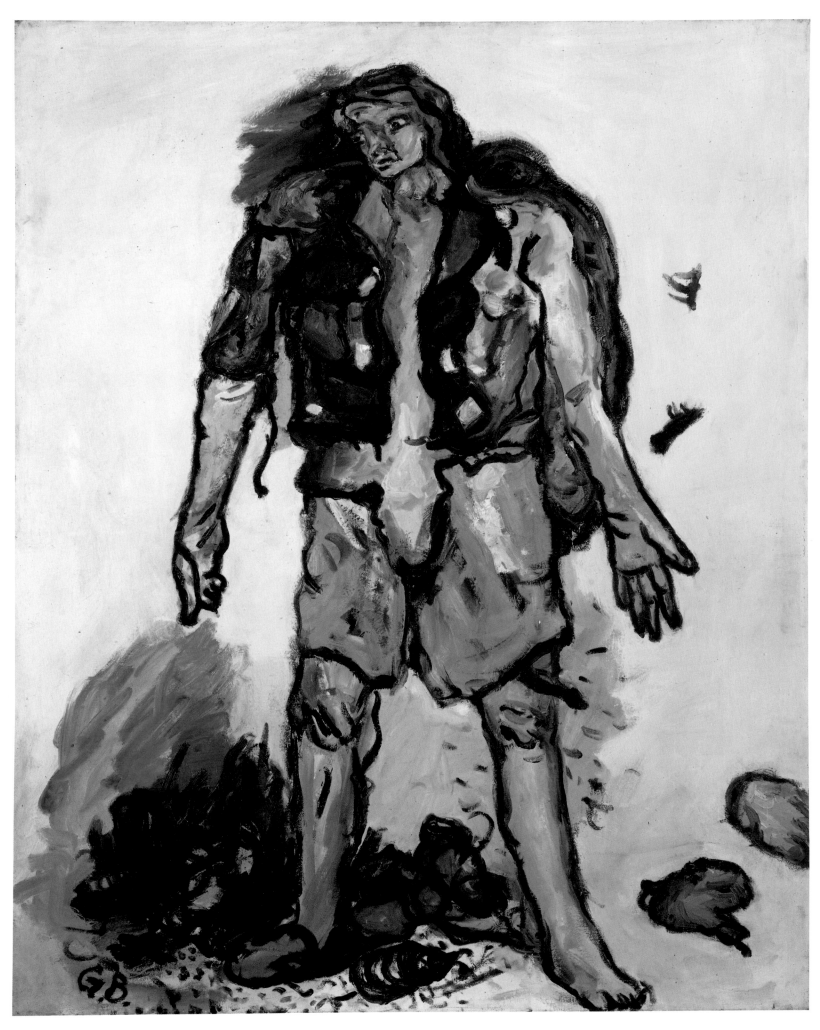

43. Georg Baselitz. *Partisan.* 1965. Oil on canvas. 162 x 130 cm (63 ¼ x 51 ⅛ inches).

Courtesy of Anthony d'Offay Gallery. London.

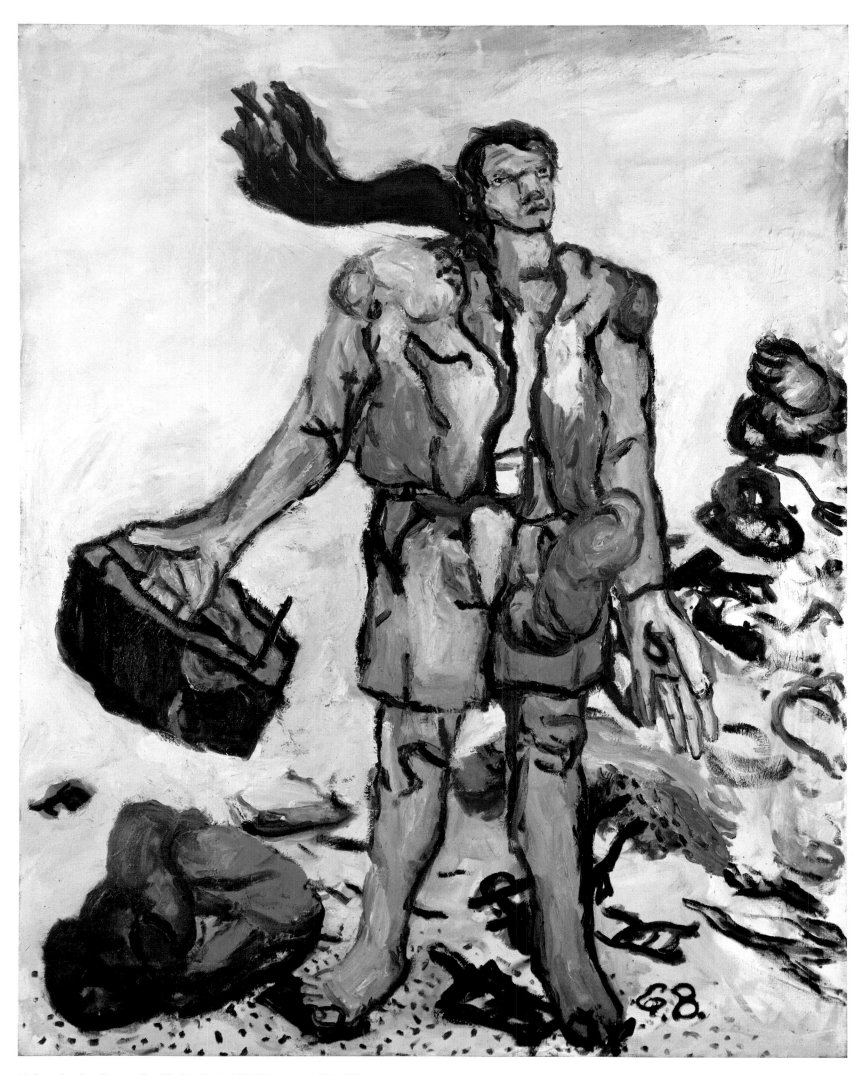

44. Georg Baselitz. *Der neue Typ* (*The New Type*), 1965. Oil on canvas. 162 x 130 cm

(63 ³/₄ x 51 ¹/₈ inches). Froehlich Collection, Stuttgart.

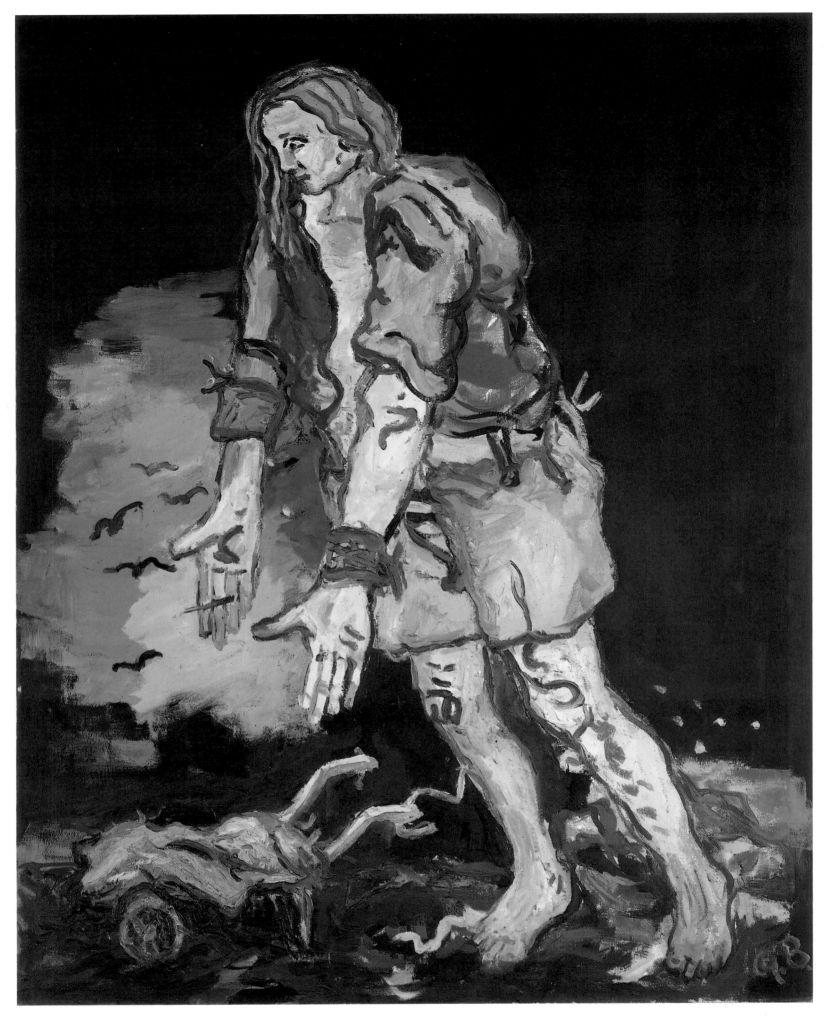

45. Georg Baselitz, *Ludwig Richter auf dem Weg zur Arbeit (Ludwig Richter on His Way to Work)*,
1965. Oil on canvas. 162 x 130 cm (63 ³/₄ x 51 ¹/₈ inches). Private collection.

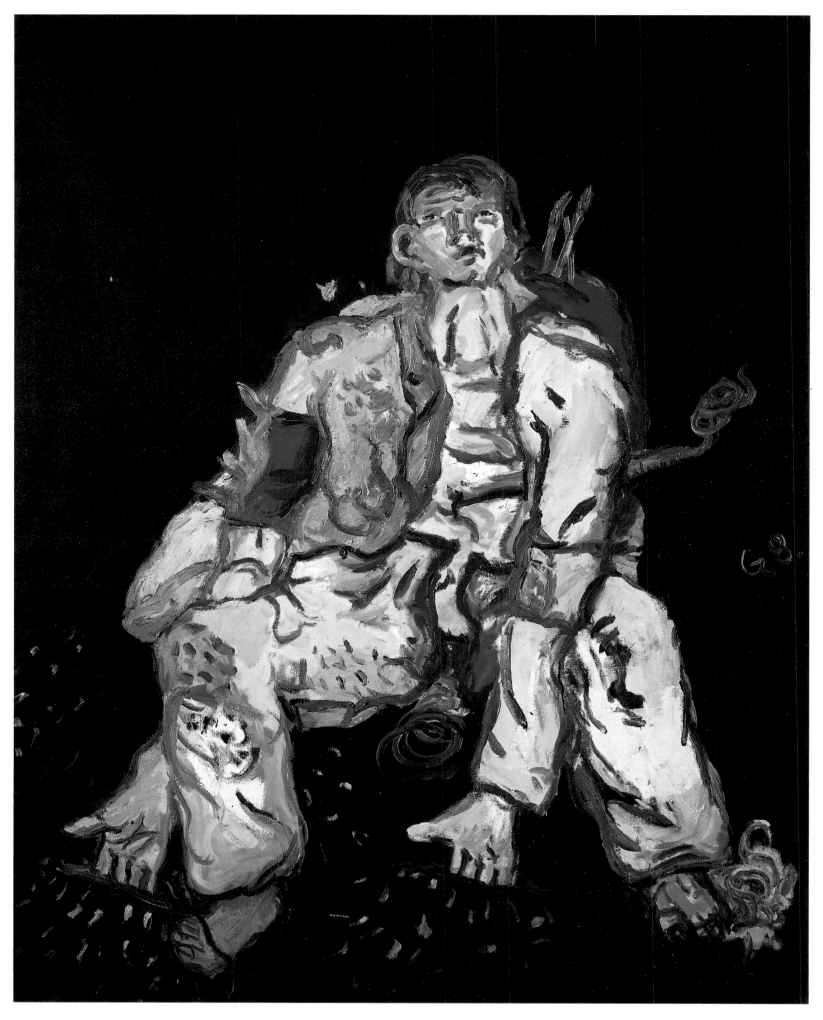

46. Georg Baselitz. *Ein moderner Maler* (*A Modern Painter*), 1966. Oil on canvas.

162 x 130 cm (63 ¾ x 51 ¼ inches). Berlinische Galerie, Berlin. Landesmuseum für Moderne

Kunst, Photographie und Architektur.

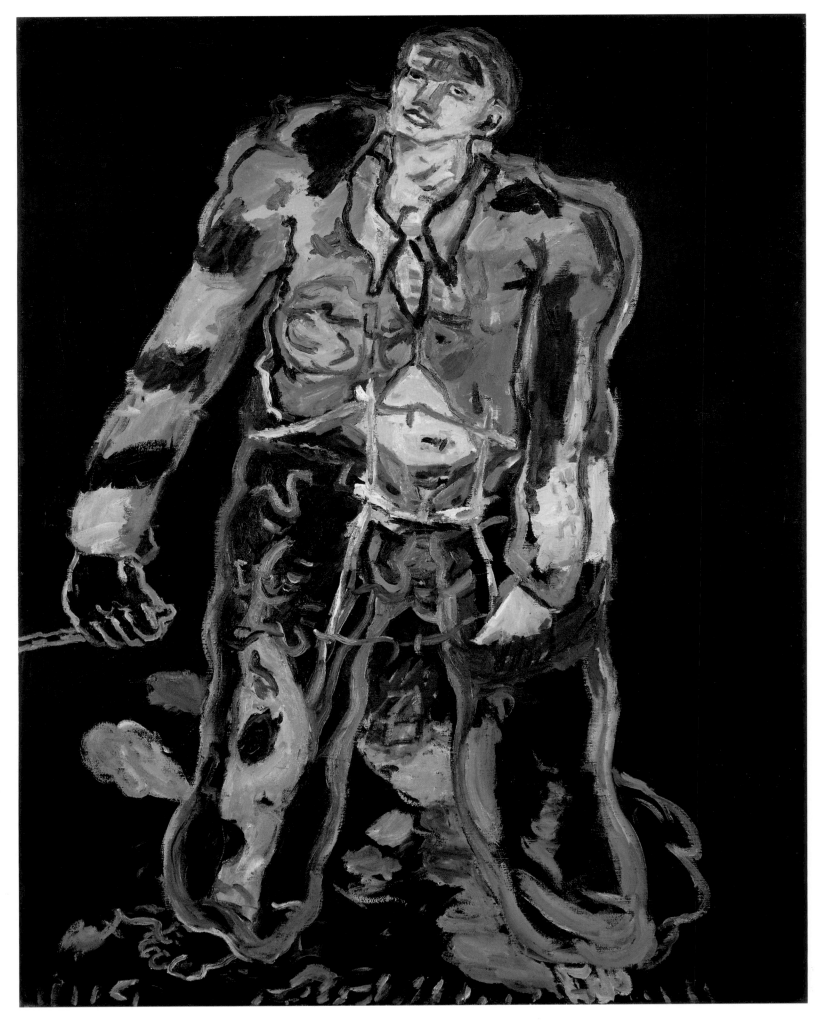

47. Georg Baselitz, *Rebell* (*Rebel*), 1965. Oil on canvas. 162 x 130 cm

(63 ³/₄ x 51 ¹/₈ inches). Tate Gallery. Purchased 1983.

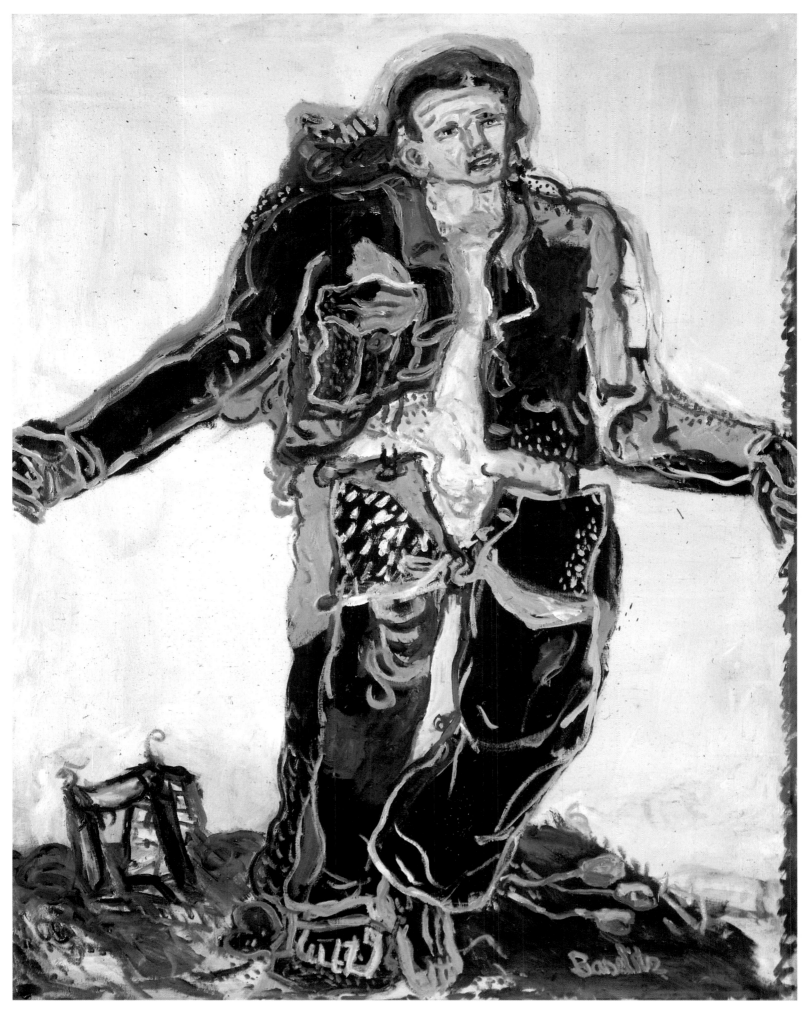

48. Georg Baselitz, *Der neue Typ* (*The New Type*), 1966. Oil on canvas, 162 x 130 cm

(63 ³/₄ x 51 ¹/₈ inches). Louisiana Museum of Modern Art, Humlebaek, Denmark.

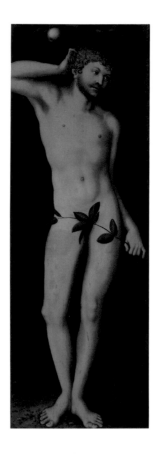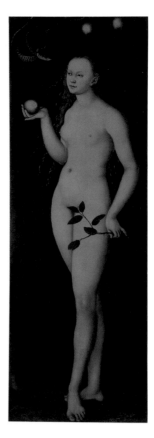

miniature cosmos."[43] In his own paintings, Baselitz has attempted to reconcile past and present, beauty and ugliness through the creation of prototypes—"motifs," as he calls them—outside time.

One of the most complex *Heroes* on formal and thematic levels is also the largest, *Die grossen Freunde* (*The Great Friends,* 1965, no. 42). The scale of the painting reflects that of the *Isenheim Altarpiece* and of the oversized canvases of the New York School. Its dimensions correlate to those of Edouard Manet's *L'Exécution de Maximilien (The Execution of Maximilien,* 1868), a painting at the Städtische Kunsthalle in Mannheim. Gohr notes that the work—the only one in the series to employ two figures—"symbolizes for Baselitz the awakening of the creative genius.'[44] In 1966, Baselitz wrote a third manifesto, in which he characterized *The Great Friends* as "an ideal picture, a gift of God, a sine qua non—a revelation. The picture is the *idée fixe* of friendship."[45]

In Cranach's *Adam* and *Eve* (1528, no. 49; n.d., no. 50), the figures are positioned against dark grounds and exhibit a restrained intimacy highlighted by the delicate foliage and the Earthly Paradise in which they are placed. In *The Great Friends,* the figures are similarly set against a dark background, but the space between them is bridged by the outstretched arm of the figure on the left. Adding to the interaction is the way in which they gaze at each other, in silent but amicable companionship, while all

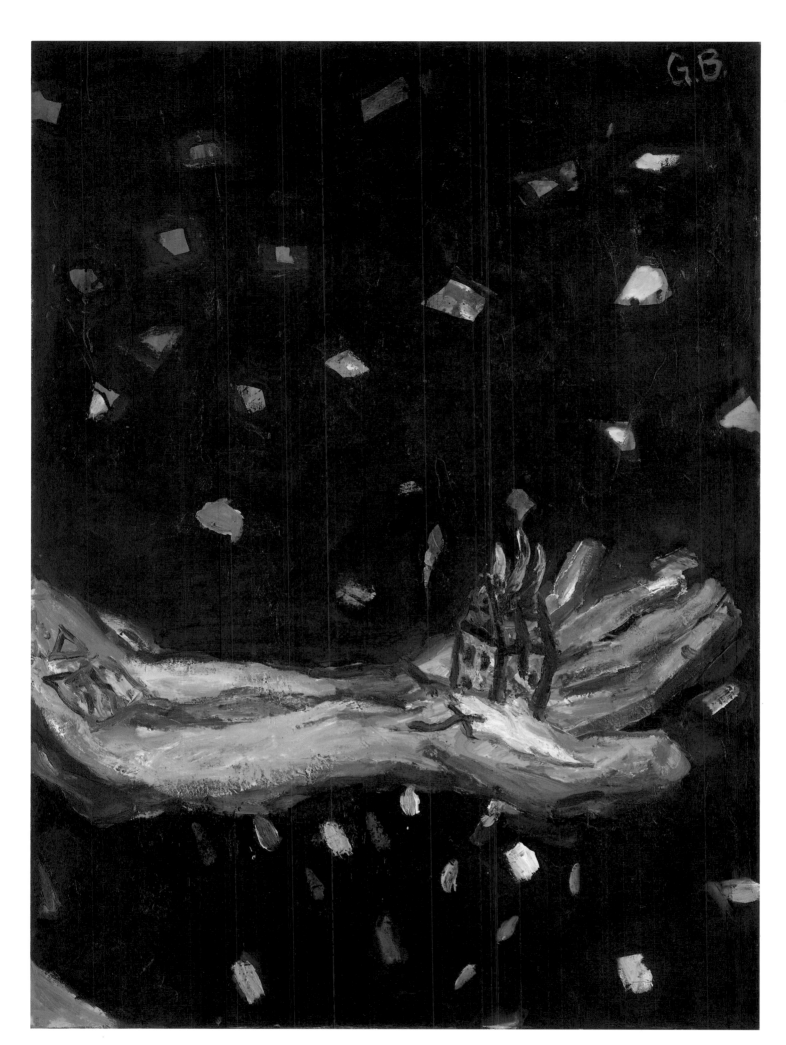

51. Georg Baselitz, *Die Hand – Das brennende Haus* (*The Hand – The Burning House*),

1964–65. Oil on canvas, 135 x 99 cm (54 ⅛ x 38 ⅞ inches). Private collection, Germany.

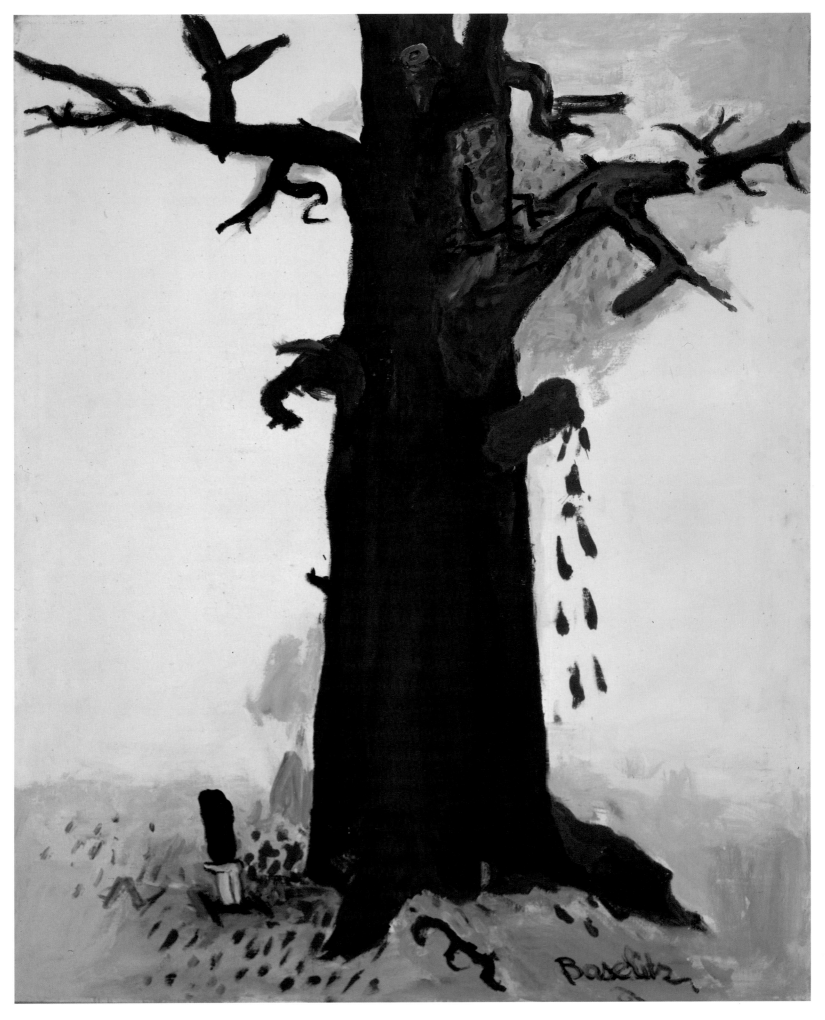

52. Georg Baselitz, *Der Baum 1 (The Tree 1)*, 1965–66. Oil on canvas, 162 x 130 cm

(63 ³/₄ x 51 ¹/₈ inches). Kunstmuseum Bonn. On permanent loan from the Grothe Collection.

around them are the ruins of their world. The building blocks of man's civilization have been torn down, the emblem of nationalism (the flag) is in tatters. Clothes in shreds, flies unzipped, these figures are the relics of a system that has failed. And yet they are also models of the future, companions determined to make their way in the new world.

Altogether unique among the *Heroes* paintings, which are otherwise human portraits, is *Der Baum 1* (*The Tree 1*) (1965–66, no. 52), in which Baselitz used the form of the tree to suggest the Crucifixion or the Tree of Knowledge, Christian emblems that reflect Baselitz's upbringing and his Uncle Wilhelm's influence. The tree motif also recalls the Romantic era in painting, exemplified by artists like Friedrich, in whose work nature and religion were often intertwined. *The Tree 1* depicts the landscape around the artist's childhood home, which he recalled from memory and through photographs. Of course, the landscape of Germany had been changed by the war; many areas were laid waste and the picture that Baselitz gives us is a scene of desolation rather than beauty. The tree, shorn of its leaves and stripped of most of its branches, is placed, like many of the figures in the *Heroes*, in the center of the canvas. (As Gohr has pointed out, Baselitz may well have been influenced by Malevich's use of the centered cross as a compositional device,[46] although in the Russian artist's iconography the cross is synonymous with the Suprematist movement and with his conviction that abstract

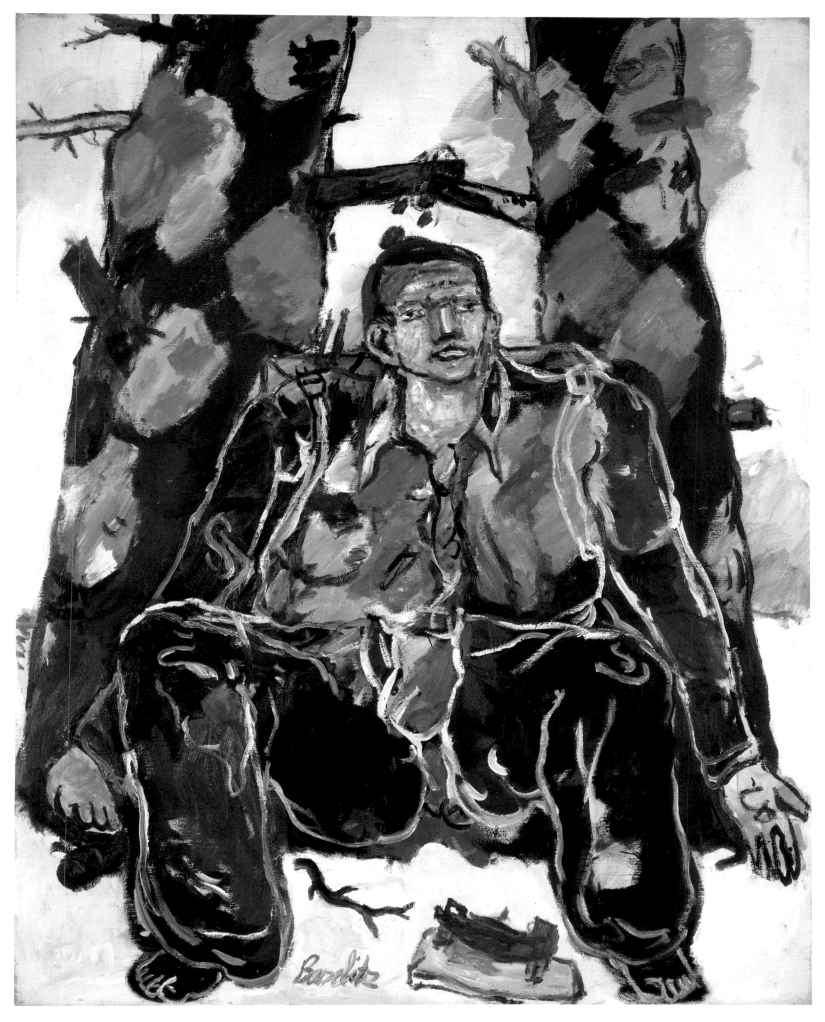

53. Georg Baselitz, *Falle* (*Trap*), 1966. Oil on canvas, 162 x 130 cm (63 ³/₄ x 51 ¹/₈ inches).

Collection IFIDA Investments, Philadelphia.

painting heralded a new order.) To the left of the tree a knife is stuck in the ground. The tree's few remaining branches are brittle; its only substantial limb is in the process of snapping in two. In light of Baselitz's references to Christian iconography in this and other works, it could be inferred that the tree sheds the blood and tears of Christ. Certainly, it is one of Baselitz's most sorrowful paintings of the period. This painting is the precursor to a group of work of the mid-1970s based on his childhood home, on Derneburg, and on landscapes by artists like von Rayski. By that time, however, nature had lost its appeal as an emblem of the religious and the sublime.

In 1966, Baselitz's figures in the *Heroes* became bolder. Their silhouettes are more rounded, their colors brighter. The outlines found in works such as *Falle* (*Trap*, no. 53) and *Schwarz Weiss* (*Black White*, no. 54) are reminiscent of the silhouetted forms used by Beckmann and Georges Rouault, the latter a painter Baselitz particularly admired. The heads are larger, more monumental, resembling figures from antiquity. The heads also relate to Georges Braque's *Canephora* paintings of 1922 (no. 57, for example), in which the artist scratched lines into his paint, creating light areas in the dark pigment. Similarly, in *Nu assis* (*Seated Nude*, 1925, no. 56), a related work, Braque drew a monumental nude whose head could be a model for *Black White*. While an element of the grotesque is still apparent in Baselitz's paintings, there is now a new

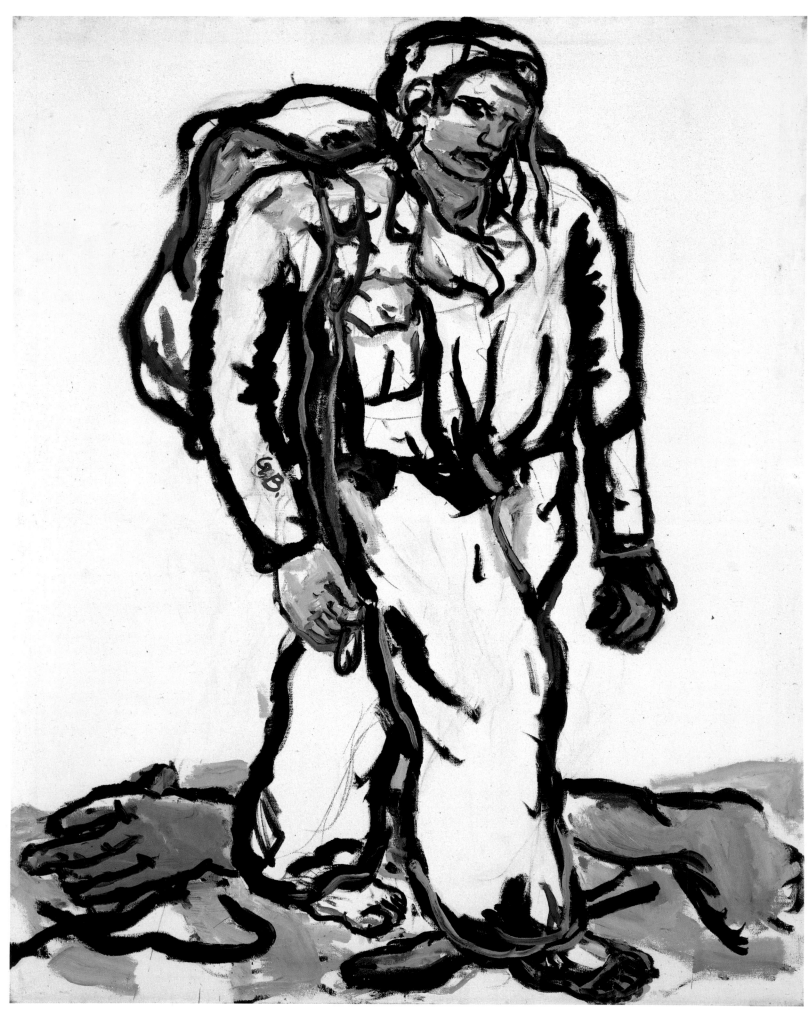

54. Georg Baselitz, *Schwarz Weiss* **(Black White)**, 1966. Oil on canvas, 162 x 130 cm
(63 ³/₄ x 51 ¹/₈ inches). Kleihues Collection.

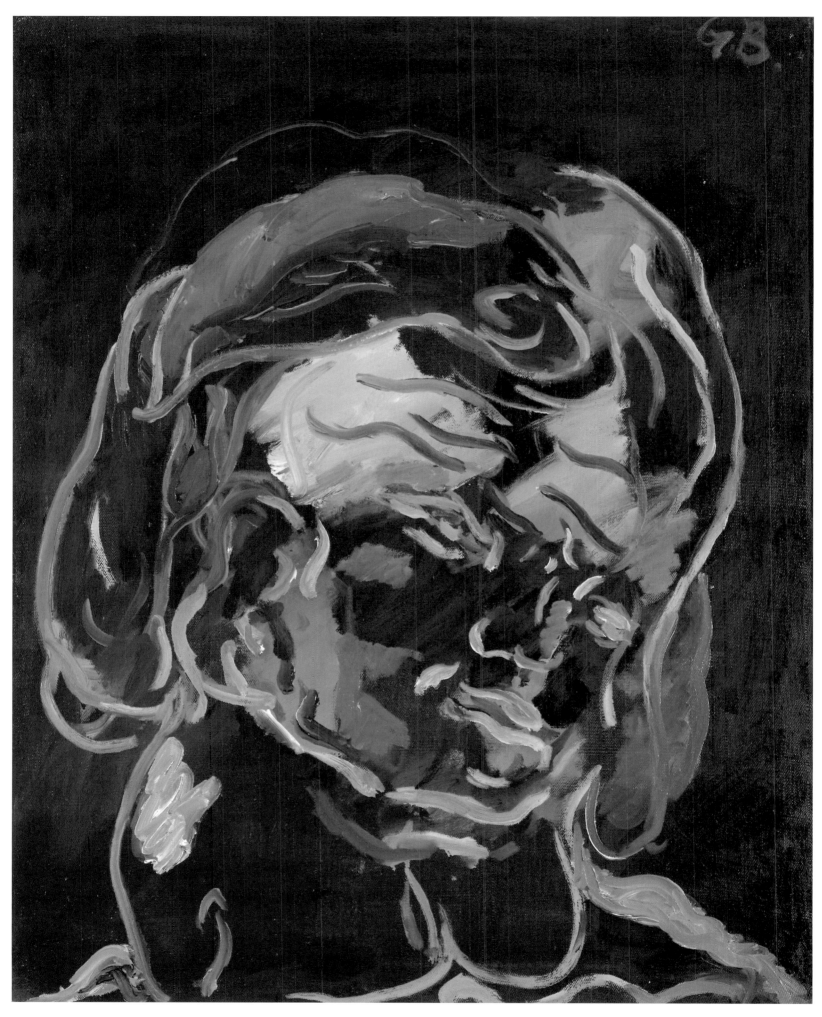

55. Georg Baselitz. *1. Kopf* (*1st Head*). 1966. Oil on canvas. 100 x 81 cm. (39 ³/₈ x

31 ⁷/₈ inches). Collection of Thomas H. Lee and Ann Tenenbaum.

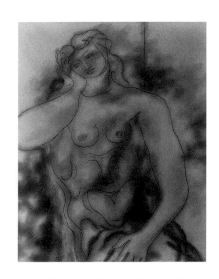

classicism, even a calmness, to many of the forms; it may reflect his stay in Italy as well as his interest in Braque, who became intrigued with classical forms after his invention, with Picasso, of Cubism.

The *Heroes* paintings represent an extraordinary achievement for the artist, for in their image he found himself. Painted in less than a year, they have continued to inform all of his subsequent work. Issues concerning the figure, form, color, and line, with which he had experimented since his student days, were resolved in these canvases. Having mastered this figuration, Baselitz then proceeded to tear it apart; the result was a new body of imagery formed by splicing together discordant segments of the figure.

Fracture Paintings: Turning the Subject Upside Down

In 1966, Baselitz moved his family from Berlin to the country village of Osthofen (near Worms), where he finished the first of his woodcuts. That year saw the development of an important new painting series, in which the subjects—hunters, woodsmen, cows, dogs, and other figures[47]—are sliced into segments and merged with landscapes. Called *Frakturbilder (Fracture Paintings)*, the series may be seen as originating with paintings such as *Ornamentale (Ornamental*, 1966, no. 58) and *Sitzender (Seated Man*, 1966,

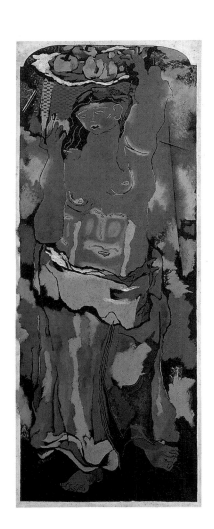

no. 64). In *Ornamental*, the figure and forest meld into one another as an array of luxuriant color sweeps across both. In *Seated Man*, only parts of the figure—the head, hands, and belly—are apparent, while much of the remainder of the figure is painted in a green wash that matches its background.

In some of the *Fracture Paintings*, Baselitz sliced the figures into equal segments; in others, he enlarged or reduced segments so that the figures appear disjointed but still recognizable. To some extent, this technique resembles that of the *cadavre exquis* (exquisite corpse), a stringing together of words and images that evolved from the Surrealists' ongoing explorations of chance. As art historian William Rubin has explained, the exquisite corpse was based on an old parlor game

> *played by several people, each of whom would write a phrase on a sheet of paper, fold the paper to conceal part of it, and pass it on to the next player for his contribution. The technique got its name from results obtained in an initial playing, "Le cadavre exquis boira le vin nouveau" (The exquisite corpse will drink the young wine). The game was adapted to the possibilities of drawing and even collage by assigning a section of the body to each player, though the Surrealist principle of metaphoric displacement led to images that only vaguely resembled the human form.[48]*

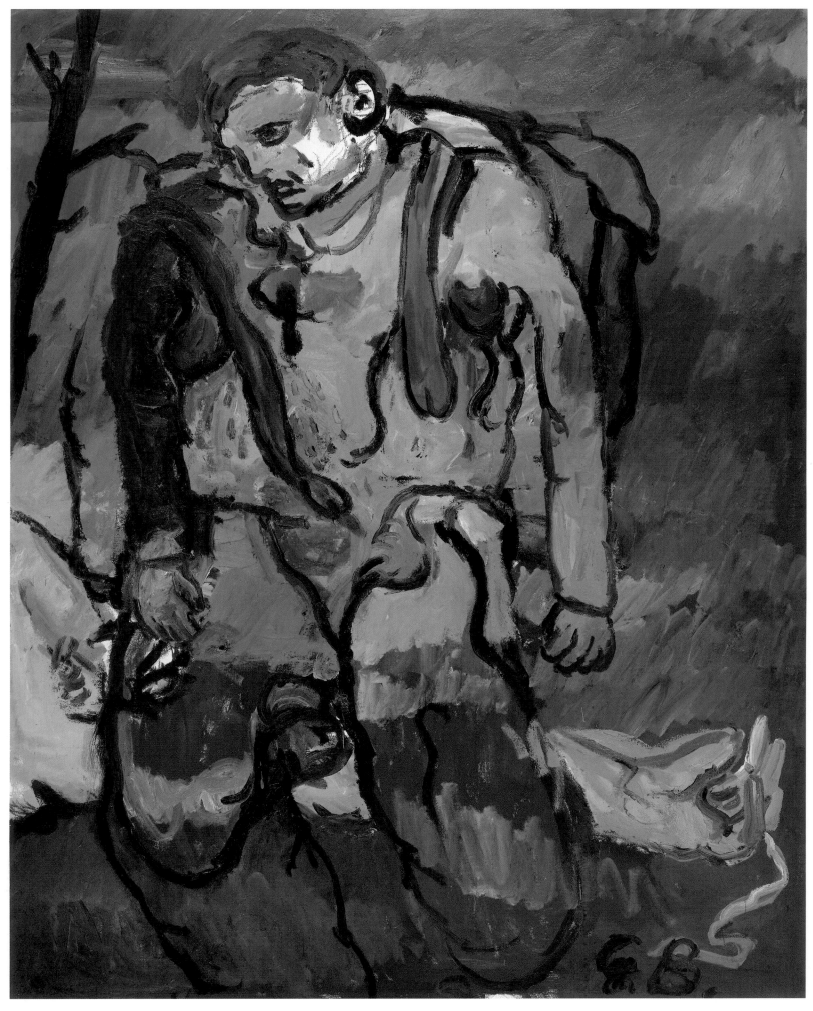

58. Georg Baselitz. *Ornamentale* (*Ornamental*), 1966. Oil on canvas, 162 x 130 cm

(63 ³/₄ x 51 ¹/₈ inches). Collection of Emily and Jerry Spiegel.

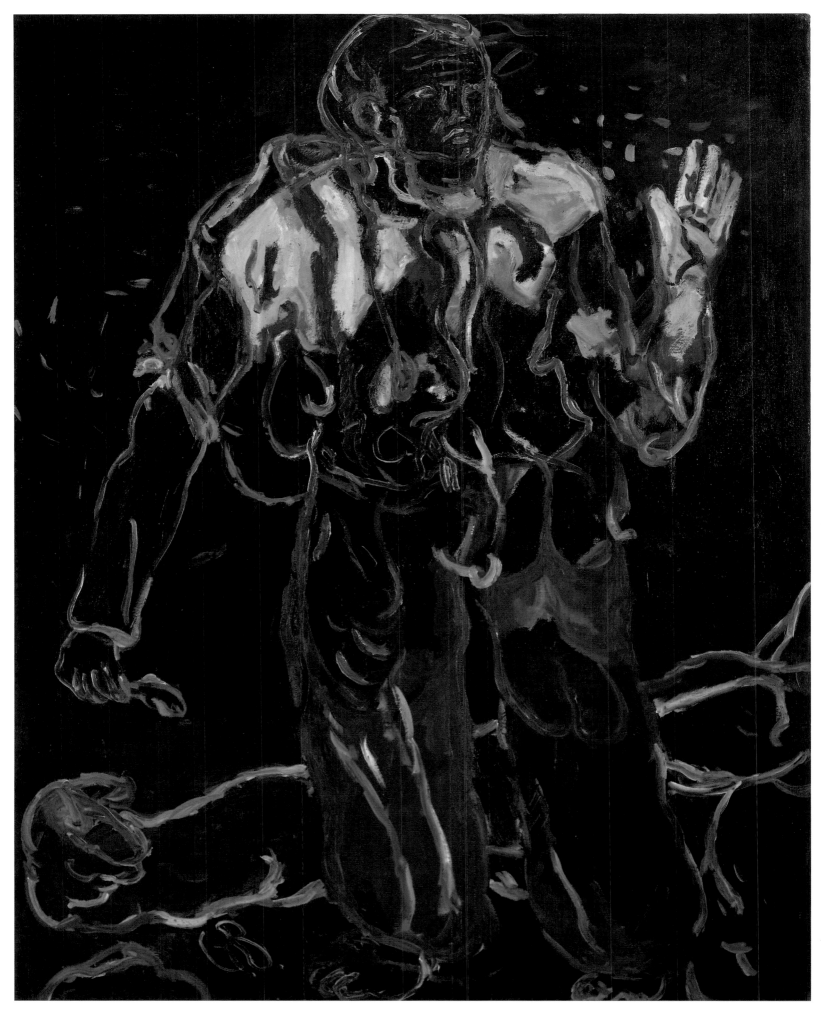

59. Georg Baselitz, *Schwarzgrünig* (*Black Grounded*), 1966. Oil on canvas, 162 x 130 cm
(63 ³/₄ x 51 ¹/₈ inches). Kunstmuseum Bonn. On permanent loan from the Grothe Collection.

Baselitz's method in treating the figure is similar to that employed by de Kooning in his monumental 1950s *Women* paintings. In these works, disparate parts of the body appear to have been cut and collaged together, yet the figure does not lose its resemblance to the human form. Through fragmenting, isolating, and collaging his subject, de Kooning could convey the semblance of a figure of goddesslike proportions without making mural-size paintings. In doing so, the figure he made appears to warp and distort the picture plane.

For both artists, the figure is the focal point of their paintings, though Baselitz's antiheroes and working men are vastly different from de Kooning's subjects. While Baselitz depicts male figures from European contexts, de Kooning's *Women* paintings derive from sources as wide ranging as American pop culture, Mesopotamian idols, and the long European tradition of the female nude. Baselitz's palette is that of the forest—muted earthtones, deep greens, and blues; de Kooning employed expressive line and luscious colors that evoke female flesh and the aura of the female figure.

While de Kooning's figures are placed in an ambiguous setting, Baselitz's are not. Nor do Baselitz's figures appear to burst forth from the picture plane, for while his figures loom large in the canvas and many of them are cropped to bring them nearer to the foreground, the suggestion of depth conveyed by the landscape imagery, and the use of

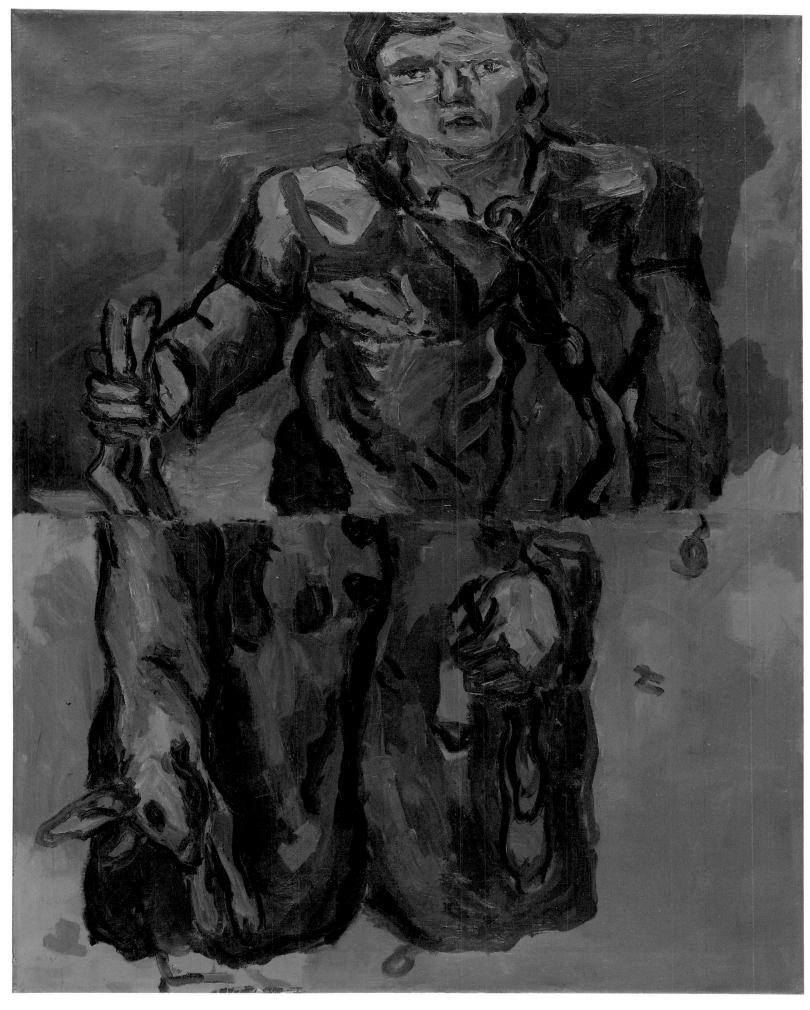

60. Georg Baselitz, *Der Jäger* (*The Hunter*), 1966. Oil on canvas, 162 x 130 cm

(63 3/4 x 51 1/8 inches). Private collection, Germany.

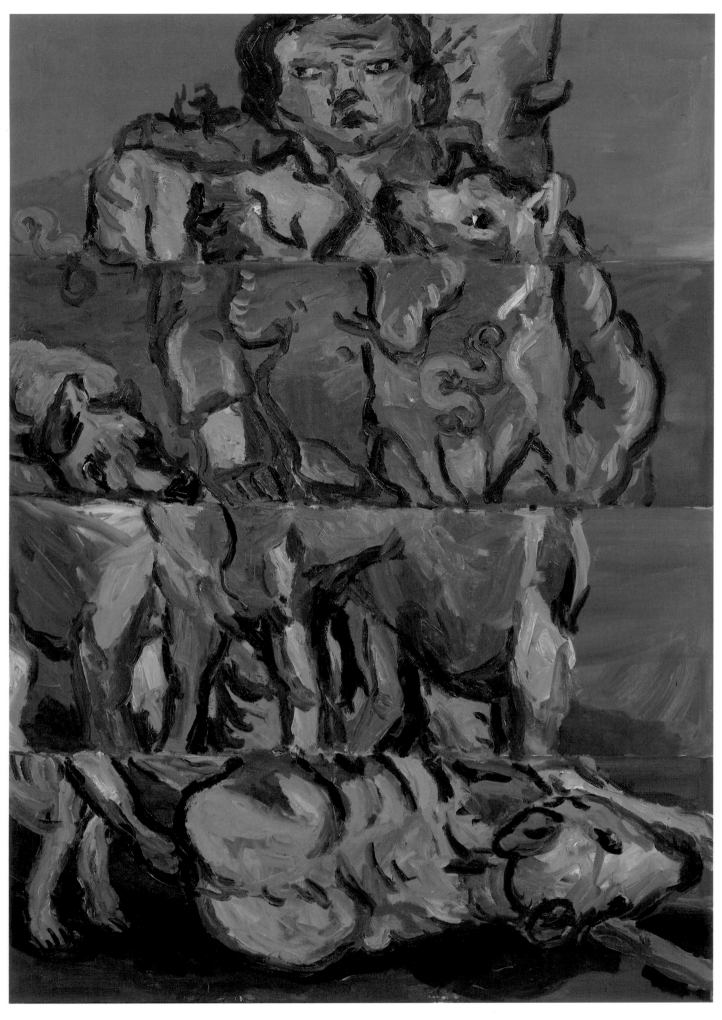

61. Georg Baselitz, *Der Jäger (Vier Streifen)* (*The Hunter [Four Stripes]*),

1966. Oil on canvas. 180 x 140 cm (70 ⁷/₈ x 55 ¹/₈ inches). Eli and Edythe L.

Broad Collection.

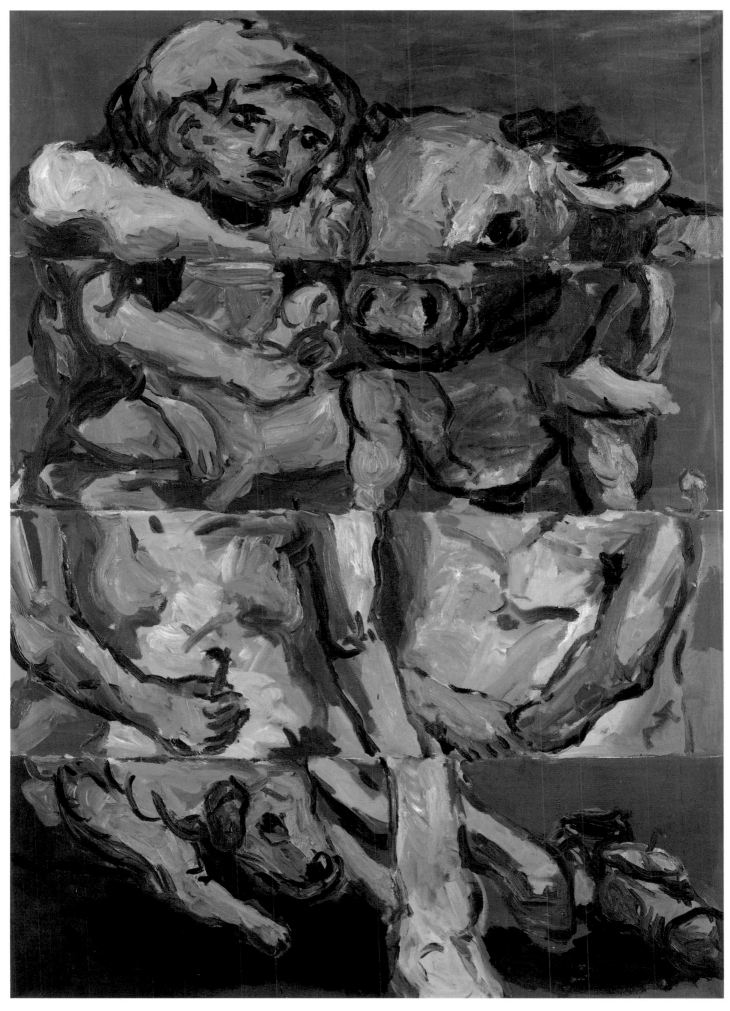

62. Georg Baselitz, *Vier Streifen Idyll (Four Stripes Idyll)*, 1966. Oil on canvas.

180 x 130 cm (70⅞ x 51⅛ inches). Private collection, Germany.

half tones to suggest light and dark create a subtle dimensionality within the picture plane. The overall impression conveyed by the *Fracture Paintings* is that precedence has been given to the placement of shapes and colors rather than, as in the *Heroes*, to the contours of a form and the colors contained within it. Despite their differences, the objectives of Baselitz and de Kooning were the same: to merge figure and ground without destroying the semblance of either.

A different parallel may be made between Baselitz and de Kooning's fellow New York School painter Mark Rothko. In the *Fracture Paintings*, Baselitz cut the image into two, three, or four horizontal bands. Rothko, in his majestic 1950s paintings, reduced form to a series of horizontal bands of color stacked one on top of the other. He banished any trace of figuration from his work, focusing instead on the power of color to convey "basic human emotions—tragedy, ecstacy, doom."[49] Although the figure has always remained an integral part of his work, Baselitz shares with Rothko a belief in the emotive powers of color, line, and form.

In many *Fracture Paintings*, the figures are made to appear disjointed by divisions in the composition or by swathes of paint that overlay the forms. Compared to the *Heroes*, Baselitz's technique here is freer, the strokes larger and more impetuous. Both *B. für Larry* (B. for Larry, 1967, no. 67) and *Meissener Waldarbeiter* (Meissen Woodsmen,

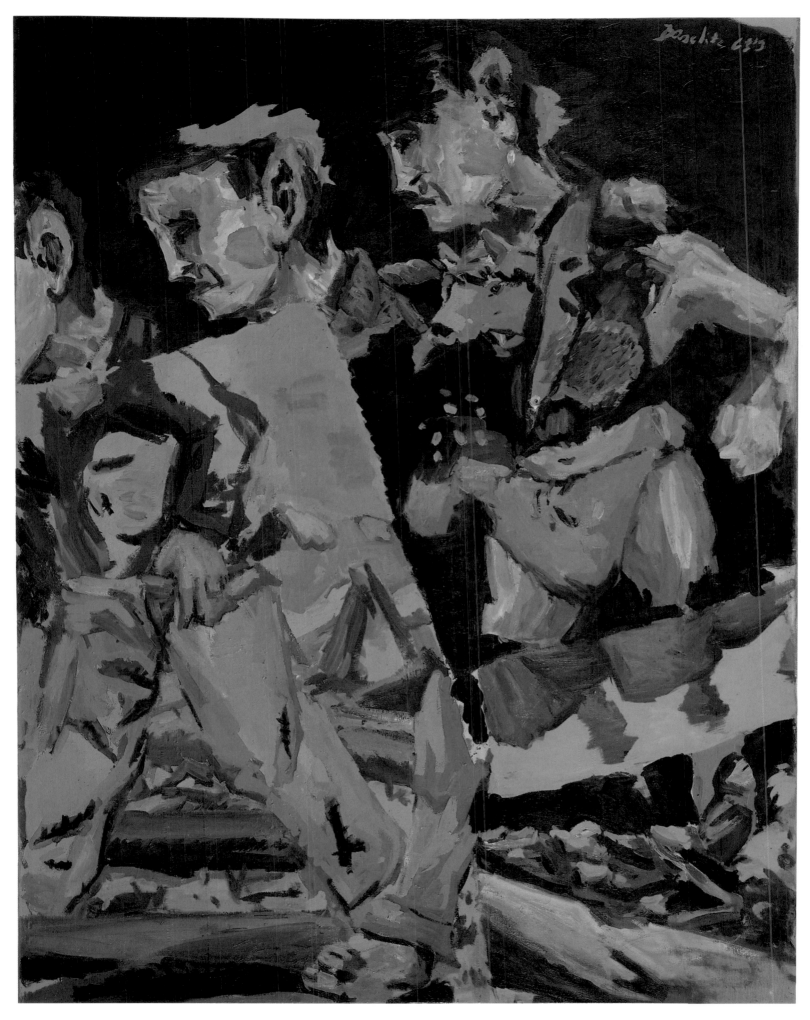

63. Georg Baselitz, *Meissener Waldarbeiter* (*Meissen Woodsmen*), 1968–69. Oil on linen,
240.7 x 195 cm (94 ³/₄ x 75 inches). Hirshhorn Museum and Sculpture Garden, Smithsonian
Institution, Washington, D.C., Holenia Purchase Fund, 1994.

64. Georg Baselitz, *Sitzender* (*Seated Man*), 1966. Oil on canvas, 160 x 130 cm

(63 x 51 ¹/₈ inches). Wittelsbacher Ausgleichsfonds, Collection Prince Franz of Bavaria.

1968–69, no. 63) are seminal examples of their kind. Baselitz made the former, he says, as a response to Jasper Johns's paintings, consciously reacting to the American's distinctive treatment of surface, brushwork, and color choices. In *B. for Larry,* a primeval figure, wearing only a loincloth, is torn into fragments and merged with the landscape. The painting forcefully evokes nature at its most elemental. This canvas merges many of the salient characteristics of the *Heroes*—particularly the use of a dominant figure as archetype placed in a symbolic setting—with the new concept of the fractured image and a bolder painting style. In *Meissen Woodsmen,* Baselitz dramatically altered his method by layering one image over another; the result is one of deliberate artificiality and hints at the "picture within a picture," a device he would first use in 1970.

Precedents for similarly overlapping figures exist in the work of Jacob Jordaens, whose paintings of cows inspired Vincent van Gogh (an artist Baselitz very much admires) to make *Les Vaches (Study of Cows, after Jacob Jordaens,* June 1890, no. 66). Baselitz's *Die Kühe (The Cows,* 1968, no. 65), in which the painting of one animal's head is superimposed on the painting of another cow, is organized in a similar manner. This arrangement, like the segmented figures of his other *Fracture Paintings,* reinforced Baselitz's belief that a figure can be positioned anywhere on the canvas.

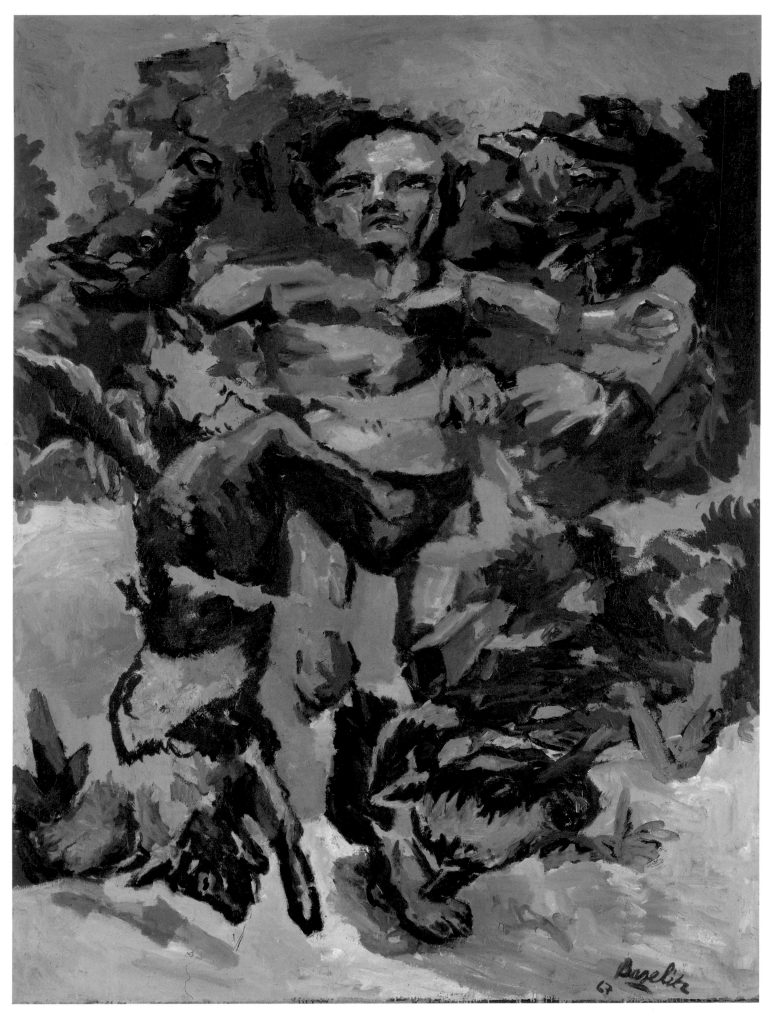

67. Georg Baselitz, *B. für Larry* (**B. for Larry**), 1967. Oil on canvas, 250 x 200 cm
(98 ³/₈ x 78 ³/₄ inches). Private collection.

68. Georg Baselitz, *Der Mann am Baum* (*The Man at the Tree*), 1969. Oil on canvas.
250 x 200 cm (98 3/8 x 78 3/4 inches). Private collection, Cologne.

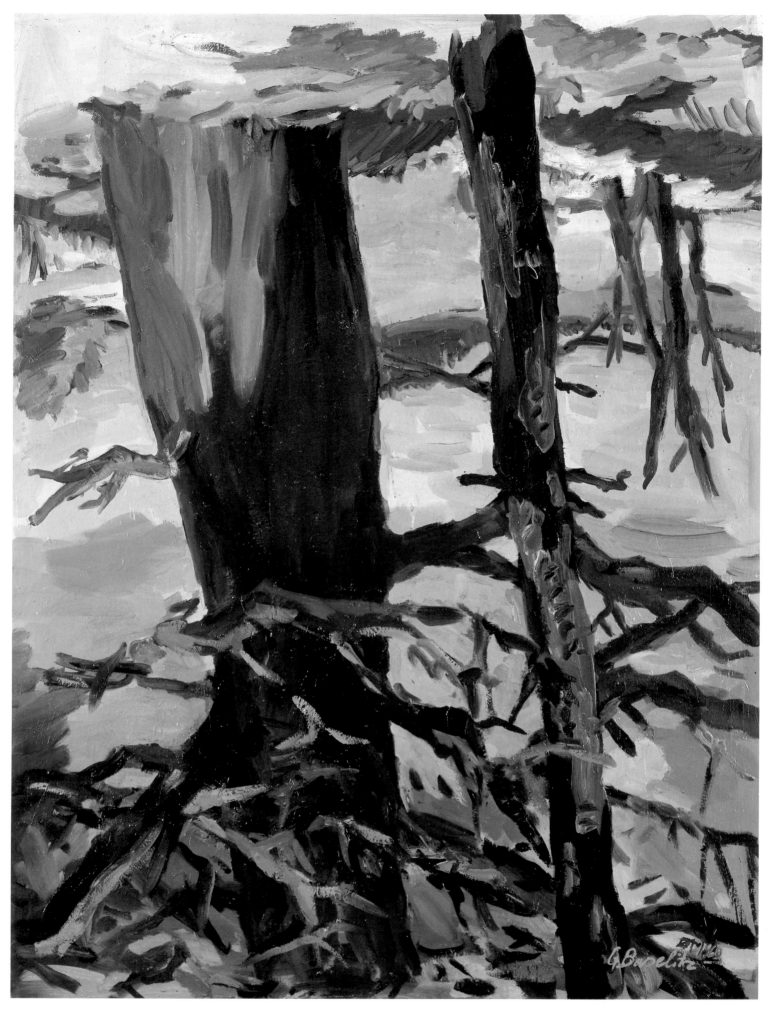

69. Georg Baselitz, *Der Wald auf dem Kopf* (*The Wood on Its Head*), 1969.

Oil on canvas, 250 x 190 cm (98 ³/₈ x 74 ³/₄ inches). Museum Ludwig, Cologne.

Ludwig donation.

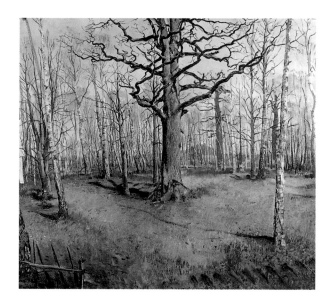

In 1969, Baselitz took this belief to greater lengths. He had experimented with upside-down images in the earlier *Das Kreuz* (*The Cross*, 1964, no. 71), which contains several inverted houses in the upper right of the composition, and in *Waldarbeiter* (*Woodsmen*, 1968, no. 72), which includes an inverted figure. But the first painting in which the entire composition is painted upside down is *Der Wald auf dem Kopf* (*The Wood on Its Head*, 1969, no. 69). Based on von Rayski's *Wermsdorfer Wald* (*Wermsdorf Wood*, 1859, no. 70), it marked a radical departure. *The Wood on Its Head* was preceded by *Der Mann am Baum* (*The Man at the Tree*, 1969, no. 68), in which a male figure is inverted on the canvas. The format was derived from art-historical depictions of the crucifixion of St. Peter in which the martyr is nailed to a cross and turned upside down. Baselitz's figure, intact but foreshortened, is compressed into the landscape in a manner reminiscent of the *Fracture Paintings*. But by depicting the figure as upside-down, Baselitz brought his art into a new realm. Why turn the object upside down?

> *The object expresses nothing at all. Painting is not a means to an end. On the contrary, painting is autonomous. And I said to myself: if this is the case, then I must take everything which has been an object of painting— landscape, the portrait and the nude, for example—and paint it upside-down. That is the best way to liberate representation from content.*[50]

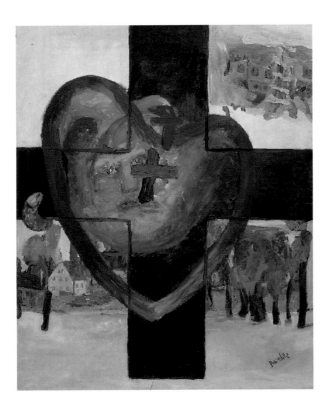

71. Georg Baselitz, *Das Kreuz (The Cross)*,
1964. Oil on canvas, 162 x 130 cm (63 ³/₄ x
51 ¹/₈ inches). Private collection, Hamburg.

He further elaborates:

> *The hierarchy which has located the sky at the top and the earth at the
> bottom is, in any case, only a convention. We have got used to it, but we
> don't have to believe in it. The only thing that interests me is the question of
> how I can carry on painting pictures.[51]*

Baselitz's upside-down images mark one of the most radical departures from painting
conventions dating to the rules of perspective developed in the Renaissance. The illusion
that the viewer of a painting was seeing an accurate reflection of the world was
maintained until the nineteenth century, when photography replaced the painted image
with a more convincing depiction of the real world. Since that time, painters have
created other ways of portraying the world around them. It was Baselitz's intention, as it
has been for many twentieth-century painters, to break with tradition—to make *new*
paintings—without sacrificing the appearance of actuality. By distorting his subjects'
form, volume, and relationship to the world—by literally turning them upside down—
Baselitz forced the viewer to accept an inverted world as a new pictorial convention.
Critic Donald Kuspit has related the upside-down image in Baselitz's paintings to the
longstanding tradition of the *mundus inversus* (or *mundus perversus*), a generally
metaphoric view of the world in which chaos replaces order.[52] While surely an allusion

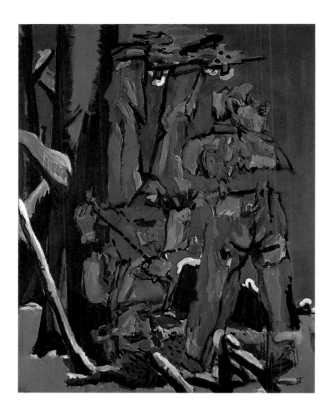

to the topsy-turvy *mundus inversus*, the image is also inspired, says the artist, by Indian philosophy, in which it is believed that the roots of the world are in the heavens.

The upside-downness in Baselitz's paintings has the effect of nullifying the significance of the figure—freed from gravity, it becomes one image among many, taking its place as part of the artist's investigation into the nature of painting. Following his initial breakthrough in 1969, Baselitz painted a series of upside-down portraits of his wife, friends, and dealers. From this point on, the upside-down figure would be a hallmark of Baselitz's style. The next year, he painted mostly pictures within pictures, in which one image—generally a landscape—is framed by another, thereby continuing the rupture with conventional pictorialism. In 1971, he moved to Forst, on the edge of the Palatinate Forest and set up a studio in the village school. The paintings that followed consist of studio interiors, bedroom scenes, and landscapes. Baselitz saw these subjects as motifs that are descriptive but devoid of specific narrative and content; thus, they become neutral forms that gave him the means to explore shape, color, and surface.

Baselitz also painted a number of canvases using the subject of the eagle. The eagle has many symbolic references; it was, for example, the standard of the ancient Romans. In this century it achieved infamy as a symbol of the Nazi party, and also served as an archetype in the writings of Carl Jung, who believed that the eagle was a totem

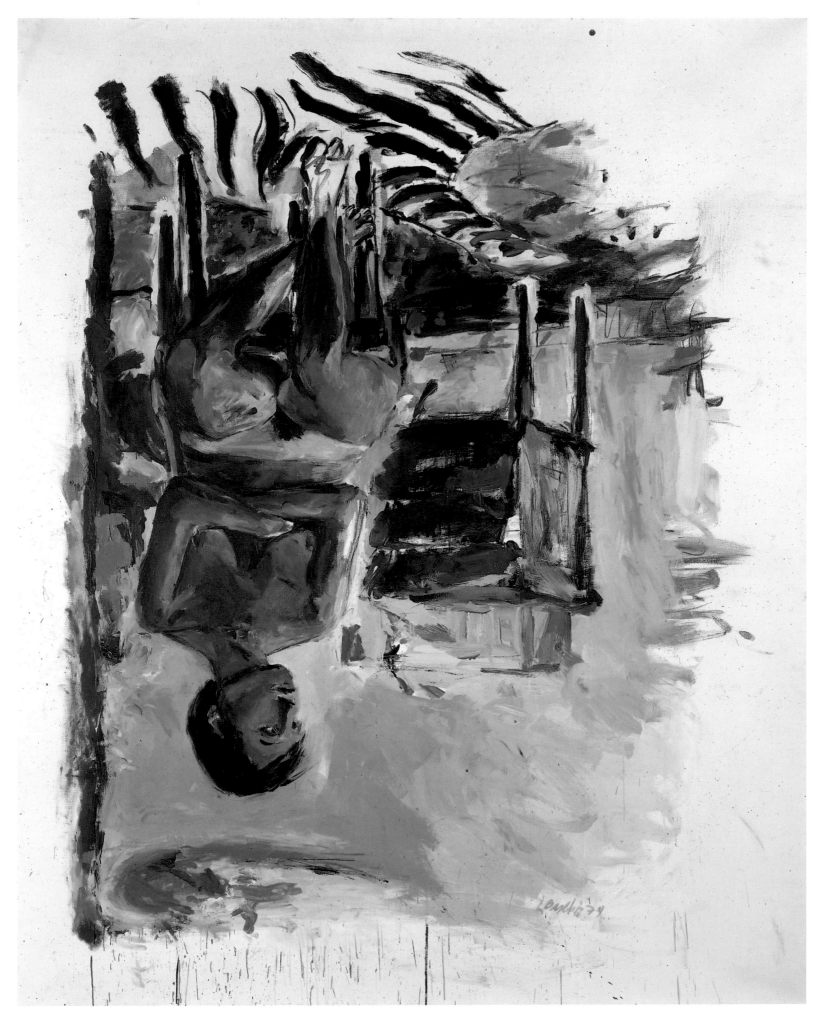

**73. Georg Baselitz, *Akt Elke* (*Nude Elke*), 1974. Oil on canvas, 250 x 200 cm

(98 ³/₈ x 78 ³/₄ inches). Private collection, Cologne.

symbolizing transcendence, release, and liberation. A bird of prey, the eagle is known for
its powers of flight, strength, and keenness of vision. As a motif used in many of
Baselitz's paintings, it is rich in reference, but it would be impossible to pin down any
fixed symbolic value. Perhaps, as the discredited emblem of the Third Reich, its
inversion in Baselitz's painting reflects the eagle's fall from grace. While this ambiguity
enriches these paintings, the eagle must nonetheless be seen primarily as a motif Baselitz
added to his personal painting vocabulary.

In 1972, the artist rented a factory space in Musbach to use as his studio, where he
experimented with various techniques, such as "finger painting." In works such as
Fingermalerie I – Adler – à la (*Fingerpainting I – Eagle – à la*, 1971–72, no. 90). *Akt
Elke* (*Nude Elke*, 1974, no. 73), *Birke – Russisches Schulbuch* (*Birch Tree – Russian
Schoolbook*, 1975, no. 78), *Damm* (*Dam*, 1975, no. 75), and *Männlicher Akt* (*Male
Nude*, April–June 1975, no. 76), he used his fingers to spread pigment on the canvas.

Baselitz also worked from photographs and from memory. He modified the images
taken from the photographs, but emulated the straightforward rendition of their
subjects. Throughout the early to mid-1970s, he painted landscapes, interiors, and
portraits of himself and his wife, Elke. In these canvases, figures are free of distortion,
and the settings are completely legible. However, the images are altered by passages of

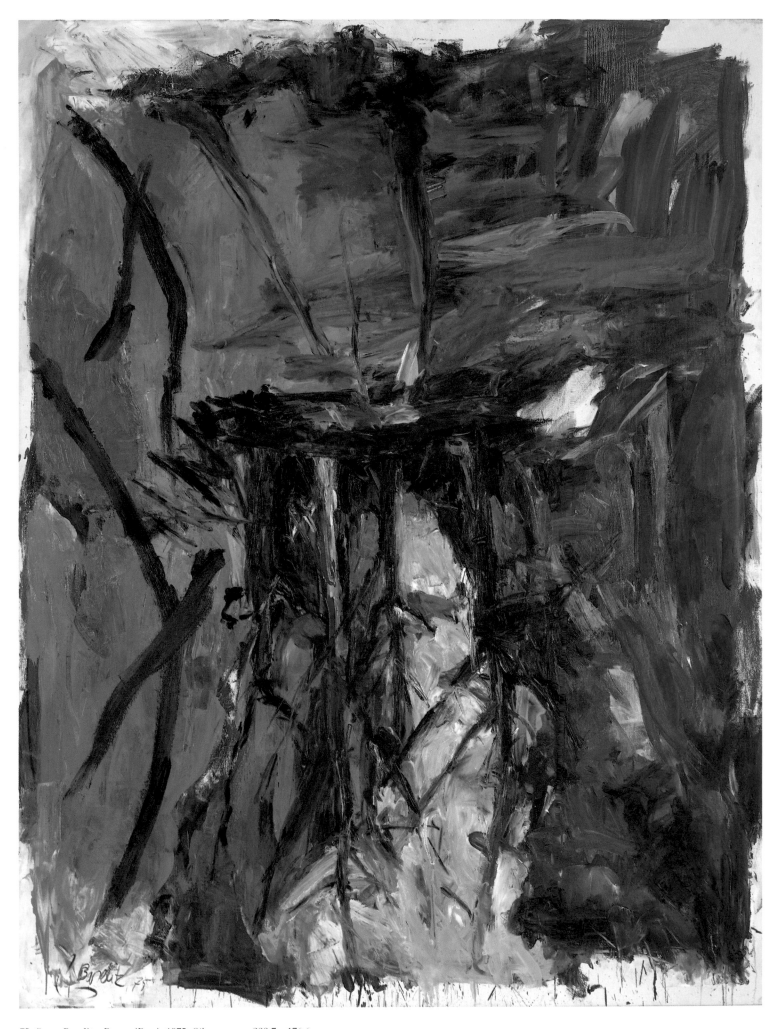

75. Georg Baselitz, *Damm* (*Dam*), 1975. Oil on canvas, 233.7 x 176.6 cm

(92 x 69 ¹/₂ inches). Kunstmuseum Bonn, On permanent loan from the Grothe Collection.

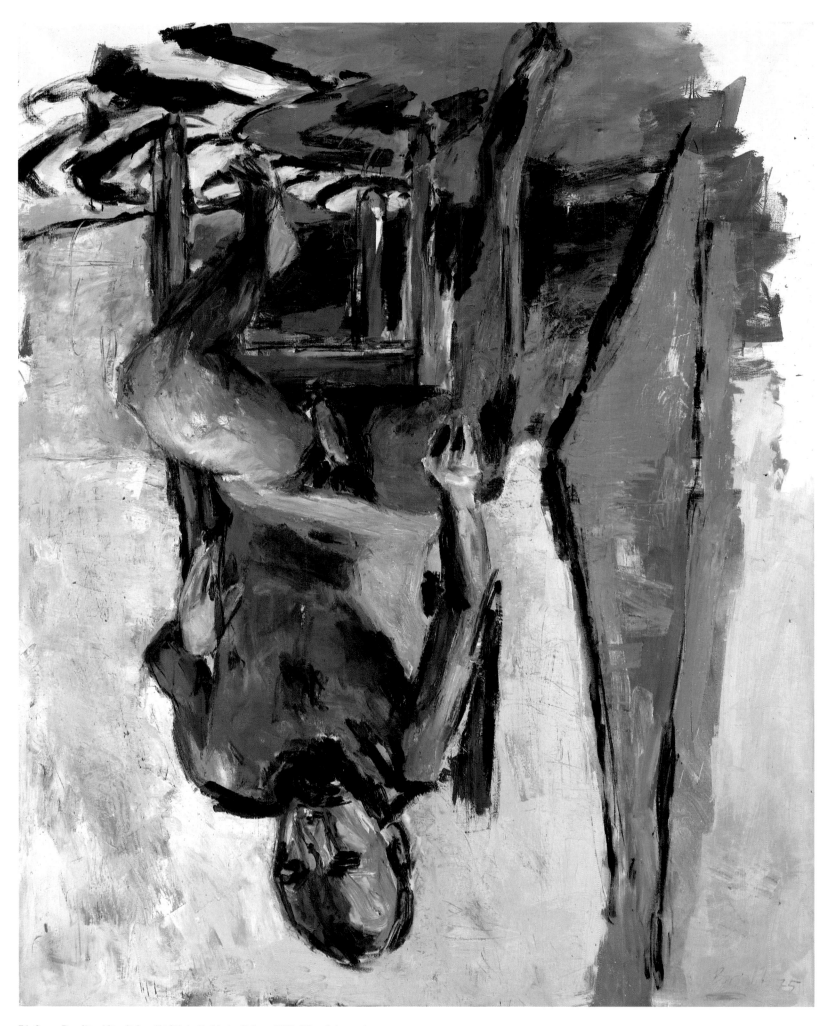

76. Georg Baselitz. *Männlicher Akt (Male Nude).* April–June 1975. Oil and charcoal
on canvas. 200 x 162 cm (78 ³/₄ x 63 ¹/₄ inches). Collection of Hartmut and Silvia
Ackermeier. Berlin.

pure color loosely brushed on, by areas of canvas left bare, or by drips at the bottom of the picture. These are domestic pictures, calm and tranquil, painted around the time in 1975 when Baselitz and his family (which by then included another son, Anton, born in 1966) moved to Derneburg, where he has resided since. They are light-filled pictures in which subject matter is further deemphasized in favor of the sovereign role of painting.

In 1975, Baselitz completed two *Schlafzimmer* (*Bedroom*) pictures (no. 77, for example) before starting a series of similarly intimate subjects. He returned to the theme of Elke nude, but the results are entirely different from those he achieved just a year before. *Elke V* (1976, no. 79), for example, is a study in painting itself. The depiction of the subject is far less descriptive, the use of outline much more active, the handling of paint more expressive, and the few marks used to delineate her form are economical. In *Männlicher schwarzer Akt* (*Black Male Nude*, 1977, no. 83), the artist altered the figure so that it reads as a black shape covered with a series of white marks, while in *Weiblicher Akt – Liegend* (*Female Nude – Lying*, August–September 1977, no. 82), he transformed the prone figure into a black-and-white shape emboldened by a few strokes of color. Similarly, in three paintings entitled *Adler* (*Eagle*, May–June 1977, no. 81; 1978, no. 84; and August 1978, no. 86), birds become forms barely distinguishable from their surroundings. Of the three, the earliest has the most

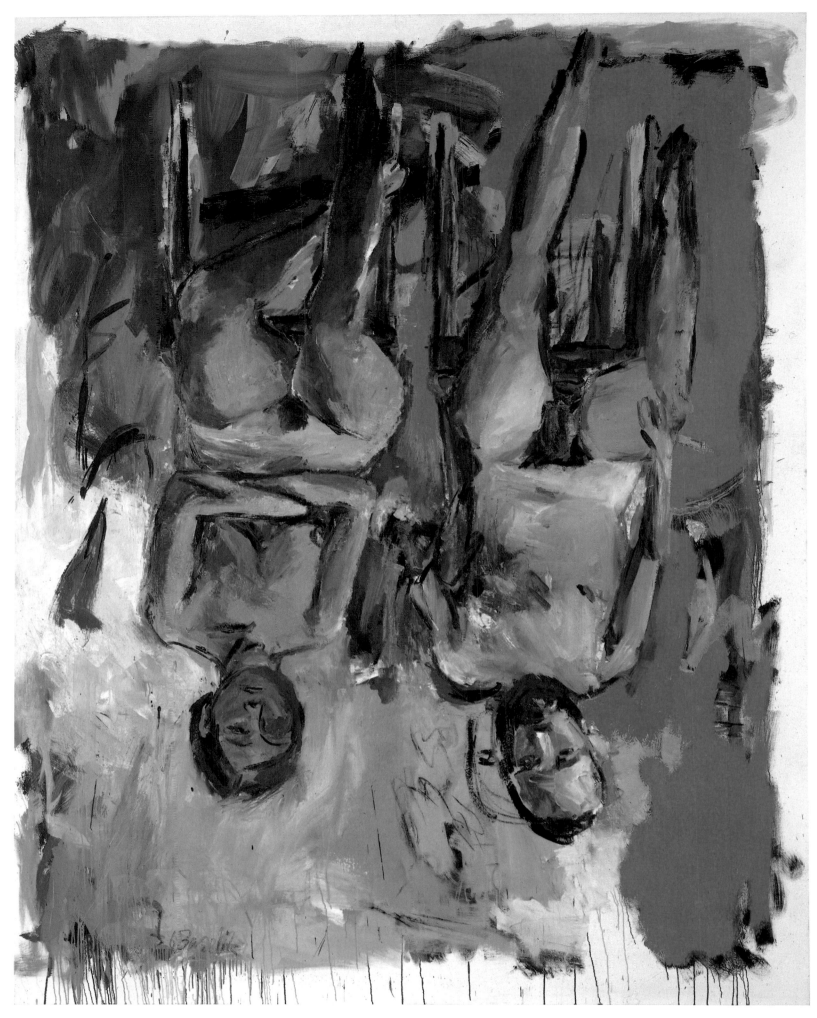

77. Georg Baselitz, *Schlafzimmer* (*Bedroom*), 1975. Oil on canvas, 250 x 200 cm

(98 ³/₈ x 78 ³/₄ inches). Private collection, Germany.

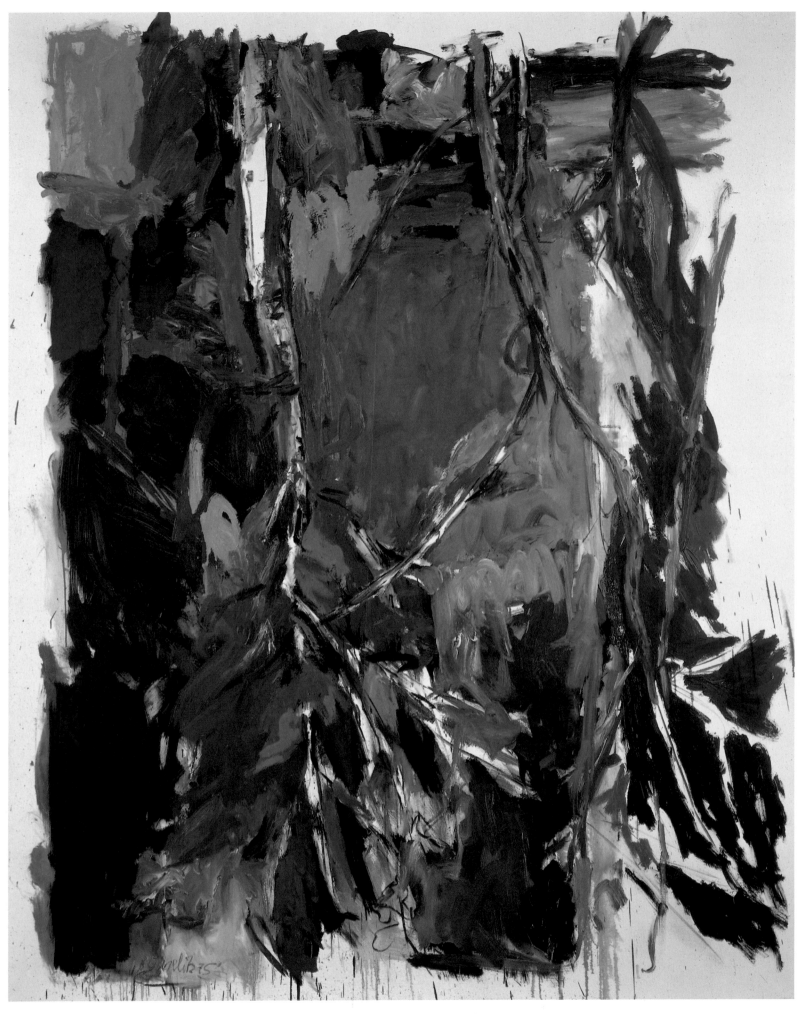

78. Georg Baselitz, *Birke – Russisches Schulbuch* **(***Birch Tree – Russian Schoolbook***),** 1975. Oil on

canvas, 250 x 200 cm (98 3/8 x 78 3/4 inches). Crex Collection, Hallen für Neue Kunst, Schaffhausen.

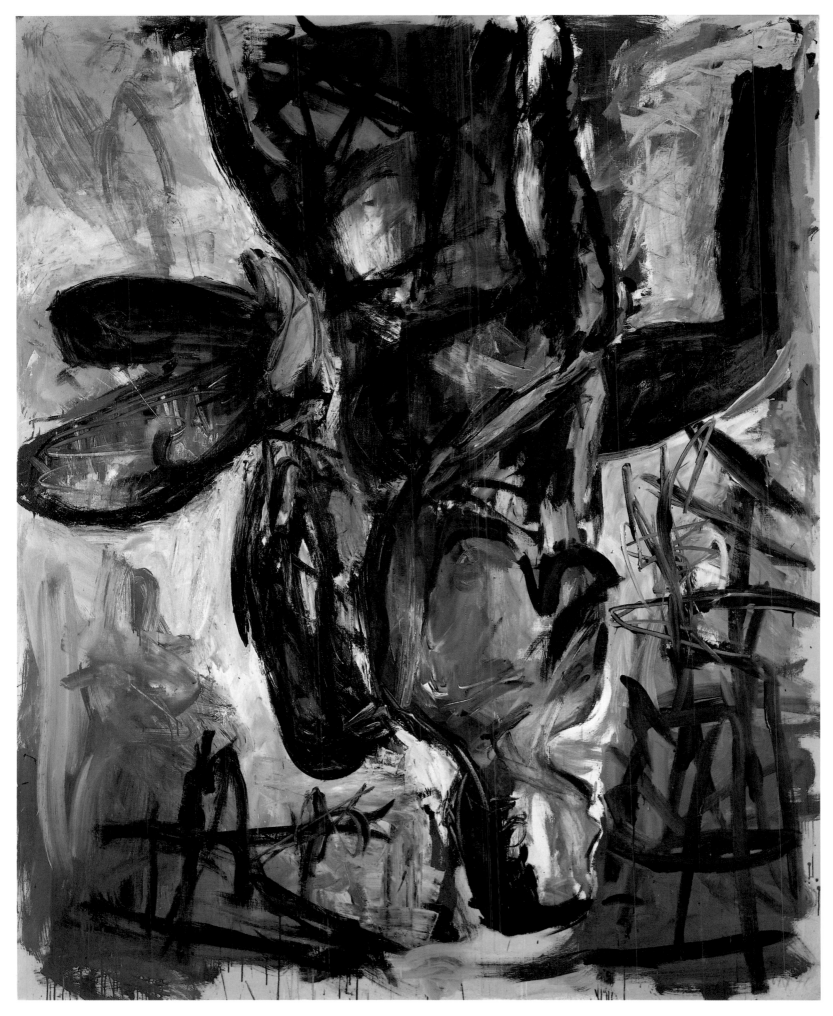

79. Georg Baselitz, *Elke V*, 1976. Oil on canvas, 200 x 162 cm (78 ³/₈ x 63 ³/₄ inches). Collection of

Ronnie and Samuel Heyman, New York.

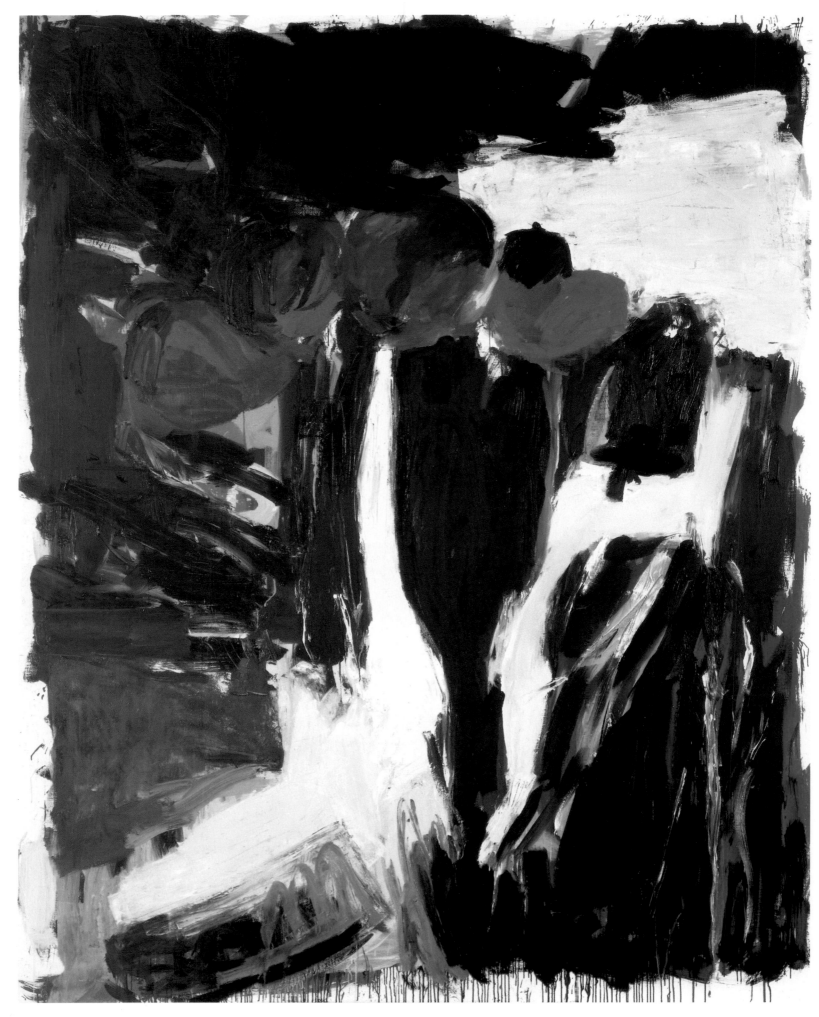

80. Georg Baselitz, *Stilleben* (*Still Life*), November 1976–April 1977. Oil on canvas, 250.1 x

200.4 cm (98 ¹/₂ x 78 ⁷/₈ inches). The Museum of Modern Art, New York, Gift of Agnes Gund, 1991.

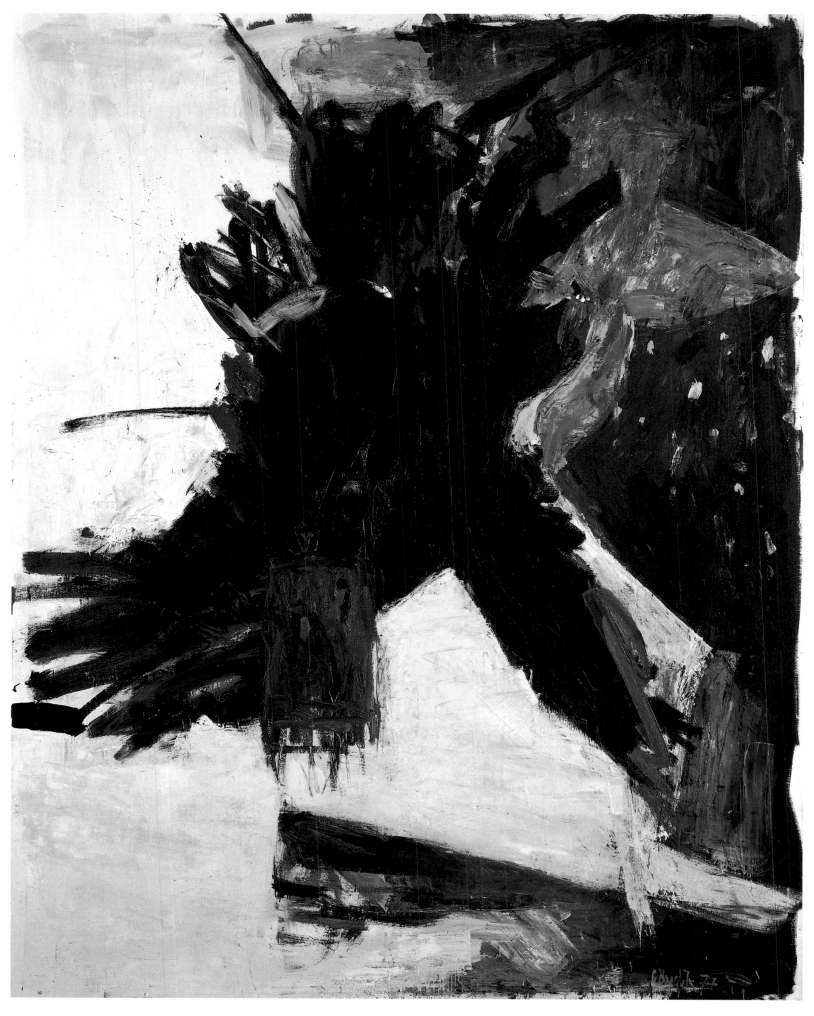

81. Georg Baselitz, *Adler* (*Eagle*), May–June 1977. Oil on canvas, 250 x 200 cm
(98 ³/₄ x 78 ³/₄ inches). Deutsche Bank AG, Frankfurt.

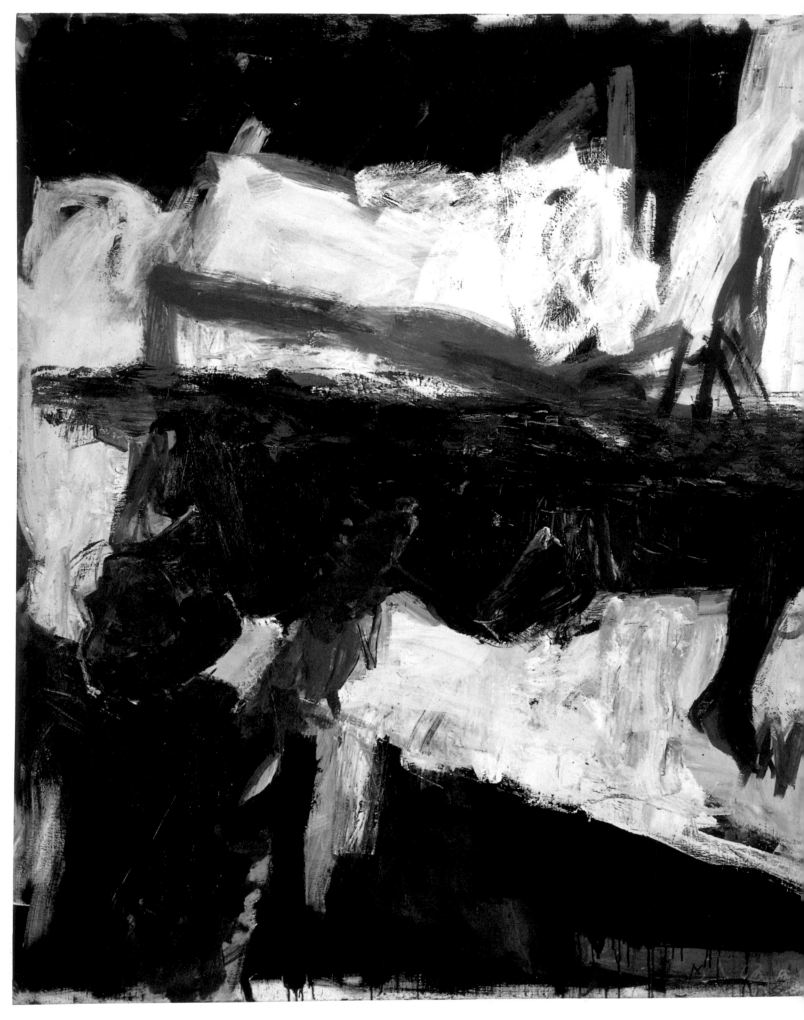

82. Georg Baselitz, *Weiblicher Akt – Liegend* (*Female Nude – Lying*), August–September 1977. Oil and tempera on canvas.

200 x 330 cm (78 ³/₄ x 129 ⁷/₈ inches). Crex Collection, Hallen für Neue Kunst, Schaffhausen.

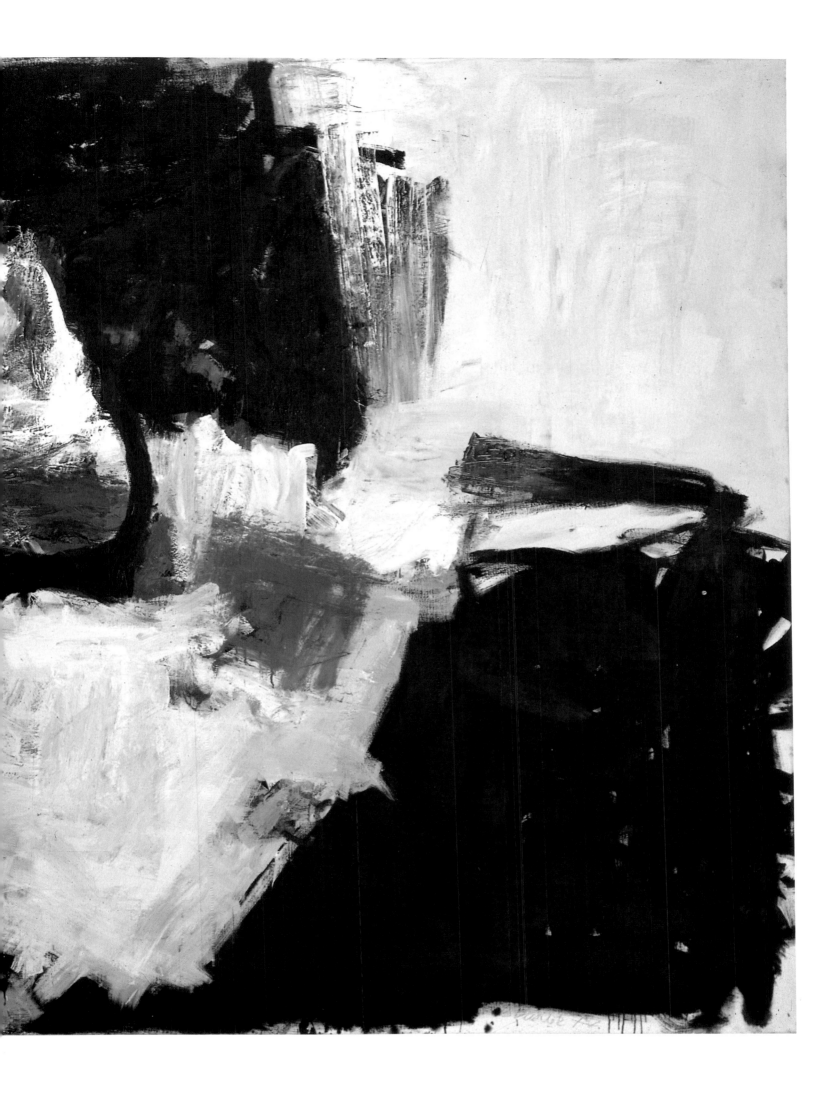

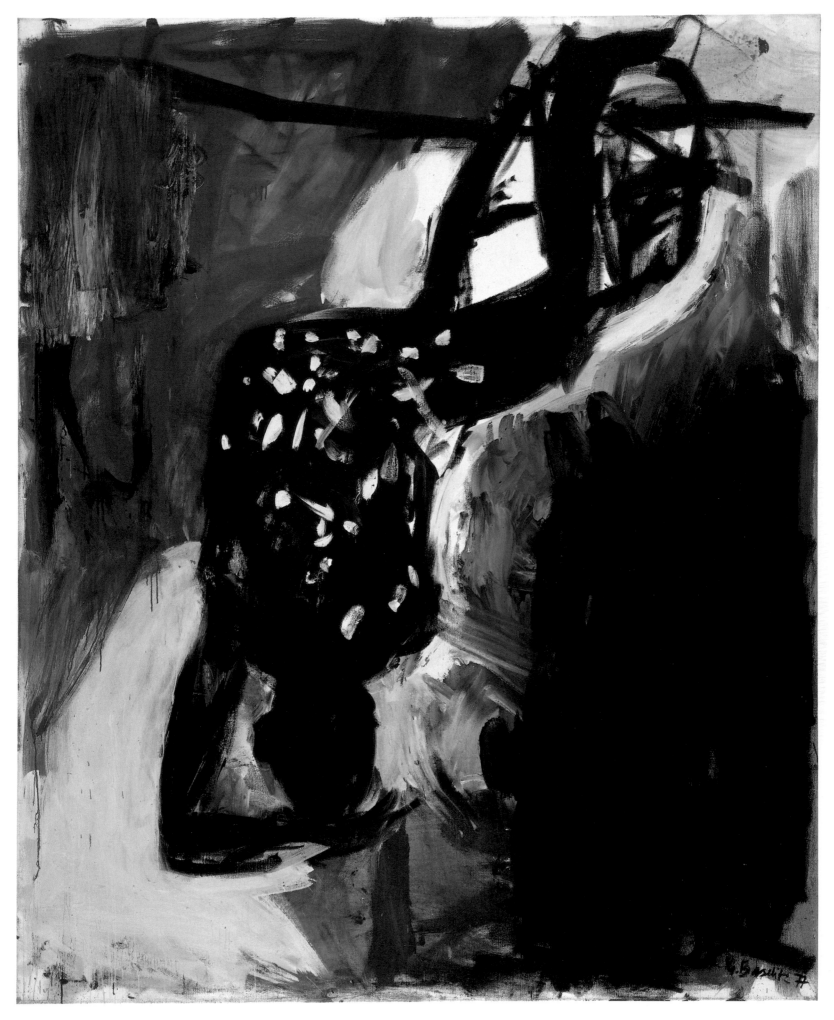

83. Georg Baselitz, *Männlicher schwarzer Akt* (*Black Male Nude*), 1977. Oil on canvas.

200 x 162 cm (78 ³/₄ x 63 ¹/₄ inches). Collection of Ealan Wingate. New York.

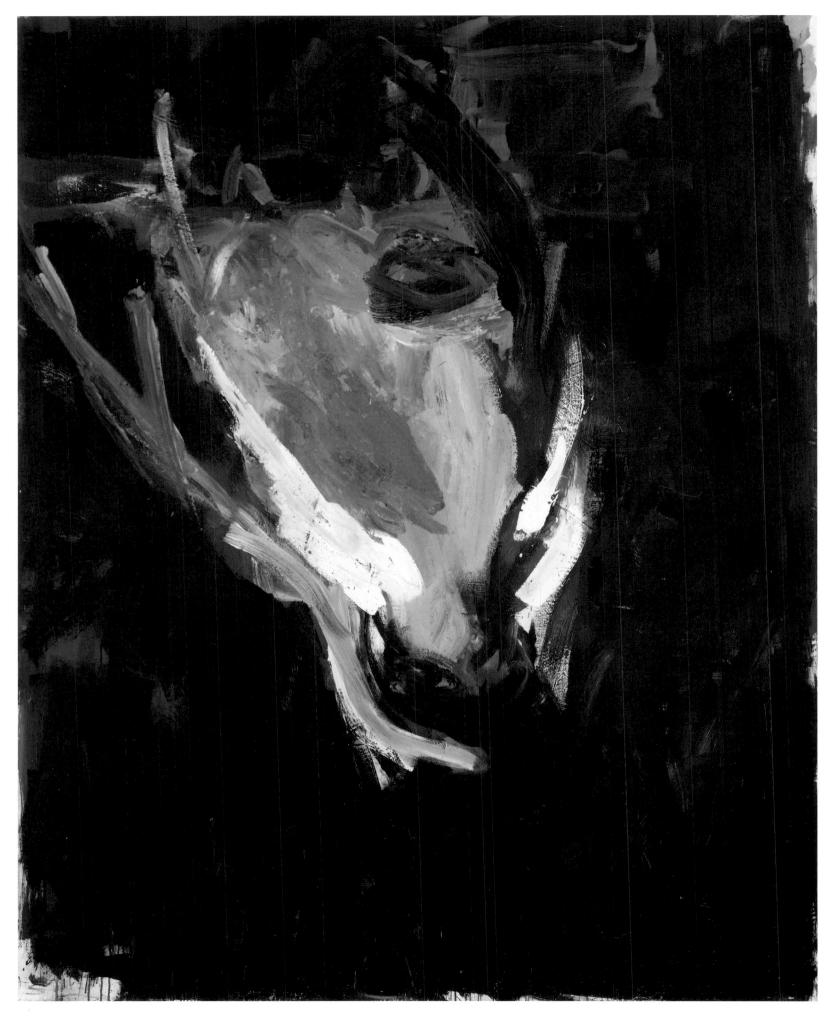

84. Georg Baselitz, *Adler* (*Eagle*), 1973. Tempera on canvas, 200 x 162 cm

(78 ³/₄ x 63 ³/₄ inches). Collection of Dr. Michael and Dr. Eleonore Stoffel.

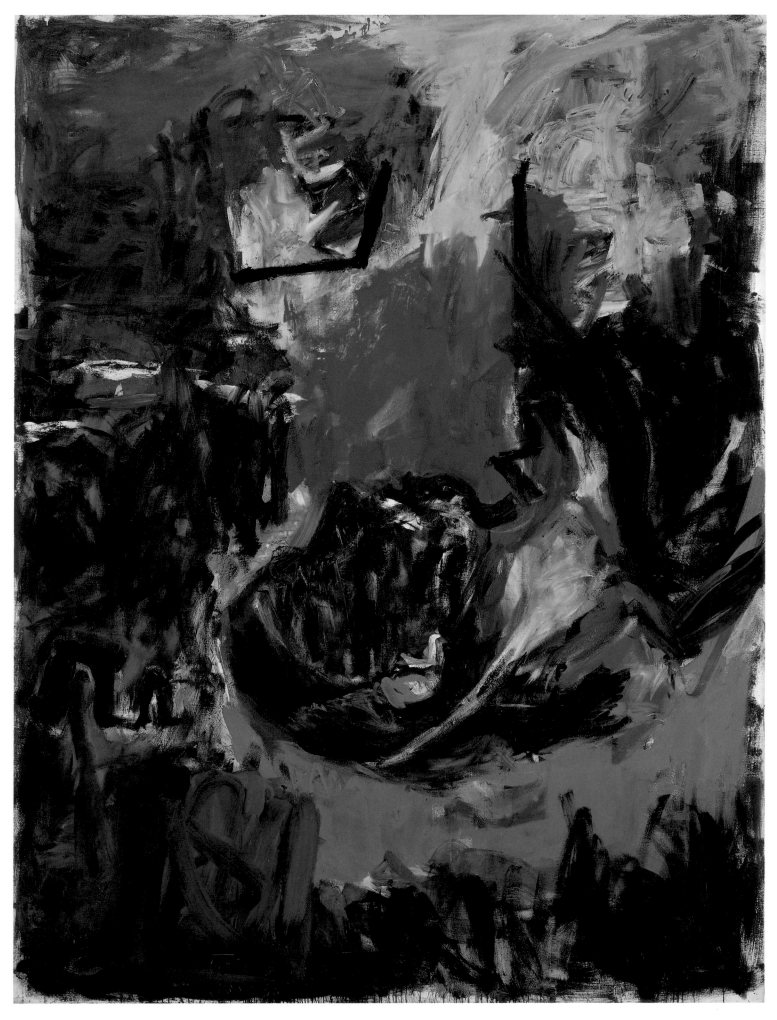

85. Georg Baselitz, *Trümmerfrau* (*Bomb-Site Woman*), August 1978. Oil and tempera on canvas,
330 x 250 cm (129 7/8 x 98 3/8 inches). Stedelijk Van Abbemuseum, Eindhoven.

86. Georg Baselitz, *Adler* (*Eagle*), August 1978. Oil and tempera on canvas, 330 x 250 cm

(129 7/8 x 98 3/8 inches). Staatsgalerie Stuttgart.

immediately legible shape, for Baselitz allowed a cursory notation of a wing to suggest the eagle and convey a sense of movement. The 1978 *Eagle* (no. 84) is more abstract, a study in color in which black predominates. In the center of the painting, the eagle is more obliquely suggested by the presence of a form shaped like an eye and by colors—creamy pinks, grays, blues, and whites—that suggest the silken coat of a bird. The August 1978 *Eagle* (no. 86) is even more explicitly abstract: the image of the eagle is comprised of a network of brushstrokes and layers of paint. One can make out an apparent bird form, but its shape is neutralized by a white square that dominates the painting and partially obscures the lower-left portion of the body.

Baselitz, who had made his first woodcuts in 1966, started to work on large-format linoleum cuts in 1977. He began to use tempera with oil paint in 1978, a practice dating to his student years. Mixing the two mediums reduces the reflective nature of the oil, creating a mattelike finish. (Baselitz recalls that in art school Trier advised him to use tempera alone because it was cheap and durable.) He also continued to work on large-scale canvases like *Trümmerfrau* (*Bomb-Site Woman*, August 1978, no. 85) and *Die Ährenleserin* (*The Gleaner*, August 1978, no. 89). In these works, both of which are painted in oil and tempera, Baselitz emphasized the process of painting more emphatically than ever. Brilliant patches of color and broad gestural brushstrokes

89. Georg Baselitz, *Die Ährenleserin* (*The Gleaner*), August 1978. Oil and tempera on canvas.

330.1 x 249.9 cm (129 7/8 x 98 3/8 inches). Solomon R. Guggenheim Museum, New York.

Purchased with funds contributed by Meryl and Robert Meltzer, 1987.

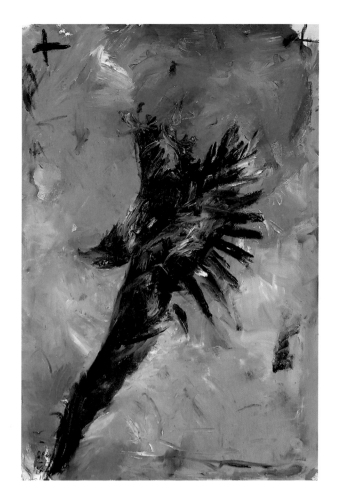

animate the canvases. This is especially true of *Bomb-Site Woman*, in which every
element of the painting is volatile, every mark expressive, every color explosive. In *The
Gleaner*, a somewhat more subdued painting, he inverted a crouching figure in the top
of the canvas, a device he used with great effectiveness in *Eagle* (no. 86). Baselitz does
observe some of the conventions of verisimilitude, however, for the crouching figure in
The Gleaner appears firmly planted on the ground, and the eagle in the latter painting
appears to be resting on a tree branch. Both figures are discernible forms in paintings
that are otherwise resolutely abstract. By retaining some conventions and flouting many
others through his volatile gestures and emotive colors, Baselitz invigorated the tradition
of both abstract and figurative painting and imbued each with a new dimension.

 The Gleaner traces its origin to Jean-François Millet's painting *L'Angelus*
(*The Angelus*, 1854–59, no. 87); for Baselitz, the motif is especially significant for its
subsequent use by many artists, from van Gogh to the Surrealist Salvador Dalí.
Baselitz's gleaner is also very similar to a figure in *Die Netzflickerinnen* (*The Net
Menders*, 1887–89, no. 88), a painting by Max Liebermann, a Berlin-based realist. The
image of the gleaner has more personal relevance for Baselitz: after World War II,
everyday people—modern-day gleaners and net menders—were engaged in rebuilding
their homes and cities, and he vividly remembers women clearing up the rubble and

cleaning old bricks to build new homes. Baselitz felt compelled to paint the motif of the gleaner as part of his own history.

In 1978, Baselitz was appointed a professor at the Staatliche Akademie der Bildenden Künste in Karlsruhe, where he had become an instructor the preceding year. He painted a number of two-panel paintings on plywood, and then began a project that was to occupy him from March 1979 until February 1980. Entitled *Straßenbild* (*Street Picture*, no. 93), it reappraises what Baselitz calls "street paintings," exemplified by the works of Italian Renaissance painter Piero della Francesca and twentieth-century French artist Balthus [Balthasar Klossowski de Rola]. Balthus's *La Rue* (*The Street*, 1933, no. 91),[53] like the work of Piero to which it makes reference, shows a street in Paris in which the figures appear detached from one another, frozen in time and place. This conception of isolation, in which figures are alienated from their surroundings, has also been used with great success by other twentieth-century artists, such as Giorgio de Chirico and Alberto Giacometti, the former in his haunting paintings of city squares, the latter in such seminal Surrealist works as *The Palace at 4 A.M.* (1932–33, no. 92). In *Street Picture*, Baselitz reinforced the concept of isolation by using eighteen separate panels, each the same size and each containing a single image. In the 1960s, Baselitz had been influenced by the writings of the Comte de Lautréamont, whose work was a major influence on the

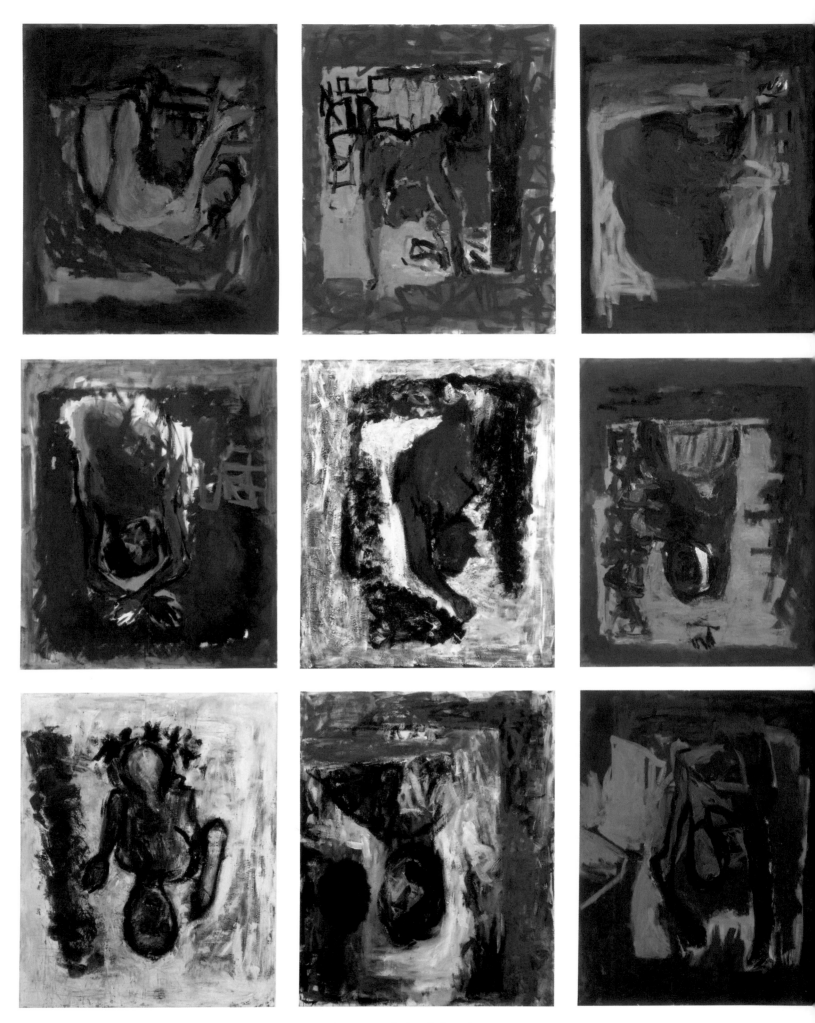

93. Georg Baselitz, *Straßenbild – Das Fenster – Eine Frau lehnt sich aus dem Fenster – Malerische Legende*
(*Street Picture – The Window – A Woman Leans Out the Window – Painterly Legend*), 1979–80. Tempera on canvas,
eighteen panels, 200 x 162 cm (78 ³/₄ x 63 ³/₄ inches) each. Kunstmuseum Bonn.

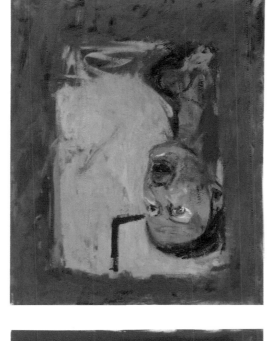
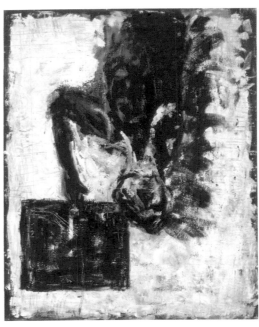
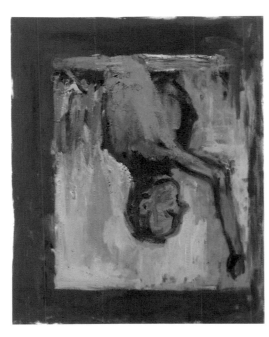
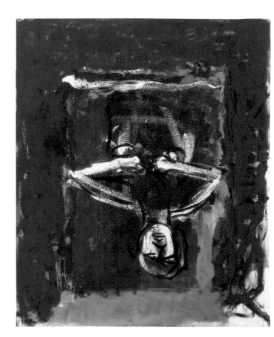

Surrealist painters and poets. At that time, he noted: "My attitude to painting is a visualization of the ideas in the Surrealist Manifestos."[54] The Comte de Lautréamont's most famous passage, "Beautiful like the fortuitous meeting, on a dissection table, of a sewing machine and an umbrella,"[55] encouraged the Surrealists to create paintings in which subjects are stripped of their original meanings and placed in new contexts, leading to an innovative and evocative imagery. While Baselitz was not interested in narrative, he was intrigued by the isolation between objects and the associations they invoked. In *Street Picture*, each of the eighteen compartments contains a fragmentary image. The figures are rendered in a cursory manner and appear to be set in a cavelike surrounding, with light and dark, candle and flame suggesting a prehistoric context. The figures, many engaged in similar activities, appear to have no relationship to one another. *Street Picture* is full of mystery and magic, and like the work of the Surrealists, suggests new and provocative relationships in the theater of the imagination.

Sculpture

Following his first solo exhibition in 1963, Baselitz showed his work with great frequency in Germany and was included in major international exhibitions such as *Documenta 5*, in 1972, and the 1975 São Paulo *Bienal*. However, it was the 1980 Venice *Biennale* that

brought him his greatest international attention to date. At the invitation of Klaus Gallwitz, Baselitz shared the West German pavilion with Anselm Kiefer. Baselitz's contribution consisted of just one work, his first major sculpture, *Modell für eine Skulptur* (*Model for a Sculpture*, 1979–80, no. 94), which created an uproar. A curious work carved from several pieces of wood, it is of a prostrate male with outstretched right arm, palm facing outward. The surface of the sculpture is marked with light hatchings and painted in red and black. Critics saw in the figure's gesture a reference to the infamous Nazi salute, while the red and black were compared to the colors of the Third Reich. Baselitz insists, however, that he based the figure's gesture on examples from African art, in which the upraised palm represents surrender in battle. In speaking of his foray into sculpture, Baselitz has said of the medium that it "is more primitive and brutal [than painting]. This was confirmed for me by the polemical vehemence of the criticism which was levelled at my sculpture in Venice."[56]

Baselitz has produced more than fifty sculptures since. For each, the artist has selected a single tree (usually linden, ash, birch, or ayous), cutting into the trunk with a chainsaw, chisel, and axe until a figure emerged. While his use of trees as a sculptural material may carry some of the same associations as the tree motif in his paintings, wood is also a medium he can attack as readily as he attacks the surfaces of his canvases. The

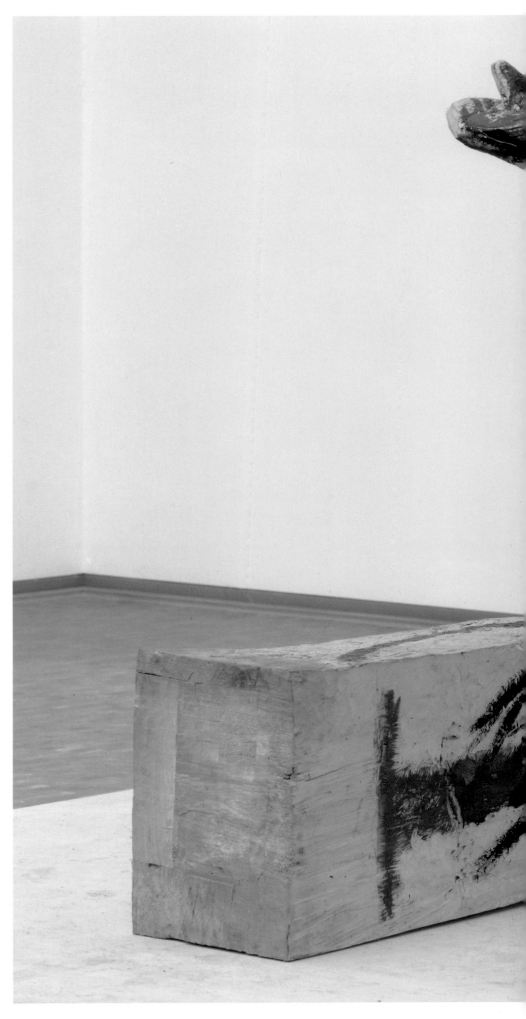

94. Georg Baselitz, *Modell für eine Skulptur* (*Model for a Sculpture*), 1979–80. Limewood and tempera, 178 x 147 x 244 cm (70 x 57 ⅞ x 96 inches). Museum Ludwig, Cologne, Ludwig Collection.

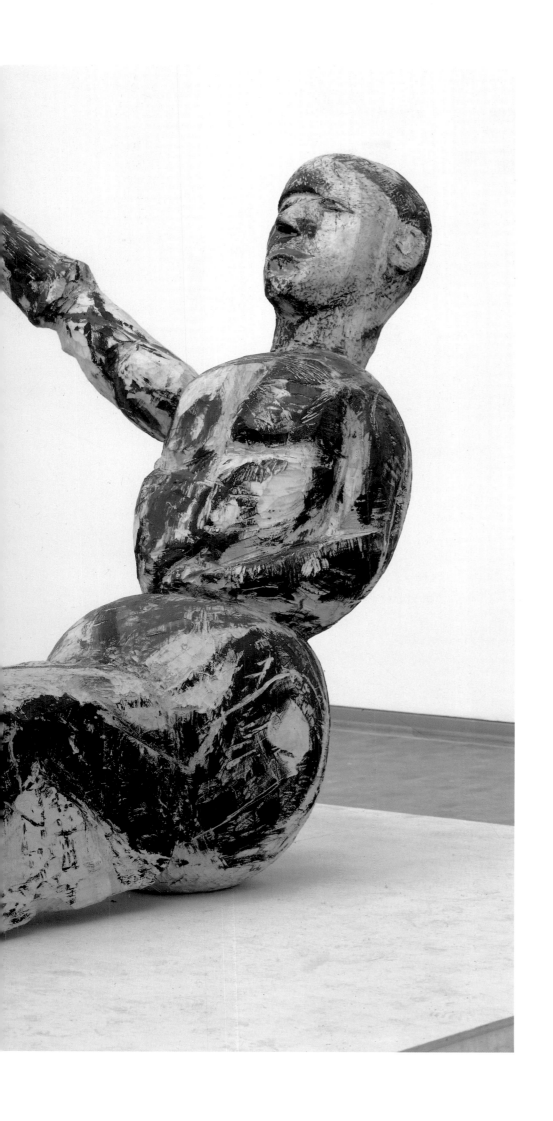

sculptures that followed *Model for a Sculpture* are characterized by more pronounced incisions and hatchings. He said in 1983:

> *In sculpture, using the saw is an aggressive process which is the equivalent of drawing. It's a linear signal. . . . By working in wood, I want to avoid all manual dexterity, all artistic elegance, everything to do with construction. I don't want to construct anything.*[57]

Baselitz brings to his sculpture an intense interest in the physical properties of his medium. He eschews the modeling of forms in favor of a direct-carving technique, and thus aligns himself with such artists as Paul Gauguin, Constantin Brancusi, Picasso, and Ernst Ludwig Kirchner. These early Modernists had been intrigued by "primitive" art, finding in tribal sculpture a new way to approach abstract form and thus to make a decisive break with the nineteenth-century academic tradition. Like his precursors, Baselitz was impressed both by the technique employed in the making of tribal art and by its spiritual dimension. He found a parallel for African art in German Gothic sculpture, whose forms are also abstract, schematic, and mystical. Borrowing from both traditions has allowed him to circumvent the concept of monumental sculpture, which, under both the Nazi and Soviet regimes, represented to him the worst aspects of European civilization.

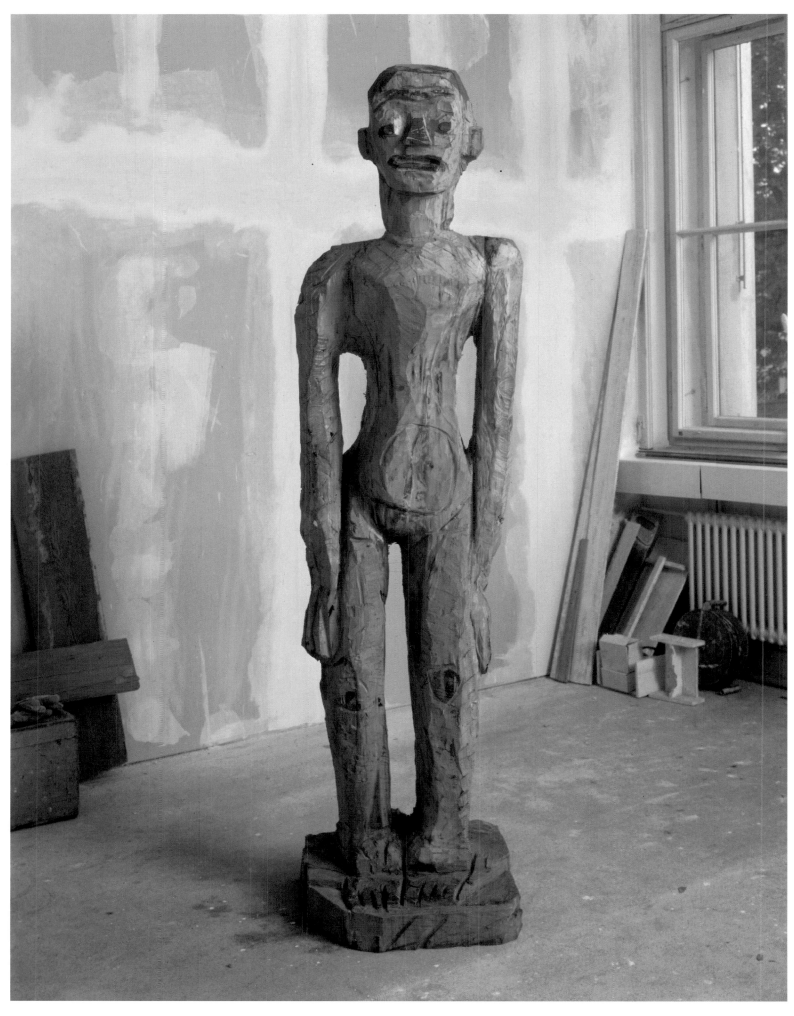

96. Georg Baselitz, *Ohne Titel* (*Untitled*), 1982–83. Limewood and oil, 209.5 x 58.5 x 51.5 cm
(82 1/2 x 23 x 20 1/4 inches). Kunstmuseum Bonn. On permanent loan from the Grothe Collection.

Baselitz's work in sculpture led him to an analysis of the Western tradition. He saw in European sculpture a lineage in which each body of work was formed in reaction to the one that preceded it: Renaissance sculpture, for example, was made in response to Roman sculpture, which was itself a reaction to classical Greek forms. He has said:

> *We make a sculpture or a painting* against *a sculpture or a painting that someone else has made before us; always* against *something. We can't work as sculptors against other people without destroying other people's work. Because sculptures and paintings in Europe are things that are present, we can relate to all the sculptures that have been done in Europe over the last eight hundred years. . . . In Africa this issue doesn't arise. There are sculptures that people have been making for several thousand years and which are constants—even when they are brand-new, even when they were made yesterday. The reason is that to them, the father, the ancestor, is not an enemy. The artist's relationship to his work does not exist, so all there is to do is to remake something. If you consider several millennia of civilization in the Congo, for example, and look at a single figure that has been standardized over the entire period, there is hardly any difference. There is some talk of degeneration, but it is minimal, just details.*[58]

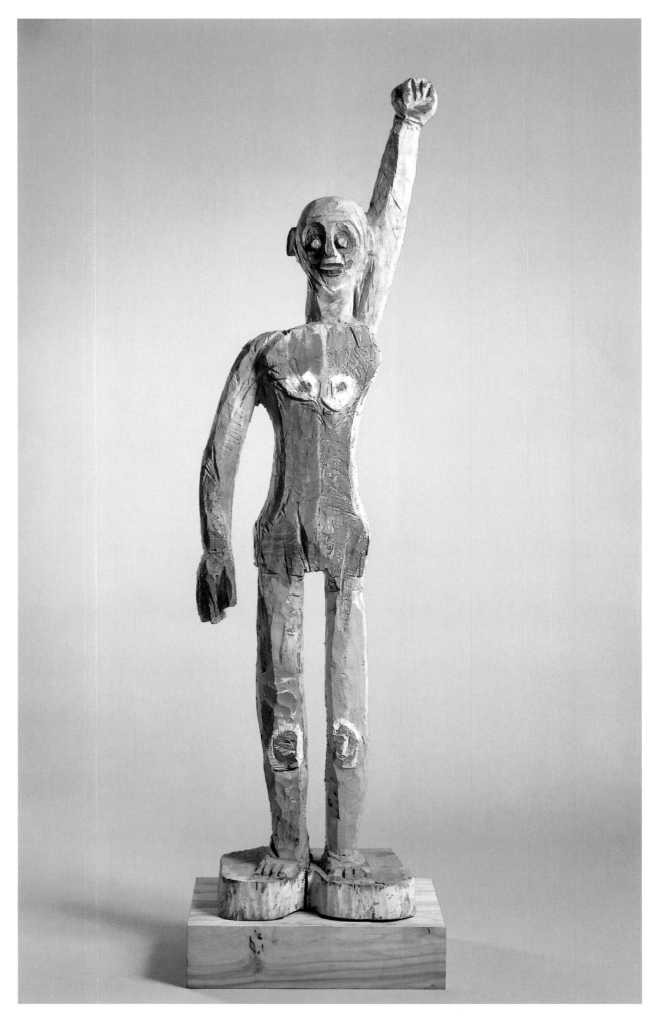

98. Georg Baselitz, *Ohne Titel* (*Untitled*), 1982–84. Limewood and oil, 253 x 71 x 46 cm

(99 ¹/₂ x 28 x 18 ¹/₈ inches). Scottish National Gallery of Modern Art, Edinburgh.

Purchased with assistance from the National Art Collections Fund (William Leng Bequest), 1989.

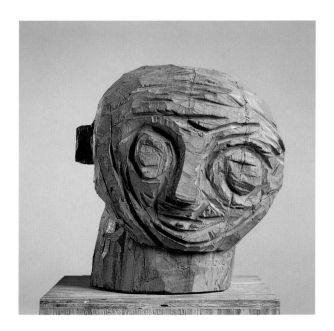

Regarding the relationship of African art to the sculpture of the early twentieth-century Modernists, Baselitz has said:

> They all took these unfamiliar things that come from Cameroon, or Gabon, and appreciated the element of something "never before seen" that is in them. For my part, this is an issue that concerns me too. I am not interested in adopting the elevated cultural vantage-point of European sculpture and making use of all its sophisticated refinements in order to "improve" on anything. That's a situation I loathe. Whenever I start a painting I set out to formulate things as if I were the first one, the only one, and as if the precedents did not exist; even though I know that there are thousands of precedents ranged against me. One has always to think of making *something, something valid. That is my life.*[59]

The figure was the starting point for Baselitz's sculpture just as it was in his painting. But rather than inverting the figure or making it prone, in his sculpture he has contorted its proportions, investigated asymmetrical compositions, and developed unique approaches to both volume and void in order to confound conventional readings of the object. While the figures in his paintings have been forced into a unique, new

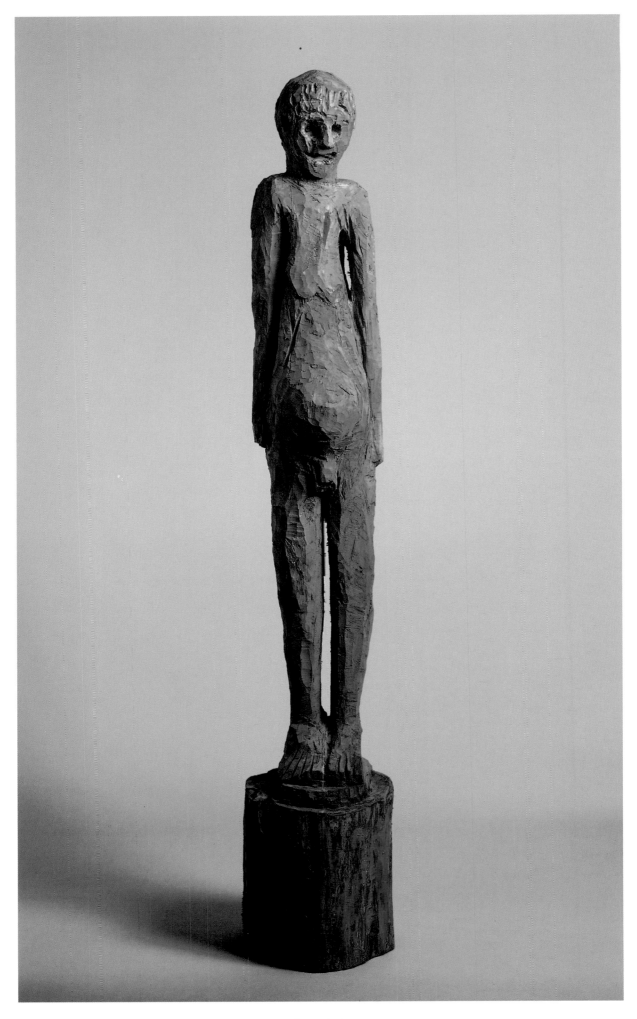

100. Georg Baselitz. *Der rote Mann* (*The Red Man*), 1984–85. Willow and oil.
299.5 x 54.5 x 55 cm (117⅞ x 21½ x 21⅝ inches). Private collection, Switzerland.

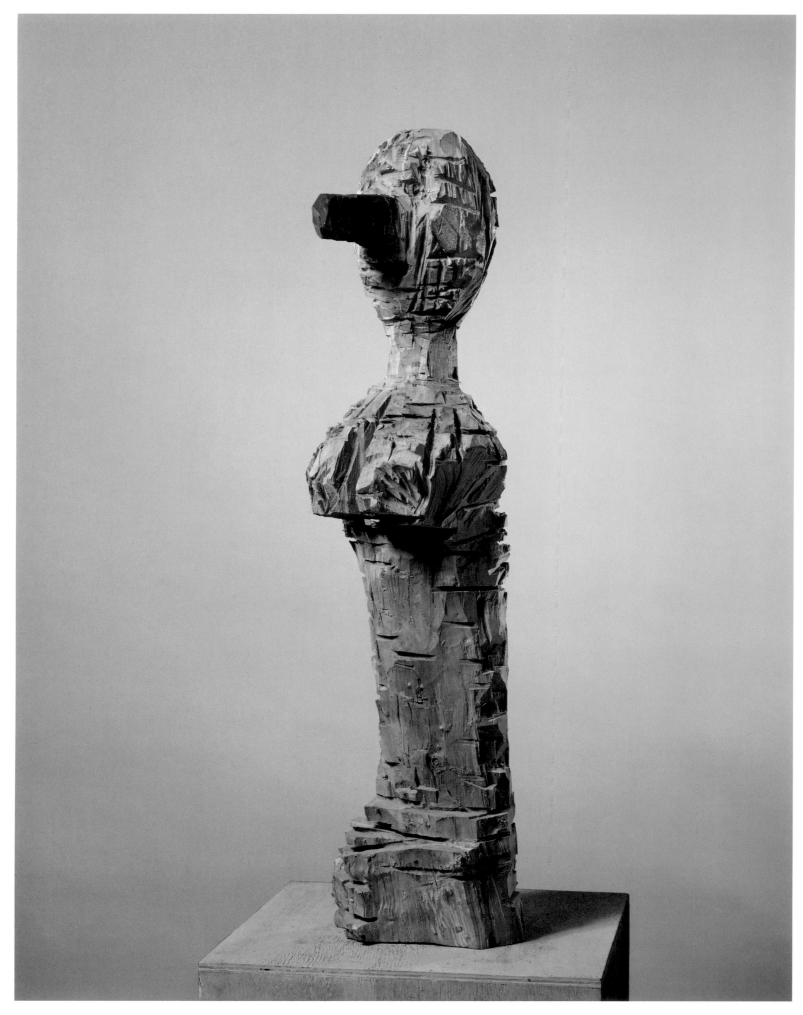

101. Georg Baselitz, *Tragischer Kopf* (*Tragic Head*), 1988. Birch and oil,

128.5 x 33 x 37 cm (50 ⁵/₈ x 13 x 14 ⁵/₈ inches). Stefan T. Edlis Collection.

relationship with *illusionistic* space, his sculptural objects have been forced into a new relationship with *real* space.

Many of these qualities can be seen in *Ohne Titel* (*Untitled*, 1982–83, no. 96), a totemic work that has been compared to Kirchner's *Male Nude (Adam)* (1912, no. 95).[60] Both sculptures share an elongated, frontal pose. While the surface of Baselitz's sculpture is far cruder than that of Kirchner's, both are unpolished, with surface markings animating the representation of flesh. However, Kirchner's use of precise incised cuts to denote anatomy was replaced in Baselitz's work by only the slightest circular incision on the stomach, and the phallus was eliminated altogether. The sculptures also differ compositionally. In *Male Nude (Adam)*, Kirchner established a careful symmetry by balancing the shoulders, hollowing out and dividing the chest, and distributing the weight of the legs evenly. In Baselitz's figure, however, such symmetry is toppled by the wrenched oversized right arm, protruding, uneven chest, and destabilized legs. The sculpture reflects Baselitz's interest in uncovering what he refers to as a system underlying asymmetry[61] and in discovering its ability to shape new perceptions.

Ohne Titel (*Untitled*, 1982–84, no. 98) is another sculpture that reflects Baselitz's interest in the artists of Die Brücke as well as their precursor, Edvard Munch. In this work, Baselitz used color to define the torso, hands, eyes, nose, mouth, nipples, and

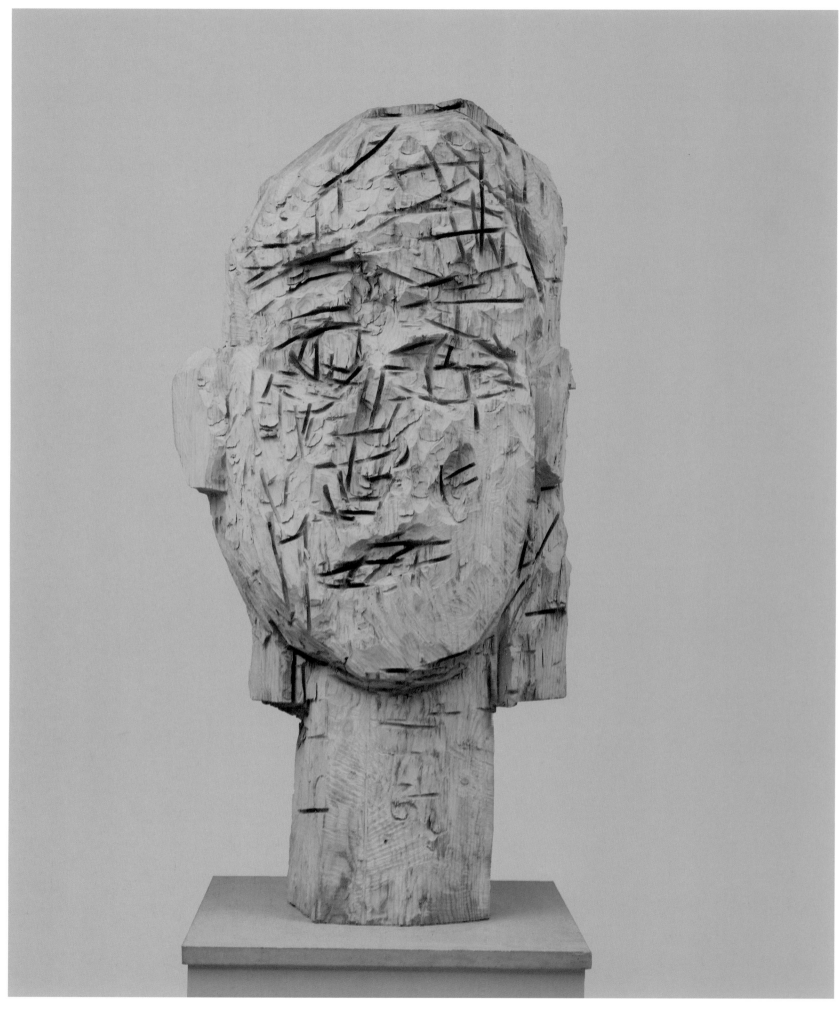

102. Georg Baselitz, *Dresdner Frauen – Besuch aus Prag* (*Women of Dresden – Visit from Prague*), May 30, 1990.

Ash and tempera, 150 x 75 x 43 cm (59 x 39 1/2 x 16 7/8 inches). Collection of Darwin and Geri Reedy.

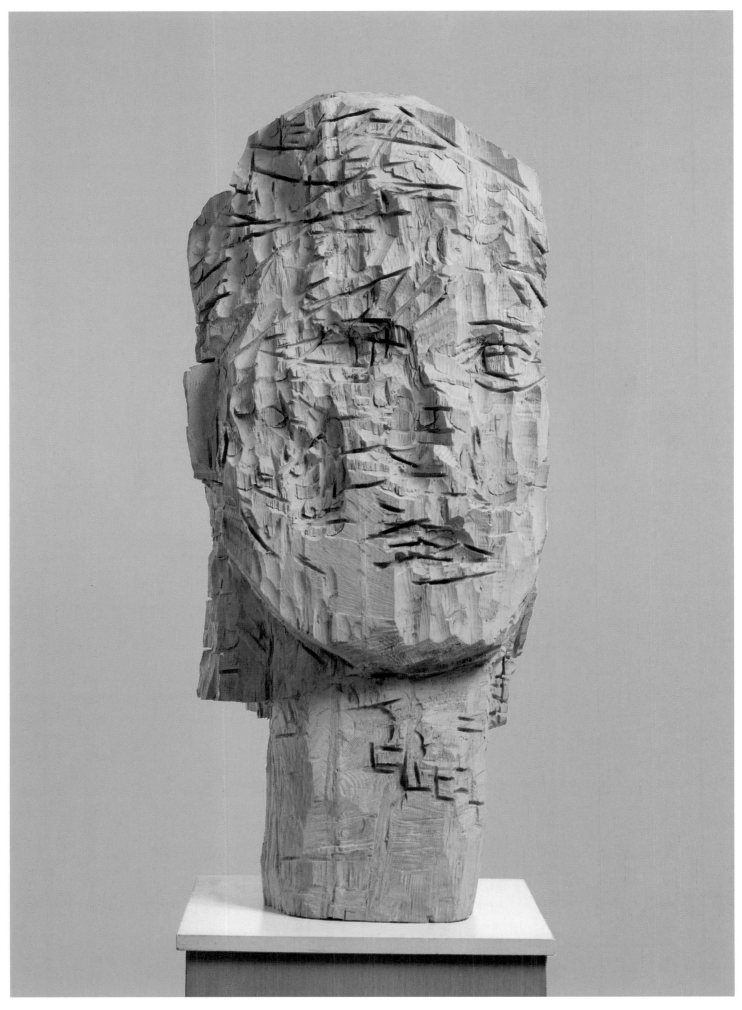

103. Georg Baselitz. *Dresdner Frauen – Karla (Women of Dresden – Karla)*, March 5, 1990. Ash and tempera.

158 x 67.5 x 57 cm (62 ¼ x 26 ⅝ x 22 ½ inches). Froehlich Collection, Stuttgart.

knees, recalling ritualistic body painting. With its ovoid head and heavily outlined eyes, *Untitled* is also related to the paintings *Nachtessen in Dresden* (*Supper in Dresden*, February 18, 1983, no. 139) and *Die Brückechor* (*Die Brücke Choir*, August 1, 1983).

Some of Baselitz's sculptures of the early and mid-1980s are reminiscent of the jamb figures found on the portals of Gothic cathedrals throughout Europe, in which the figure is confined within a niche, arms contained within the frame of the body, feet pointing downward. The proportions of *Der rote Mann* (*The Red Man*, 1984–85, no. 100), particularly the figure's narrow torso, bring to mind these Gothic sculptures. The wooden pedestal of *The Red Man*, fused to the figure, also recalls the carved wooden bases made by Brancusi; though separate pieces, bases are often integral parts of Brancusi's works.

In Baselitz's sculptures of the early and mid-1980s, color was usually applied to the wood to define only certain areas of the figure; by the late 1980s and early 1990s, color dominated his forms, becoming as gestural and expressive in his sculptures as it was in his paintings of the period. *The Red Man* anticipated Baselitz's use of a single color to coat the sculptures of the 1989–90 series *Dresdner Frauen* (*The Women of Dresden*, nos. 102–04, for example),[62] which he painted in cadmium yellow. In *Tragischer Kopf* (*Tragic Head*, 1988, no. 101), Baselitz coated the jutting nose of the androgynous figure with red paint and obliterated the eyes and mouth. The nose as a central focus in this

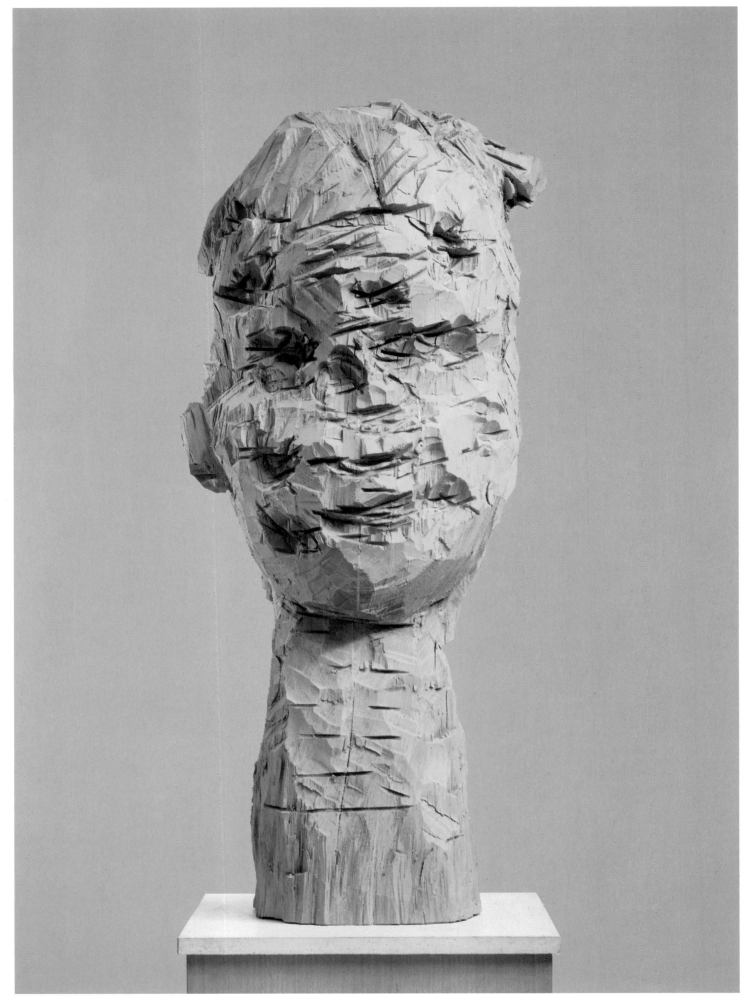

104. Georg Baselitz, *Dresdner Frauen – Die Heide* (***Women of Dresden – The Heath***), October 1990. Limewood and tempera,

155 x 70 x 56 cm (61 x 27 ⁵/₈ x 22 inches). Louisiana Museum of Modern Art, Humlebaek, Denmark.

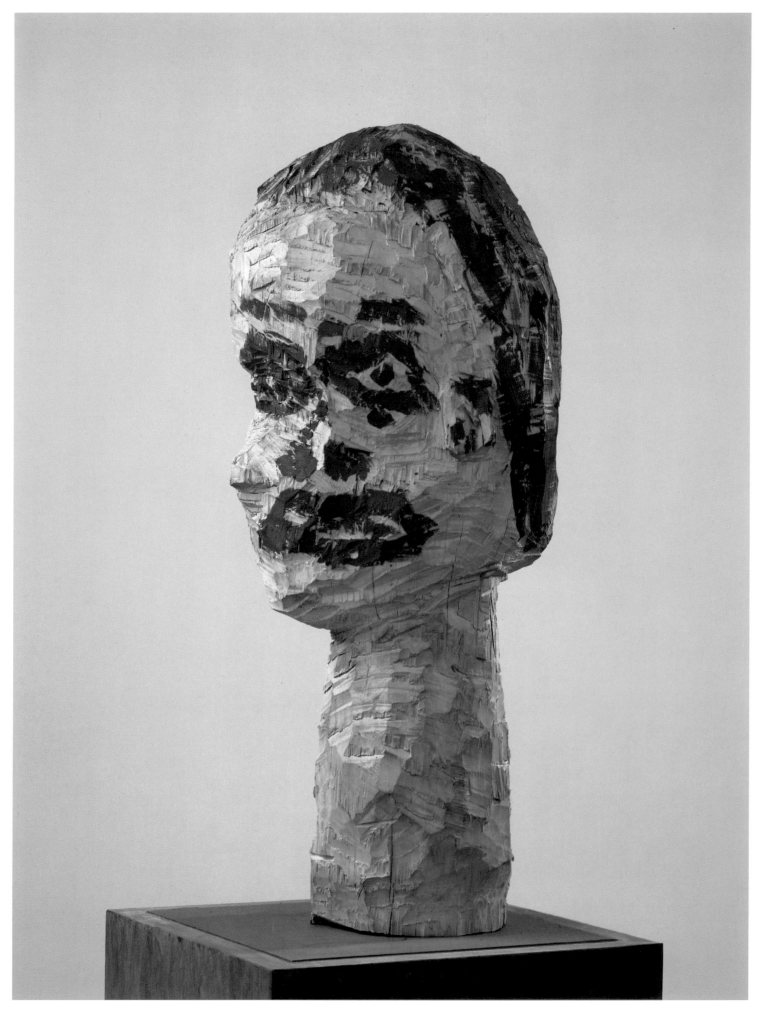

105. Georg Baselitz. *Elke.* March 4, 1993. Limewood and synthetic resin, 126.5 x 53.5 x 52 cm (49 x 21 x 20 ¹/₂ inches).

Jamileh Weber Gallery, Zurich.

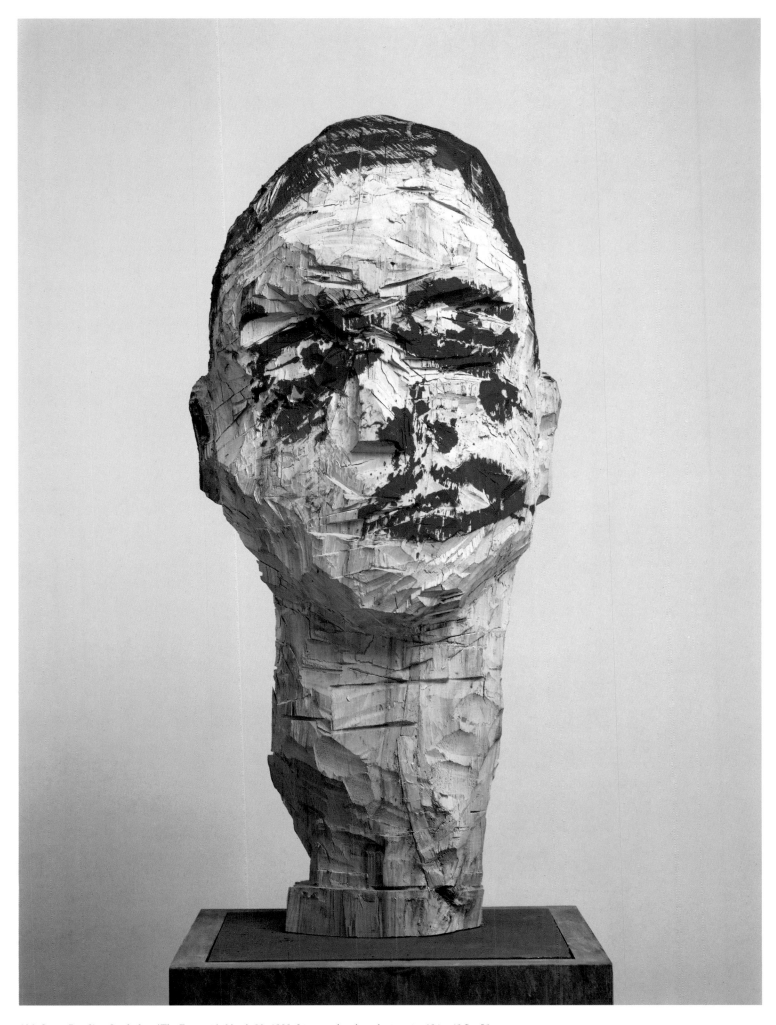

106. Georg Baselitz, *Sonderling* (*The Eccentric*), March 20, 1993. Limewood and synthetic resin, 134 x 62.5 x 52 cm

(52 ³/₄ x 24 ¹/₂ x 20 ¹/₂ inches). Kunstmuseum Bonn, On permanent loan from the Grothe Collection.

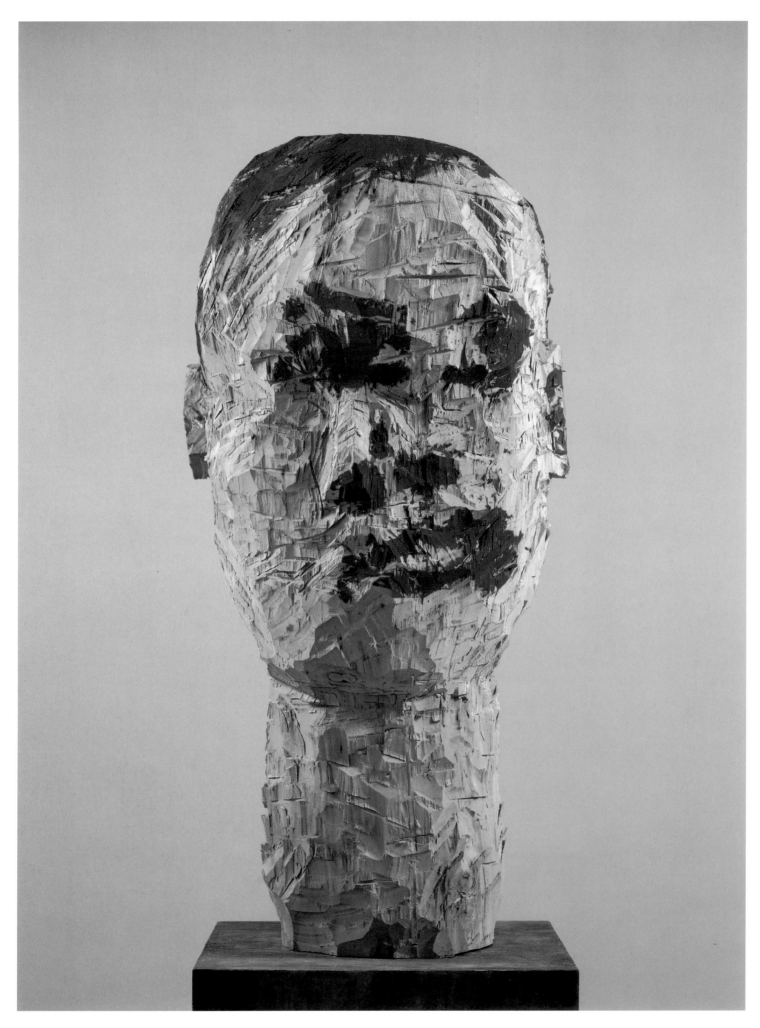

107. Georg Baselitz, _Rautenkopf_ (_Diamond Head_), April 5, 1993. Limewood and synthetic resin.

172 x 81.9 x 73 cm (67 ³/₄ x 32 ¹/₄ x 28 ³/₄ inches). PaceWildenstein, New York.

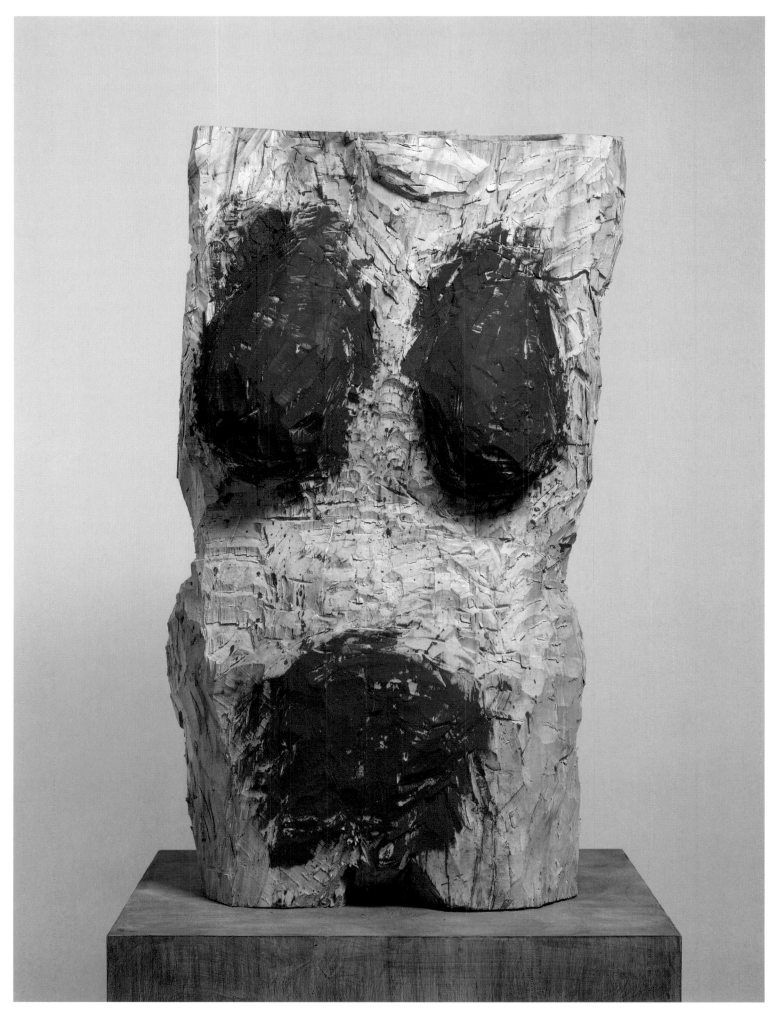

108. Georg Baselitz, *Weiblicher Torso* **(***Female Torso***),** April 22, 1993. Limewood and synthetic resin.

149 x 91 x 74 cm (58 ³/₄ x 35 ⁷/₈ x 29 ¹/₈ inches). PaceWildenstein, New York.

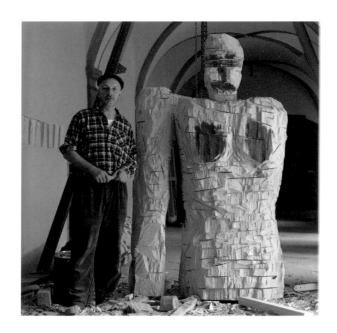

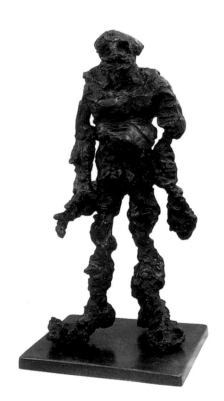

and several other sculptures harks back to his *Rayski Head* series of 1959–60. In the *Dresden* heads, it is the *absence* of the nose that commands attention.

In some respects, the *Dresden* heads bring to mind Giacometti's 1950s sculptures, Dubuffet's craggy *Petites Statues de la vie précaire* (*Little Statues of Precarious Life*, 1954), and de Kooning's kneaded sculptures of the early 1970s, such as *Clamdigger* (1972, no. 110).[63] In his attenuated sculptures, Giacometti radically altered the relative proportions of the head and body, and he diminished their customary mass and volume. While the mass and volume of Baselitz's *Dresden* heads are considerable, their relationship to real-life figures remains as distant as that of Giacometti's. About them is an air of ambiguity, a sense of solitude that recalls the mood of Giacometti's existential figures. The tactile surface quality found in both de Kooning's and Giacometti's sculptures is also an element in Baselitz's works. The pummeled surfaces of de Kooning's figures are an extension of the twisted and knotted shapes in his paintings. As Baselitz has observed, de Kooning's sculptures "don't respect the principles of sculpture. They have no muscles, no skeletons, no skin."[64] Baselitz's larger-than-life heads possess the same power and fragility as Dubuffet's much smaller figures. Baselitz also shares with the French artist an interest in the art of the mentally ill, the use of "primitive forms," and idiosyncratic textures.

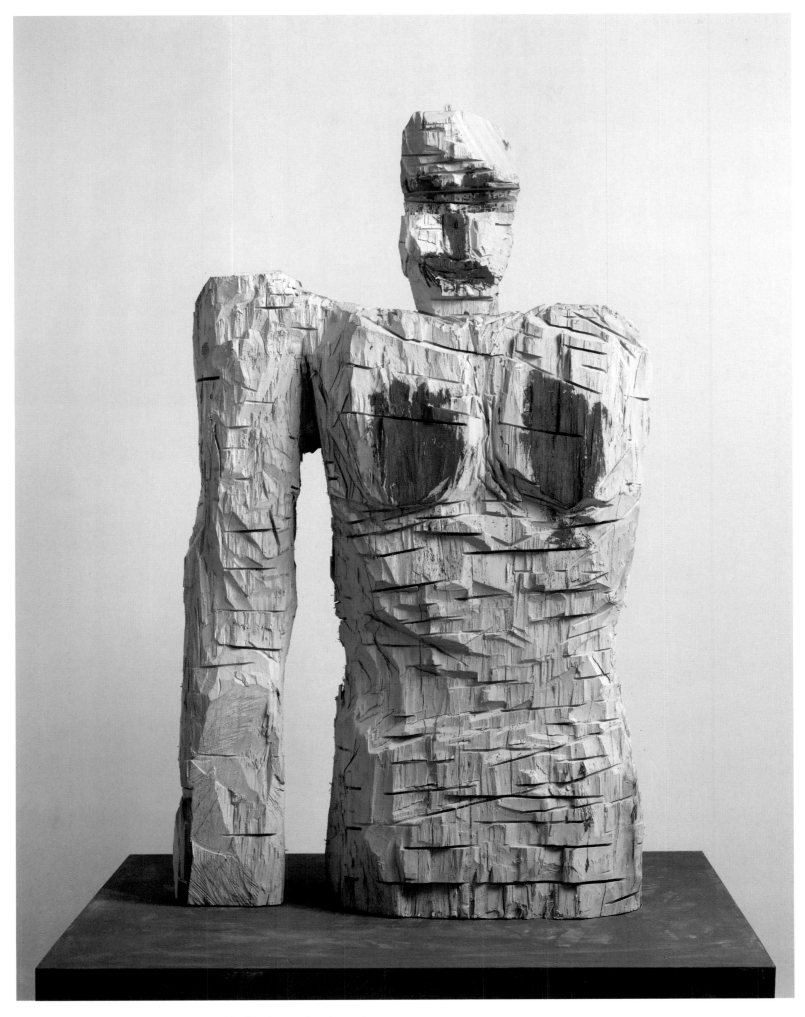

111. Georg Baselitz, *Frau Paganismus,* February 28, 1994. Ayous and synthetic resin,
215 x 132 x 68 cm (84 ½ x 54 x 26 ¾ inches). Hess Collection, Napa, California.

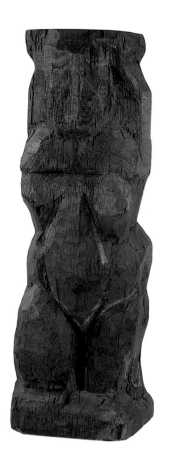

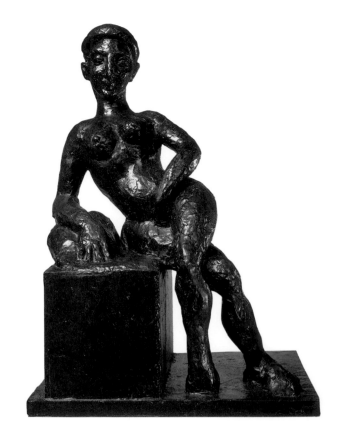

The full-length figure was the standard for Baselitz's first sculptures, but by the end
of the decade he was focusing on heads. *Sonderling* (*The Eccentric*, March 20, 1993,
no. 106) and *Rautenkopf* (*Diamond Head*, April 5, 1993, no. 107) contain some of the
features of his 1980s work, especially in those areas where the facial features have been
outlined in a brilliant red, but their scale is vast, calling to mind the powerful forms of
Olmec heads and Easter Island totems. He created truncated torsos as well, dismembered
figures that recall the formal qualities, if not the ferocity, found in the *Fracture
Paintings*. *Weiblicher Torso* (*Female Torso*, April 22, 1993, no. 108) and *Frau
Paganismus* (February 28, 1994, no. 111), with their amputated forms, deep cuts into
the surface of the wood, and intense red pigment used to define face, breasts, and pubes,
suggest a bloody rawness that is both disturbing and powerful. Baselitz is at his best here
in conveying pure emotion through his forms. Even the title *Frau Paganismus* conveys
elemental and eternal forces. As Heinrich Heil has noted:

> *In official Roman parlance,* paganismus *stands for the infiltration of
> heathen elements into the purity of doctrine. The alien admixture generates
> impurity. . . . To the guardians of tradition, the monstrous products of
> such interference are, and were always held to be, bastard, deranged,
> impure, pagan.*[65]

114. Georg Baselitz, *Armalamor,* August–September 1994. Elm, covered with fabric,
241 x 100 x 78 cm (94 7/8 x 39 3/8 x 30 3/4 inches) Private collection, Germany.

115. Georg Baselitz, *Der Adler* (*The Eagle*)**,** September 1980. Oil and tempera on canvas,
200 x 250 cm (78 ³/₄ x 98 ³/₈ inches). Le Musée d'Art Moderne et Contemporain de Strasbourg.

116. Georg Baselitz, *Frau am Strand – Night in Turisia* (*Woman on the Beach – Nacht in Tunesien*),
October 1980. Oil and asphalt on canvas, 250 x 200 cm (98 ³/₈ x 78 ³/₄ inches). Stedelijk Museum, Amsterdam.

117. Georg Baselitz, *Die Kaffeekanne* (*The Coffeepot*), December 1980. Oil and tempera on canvas,
200 x 250 cm (78 ³/₄ x 98 ³/₈ inches). Private collection.

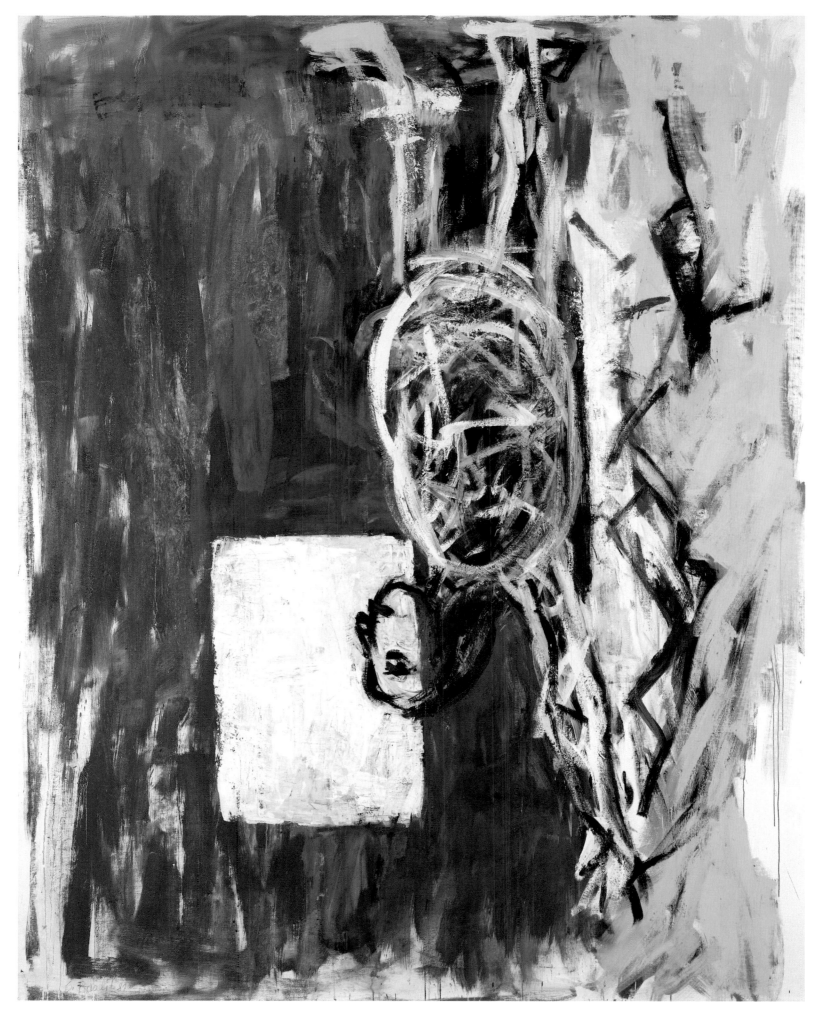

118. Georg Baselitz, *Blick aus dem Fenster nach draußen – Strandbild 7* **(***View Out the Window – Beach Picture 7***),**

January 1981. Oil and tempera on canvas, 250 x 200 cm (98 3/8 x 78 3/4 inches). Collection of Hartmut and Silvia Ackermeier, Berlin.

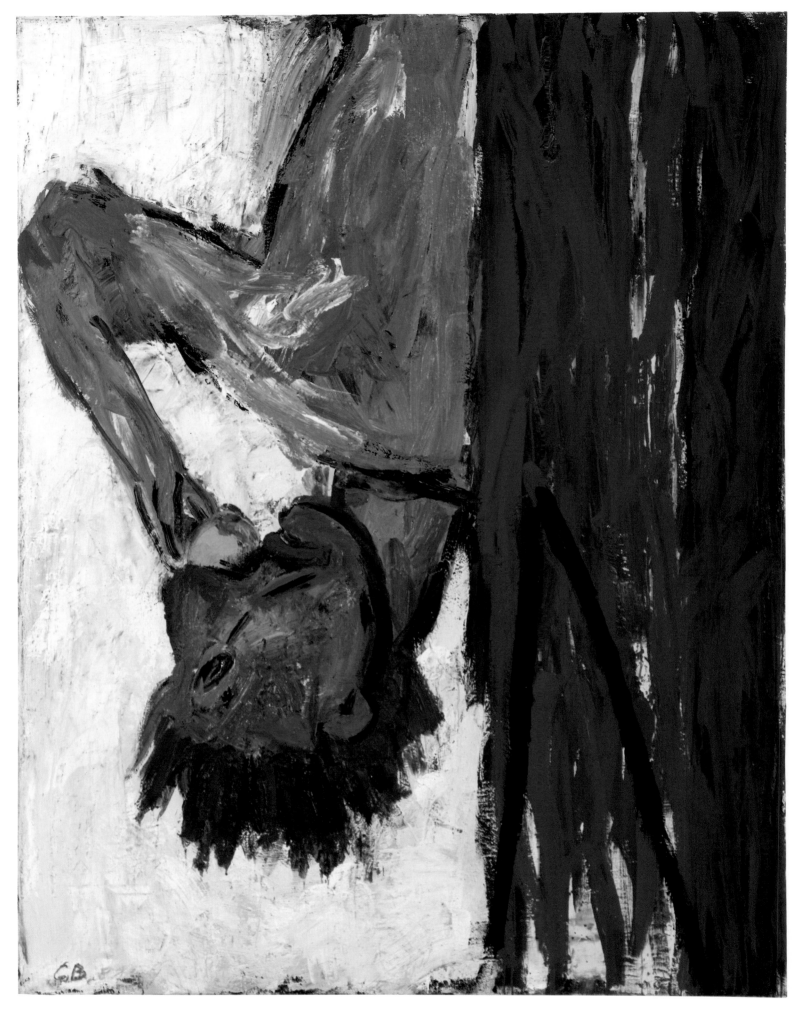

119. Georg Baselitz, *Orangenesser (IV)* (*Orange Eater [IV]*)**,** April 1981. Oil and tempera

on canvas, 146 x 114 cm (57 ¹/₂ x 44 ⁷/₈ inches). Staatsgalerie Moderner Kunst, Munich,

On loan from Wittelsbacher Ausgleichsfonds, Collection Prince Franz of Bavaria.

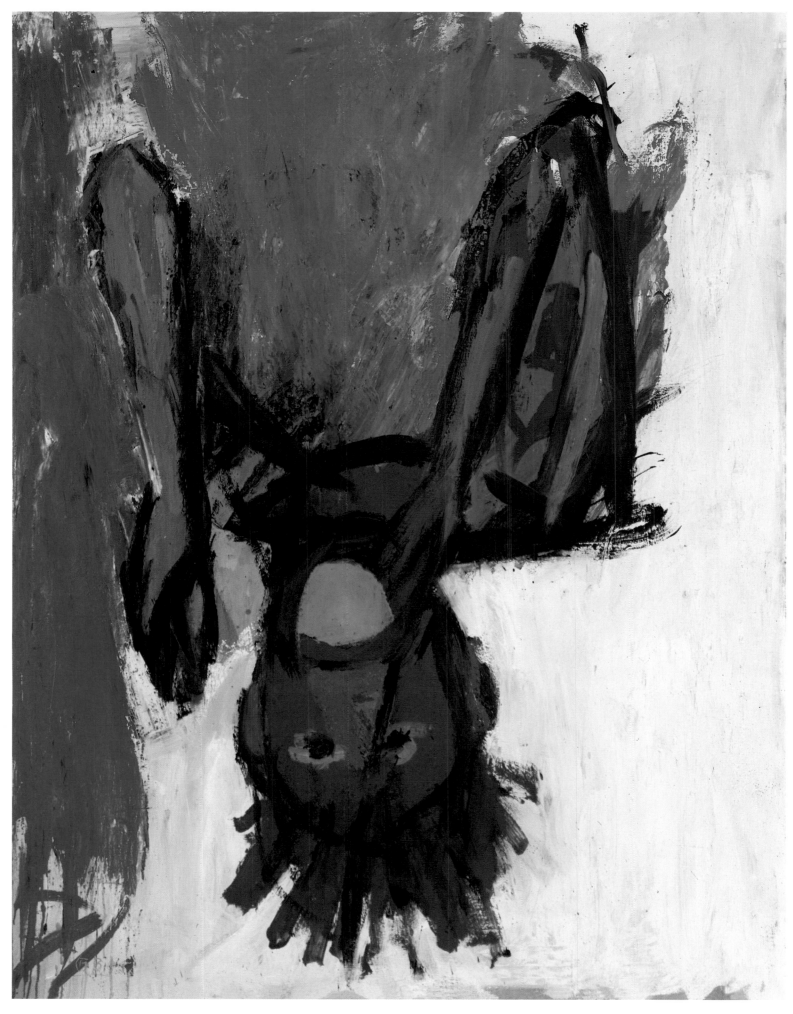

120. Georg Baselitz, *Orangenesser (X)* (*Orange Eater [X]*)**,** June 1981. Oil and tempera on canvas, 146 x 114 cm (57 1/2 x 44 7/8 inches). Collection of Judith and Mark Taylor

The change in direction that followed *Frau Paganismus* was startling, leading to *Armalamor* (August–September 1994, no. 114). Unlike the severed, naked *Frau Paganismus*, *Armalamor* is gentle and clothed. Swathed in fabric patches, she recalls the tattered figures of the *Heroes* paintings, but she is more assured and far less vulnerable. In *Armalamor* the left arm sweeps up to rest on the figure's head, a connection between the limbs and the torso that is in marked contrast with the amputated sculptures that preceded it. The alienated, troubling figures culminating in *Frau Paganismus* have been replaced by the lyrical, organic *Armalamor*. Her fabric covering (an "armor of love") protects her from the elements, her form inviting rather than repelling. She is Eve, the eternal seductress.

Picasso's *Figure 1* (1907, no. 112)[66] and Matisse's *Decorative Figure* (1908, no. 113) could have served as models for *Armalamor*. Picasso ventured into wood sculpture during 1906 and 1907; *Figure 1*'s blunt forms reflect those of Iberian works, which were shown at the Louvre in 1906, and of African sculpture, which Picasso would have seen during his visits to the Musée d'Ethnographie du Trocadéro in the summer of 1907. The sculpture is crudely carved from an oak log and contains features that are highlighted with red and white paint.[67] By the time of Picasso's first contact with "primitive" art, Matisse had already begun to collect African sculpture. He became obsessed with the

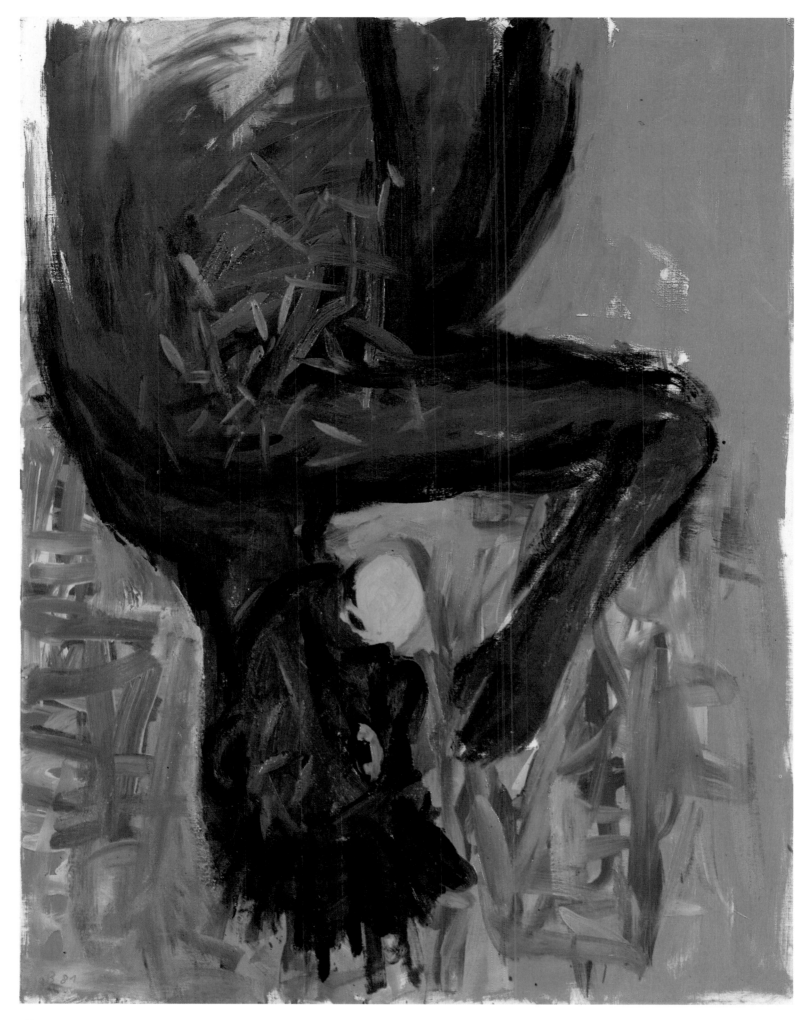

122. Georg Baselitz, *Orangenesser (VII)* (*Orange Eater [VII]*), May 1981. Oil on canvas.

146 x 114 cm (57 ¹/₂ x 44 ⁷/₈ inches). Collection of Phoebe and Herbert Chason.

sculptural arabesque; in *Decorative Figure*, the contrast between vertical and curved forms, between volume and void, is typical of both his sculpture and paintings of the period. Baselitz's figure is similarly concerned with volume and void, but its forms, like those of his previous work, are still more angular.

The cloth collaged onto the surface of *Armalamor* was cut from several bolts of fabric. The checkerboard pattern is reminiscent of the configurations he used in paintings such as *Adieu* (March 17, 1982, no. 132) and *Volkstanz* (*Folkdance*, December 28, 1988–January 5, 1989, no. 153), but here the pattern's boxes are miniscule, so that from a distance it reads as solid color. Ornamentation is a distinctive feature of Baselitz's paintings of the 1990s, so it comes as no surprise that he found a way of using pattern in his sculpture. Collaging or assembling materials is not, in itself, new; the twentieth century is replete with artists who, since the invention by Braque and Picasso of *papier-collé* in 1912, have combined different materials into evocative new forms. The Dadaists and Surrealists created memorable poetic objects in which found and altered fragments from the real world were combined into works that were anarchical and irreverent. Baselitz brings these same qualities to bear on his work.

Baselitz has said the *Armalamor* is based on the work of Jean Arp, Henri Laurens, and Henry Moore, and its title appears to be a conflation of these artists' names. In his work

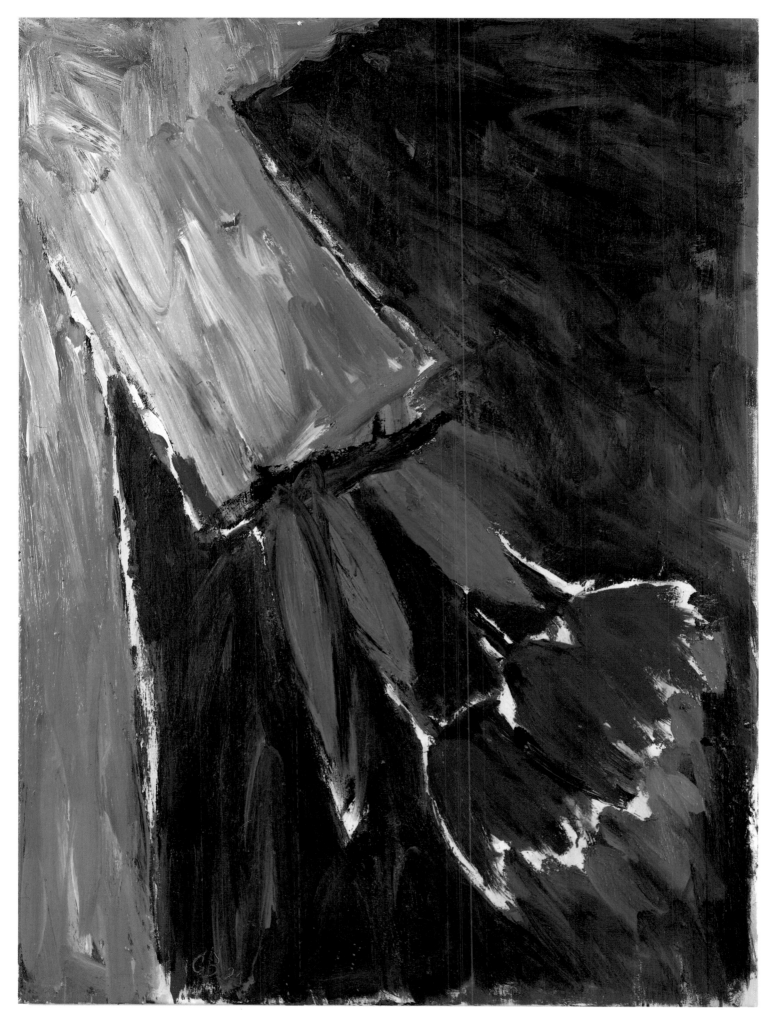

123. Georg Baselitz, *Tulpen* (*Tulips*), August 1981. Oil and tempera on canvas,
130 x 97 cm (51 ¹/₈ x 38 ¹/₂ inches). Private collection, New York.

of the Dada period, Arp used chance to determine the arrangement of his collages. The Cubist Laurens fused planar forms made from wood and metal to construct a series of still lifes and figures. As a sculptor, Arp was influenced by the biomorphic imagery found in Surrealism and he, like Moore, evolved a body of work in which the human figure was abstracted into a new language of form. Arp's preferred medium was marble or bronze, while Moore's was bronze; they used traditional materials to create the unexpected. Baselitz follows their lead, using wood but altering its personality by adding cloth to its surface. Like the Cubists, Dadaists, and Surrealists, he manipulated the expected in order to produce the unusual.

"The Painter's Equipment"

Baselitz's venture into sculpture soon made itself felt in his paintings. Both *Frau am Strand – Night in Tunisia* (*Woman on the Beach – Nacht in Tunesien*, October 1980, no. 116) and *Frau am Strand* (*Woman on the Beach*, January 12, 1982, no. 131) depict imposing, three-dimensional bodies suspended at the tops of the canvases. Their bulk lends them a definite sense of weight, while their roughly defined silhouettes have a tactile quality related to the irregular, protruding exteriors of Baselitz's contemporaneous sculpture.

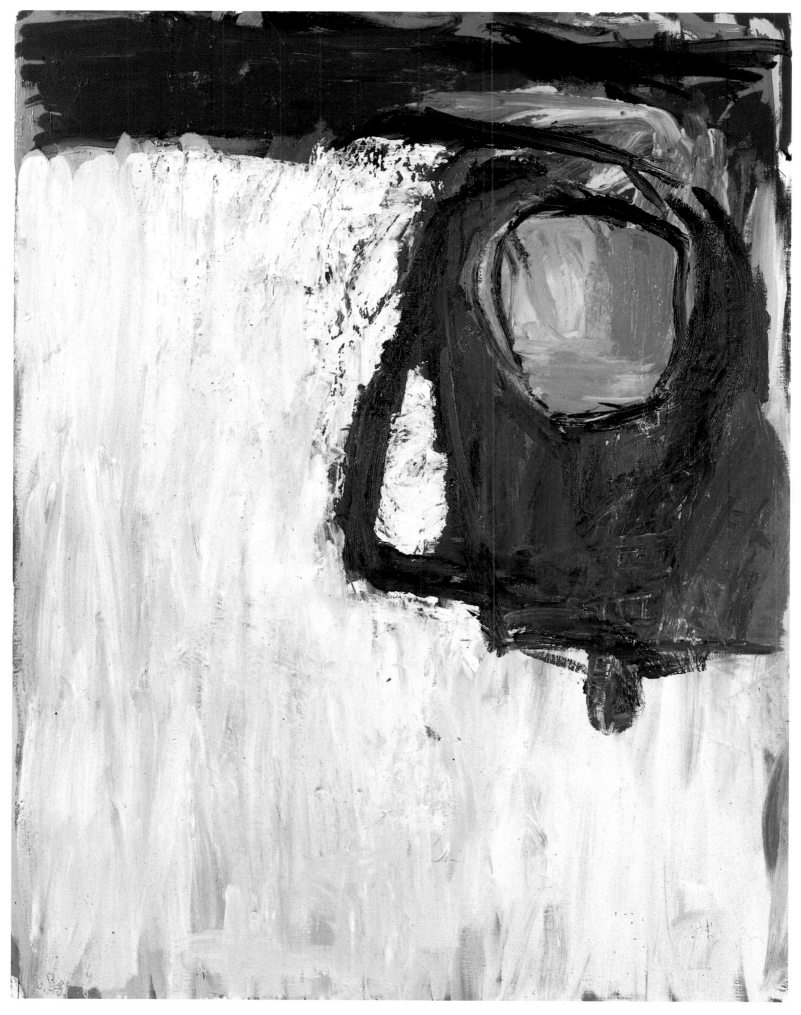

124. Georg Baselitz, *Kaffeekanne und Orange* (*Coffeepot and Orange*), August 1981. Oil on canvas.

146 x 114 cm (57 ¹/₂ x 44 ⁷/₈ inches). Private collection. Courtesy of L. A. Louver, Venice, California.

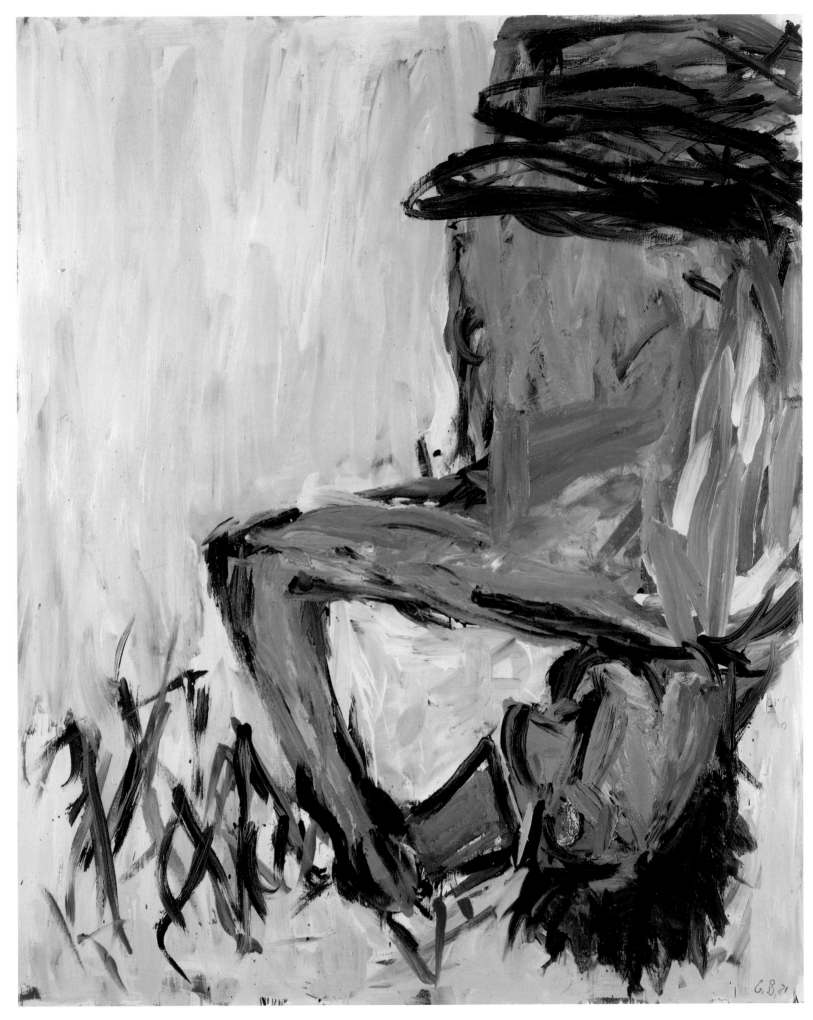

125. Georg Baselitz, *Glastrinker* (*Glass Drinker*), August 1981. Oil on canvas, 162 x 130 cm

(63 ³/₄ x 51 ¹/₈ inches). Collection of Jeanne and Richard Levitt, Des Moines.

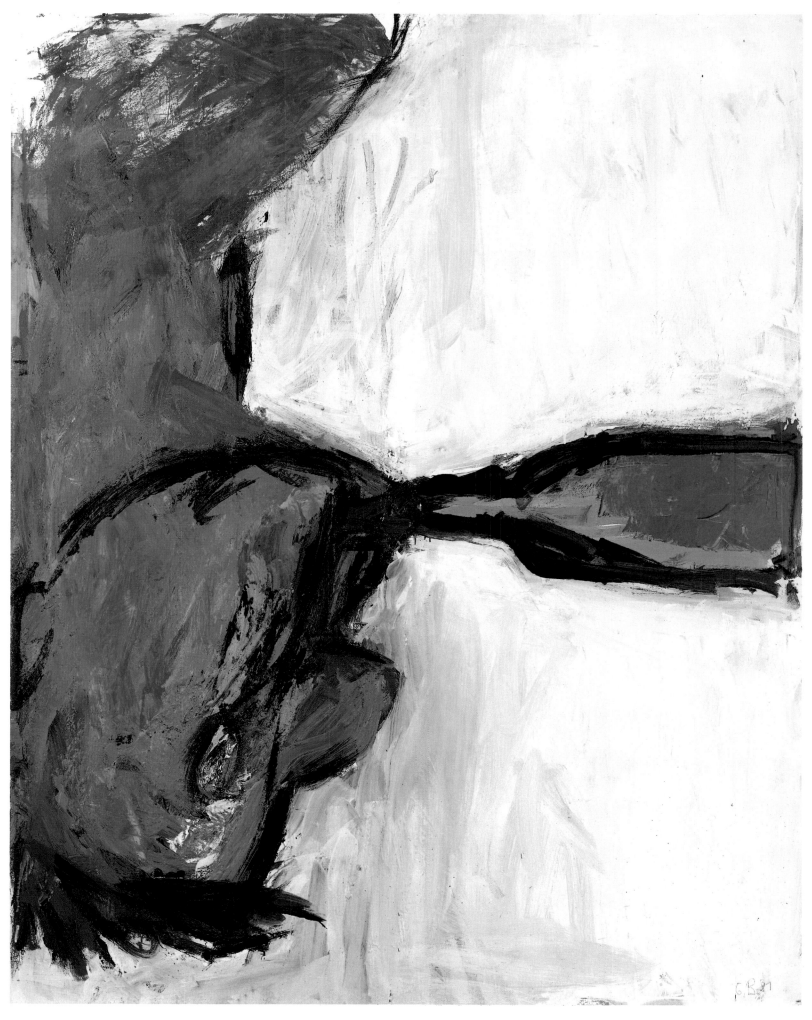

126. Georg Baselitz, *Flaschentrinker* (*Bottle Drinker*), August 1981. Oil on canvas, 162 x 130 cm

(63 ³/₄ x 51 ¹/₈ inches). Private collection, Courtesy of Galerie Michael Werner, Cologne and New York.

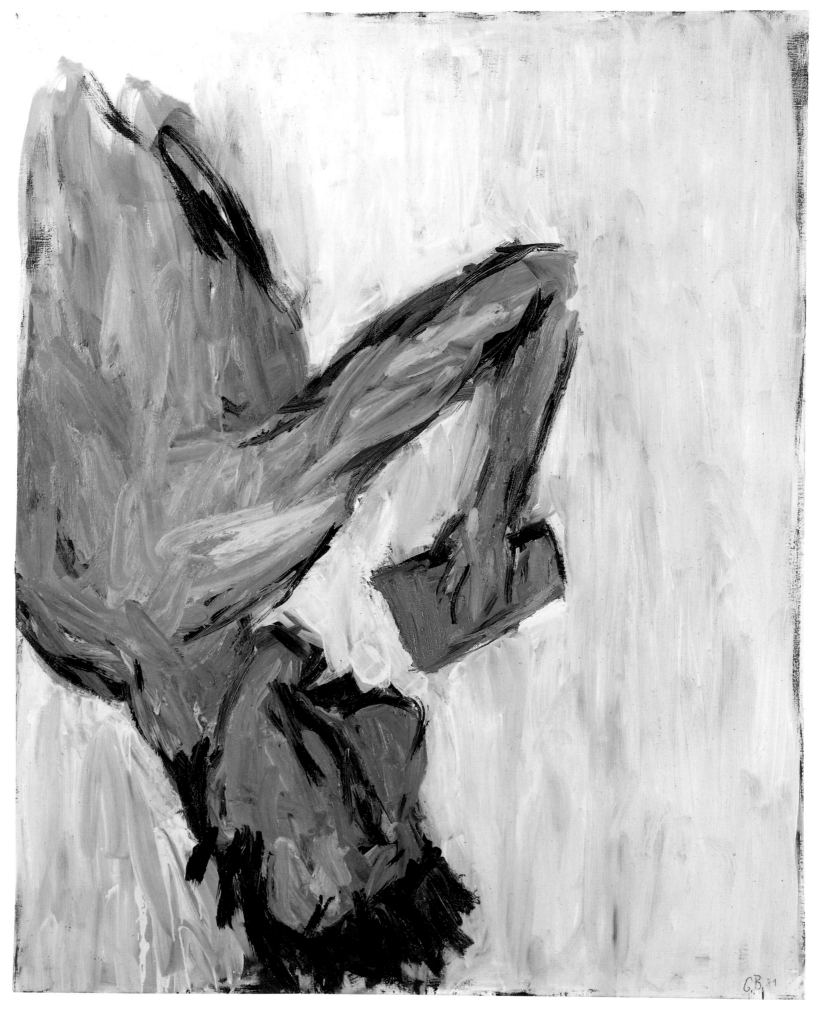

127. Georg Baselitz, *Glastrinker* (*Glass Drinker*), August 1981. Oil on canvas.

162 x 130 cm (63 ³/₄ x 51 ¹/₈ inches). Private collection.

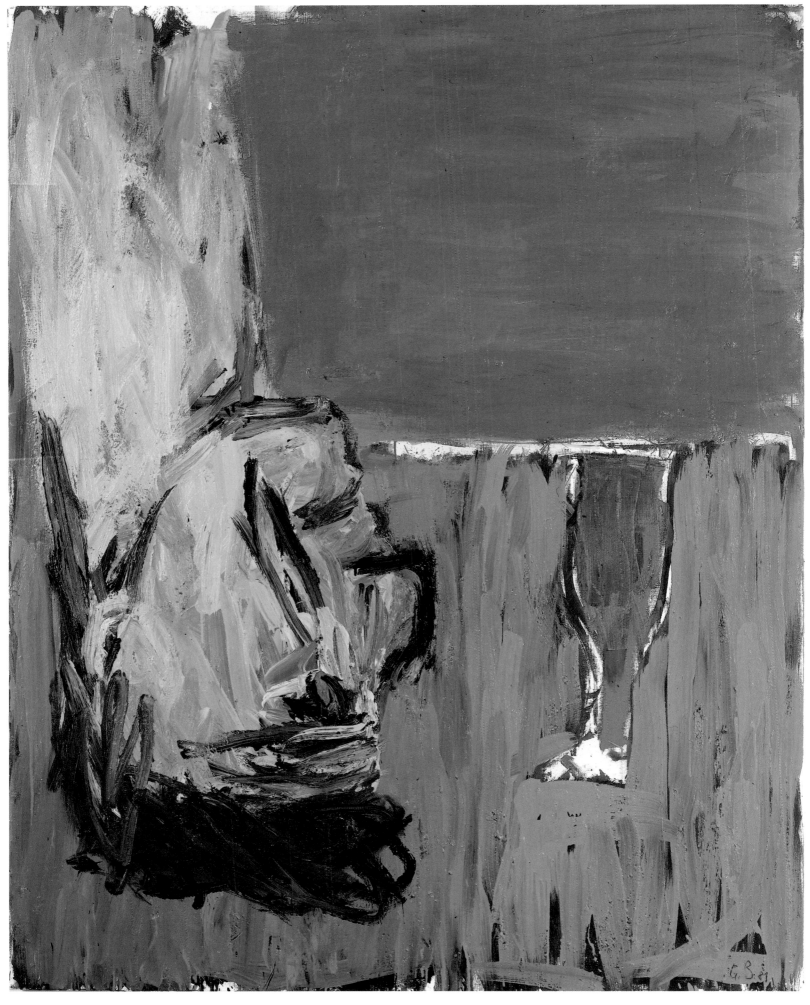

128. Georg Baselitz, *Trinker und Flasche* (*Drinker and Bottle*). August 1981. Oil on canvas.

162 x 130 cm (63 ³/₄ x 51 ¹/₄ inches). Collection of Patricia Withofs, London.

Nonetheless, these canvases remain resolutely painterly. Both of the *Woman on the Beach* paintings exhibit a completely new relationship between figure and ground. *Woman on the Beach – Nacht in Tunesien* features several intriguing, new elements: the paint itself is a mixture of asphalt and oil, which gives the pigment added density and viscosity; the upper part of the horizontal figure is turned face downward, while the lower portion is feet upward; and the cursorily modeled figure is set against a dirty-gray field in which many colors, including blue, pink, yellow, and brown, are revealed just below the surface.

A white void appears in the center of several canvases of this time, including *Der Adler* (*The Eagle*, September 1980, no. 115), *Blick aus dem Fenster nach draußen – Standbild 7* (*View Out the Window – Beach Picture 7*, January 1981, no. 118), and *Woman on the Beach – Nacht in Tunesien*. In the last painting, this void takes the form of a white triangle, which seems to pierce the ground, insinuating a space beyond the surface of the canvas.

In contrast to the haunting palette of the *Woman on the Beach* paintings, a striking wash of brilliant yellows and luscious oranges distinguishes *Die Mädchen von Olmo II* (*The Girls of Olmo II*, October 1981, no. 129), a painting that Baselitz made upon seeing several girls bicycling in Italy. The gleaming background, which reflects the sunny

southern clime of Olmo, a small town near Arezzo, is accentuated by the solid blue-green bicycle wheels and handlebars. A black outline defines each form, but there is in this painting a unique sense of movement and depth. Each upside-down figure appears to be riding out from the painting itself, and the girl on the right is shown partly from the front, partly in profile. This oscillation introduces the element of time into Baselitz's work, which is absent from his previous paintings and in the sculptural figures, most of which are frozen in a gesture or stand erect and motionless.

The subjects of *The Girls of Olmo II* are engaged in a definite activity. In this regard, they are related to an expansive group of work Baselitz created at the same time encompassing two series, the *Orangenessers* (*Orange Eaters*) and the *Trinkers* (*Drinkers*). In these works—and in related still-lifes, such as *Kaffeekanne und Orange* (*Coffeepot and Orange*, August 1981, no. 124) and *Tulpen* (*Tulips*, August 1981, no. 123)— Baselitz introduced a brilliant range of color, a simplicity of format, and a tight focus on the relationship between the single figure (or a small group of objects) and the background. The subjects of the *Orange Eaters* and *Drinkers* are, like the figures in *Street Picture*, truncated at the waist and placed in the foreground. Frequently, the figures are positioned to the left, with the right side of the canvas free of imagery. In *Orangenesser (IV)* (*Orange Eater [IV]*, April 1981, no. 119), the pink figure is opposed

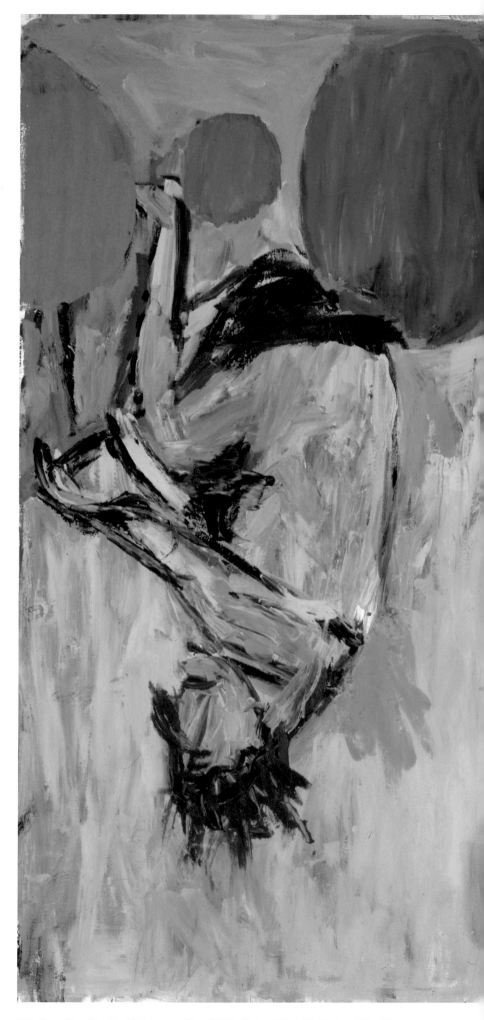

129. Georg Baselitz, *Die Mädchen von Olmo II* (*The Girls of Olmo II*), October 1981. Oil on canvas, 250 x 249 cm (98 ³/₈ x 98 inches). Musée National d'Art Moderne, Centre Georges Pompidou, Paris, 1982.

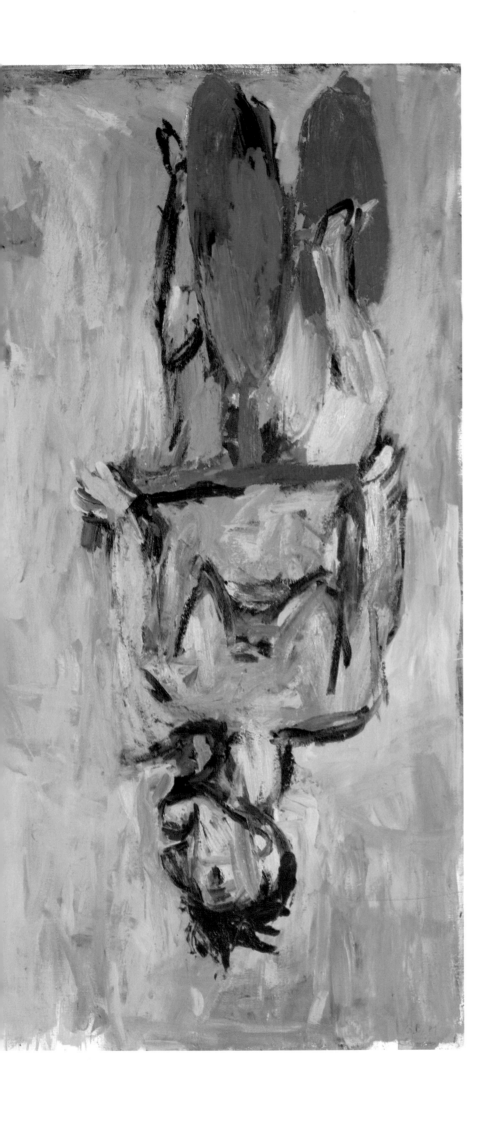

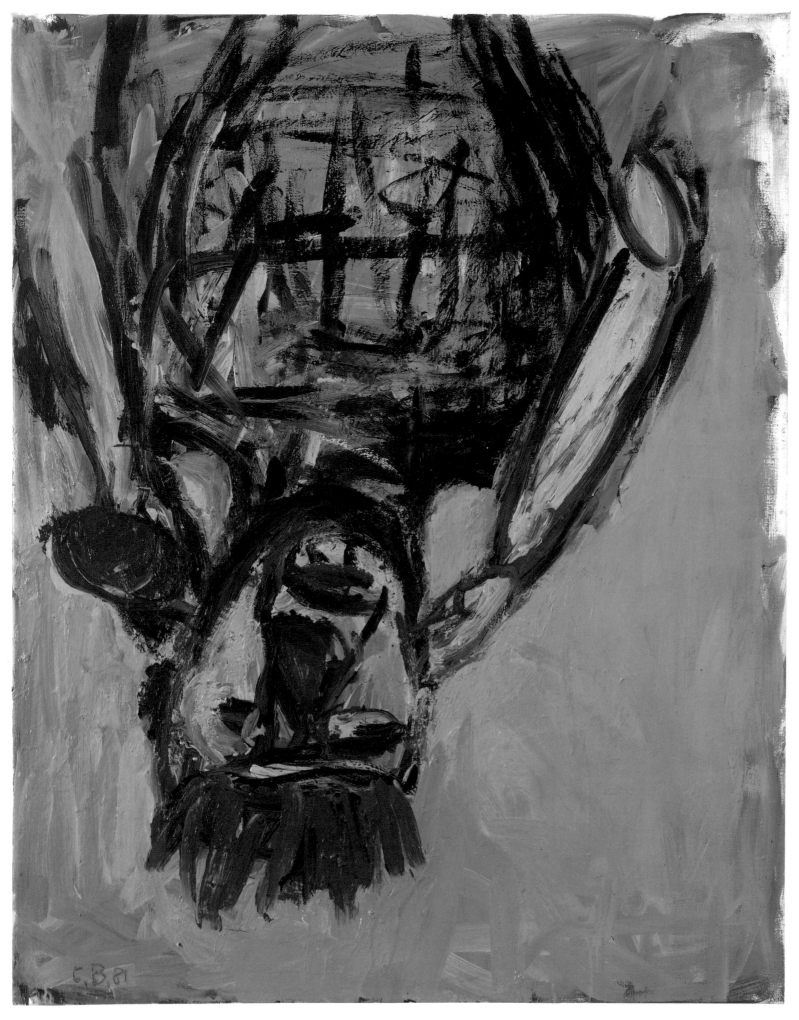

130. Georg Baselitz, *Orangenesser* (*Orange Eater*), December 1981. Oil on canvas.
146 x 114 cm (57 ¹/₂ x 45 inches). Collection of Elaine and Werner Dannheisser.

by a bright red rectangle; both are surrounded by white, which creates a high contrast between figure and ground, but also establishes a balance among all the painting's elements. Similarly, *Flaschentrinker* (*Bottle Drinker*, August 1981, no. 126) contains a figure that is off-center and aligned with the left edge of the canvas. It, too, is set against a white ground, but one that is bisected by a blue bottle, which balances the relationship between figure and frame by its interaction with the right edge of the picture frame. In the *Orange Eaters* and *Drinkers*, the equilibrium established between figure and field, and among form, color, and surface, recalls the balanced asymmetry that Piet Mondrian achieved in his *Compositions* of the 1920s and 1930s.

These bold canvases were produced during a period in which painting and realist idioms enjoyed a dramatic reemergence in the international art world. With a rough treatment of the figure, and a simple, powerful format that made the upside-down image seem newly reinvented, Baselitz's paintings were collapsed into a broad category dubbed Neo-Expressionism by critics in the United States and Europe. The impression that Baselitz was pursuing a link with the German Expressionists and their forebears was furthered by two extraordinary paintings that owe a clear debt to Nolde and Munch. Munch's horrific depiction of a screaming figure in *Der Schrei* (*The Scream*, 1893, no. 137), and Nolde's masked faces, as in *Pfingsten entstanden* (*Created at Whitsuntide*,

1909, no. 138),[68] form the basis for Baselitz's *Supper in Dresden*. The composition of the painting is based on the traditional arrangement used by artists from Leonardo da Vinci to Nolde to depict the exalted theme of the Last Supper. Like these artists, Baselitz has situated his figures in a horizontal row. In place of Christ and His apostles, however, Baselitz has painted some of the artists of Die Brücke, the German Expressionist group founded in Dresden in 1905. Influenced by the Arts and Crafts movement and Jugendstil, artists of Die Brücke—which included Kirchner, Erich Heckel, Otto Müller, Nolde (for a brief period), Max Pechstein, and Karl Schmidt-Rottluff—were also drawn to the work of Paul Cézanne, Gauguin, Munch, and van Gogh. They soon were influenced by the Fauves' use of color, but nonetheless retained a Northern sense of expressive subject matter, and adopted the jagged forms of the Gothic era. The group disbanded in 1913.

In *Supper in Dresden*, Baselitz paid homage to these artists. Schmidt-Rottluff is depicted in the center, to his left is Kirchner, and to his right are Müller and the head of Heckel. (In *Die Brücke Choir*, a companion painting, Schmidt-Rottluff is again in the center, but Müller is to his left, the head of Munch to his right, and the figure of Kirchner is to his far right.) The colors orange, black, red, and blue dominate the composition, as do the ovoid heads and expansive table that runs like a band at the top. Although

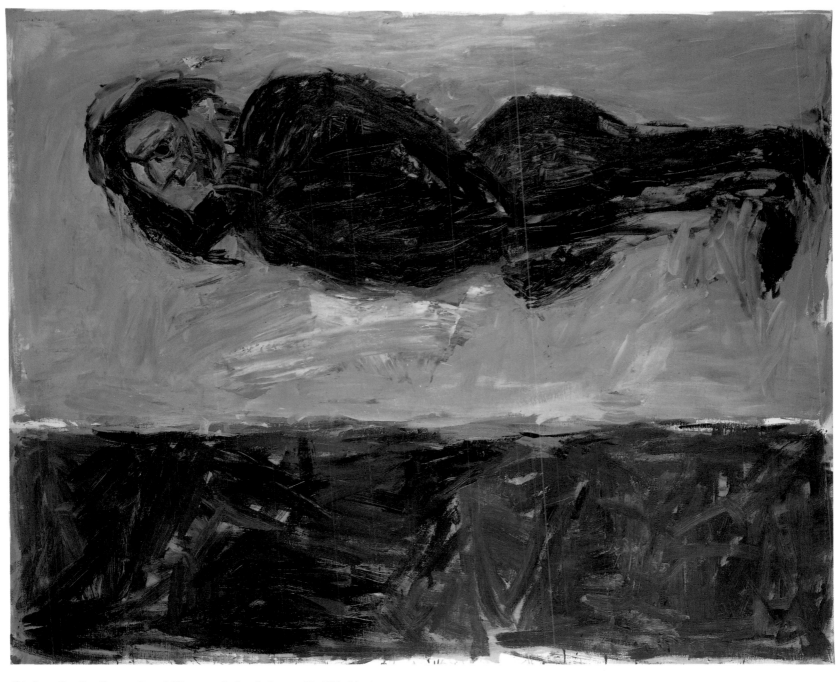

131. Georg Baselitz, *Frau am Strand* (*Woman on the Beach*), January 12, 1982. Oil on canvas,

200 x 250 cm (78 ³/₄ x 98 ³/₈ inches). The Arthur and Carol Goldberg Collection.

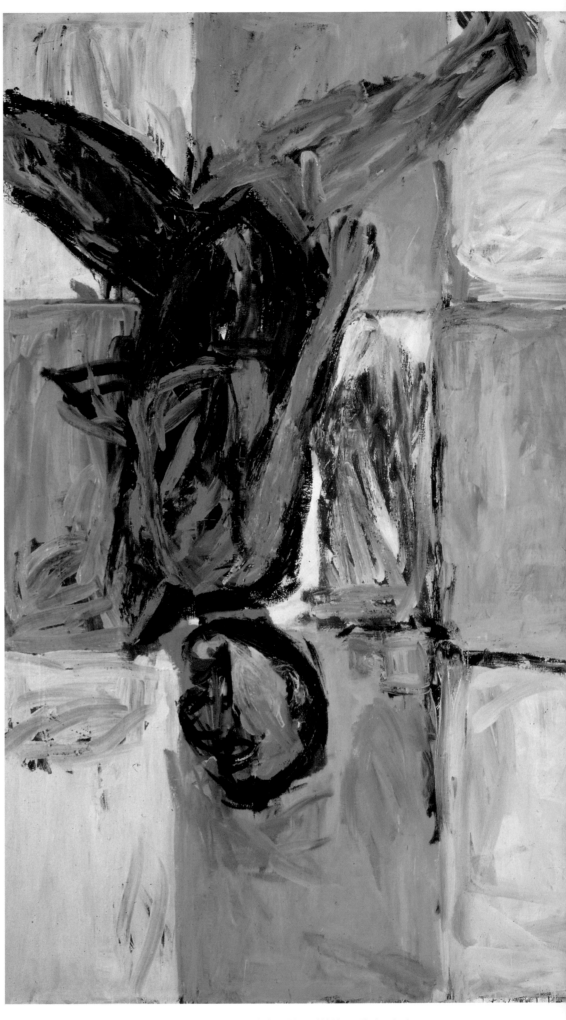

132. Georg Baselitz. *Adieu.* March 17, 1982. Oil on canvas. 250 x 300 cm (98 ³/₈ x 118 ¹/₈ inches).
Tate Gallery, London. Purchased 1983.

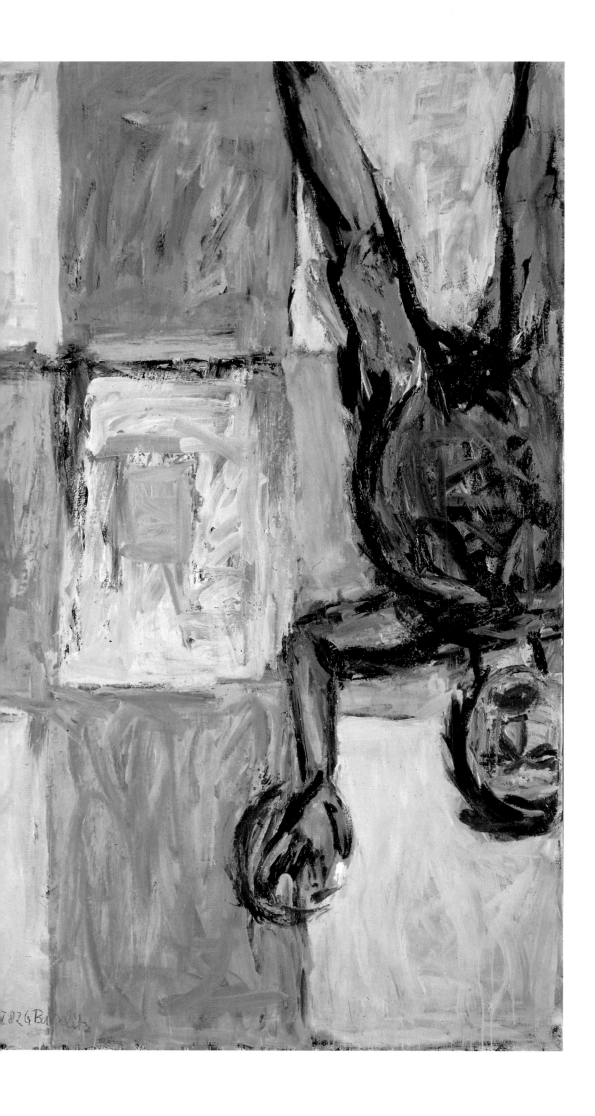

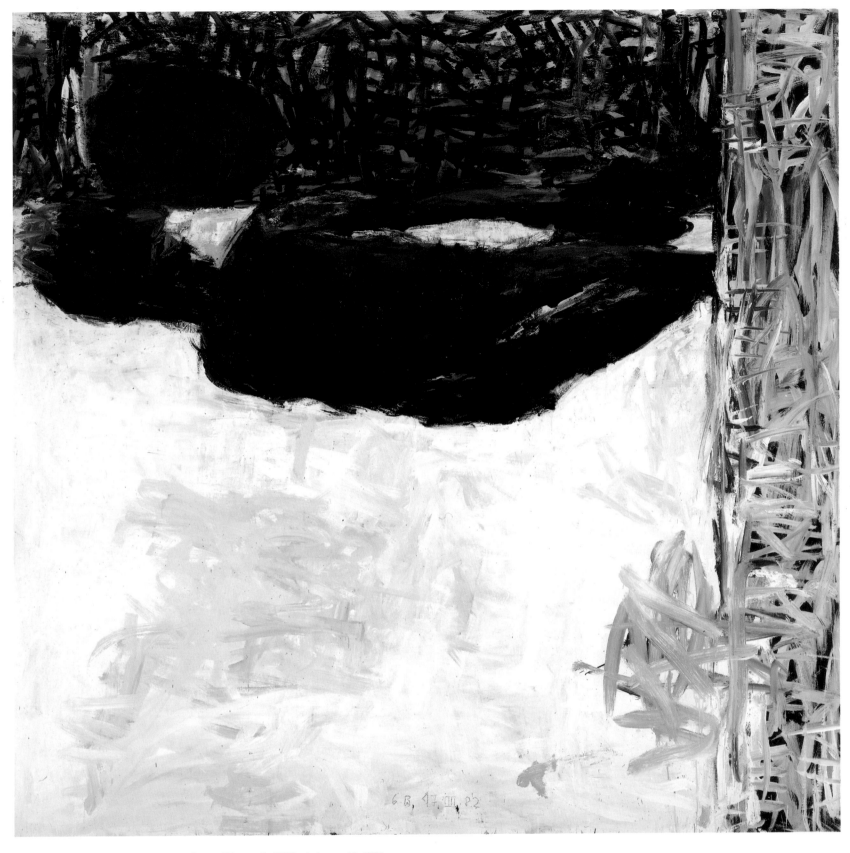

133. Georg Baselitz, *Mann auf rotem Kopfkissen* (*Man on Red Pillow*), August 17, 1982.

Oil on canvas, 250 x 250 cm (98 ³/₈ x 98 ³/₈ inches). Froehlich Collection, Stuttgart.

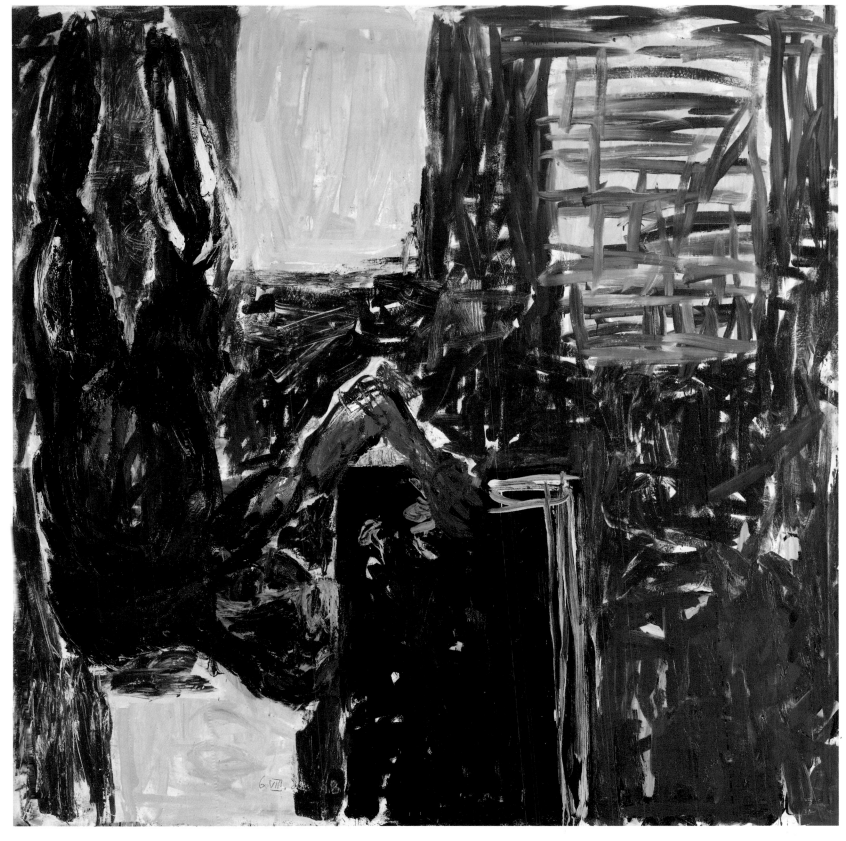

134. Georg Baselitz, *Sterne im Fenster* (***Stars in the Window***)**, August 6, 1982. Oil on canvas,
250 x 250 cm (98 3/8 x 98 3/8 inches). Collection IFIDA Investments, Philadelphia.

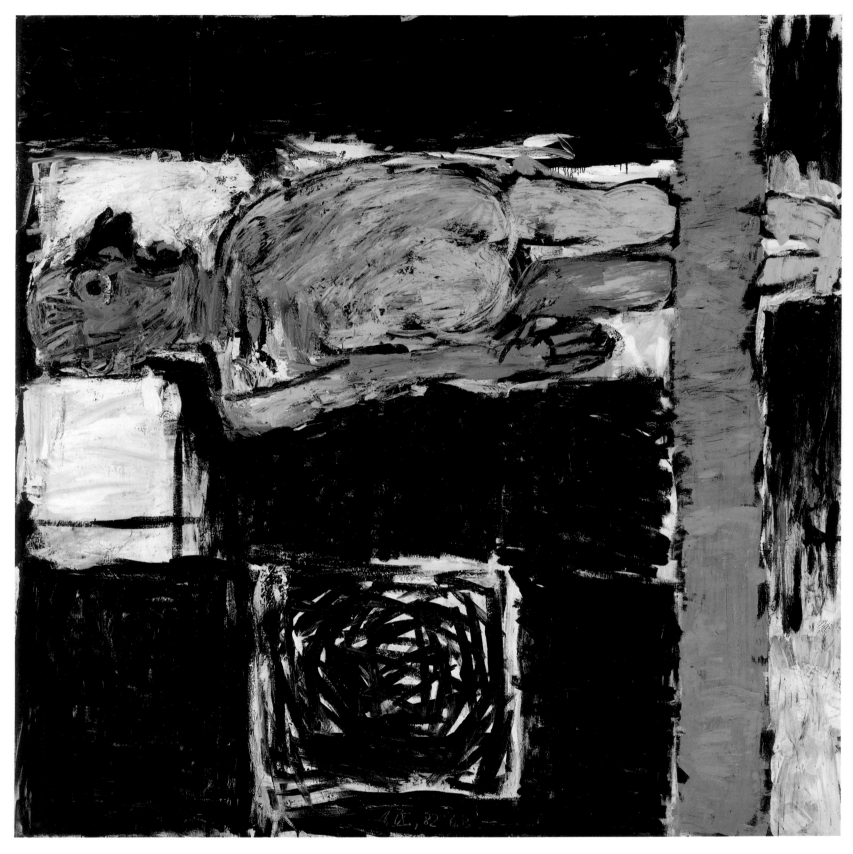

135. Georg Baselitz, *Franz im Bett* (*Franz in Bed*), September 1, 1982. Oil on canvas.
250 x 250 cm (98 ³/₈ x 98 ³/₈ inches). Collection of Phil Schrager, Omaha.

Nolde's depiction of the Last Supper is a prototype for Baselitz's painting, the schematic nature of the figures and the agitated brushstrokes relate it more closely to the work of Munch. The brushstrokes seem random in some areas, while they follow the contours of the figures in others; overall, they create an aura of hysteria and madness, comparable to that captured so poignantly in *The Scream*.

A focus of *Supper in Dresden* is the rounded form of the orange, emblem of the *Orange Eaters*. Baselitz's orange brings to mind the distinctive orange form found in some of Henri Matisse's paintings, but it also carries with it a certain iconographic weight. Historically, oranges have appeared in paintings in lieu of apples as a reference to the Temptation. While Baselitz states that he uses the motif as a formal device, in *Supper in Dresden* the orange conveys clear Christian—and art-historical—references.

Although Baselitz was drawn to certain artists of Die Brücke, he has denied a connection with German Expressionism per se:

> *People were starting to say that my works had a link with German Expressionism. In fact this only applies to the way I handle the canvas, my manual use of the canvas. I have never had any relationship with Expressionism. In fact I have always wondered why it was so alien to me. The reason is that the Expressionists use a method that illustrates our*

environment, the world we live in. They use what exists; they extract from it
an illustrative method of making a painting. Everything is linked. Painting a
green cow doesn't necessarily entail losing touch with one's environment. I
have always invented the objects and the various figurations that I wanted to
show. I have never had a model. That is something that has remained entirely
alien to me, something that does not suit me at all.[69]

In 1984, Baselitz began a series entitled *Das Abgarbild* (*The Abgar Picture*). According to legend, the ailing king Abgar sent an emissary to Jesus; he returned with a towel that, miraculously, had His image on it. The king was cured immediately upon being presented with it. As with the other paintings in this series, *Der Abgarkopf* (*The Abgar Head*, April 10, 1984, no. 140) resembles a group of heads painted by Alexei Jawlensky from about 1910 through the 1930s.[70] Jawlensky's heads became progressively more geometric in the 1920s, and they became more gestural and abstract in the 1930s. *The Abgar Head* is a marvel of color and form, its dark shape lit by slashing marks for eyes, nose, and mouth. Baselitz shaped the mouth with red and green strokes, the nose with strokes of blue and pink, and given light to the eyes with green and blue. The masklike nature of the face lends it an air of unreality and suggests the miracle of Christ's "face" appearing on the canvas. In some paintings in the series, the face is

136. Georg Baselitz, *Rotschopf* (*Redhead*), September 19, 1982. Oil on canvas,

250 x 200 cm (98 ³/₈ x 78 ³/₄ inches). Collection of Katharina and Wilfrid Steib, Basel.

137. Edvard Munch, *Der Schrei*
(*The Scream*), 1893. Tempera and
oil pastel on cardboard, 91 x 73.5 cm
(35 ⅞ x 29 inches). Nasjonalgalleriet, Oslo.

bisected vertically into two planes of color, which enhances the masklike quality. In others, the face covers the entire picture plane to create an amorphous silhouette.

In 1985 and 1986, Baselitz painted two monumental *Pastorale* (*Pastoral*) paintings, a name that suggests an idyllic countryside replete with herdsmen and livestock. *Pastorale – Die Nacht* (*Pastoral – The Night*, December 1, 1985–January 11, 1986, no. 144) is a summation, comprising a selection of motifs and themes from different periods in Baselitz's work. Assimilated into this rural cosmos are motifs that he used through the 1960s and 1970s. Included are heads from the *Heroes* series, eagles, pitchers, grazing animal forms, a house that is reminiscent of similar depictions in his very early paintings, and the figure of Elke, who represents the eternal female. A head and a figure are positioned in opposite directions within the painting's vertical halves. On the left, the head is right-side up and placed left of center. A form suggesting a small black dog covers part of the right eye. Where the torso would normally be, there is a large dark form, a horse turned upside down. (This same form appears in *Rotes Pfend* [*Red Horse*, 1986], a rare example of a Baselitz sculpture in the form of an animal.) The remainder of the left half consists of a dense mass of color—the background surrounding the figure resembles the sky on a chilly winter's day—and a glimpse of an upended house surrounded by trees. In the right half, the figure is a giant nude cut off below the knees,

138. Emil Nolde. *Pfingsten entstanden*
(*Created at Whitsuntide*), 1909. Oil on
canvas. 87 x 107 cm (34 ¼ x 42 ⅛ inches).
Nationalgalerie. Staatliche Museen zu Berlin.
Preußischer Kulturbesitz.

its right hand obscured by a white pitcher, its pubic area by a tree form bathed in red, its
mouth by a birdlike form resembling his eagle motifs. The tree and the other covering
motifs could be stand-ins for the fig leaf used in late Gothic depictions of Adam and Eve,
such as those by Cranach and Dürer. In *Pastoral – The Night*, such motifs add an
enigmatic dimension to each figure.

The artist was free with the arrangement of his figures in this canvas, and he created
space in an ingenious manner. For example, the head on the left recedes while the nude
on the right advances. Simultaneously, the figure on the right appears to be both more
volumetric and more planar. In this canvas, Baselitz created a montage of disparate
forms that recalls the techniques used in Dada photomontages by Georg Grosz. Raoul
Hausmann, John Heartfield, and Hannah Höch. The forms are stabilized despite their
unequal size, relative placement, and disparate colors. Myth and reality are woven
together in a painting that is a tour de force.

In *Das Malerbild* (*The Painter's Picture*, July 22, 1987–May 18, 1988, no. 151), the
artist again reworked familiar motifs—for example, the tree and house from the 1960s
together with the female torso and bust, and chairs from recent paintings such as *Die
Mühle brennt – Richard* (*The Mill is Burning – Richard*, January 2–14, 1988, no. 150).
The work also incorporates a painted grid that obscures the depictions of several of the

139. Georg Baselitz, *Nachtessen in Dresden* (*Supper in Dresden*), February 18, 1983. Oil on canvas, 280 x 450 cm
(110 1/4 x 177 1/8 inches). Kunsthaus Zürich, Purchased with the Assistance of the Fund for Public Utility, 1994.

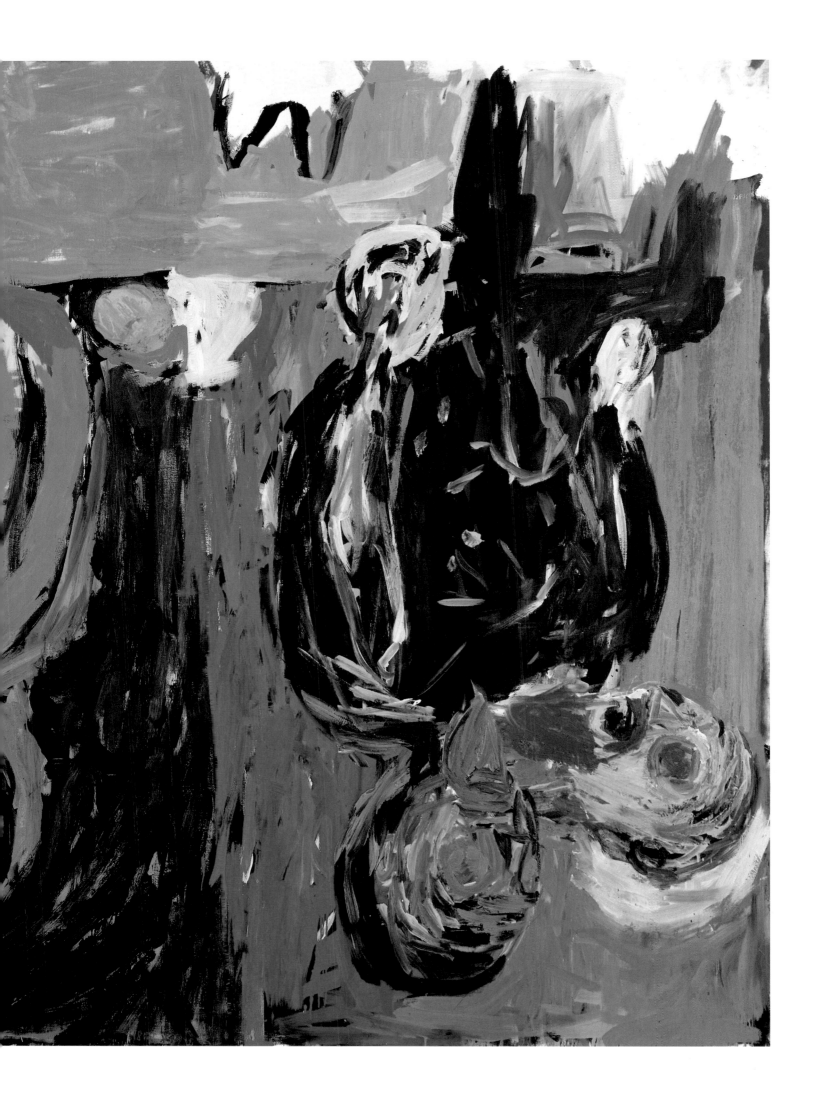

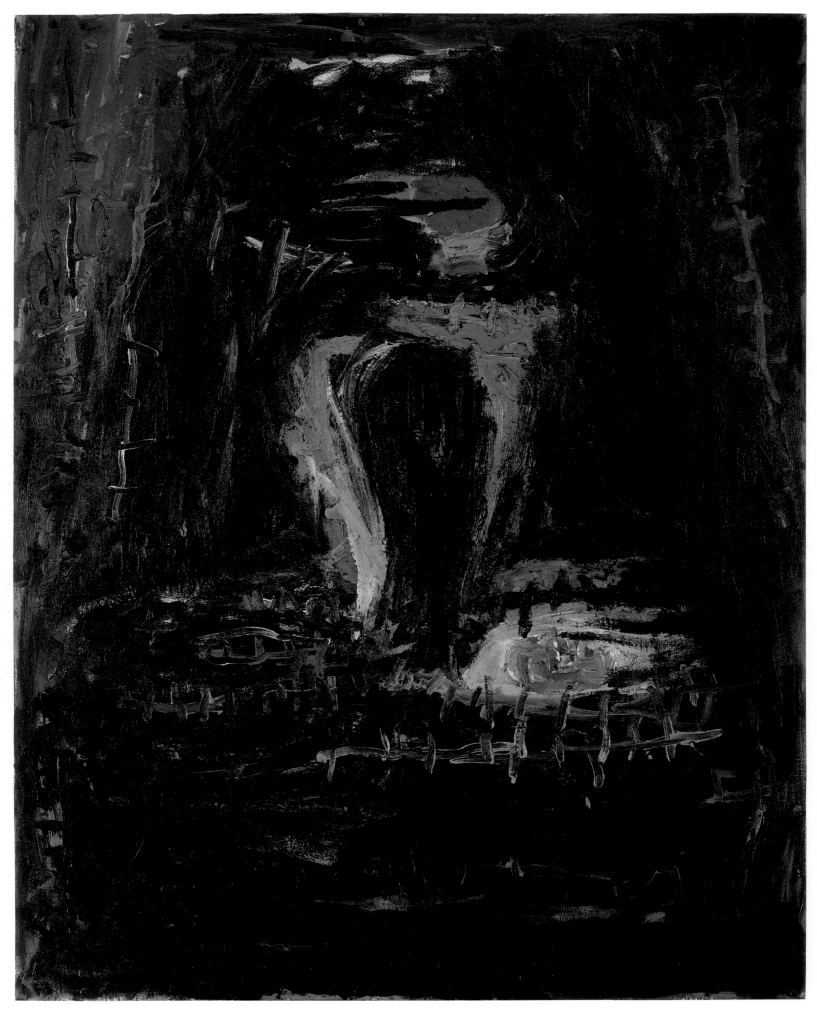

140. Georg Baselitz, *Der Abgarkopf* (*The Abgar Head*), April 10, 1984. Oil on canvas.

250 x 200 cm (98 ³/₈ x 78 ³/₄ inches). Louisiana Museum of Modern Art, Humlebaek, Denmark.

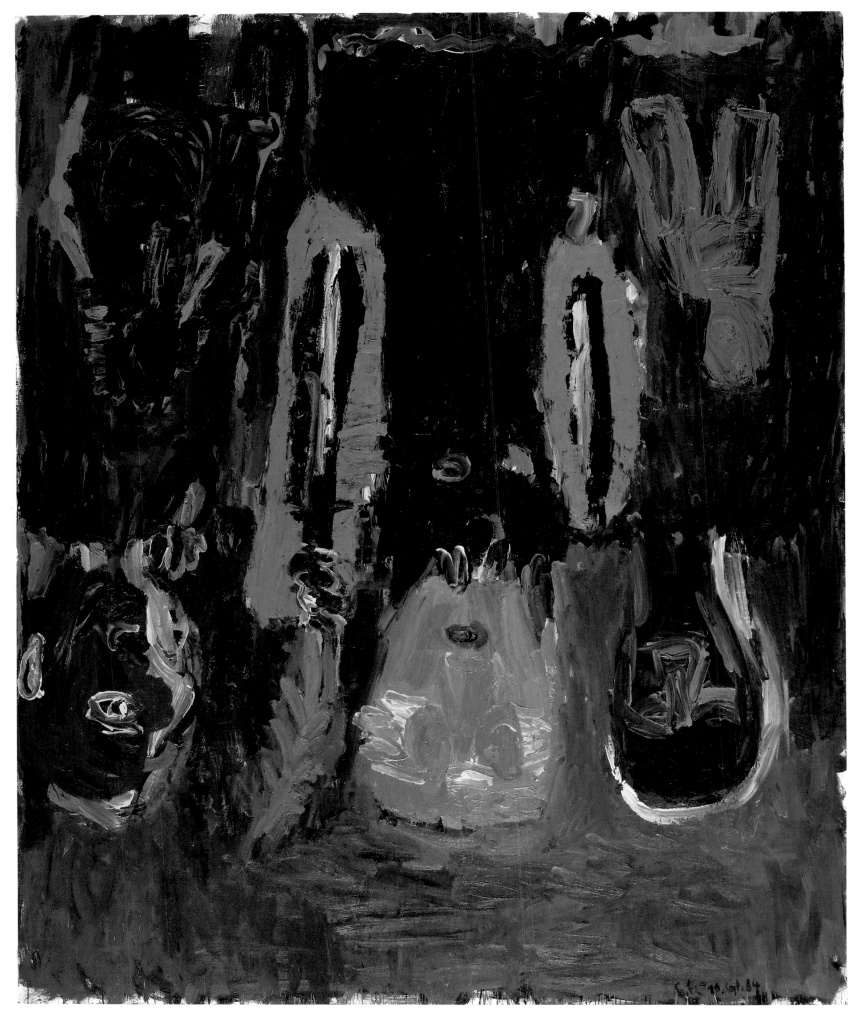

141. Georg Baselitz, *Die Verspottung* **(*The Mocring*),** August 28–September 10, 1984. Oil on canvas, 300 x 250 cm (118 1/8 x 98 3/8 inches). The Carnegie Museum of Art, Pittsburgh, Gordon Bailey Washburn Memorial Fund, The Women's Committee Washburn Memorial Fund, and Carnegie International Acquisition Fund, 1985.

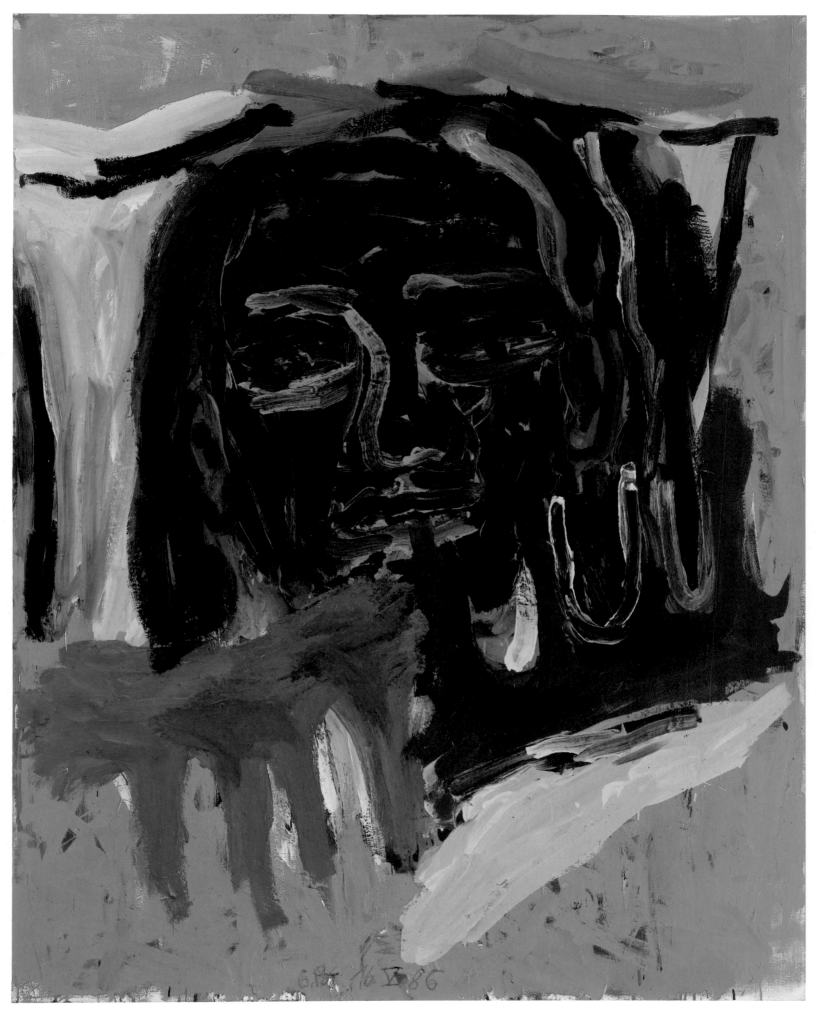

142. Georg Baselitz, *Zerbrochene Brücke – Wendenbraut* (*Shattered Bridge – Wendish Bride*),

April 29–May 16, 1986. Oil on canvas, 162 x 130 cm (63 ³/₄ x 51 ¹/₈ inches). Collection of

Hartmut and Silvia Ackermeier, Berlin.

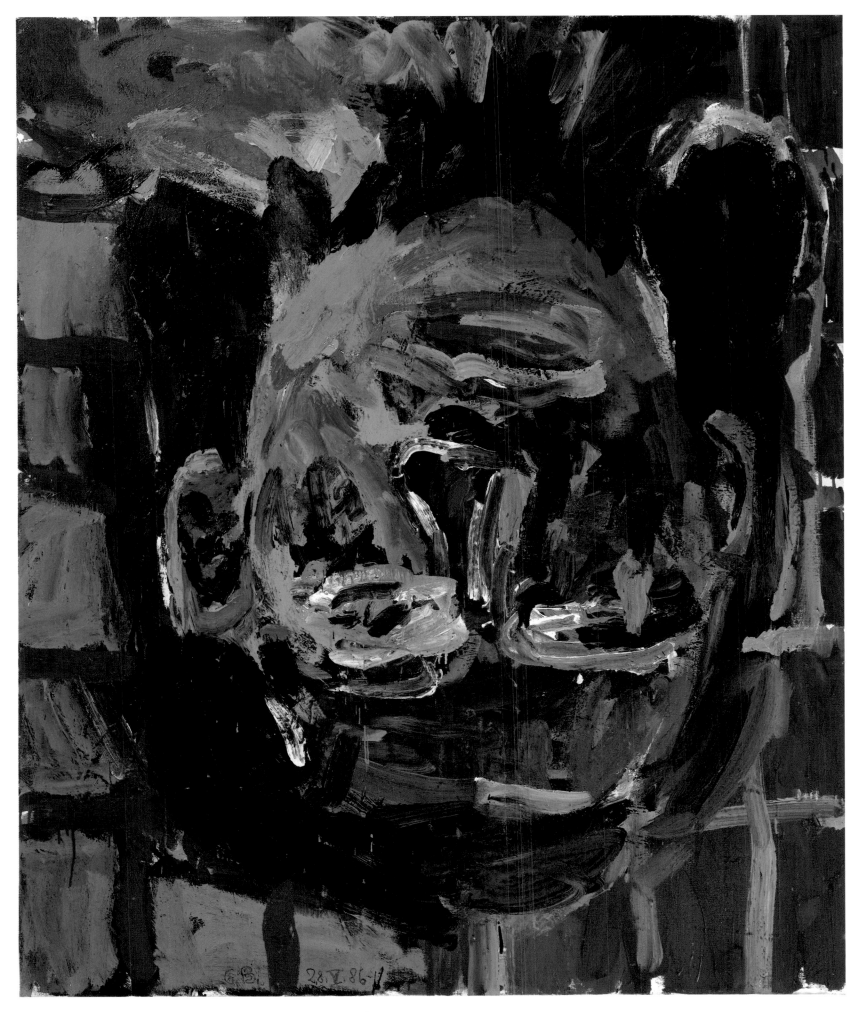

143. Georg Baselitz. *Nachkriegsmalerei (Postwar Painting).* May 10–26, 1986. Oil on canvas.

148 x 125 cm (58 ¼ x 49 ¼ inches). Galerie Michael Haas, Berlin.

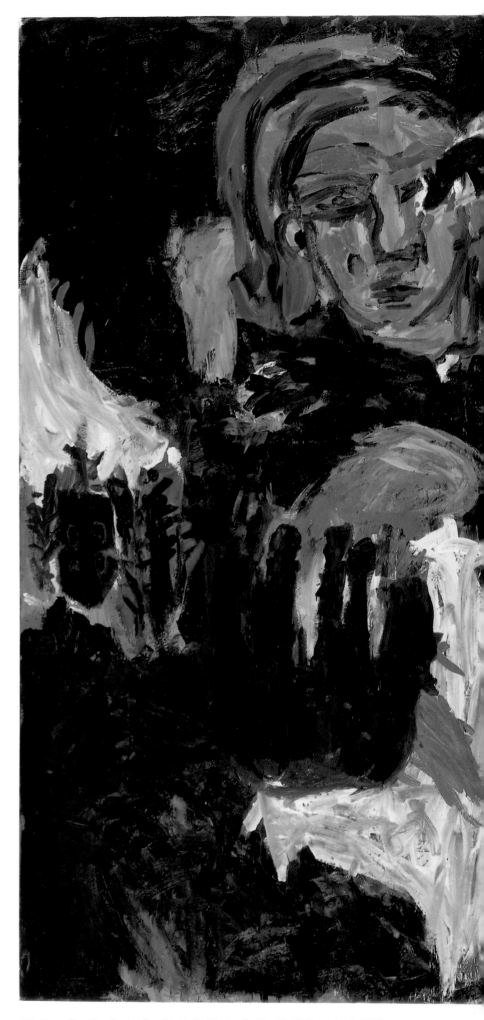

144. Georg Baselitz, *Pastorale – Die Nacht (Pastoral – The Night)*, December 1, 1985–
January 11, 1986. Oil on canvas, 330 x 330 cm (129 ⅞ x 129 ⅞ inches). Museum Ludwig, Cologne,
Ludwig Collection.

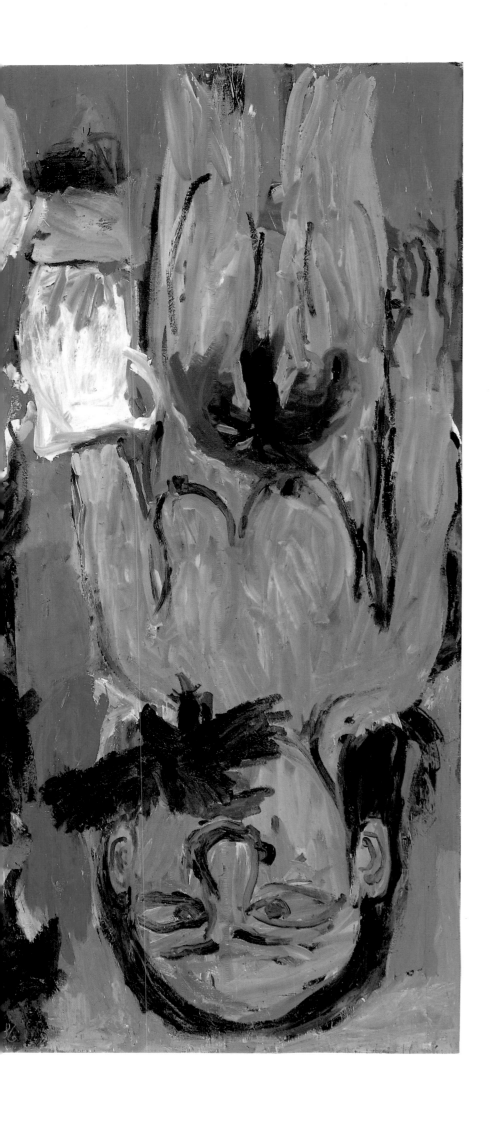

boxed forms within the canvas and signals his growing use of grids and other ornaments in later works. Baselitz professes surprise that the motif of the female nude is repeated throughout the composition. He says:

> I paint artists whom I admire. I paint their pictures, their work as painters,
> and their portraits too. But oddly enough, each of these portraits ends up as
> a picture of a woman with blonde hair. I myself have never been able to work
> out why this happens.

Among the artists he set out to paint are Richard Gerstl, Carl Fredrick Hill, Jörg Immendorff, Ludwig Meidner, and A. R. Penck, and the composer/painter Arnold Schönberg. Baselitz notes that the large central figure in *The Painter's Picture* is "an amalgam of the spirits of Edvard Munch and Karl Schmidt-Rottluff."[71]

Elsewhere, references to other painters are more transparent. For example, the blowsy blonde featured in *Dicke Blonde* (*Fat Blond*, March 25–September 12, 1987, no. 146) is reminiscent of de Kooning's *Women* series, and the chair in *The Mill is Burning – Richard* is based on van Gogh's images of the chair in his bedroom. Thus, van Gogh's chair joins the repertory of Baselitz's images. Culling from the annals of art history, memory, myth, and legend, Baselitz created a tantalizing body of work that would solidify his place as one of the most compelling painters of the decade.

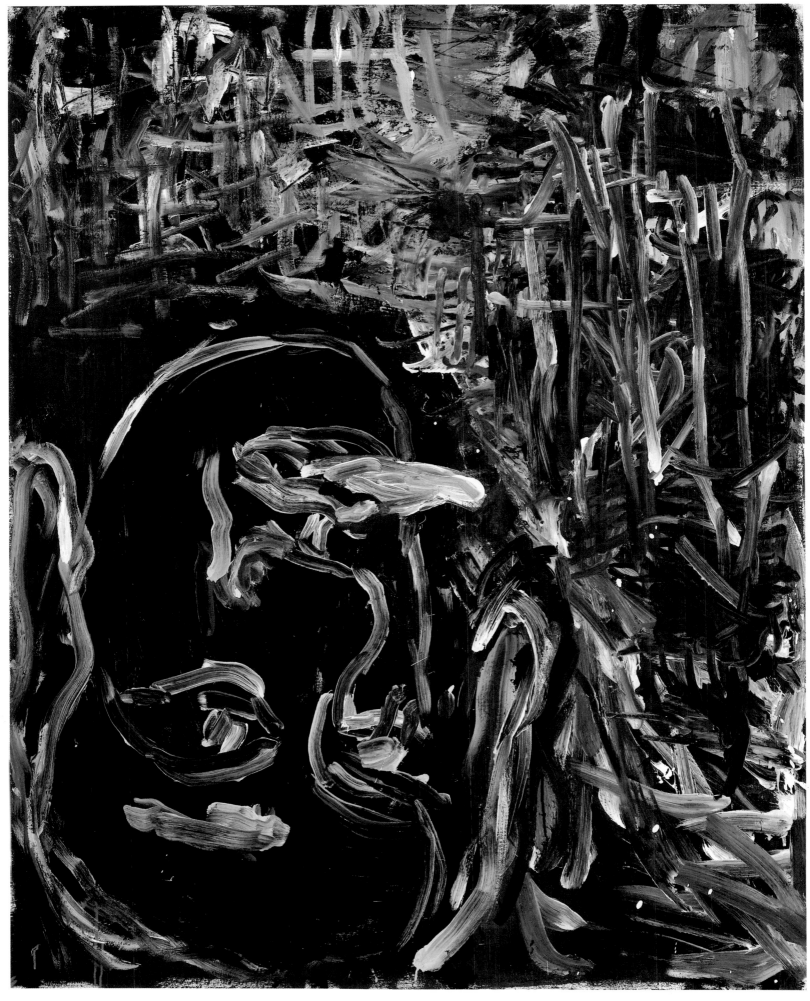

145. Georg Baselitz, *Zunge* (*Tongue*), October 19–20, 1985. Oil on plywood, 162 x 130 cm

(63 ³/₄ x 51 ¹/₈ inches). Galerie Michael Werner, Cologne and New York.

The Return of the Hero

Baselitz's early development was dependent upon his identity as a German artist maturing after World War II in Berlin. Starting out, he was eager to renounce Tachisme, but he nonetheless remained cognizant of making painting that was essentially about painting. Baselitz's art opened with the figure—dissected, distorted, fractured, upside-down, or prone—and was enriched by manifold references to the realms of art, philosophy, religion, and personal history. Simultaneously, he addressed the requirements of his mediums. In painting, the resulting dialogue between figure and field has always been directed at creating form anew.

For the viewer, this dialogue was reinforced by several elements: the recognizability of the figure, the less easily grasped historical antecedents, and the often slow process of understanding the way in which the work was made. Baselitz's inpainting in his oils and the concentrated process of cutting into his sculpture demand reflection and contemplation. The manner of viewing invited by this approach is at odds with the way in which much recent art is made to be apprehended—quickly and easily. For Americans, weaned on media-related imagery and ready-made forms, Baselitz's images are too full of historical, philosophical, and personal references to be dealt with quickly; his images—on the surface at least—are all too disposable. The dialogue between image

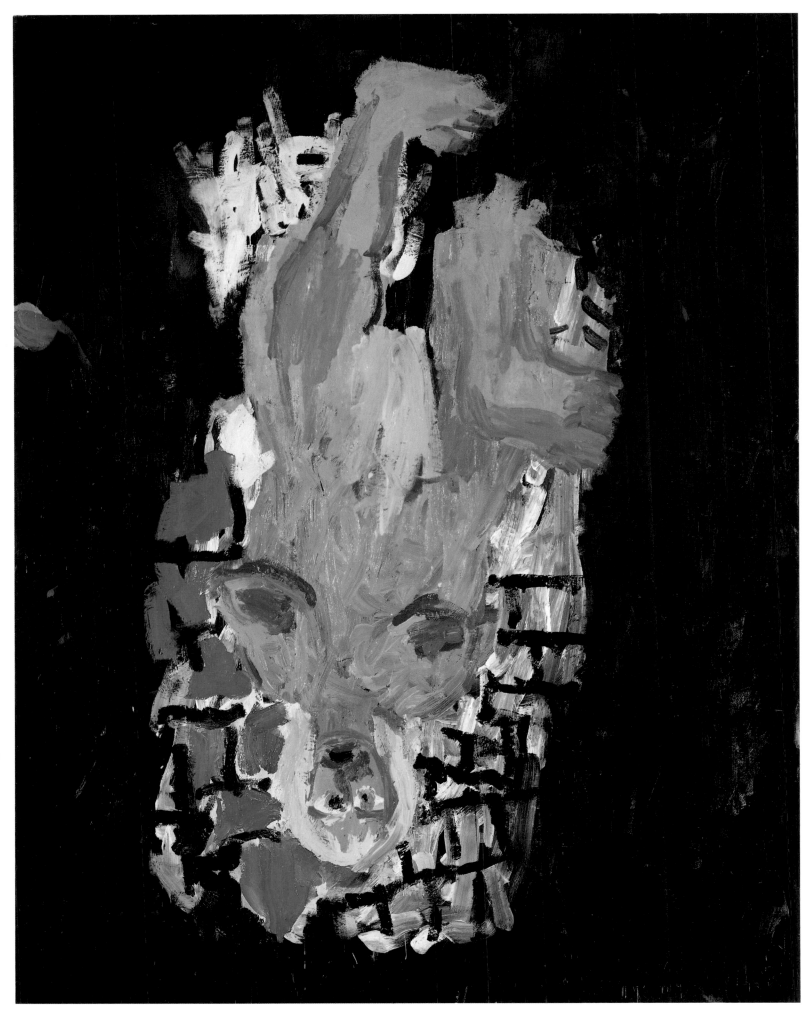

146. Georg Baselitz, *Dicke Blonde* (*Fat Blonde*), March 25–September 12, 1987. Oil on canvas.
250 x 200 cm (98 ³/₈ x 78 ³/₄ inches). Galerie Michael Werner, Cologne and New York.

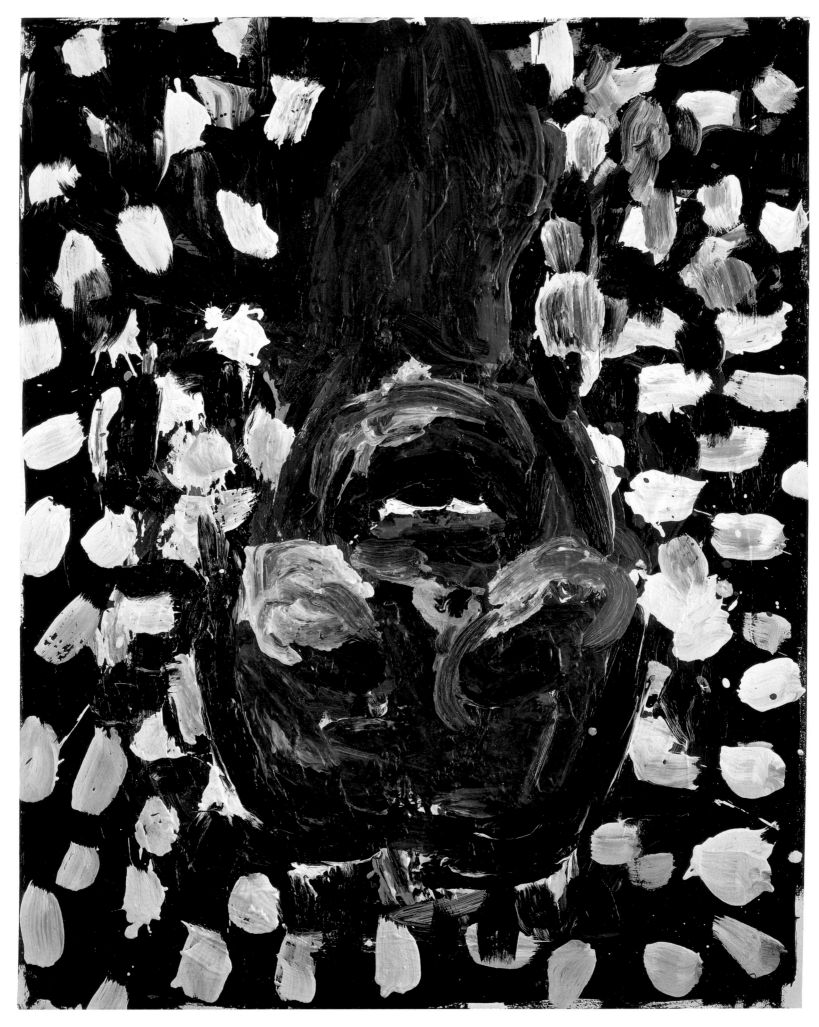

147. Georg Baselitz, *6 schöne, 4 hässliche Porträts: Schönes Porträt 3*
(*6 Beautiful, 4 Ugly Portraits: Beautiful Portrait 3*), December 15, 1987–January 4, 1988.
Oil on wood, 90 x 71.5 cm (35 ³/₈ x 28 ¹/₈ inches). Musée de l'Abbaye Sainte-Croix, Les Sables-d'Olonne.

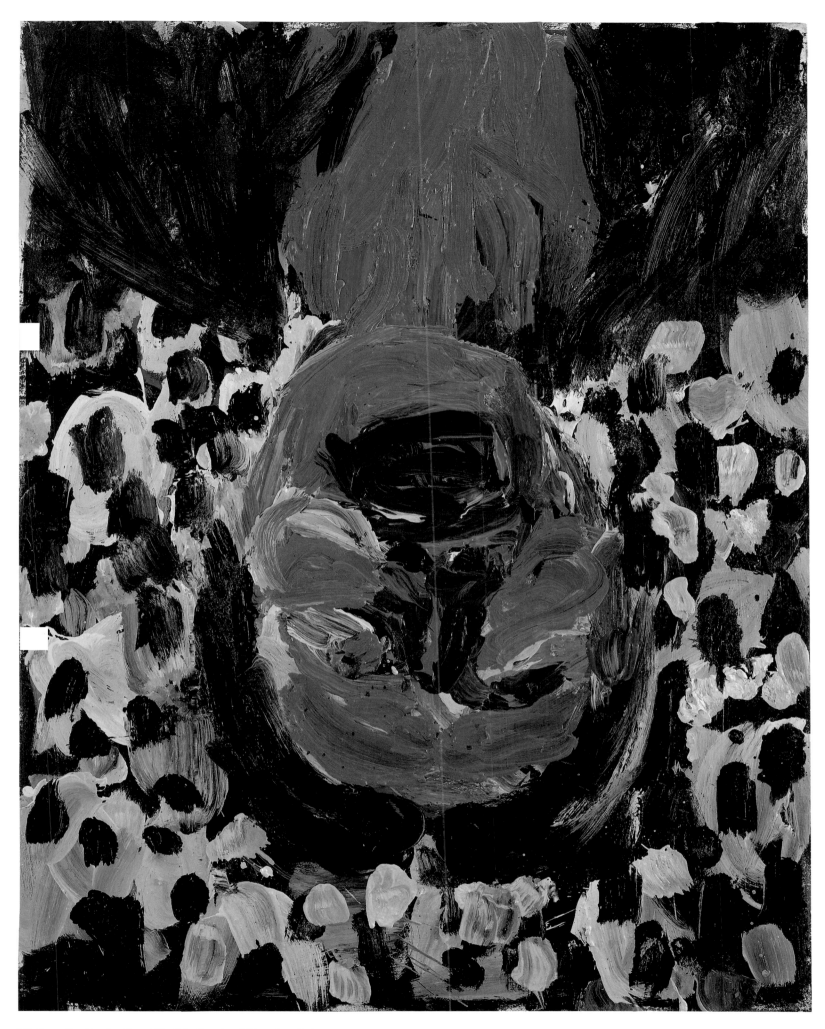

148. Georg Baselitz, *6 schöne, 4 hässliche Porträts: Schönes Porträt 4*

(*6 Beautiful, 4 Ugly Portraits: Beautiful Portrait 4*), December 22, 1987–January 6, 1988.

Oil on wood, 90 x 71.5 cm (35 ³/₈ x 28 ¹/₈ inches). Private collection, Bergamo.

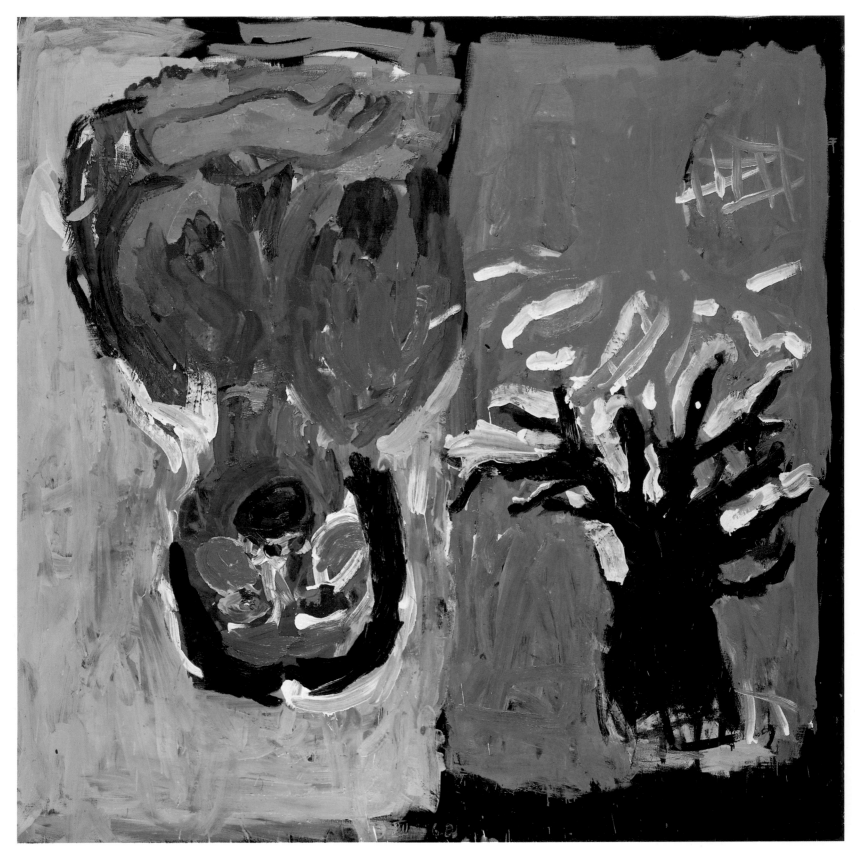

149. Georg Baselitz, *Edvard,* November 6, 1987–January 2, 1988. Oil on canvas, 200 x 200 cm

(78 ³/₄ x 78 ³/₄ inches). Collection of Ellyn and Saul Dennison, Bernardsville, New Jersey.

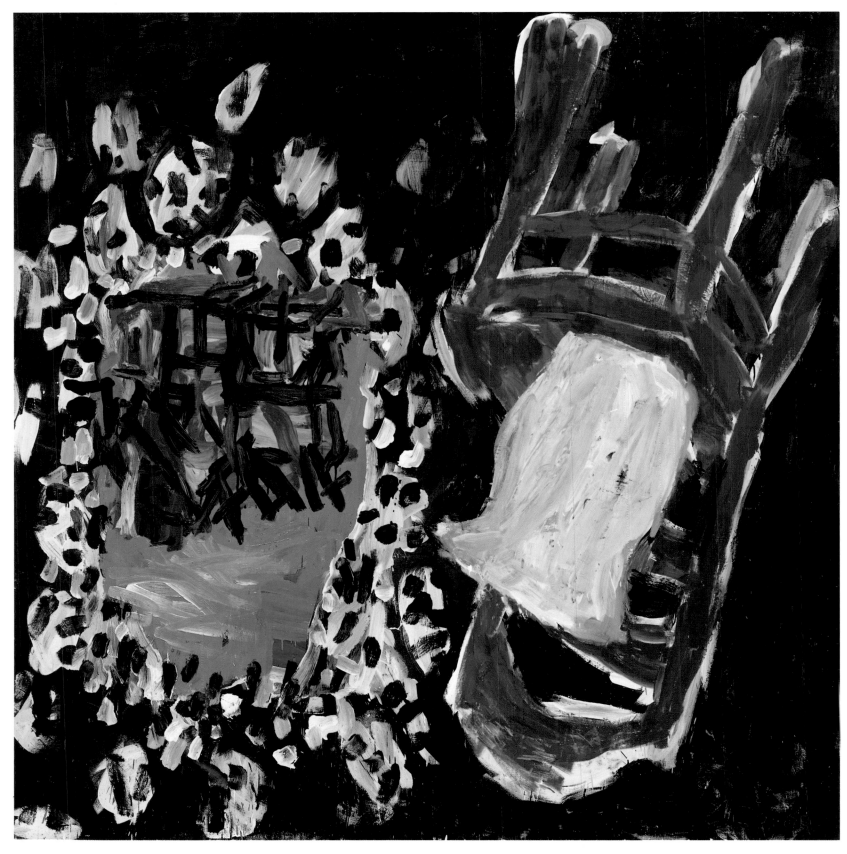

150. Georg Baselitz, *Die Mühle brennt – Richard* (*The Mill Is Burning – Richard*),
January 2–14, 1988. Oil on canvas, 200 x 200 cm (78 3/4 x 78 3/4 inches). Galerie Michael Werner,
Cologne and New York.

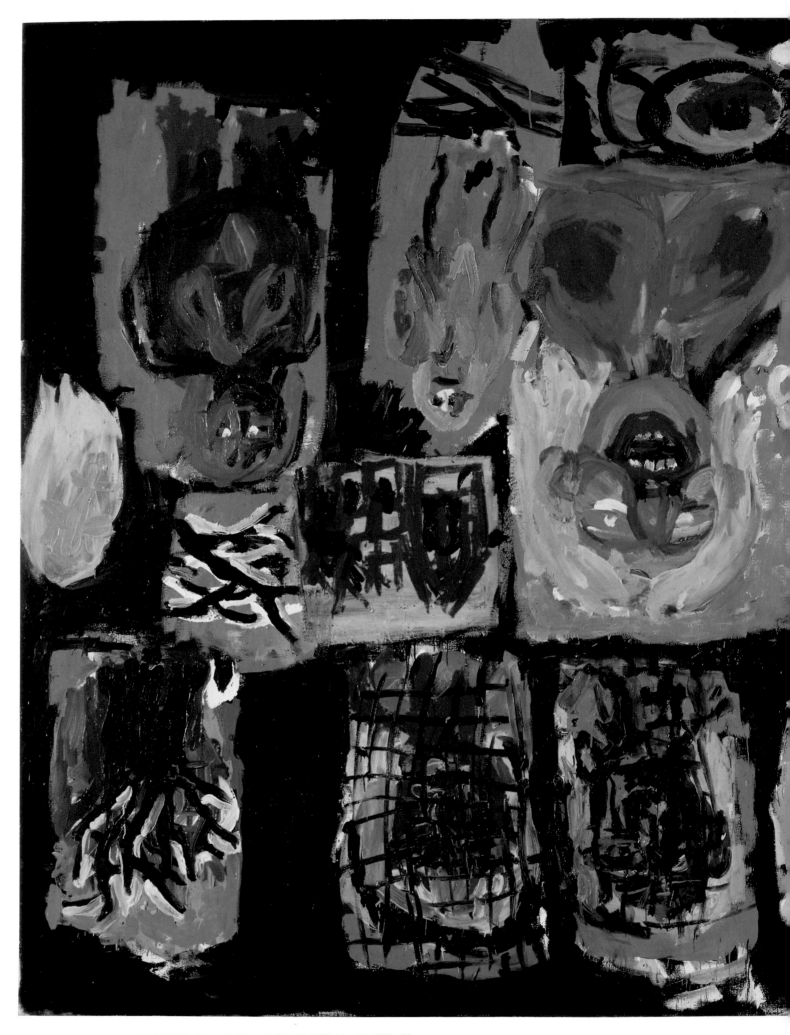

151. Georg Baselitz, *Das Malerbild* (*The Painter's Picture*), July 22, 1987–May 18, 1988. Oil on canvas,

280 x 450 cm (110 ¹/₄ x 177 ¹/₈ inches). Galerie Michael Werner, Cologne and New York.

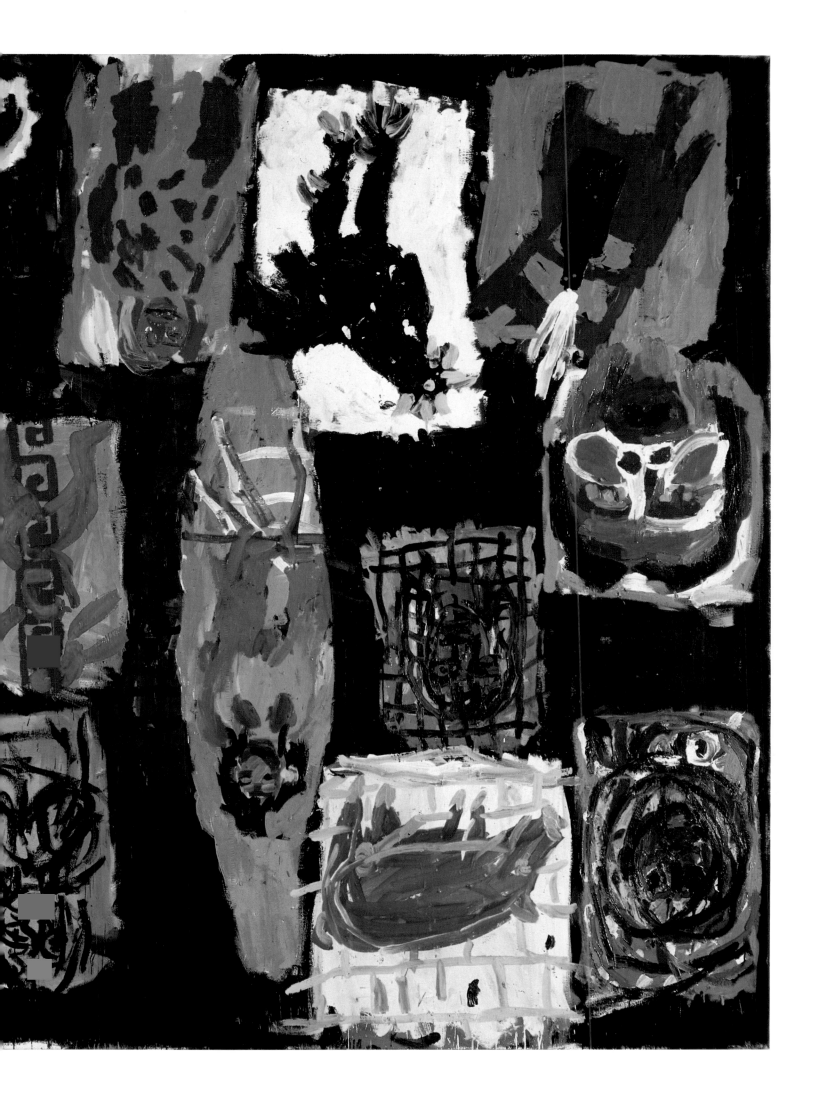

and reference is enhanced through the act of making. The existentialist Baselitz of the late 1950s and 1960s, who was concerned with relating the experience of "tragedy and pain," balances what he calls his "ecstatic assimilation and appropriation of the world" in the 1990s.

In the 1980s and 1990s, Baselitz's overriding commitment to the autonomy of painting has become more and more apparent. Rather than focus on the figure, per se, he turns his attention more than ever to the formal aspects of his painting: color, shape, line, and brushstroke. Beginning in the late 1970s, he began to use checkerboard patterns and ornamentation increasingly in his work (his first use of ornamentation can be traced back to his drawings of the late 1950s); simultaneously, his focus shifted from the figure-ground relationship that he first investigated in his *Heroes* series to a more abstract idiom characterized by an allover style in which the figure is interwoven within the painted armature. In concert with this formal change, he once again turned to the motif of the hero.

In *Volkstanz* (*Folkdance*, December 28, 1988–January 5, 1989, no. 153), a checkered pattern is created by overlapping jugs, pitchers, and bottles; in *Volkstanz IV* (*Folkdance IV*, February 15–March 3, 1989, no. 155), small blocks of color are pressed together to form a patch, as jugs and other vessels surround it like tassels on cloth. In contrast to the

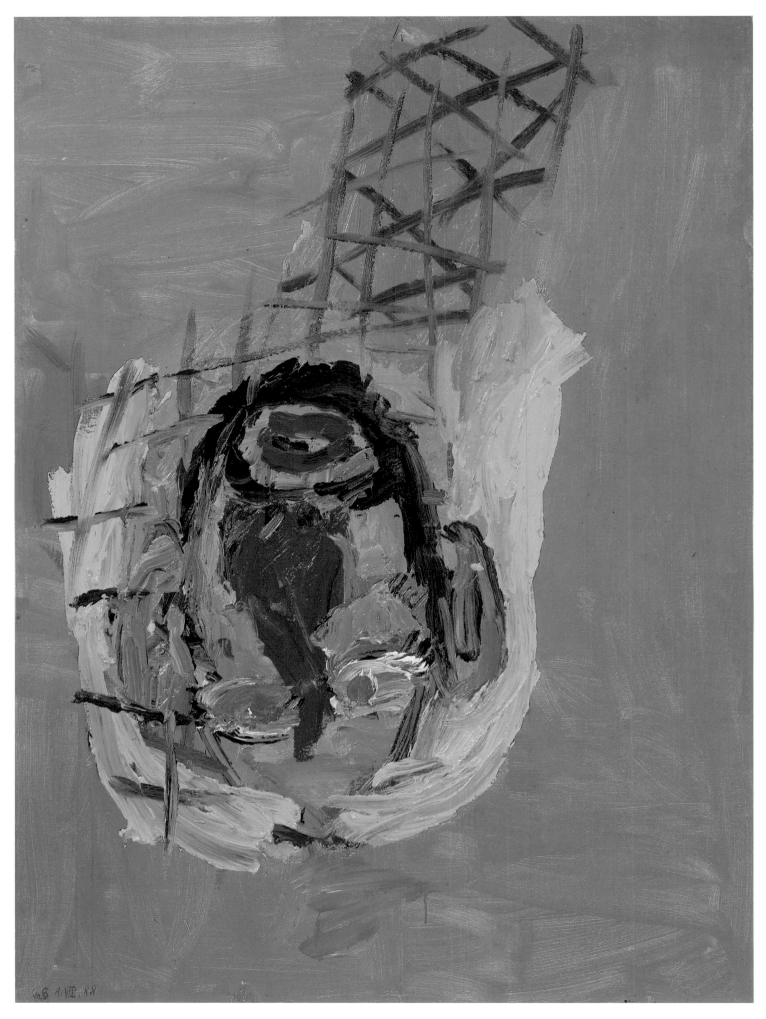

152. Georg Baselitz, *Das Motiv: Giraffe* (*The Motif: Giraffe*), July 28–August 1, 1988. Oil on

canvas, 130 x 97 cm (51 ¹/₈ x 38 ¹/- inches). Collection of Hartmut and Silvia Ackermeier, Berlin.

Heroes paintings, there is no central form in these two works; rather, the focus of the composition moves from the center of the canvas to its edges. Motifs such as the pitcher are deployed in both paintings largely for their shape and color. Each pitcher is only cursorily defined, becoming one form among many.

Folkdance bears a distinct relationship to the 1950s work of Guston (see, for example, no. 12). The impression created by the work of artists such as de Kooning, Guston, Pollock, and Still resonate throughout Baselitz's 1980s work, three decades after he was first exposed to the paintings of the New York School. For example, the composition of the figure in *Mann auf rotem Kopfkissen* (*Man on Red Pillow*, August 17, 1982, no. 133) and its relation to the space around it recalls the work of Still, an artist Baselitz very much admires, while the brushwork owes something to Guston.

In format, the 1980s work shows clear affinities to Mondrian's *Compositions* of the 1920s through 1940s. *The Bottle Drinkers*, with their simple grid structure and large blocks of white recall Mondrian's classic De Stijl canvases. In *Adieu* (March 17, 1982, no. 132), on the other hand, the alternating yellow and white squares, which are the predominant feature of the work, bear a strong relationship to Mondrian's paintings of New York City from the late 1930s and early 1940s. In *Folkdance IV*, the arrangement of rectangles differs from that in *Adieu*, which defined the painting as an allover grid. The

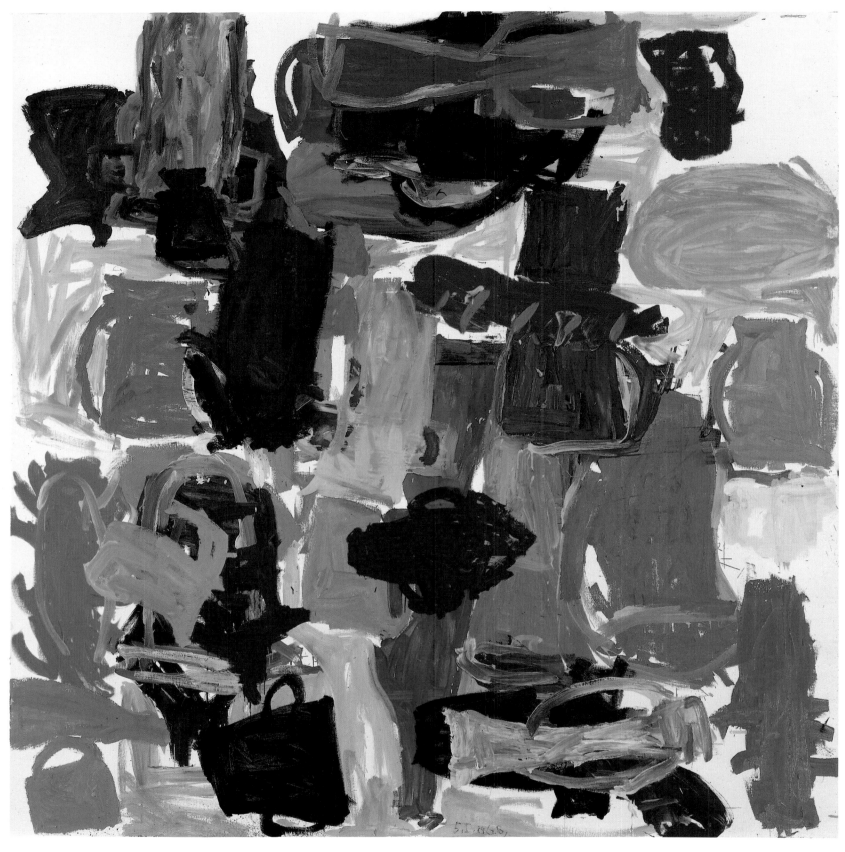

153. Georg Baselitz, *Volkstanz* (*Folkdance*), December 28, 1988–January 5, 1989. Oil on canvas.

250 x 250 cm (98 3/8 x 98 3/8 inches). Collection of Katharina and Wilfrid Steib, Basel.

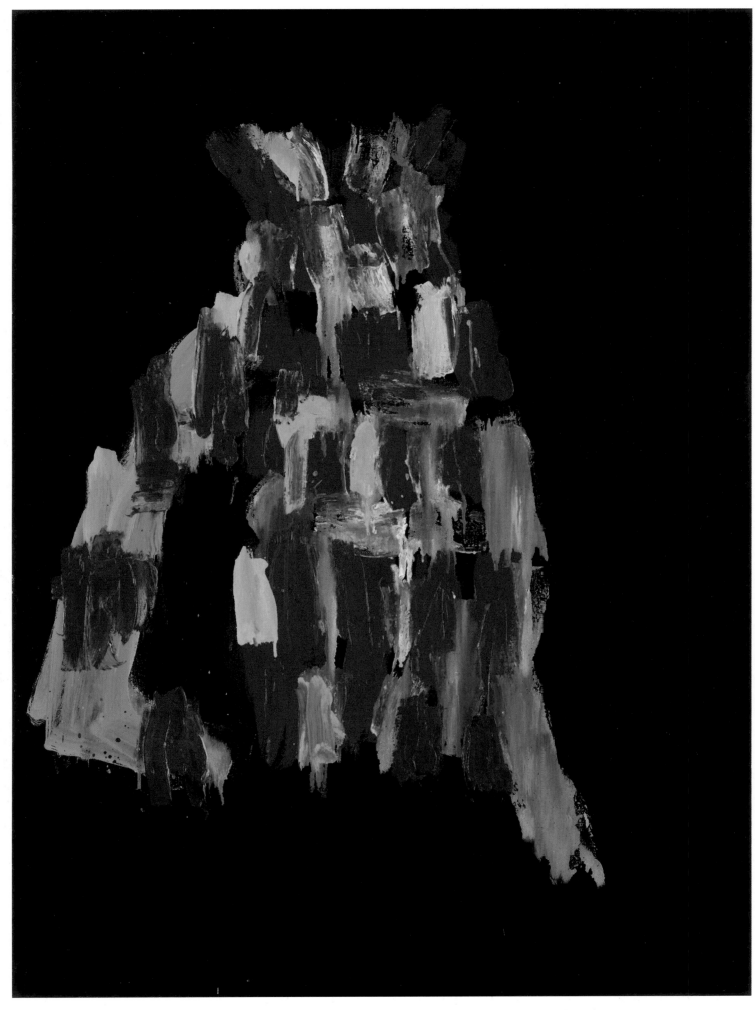

154. Georg Baselitz, *Der Krug* (*The Pitcher*), May 25–28, 1989. Oil on canvas.

130 x 97 cm (51 ¹/₈ x 38 ¹/₄ inches). Private collection. Germany.

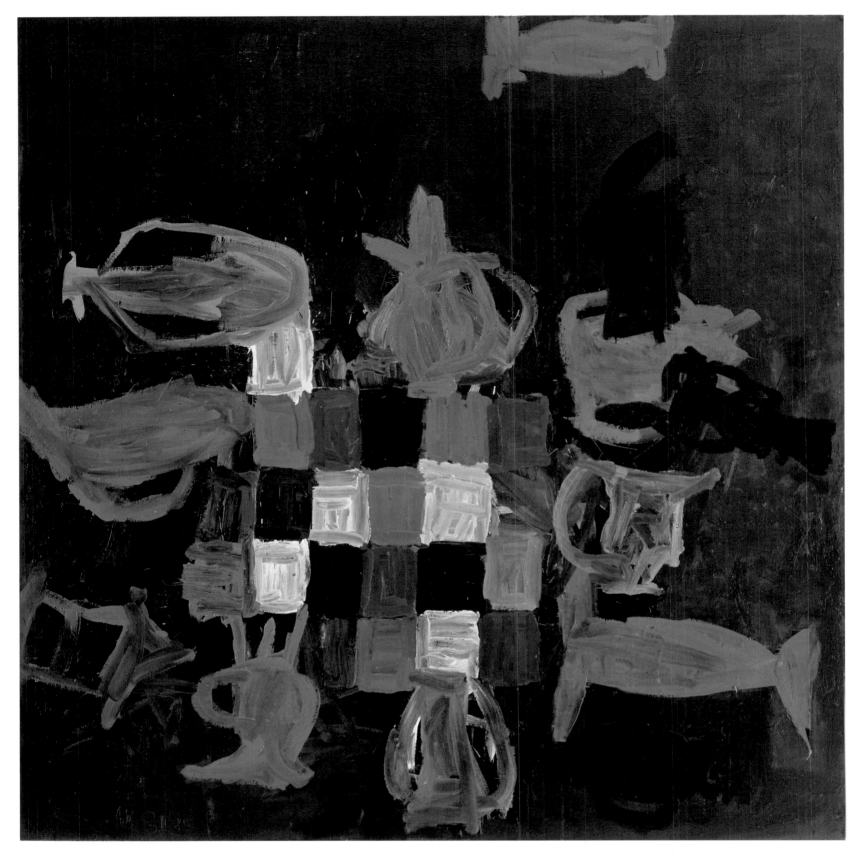

155. Georg Baselitz, *Volkstanz IV* (*Folkdance IV*), February 15–March 3, 1989. Oil on canvas.

250 x 250 cm (98 ³/₈ x 98 ³/₈ inches). Private collection, Cologne.

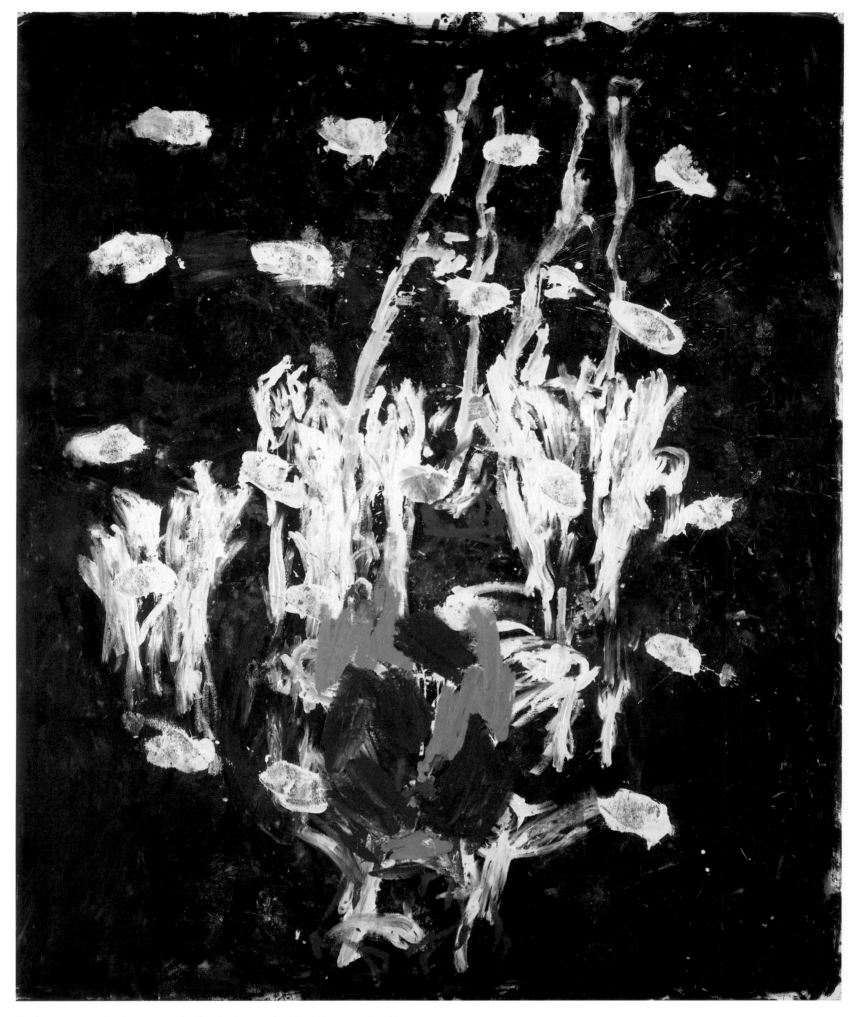

156. Georg Baselitz, *Geschwister Rosa* (*Sibling Rosa*), December 28, 1990–January 9, 1991.

Oil on canvas, 300 x 250 cm (118 1/8 x 98 3/8 inches). PaceWildenstein, New York.

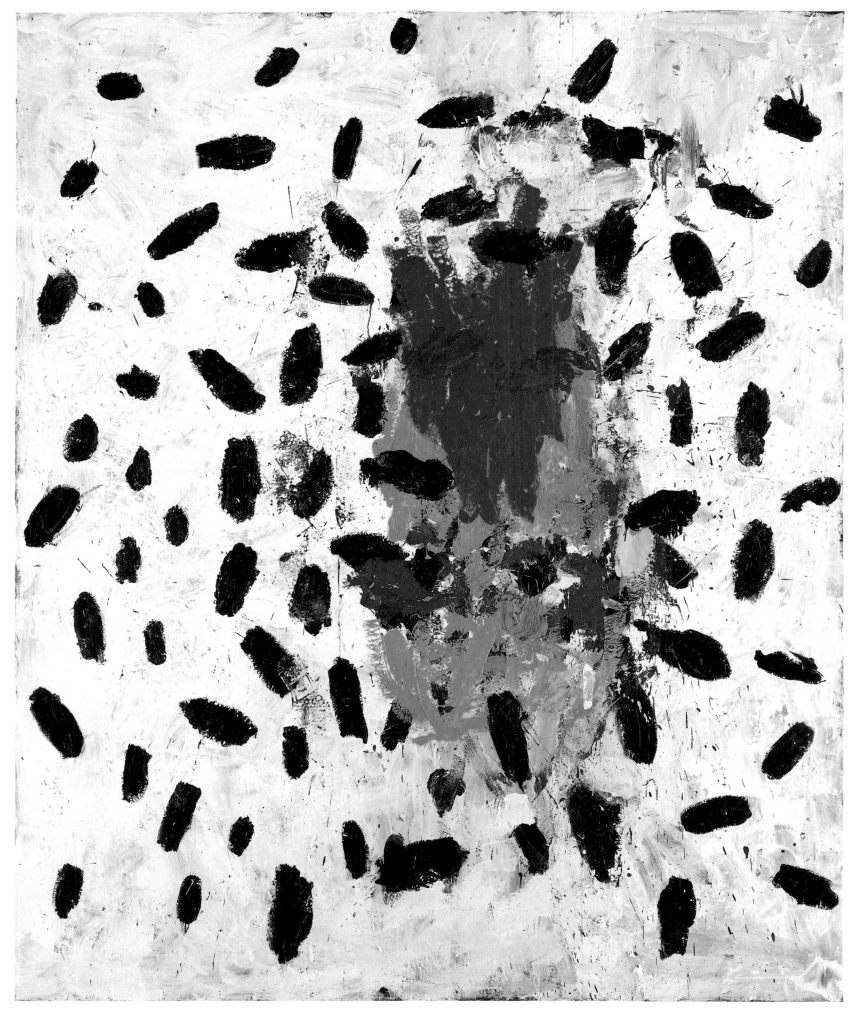

157. Georg Baselitz, _Lamento_ (_Lament_), October 26, 1988–November 1, 1990. Oil on canvas.

300 x 250 cm (118 1/8 x 98 3/8 inches). Collection of Katharina and Wilfrid Steib, Basel.

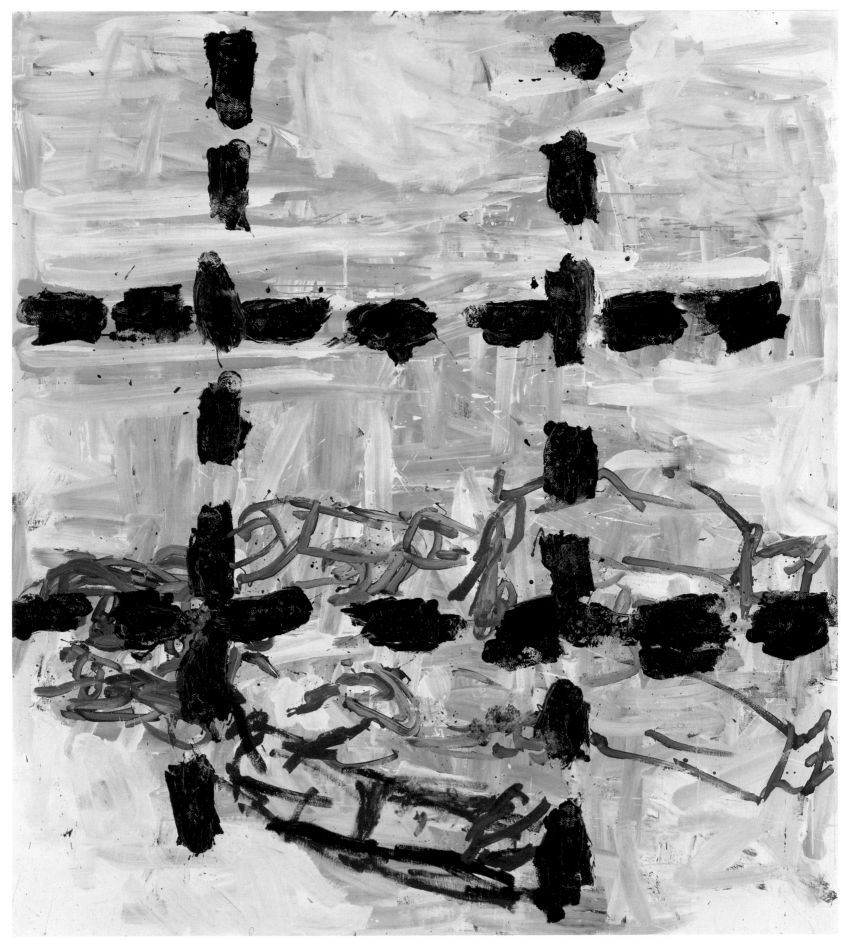

158. Georg Baselitz, *Roter Arm* (*Red Arm*). April 24–30. 1991. Oil on canvas. 290 x 260 cm

(114 ¹/₈ x 102 ³/₈ inches). Collection of Contemporary Art. Fundació "La Caixa," Barcelona.

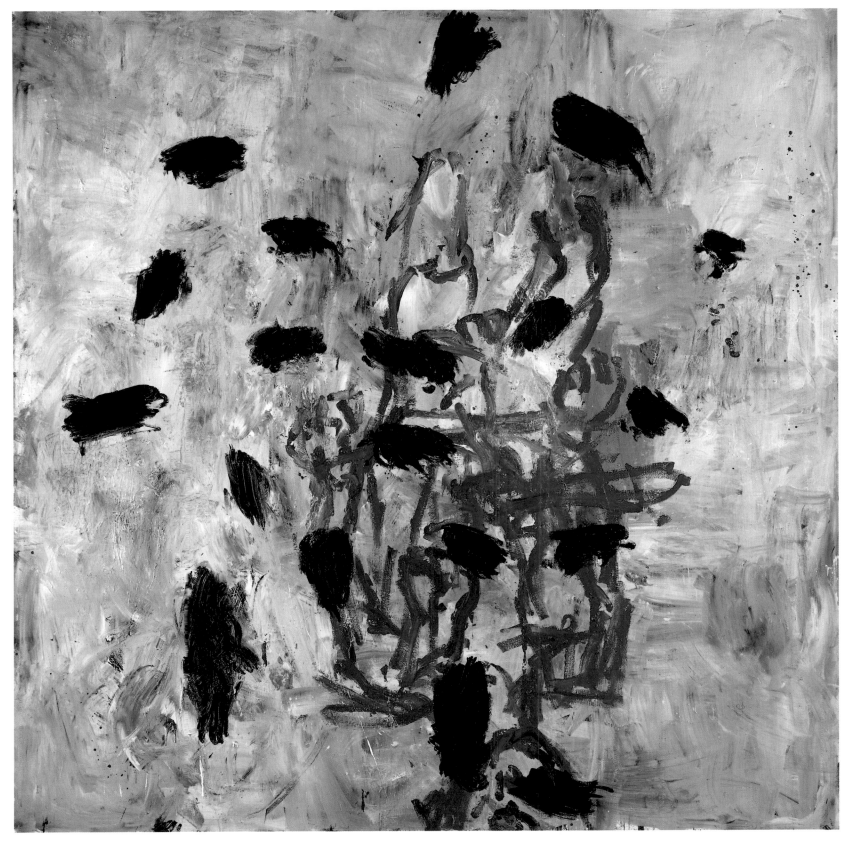

159. Georg Baselitz, _Elch kaum_ (_Elk Hardly_), July 21–December 3, 1990. Oil on canvas.

290 x 290 cm (114 ¹/₈ x 114 ¹/₈ inches). Collection of Michael and Judy Ovitz, Los Angeles.

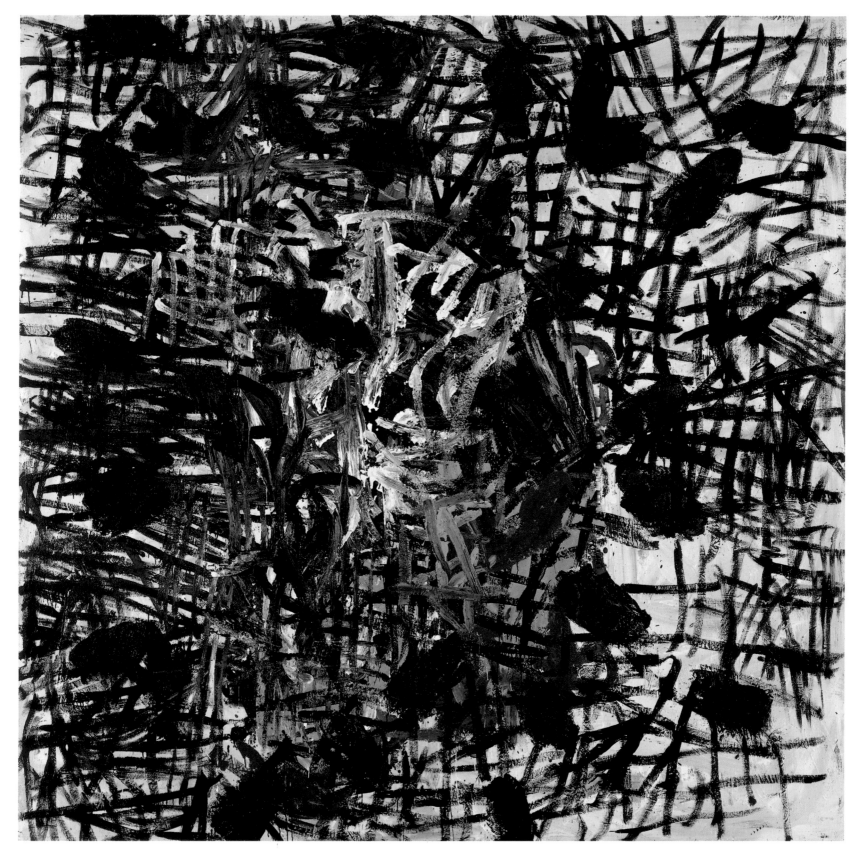

160. Georg Baselitz, *Schwarze Nase* (***Black Nose***), August 14, 1990–February 24, 1991.

Oil on canvas, 250 x 250 cm (98 3/8 x 98 3/8 inches). Collection of L. C. Heppener, The Netherlands.

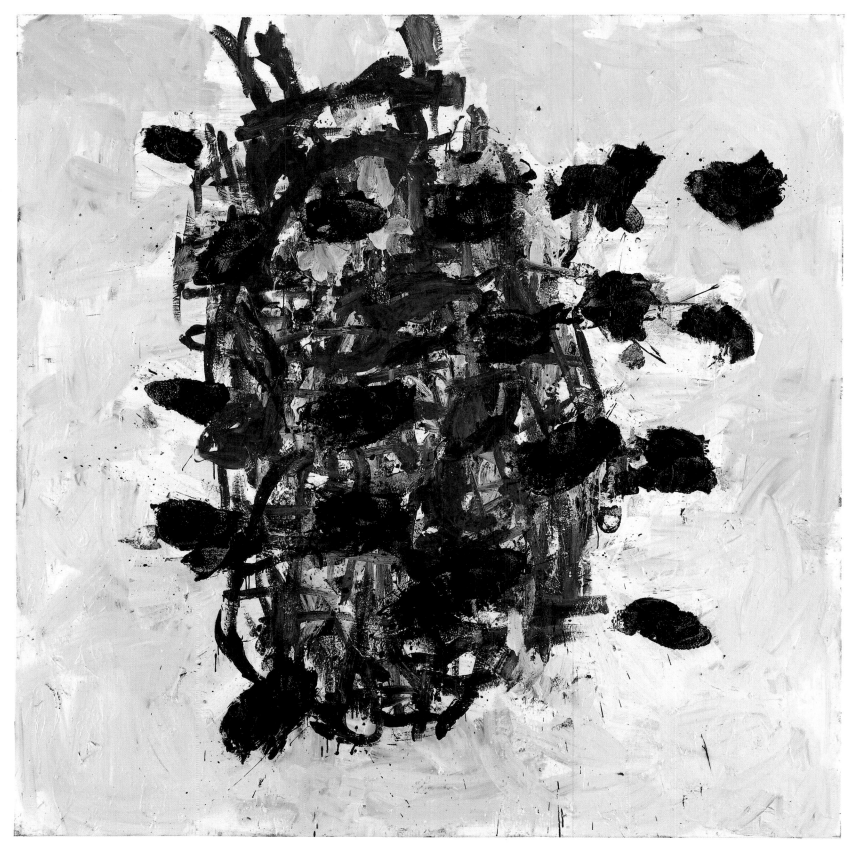

161. Georg Baselitz, *Zwiebelturm* (*Onion Tower*), August 17, 1990–February 1991. Oil on canvas.
250 x 250 cm (98 3/8 x 98 3/8 inches). Private collection, Germany.

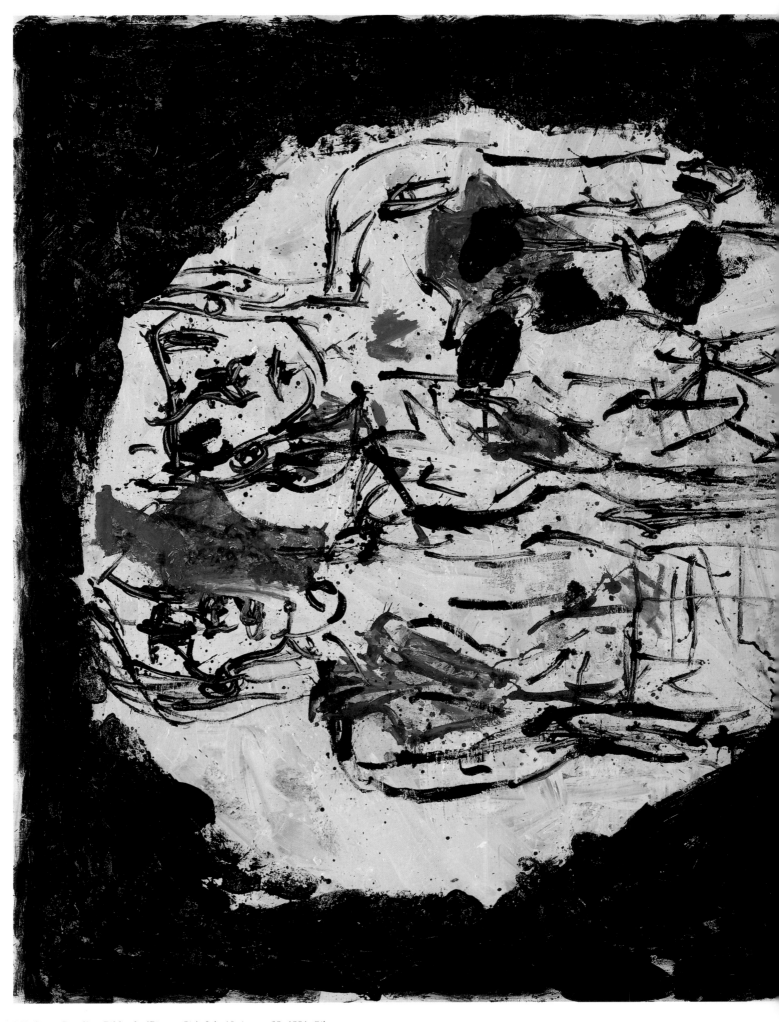

162. **Georg Baselitz**, *Bildsechs* (*Picture Six*), July 10–August 29, 1991. Oil on canvas.

285 x 457 cm (110 ⅝ x 180 ¼ inches). Collection Ludwig. Ludwig Forum für Internationale Kunst. Aachen.

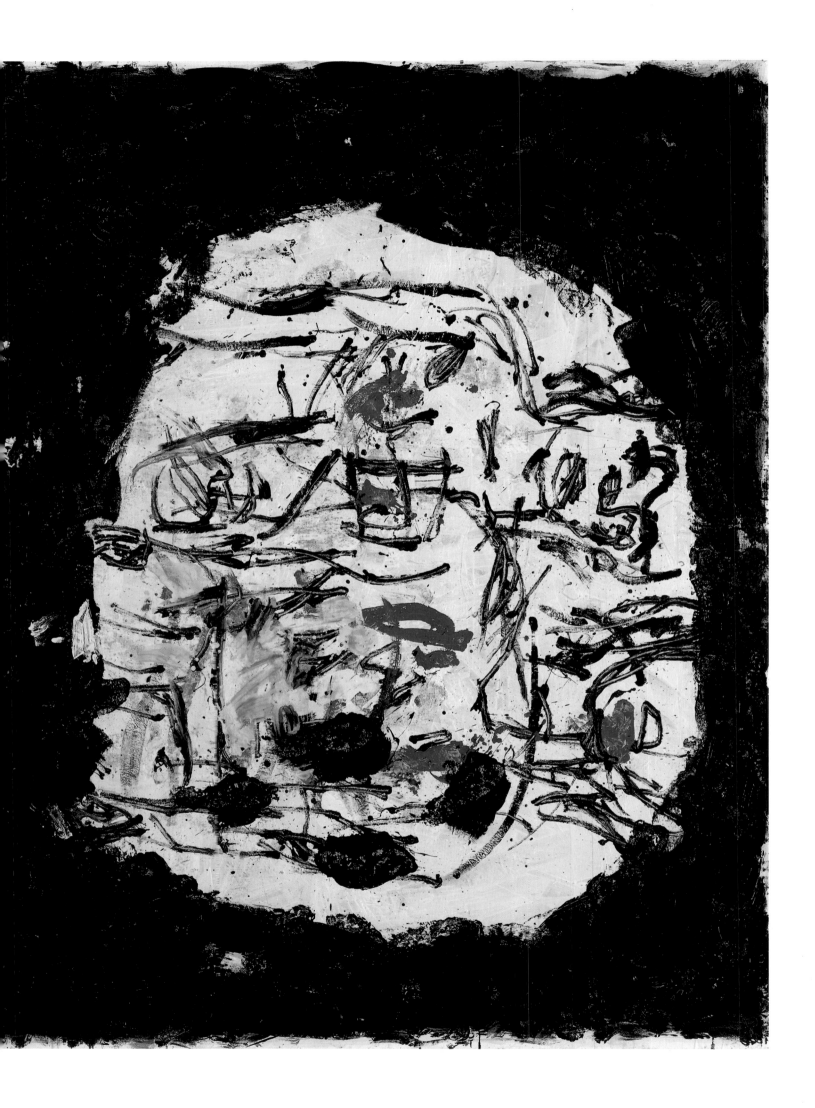

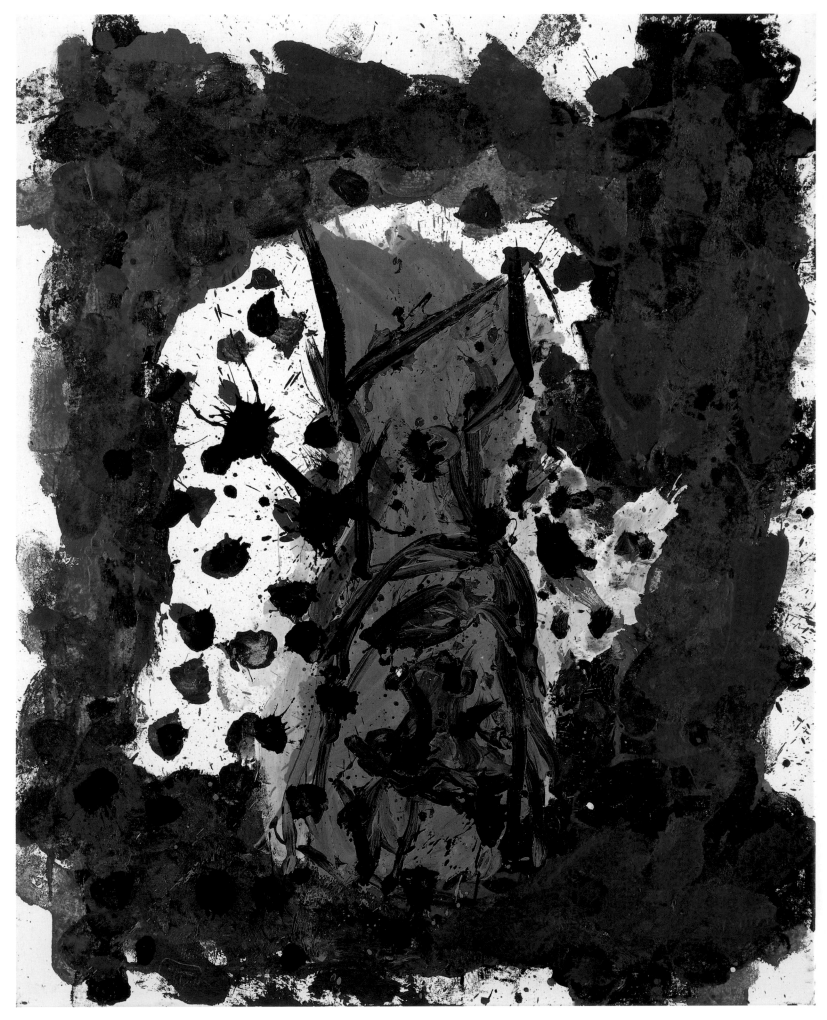

163. Georg Baselitz, *Weiter im Norden (Further North)*, May 3–6, 1992. Oil on canvas.

162 x 130 cm (63 ³/₄ x 51 ¹/₈ inches). Galerie Michael Werner, Cologne and New York.

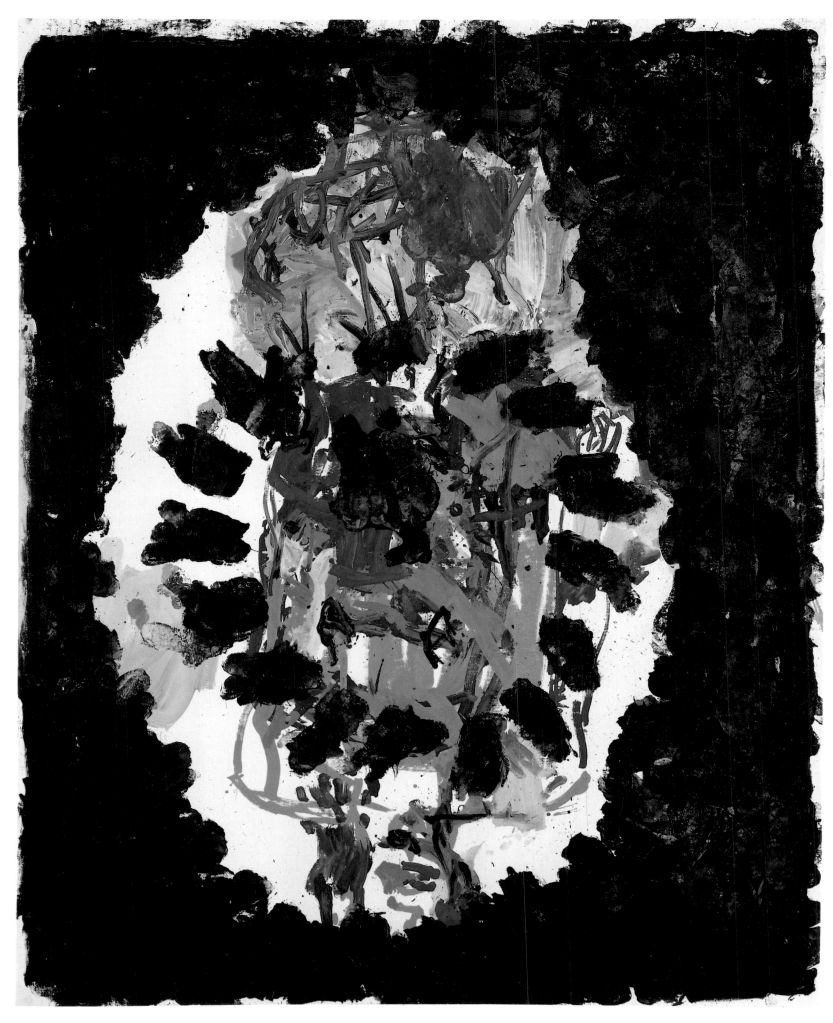

164. Georg Baselitz, *Der letzte Adler* (*The Last Eagle*), August 1–8, 1991. Oil on canvas.
290 x 236 cm (114 1/8 x 92 7/8 inches). Private collection, Cologne.

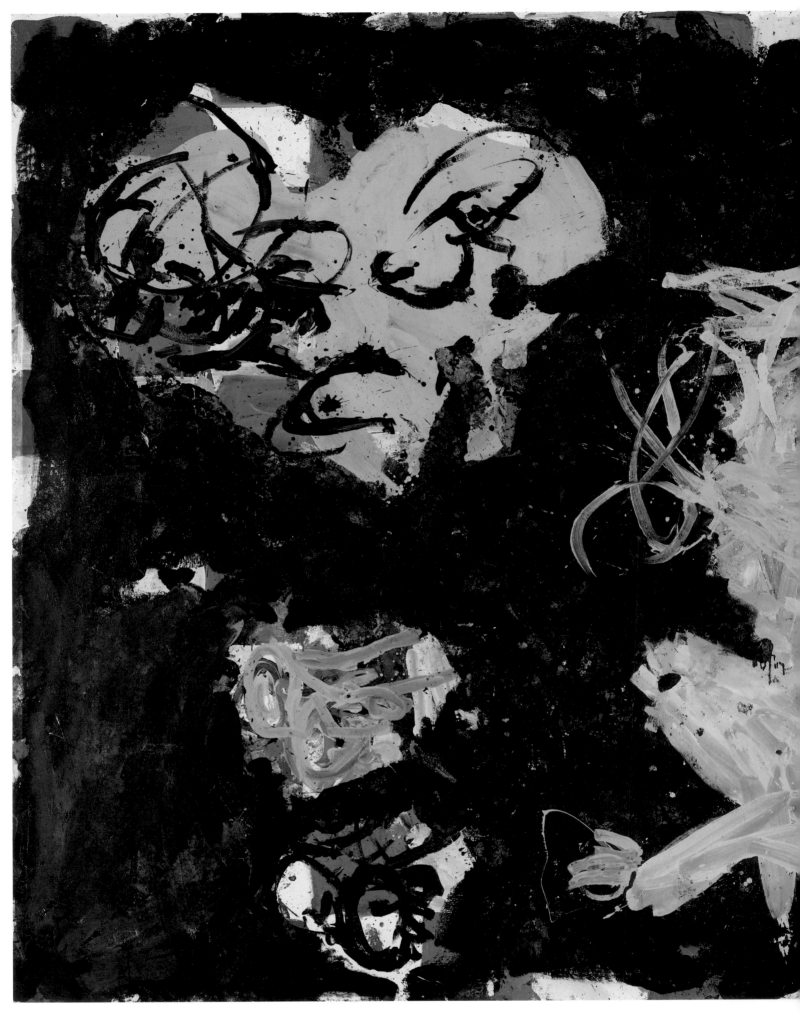

165. Georg Baselitz, *Bildzwölf* (*Picture Twelve*), May 28–June 22, 1992. Oil on canvas. 289 x 475 cm (113 ³/₄ x 187 inches). Galerie Michael Werner, Cologne and New York.

rectangles forming a checkerboard in *Folkdance IV* occupy the lower portion of the center and act as a foil for the objects that surround it. The pattern is painted in brilliant red, black, blue, and white squares while the slightly larger, more loosely defined, but equally colorful objects that radiate from it animate the dark gray field of the canvas. *Der Krug* (*The Pitcher*, May 25–28, 1989, no. 154) is an even more astonishing abstraction, for its "pitcher" is made up of patches of red, white, blue, and gray, with black serving as the impenetrable ground on which the object rests. Baselitz speaks fondly of this painting for it is one that came easily to him. The paint just flowed on, as he relates it, and its surface lacks the heavily worked overpainting of other pictures.

In many recent works, Baselitz has revisited the central figure of the *Heroes* paintings; but now, this motif can no longer be read as an anti-hero. Rather, the figure is disembodied, emptied of its former meanings and ready to take on new ones. In *Lamento* (*Lament*, October 26, 1988–November 1, 1990, no. 157), a *Heroes* figure, only summarily rendered, is buried under a maelstrom of black marks. A similar effect is achieved in *Elch kaum* (*Elk Hardly*, July 21–December 3, 1990, no. 159), where once again a *Heroes* figure is summarily drawn, this time delineated by a green outline. An actively painted white field threatens to engulf the figure, parts of which are obliterated by black spots. In *Roter Arm* (*Red Arm*, April 24–30, 1991, no. 158) and *Der letzte Adler* (*The Last Eagle*,

167. Georg Baselitz, *Ida*, July 25–August 4, 1992. Oil on canvas, 131 x 98 cm (51 1/4 x 38 7/8 inches).

Private collection, Germany.

168. Georg Baselitz, *Paula*, July 18, 1992. Oil on canvas, 131 x 98 cm (51 ¹/₄ x 38 ⁷/₈ inches).

Galerie Michael Werner, Cologne and New York.

169. Georg Baselitz, *Xenia,* July 17, 1992. Oil on canvas, 131 x 98 cm (51 1/4 x 38 7/8 inches).

Private collection, Germany.

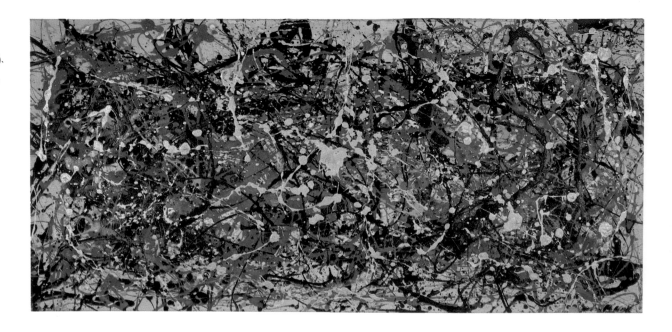

August 1–8, 1991, no. 164), the schematic renderings make the figures barely visible. In *Red Arm*, the green figure appears for the most part to be caged in by the black grid; yet, here and there on the canvas, the frenetic form appears to rest atop the black strokes and its vibrantly painted red arm lurches out from the grid's confines. In *The Last Eagle*, the figure encased in a white sphere abutted by a black ground has been painted with brushstrokes of varying weight and effect. The pale pink paint he has used to define the outer shoulders of the figure and fleshy left thigh is entangled with the green, blue, black, and white paint that merges within the interior of the figure. In both works, Baselitz has created a form that seems to exist within and above the picture plane.

In *Elk Hardly*, Baselitz appears to have walked on the canvas itself. Many paintings from the 1990s evidence the artist's footprints. At this time, he began laying his canvases on the floor. Initially, he tried to avoid stepping on them; sometimes he erased footprints that made their way onto the paintings. But he soon decided that it would be disingenuous to conceal the marks of his painting process, and so left his footprints on the surface. Baselitz notes that this method is what differentiates these large-scale canvases from earlier ones, which were painted upright; formerly, he could stand back from the picture and see it in its entirety, but now he works on a large surface on the floor, as did Pollock, and he can see only a small part of the entire canvas at any one

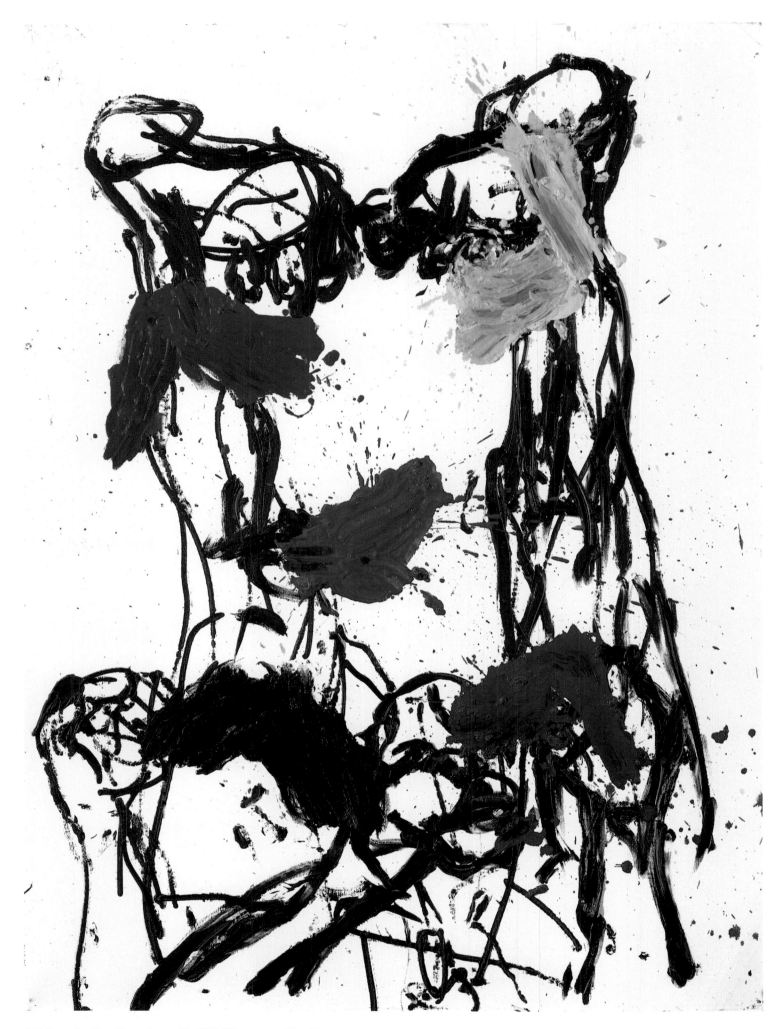

171. Georg Baselitz, *Hanna,* August 10, 1992. Oil on canvas, 131 x 98 cm

(51 ¹/₂ x 38 ¹/₂ inches). Private collection.

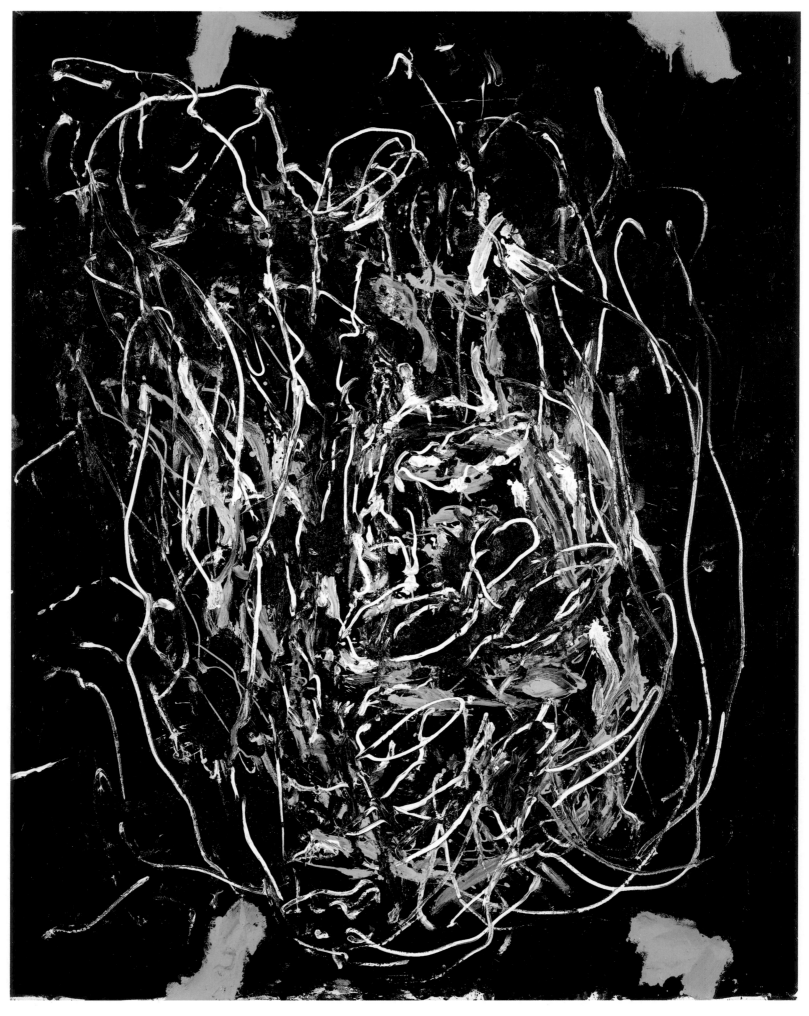

172. Georg Baselitz, *War Einmal* (*Was Once*), April 16–September 6, 1992. Oil on canvas.
250 x 200 cm (98 ¹/₂ x 78 ³/₄ inches). PaceWildenstein, New York.

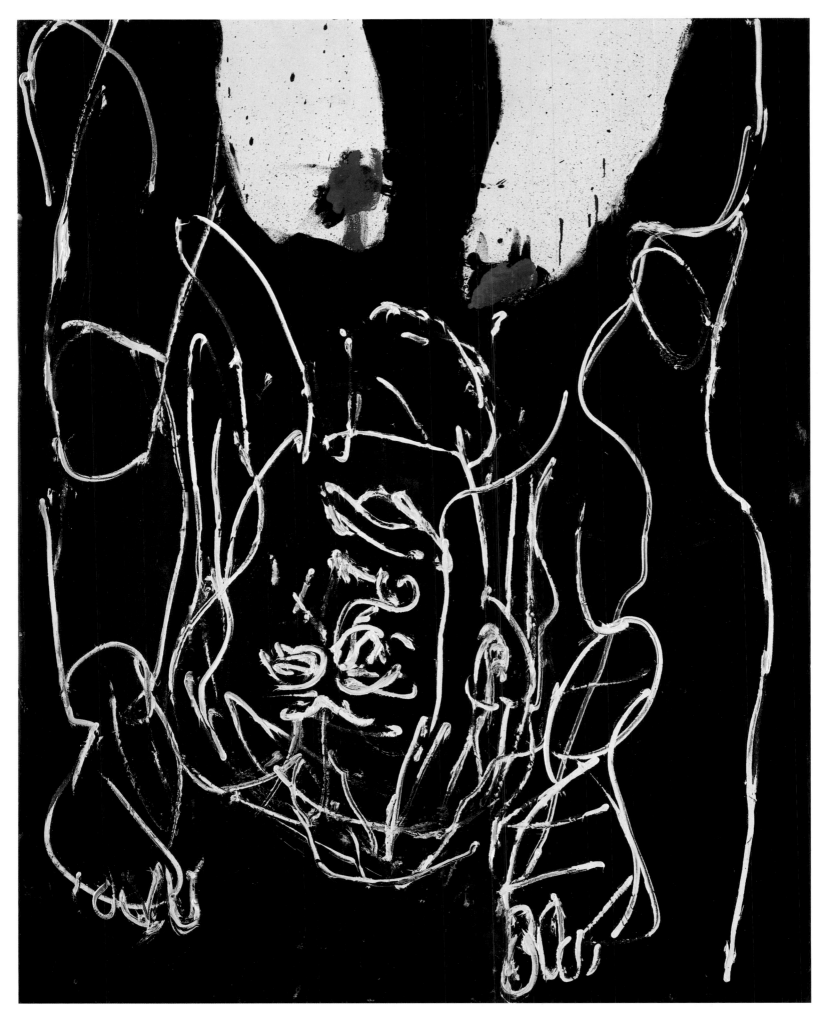

173. Georg Baselitz, *Schwester Elsas Knie* (*Sister Elsa's Knee*)**,** December 12, 1992. Oil on

canvas, 162 x 130 cm (63 ³/₄ x 51 ¹/₈ inches) Kunstmuseum Bonn. On permanent loan from the

Grohe Collection.

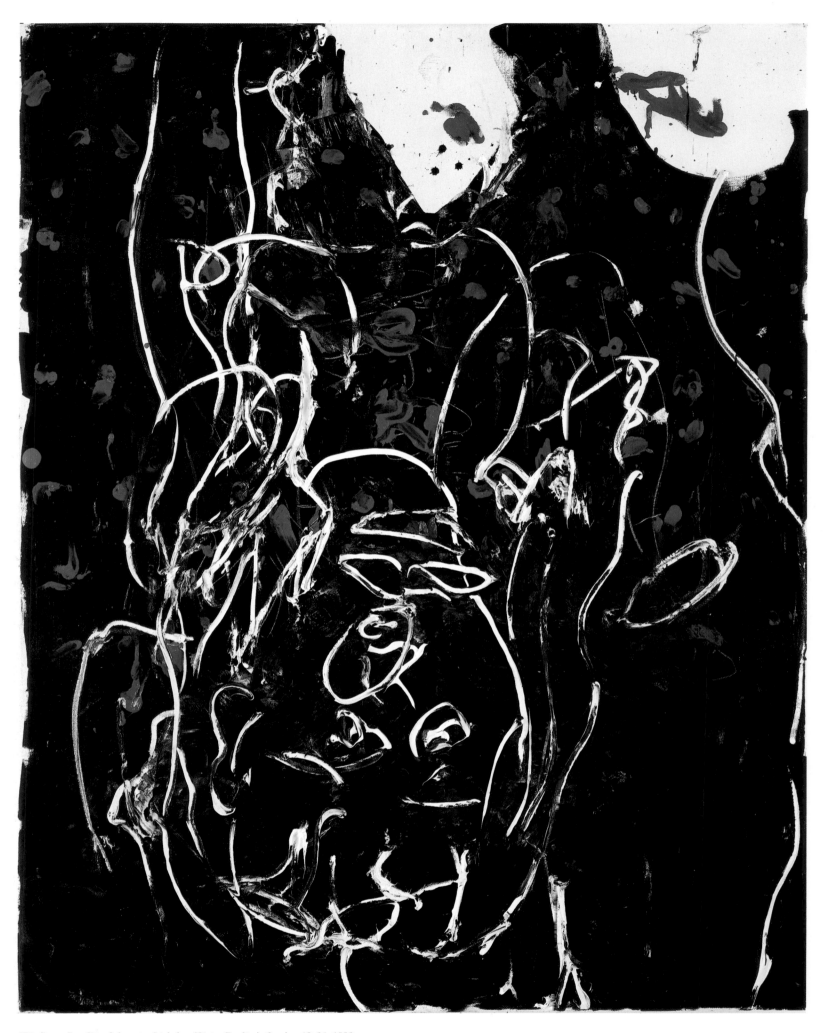

174. Georg Baselitz, *Schwester Liebchen* (*Sister Darling*), October 19–26, 1992.

Oil on canvas, 162 x 130 cm (63³/₄ x 51¹/₈ inches). Kunstmuseum Bonn, On permanent

loan from the Grothe Collection.

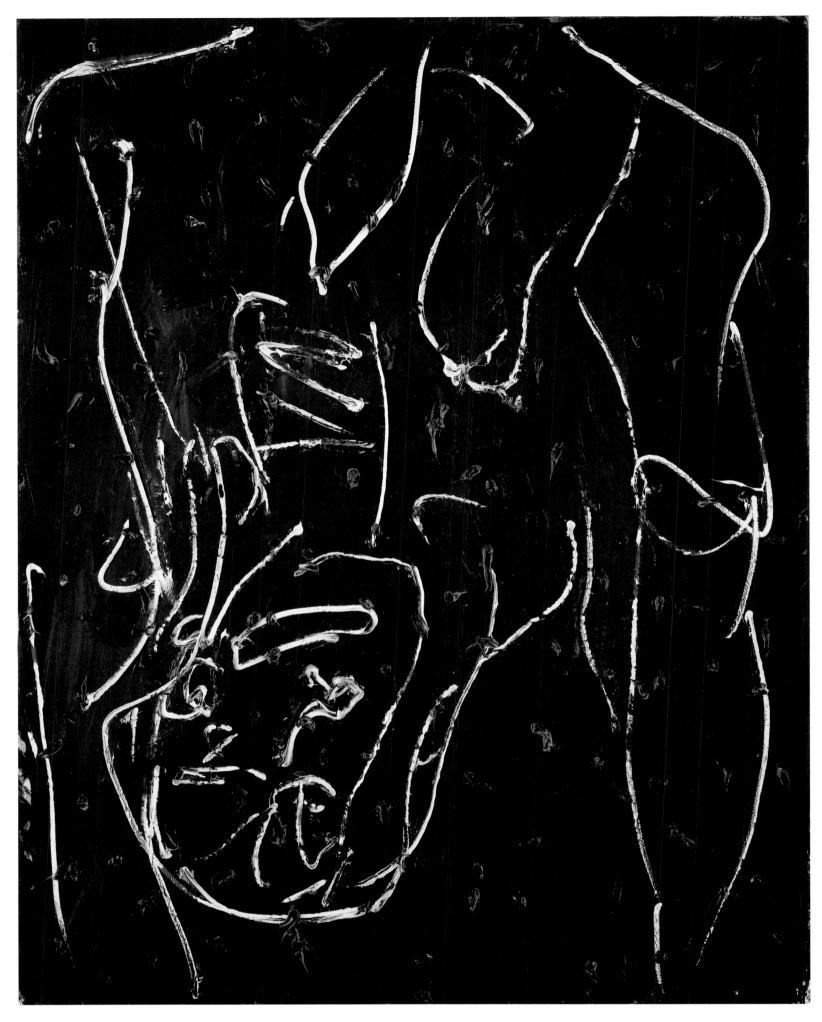

175. Georg Baselitz, *Schwester Damaskus* (*Sister Damascus*), April 17, 1992–February 1, 1993.

Oil on canvas, 162 x 130 cm (63 ³/₄ x 51 ¹/₈ inches). Jamileh Weber Gallery, Zurich.

176. Georg Baselitz, *Bildeinundzwanzig* (*Picture Twenty-one*), June 30–July 6, 1993. Oil on canvas,

290 x 450 cm (114 ¹/₈ x 177 ¹/₈ inches). Deutsche Bank Luxembourg S.A.

time. For Baselitz, this process heightens the mysteries of the creative act:

> *When I crawl around on the canvas and squeeze out the paint, I know what I*
> *am doing but I don't know what it is that I am doing. . . . What happens on*
> *the canvas happens because it is important, and because it has to happen,*
> *but I have no adequate explanation for it.*[72]

Baselitz's most recent works attack the relationship of the figure to the field in a different way. In *Schwarze Nase* (*Black Nose*, August 14, 1990–February 24, 1991, no. 160), for example, the white, red, green, and pink image is lost in a maze of thick black strokes. In *The Last Eagle*, a mandala shape surrounds the central figure of the head, while in *Bildsechs* (*Picture Six*, July 10–August 29, 1991, no. 162), two round disc shapes enclose the torsos of two pairs of figures. Baselitz was inspired by the figures that appear on grave markers found on the floors of churches throughout Italy. The flattened line he employed is reminiscent of the incisions used to delineate the two-dimensional figures on these markers. In *Picture Six*, the artist accomplished a stunning transformation: seemingly random markings come to delineate figures. Paintings like *Zwiebelturm* (*Onion Tower*, August 17, 1990–February 1991, no. 161) are based on a head by Pollock that Baselitz saw in 1958 and had previously used in his *Heroes* paintings. The title *Geschwister Rosa* (*Sibling Rosa*, December 28, 1990–January 9,

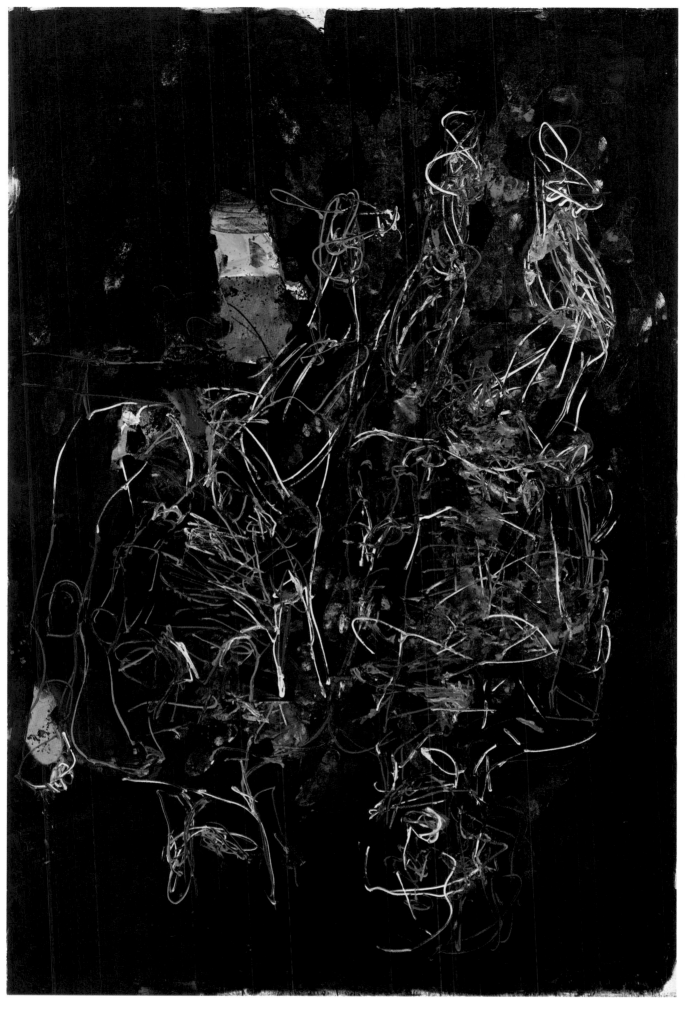

177. Georg Baselitz, *Bildsechzehn* (*Picture Sixteen*), January 20–28, 1993. Oil on canvas,
427 x 288 cm (168 x 113 ¹/₂ inches). Galerie Michael Werner, Cologne and New York.

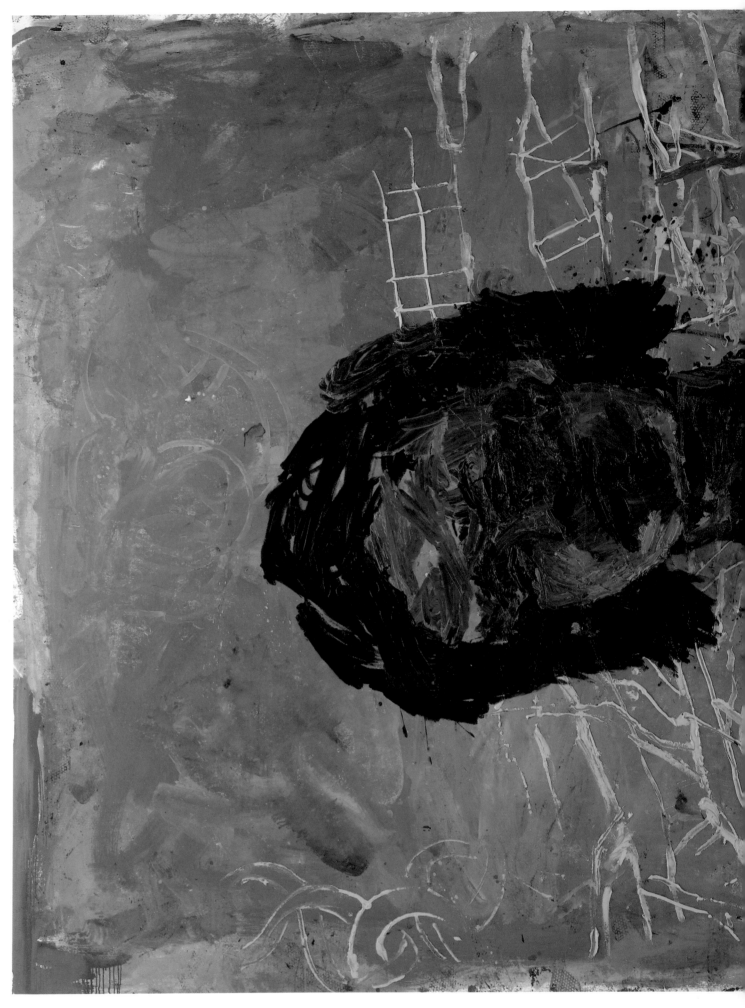

178. Georg Baselitz, *Bildachtundzwanzig – No Birds* (*Picture Twenty-eight – Keine Vögel*),

May 1–June 2, 1994. Oil on canvas, 290 x 450 cm (114 ½ x 177 ¼ inches). Private collection, Germany.

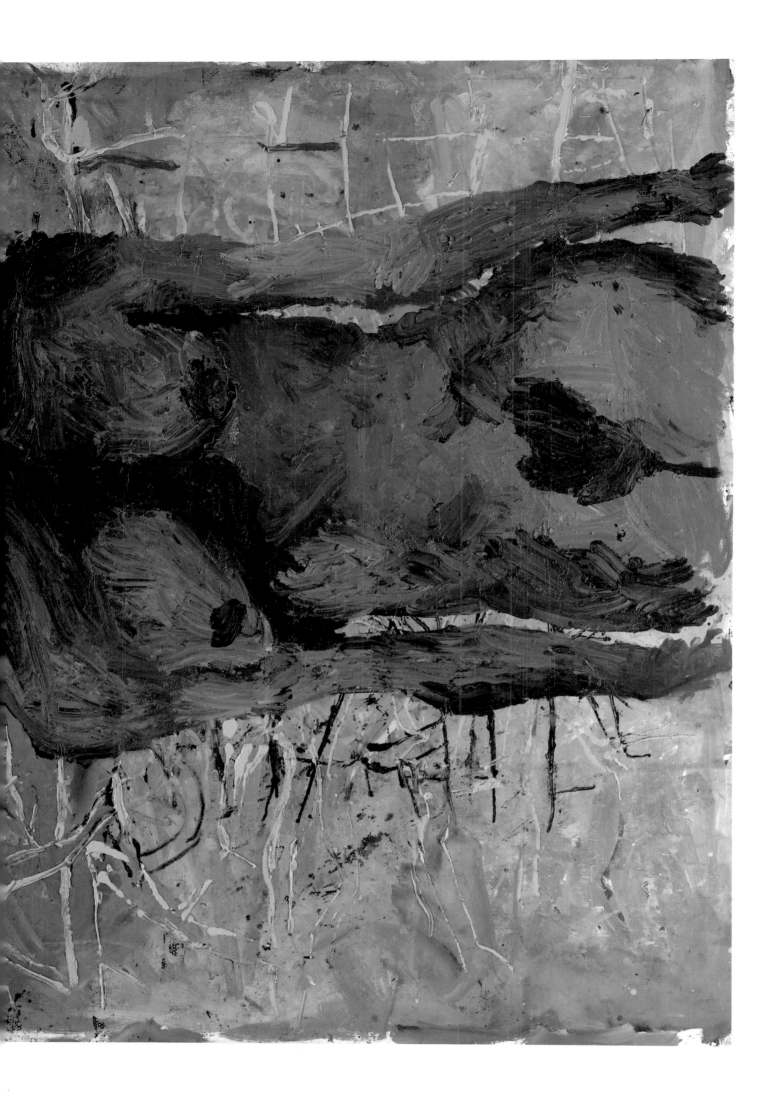

1991, no. 156) is an homage to a Greek folk singer of the 1930s; the red head is also a skull, while the background depicts three tree trunks, creating the impression that the viewer is lost in the trees' roots. In many paintings of this period, Baselitz handled his paint in a way he refers to as dirty, adding an additional element of ephemerality. In *Bildzwölf* (*Picture Twelve*, May 28–June 22, 1992, no. 165), the yellow head appears to exist on several planes. To the left is the torso of a female archetype, in which the female's sexual parts are depicted. The white shape in the center is a hare, another motif from the artist's early years. In *Bildsechzehn* (*Picture Sixteen*, January 20–28, 1993, no. 177), on the other hand, skeins of vivid colors create a web that both defines and masks Baselitz's figures, while the keyhole shape suggests a bedroom. In *Bildeinundzwanzig* (*Picture Twenty-one*, June 30–July 6, 1993, no. 176), he created an allover composition of color forms and linear accents and overlaid them with the drawings of two heads. In *Bildachtundzwanzig – No Birds* (*Picture Twenty-eight – Keine Vögel*, May 1–June 2, 1994, no. 178), the yellow linear scrawls refer to the landscape outside his studio window; the immense archaic figure is Elke, whom, in this case, he has "modeled with his hands in paint."

Several smaller works of the 1990s depict cropped female forms. In *Schwester Elsas Knie* (*Sister Elsa's Knee*, December 12, 1992, no. 173), *Schwester Liebchen* (*Sister*

Darling, October 19–26, 1992, no. 174), and *Schwester Damaskus (Sister Damascus,* April 17, 1992–February 1, 1993, no. 175), Baselitz has left some of the canvas edges bare and used white paint squeezed from the tube to create the outline of his forms. In these works, spots of green paint are applied in an irregular, allover pattern that in some cases emphasizes the nipples. *Ida* (July 25–August 4, 1992, no. 167), *Paula* (July 18, 1992, no. 168), and *Xenia* (July 17, 1992, no. 169) focus on the motif of the skull and are similarly distinguished by a stark black-and-white palette, but here Baselitz has incised their silhouettes into the black field, exposing the canvas beneath; he has also overpainted portions of the canvas with concentrated white brushstrokes. The way in which he builds his surface in these works creates distinct, illusional planes. In *Hanna* (August 10, 1992, no. 171), he chose to paint a decapitated form, highlighting its feet with vibrant red and yellow strokes. While the motif of the feet may very well be a reference to the artist and his new process of painting on the floor, Baselitz speaks of it in terms of his admiration for the Spanish artist Jusepe de Ribera, who, he says, painted feet and their flesh better than any artist he knows.

The brutality captured in Baselitz's earlier *P. D. Feet* series has been replaced by an equally daring if different form of confrontation. The exuberant freedom that characterizes Baselitz's work over the last decade has made it possible for him to revivify

old subjects, whether heroes, woodcutters, friends, trees, dogs, or hares. He has also taken on pattern and ornamentation as a subject in its own right, and, in his most recent work, used gold leaf for the first time. His attention to flourish and decoration harks back to his interest in Vrubel, Moreau, and other Symbolists, yet in Baselitz's work they are imbued with a sense of alchemy. He continues to pursue new avenues in his art relentlessly, always daring us to follow him. Now his work is poised at another threshold, one in which nature and myth converge.

Baselitz questions the painters of today:

> *Are the painters still those painters who are painting the great cave? Do they paint the buffalo on the wall as hunger, the eagle as freedom, and the woman with the big bottom as love? Do they paint the buffalo as the table which magically sets itself? Have they meanwhile left the cave, cleared out of the community and forgotten all those universal, comprehensible agreements, because magic does not still hunger, because flying does not work, and yearning for love does not breed love? Have they traded the cave for some other place?*[73]

Many painters have left the cave, but Baselitz is still searching for the answers to be found there.

1. Quoted in Eric Darragon, "Georg Baselitz," *Galeries Magazine* (Paris) 58 (Feb.–March 1994), p. 71. Translation by Brian Holmes.

2. For a full account of the incident, see Martin G. Buttig, "Baselitz Case," *Censorship* (London), vol. 2, no. 1 (winter 1966), pp. 35–41. These quotations are from pp. 35–37.

3. Buttig, p. 36.

4. Heinz Ohff, "Beim Namem gennant: Georg Baselitz zur Eröffnung der Galerie Werner und Katz," *Der Tagesspiegel* (Berlin), Oct. 3, 1963, p. 4. Translation by Anne Jones.

5. H[einz] O[hff], "Eine Frage für den Staatsanwalt: Zur Auseinandersetzung über die Ausstellung Georg Baselitz in der Galerie Werner & Katz," *Der Tagesspiegel*, Oct. 4, 1963, p. 4. Translation by Anne Jones.

6. Buttig, pp. 39–40.

7. The avant-garde has experienced many similar episodes of censorship. In Germany, for example, the 1919 Cologne exhibition *Dada-Vorfrühling* (Dada early spring) was closed down by the police in response to the works of Johannes Theodor Baargeld and Max Ernst. According to Ernst, one of the items confiscated as pornography was a reproduction of Dürer's *Adam and Eve*. See Ernst's "Biographische Notizen (Wahrheitgewebe und Lügengewebe)," trans. R.W. Last, in Uwe M. Schneede, *Max Ernst* (New York: Praeger, 1973), p. 25.

8. For a comprehensive account of the Third Reich's systematic pillorying, removal, and destruction of works in public and private collections throughout Nazi-annexed Europe, see Lynn H. Nicholas, *The Rape of Europa: The Fate of Europe's Treasures in the Third Reich and the Second World War* (New York: Alfred A. Knopf, 1994).

9. Unless otherwise noted, all quotations by the artist are from interviews and conversations with the author in Derneburg, Germany, and New York City, from 1992 through 1995.

10. The term "l'art informel" was coined by French critic Michel Tapié in 1952 to distinguish the new more painterly abstraction from Cubism and Geometric Abstraction, two movements that had been the dominant forces in French painting until the end of World War II. Art Informel, along with Tachisme (from the French word, *tache*, for "blot," "stain," or "spot") are roughly equivalent to American Abstract Expressionism.

11. According to Baselitz, *The Big Night Down the Drain* was painted in response to drawings of pissing men by Jean Dubuffet and Claes Oldenburg.

12. Buttig, p. 35.

13. "P. D." in Baselitz's titles of this period refers to *Pandämonium*, the title of two manifestos of 1961 and 1962 written by Baselitz and Eugen Schönebeck.

14. Information regarding the artist's childhood and student years, including details about his family history, education, and development as an artist, is based largely on the aforementioned interviews with the author.

15. The term Neue Sachlichkeit, introduced in 1923 by Gustav Hartlaub, was given to a group, which included Otto Dix and George Grosz, whose realistic works were often darkly sardonic.

16. See Jean-Louis Froment and Jean-Marc Poinsot, "An Interview with Georg Baselitz by Jean-Louis Froment and Jean-Marc Poinsot," trans. David Britt, in *Georg Baselitz: Sculpture and Early Woodcuts*, exh. cat. (London: Anthony d'Offay Gallery, 1988), unpaginated.

17. Ernst Wilhelm Nay, "My Color" (statement), in *Nay: Last Paintings*. exh. cat. (New York: M Knoedler & Co., 1968), p. 10.

18. The exhibition traveled to Basel, Milan, Madrid, Berlin, Amsterdam, Brussels, Paris, and London before coming to New York, where it was shown at the Museum of Modern Art from May 28 through Sept. 8, 1959.

19. About the Pollock exhibition, Baselitz has said: "The biggest shock was the huge crates in which Pollock's paintings came. They were so huge that they did not fit into the hall. . . . Nothing like it had ever been seen before, and there were no doubts about Pollock or his paintings. Nevertheless, at the academy, Pollock had very little influence; particularly with the younger students. De Kooning had much greater influence because his painting was European, or of European origin, and its means of depiction were more easily comprehended." Quoted in Henry Geldzahler, "Georg Baselitz," *Interview* (New York) 14, no. 4 (April 1984), p. 84.

20. Wibke von Bonin, "Germany: The American Presence," *Arts Magazine* (New York) 44, no. 5 (March 1970), pp. 52–53.

21. Ibid., p. 53.

22. See Erika Rödiger-Diruf, "Georg Baselitz und Ferdinand Rayski," in *Georg Baselitz: Gemälde, Schöne und häßliche Porträts*, exh. cat. (Karlsruhe: Städtische Galerie im PrinzMaxPalais, 1993), pp. 70–71.

23. Ibid., p. 80.

24. See Richard Calvocoressi, "A Source for the Inverted Imagery in Georg Baselitz's Painting," *The Burlington Magazine* (London) 127, no. 993 (Dec. 1985), p. 894.

25. Published in English as *Artistry of the Mentally Ill: A Contribution to the Psychology and Psychopathology of Configuration*, trans. Eric von Brockdorff (New York: Spring, 1972), Prinzhorn's seminal study emphasizes the formal qualities of the art of the mentally ill as opposed to any diagnostic value. A Heidelberg psychiatrist, Prinzhorn amassed an extensive collection of the art of mentally ill patients; the Prinzhorn Collection is preserved at the Heidelberg Psychiatric Clinic.

26. "G." in Baselitz's titles of this period refers to one of Prinzhorn's subjects.

27. Georg Baselitz, [Pandämonisches Manifest I, 2. Version], trans. David Britt, in *Baselitz Paintings 1960–63*, exh. cat. (London: The Whitechapel Art Gallery, 1983), p. 23.

28. See Camilla Gray, *The Russian Experiment in Art: 1863–1922*, rev. and enl. ed. (New York: Thames and Hudson, 1986), p. 9. Gray calls Vrubel the Russian Cézanne, little recognized in his lifetime but revered by artists of the Russian avant-garde.

29. Ibid., p.34.

30. Rödiger-Diruf, p. 79.

31. Martin G. Buttig, "Begegnung mit Baselitz," in *Baselitz*, exh. cat. (Berlin: Galerie Werner & Katz, 1963), unpaginated. Translation by Anne Jones.

32. Spur, "Manifest," in Städtische Kunsthalle, Düsseldorf, *Upheavals: Manifestos, Manifestations—Conceptions in the Arts at the Beginning of the Sixties, Berlin, Düsseldorf, Munich/Aufbrüche: Manifeste, Manifestationen—Positionen in der bildenden Kunst zu Beginn der 60er Jahre in Berlin, Düsseldorf und München*, exh. cat., ed. Klaus Schrenk (Cologne: Dumont, 1984), p. 8. Translation by Anne Jones.

33. For an in-depth discussion of Spur, see Hans M. Bachmayer, "The ›Spur‹-Group – On Art, Fun, and Politics," in *Upheavals*, pp. 134–38.

34. Georg Baselitz, [Pandämonisches Manifest II], unpublished translation provided by the artist.

35. Conversation with the author.

36. Quoted in Franz Dahlem, "An Imaginary Conversation between Baselitz, Dahlem and Pickshaus," trans. John Ormond and Norbert Messler, in *Georg Baselitz* (Cologne: Benedikt Taschen, 1990), p. 23.

37. Calvocoressi, "Richard Calvocoressi: Georg Baselitz," in *Baselitz Paintings 1960–83*, pp. 12–13.

38. Giorgio Vasari, *Lives of the Artists*, 2 vols., trans. George Bull (London: Penguin Books, 1987), especially vol. 2, p. 184 (on Rosso), p. 196 (on Parmagianino), and p. 272 (on Pontormo).

39. Ibid., vol. 1, p. 95.

40. Calvocoressi, "Richard Calvocoressi: Georg Baselitz," p. 12.

41. Quoted in Georg Baselitz, "Reflections on the School of Fontainebleau," trans. Henri Zerner, in *The French Renaissance in Prints from the Bibliothèque Nationale de France*, exh. cat. (Los Angeles: Grunwald Center for the Graphic Arts, University of California, 1994), p. 13.

42. Siegfried Gohr, "In the Absence of Heroes: The Early Work of Georg Baselitz," trans. Frederic J. Hosenkiel, *Artforum* (New York) 20, no. 10 (summer 1982), p. 67.

43. Quoted in Heinz Peter Schwerfel, "Das Land der häßlichen Bilce," in *Georg Baselitz im Gespräch mit Heinz Peter Schwerfel* (Cologne: Kiepenheuer & Witsch, 1989), p. 16.

44. Gohr, p. 67.

45. Georg Baselitz, "Why the Picture 'The Great Friends' is a Good Picture," trans. David Britt, in *Baselitz Paintings 1960–63*, p. 33.

46. Gohr, p. 67.

47. Baselitz draws a parallel between his *Fracture Paintings* and the European fascination with the ruins of past civilizations.

48. William S. Rubin, *Dada, Surrealism, and Their Heritage* (New York: The Museum of Modern Art, 1968) p. 83.

49. Quoted in Selden Rodman, *Conversations with Artists*, (New York: Devin-Adair, 1957) p. 93.

50. Quoted in *Georg Baselitz* (Benedikt Taschen), p. 88.

51. Ibid., p. 96.

52. See Donald Kuspit, "Georg Baselitz at Fourcade," *Art in America* (New York) 70, no. 2 (Feb. 1982), p. 140; see also Calvocoressi, "A Source for the Inverted Imagery in Georg Baselitz's Painting," pp. 894–99.

53. See Alexander van Grevenstein, *Georg Baselitz: Das Strassenbild*, trans. Patricia Wardle, exh. cat. (Amsterdam: Stedelijk Museum, 1981), unpaginated.

54. Quoted in Jill Lloyd, "Georg Baselitz Comes Full Circle: The Art of Transgression and Restraint," *Art International* (Lugano) 5 (winter 1988), p. 90.

55. Quoted in Comte de Lautréamont, *Les Chants de Maldoror*, trans. in Anna Balakian, *Surrealism: The Road to the Absolute* (Chicago: University of Chicago Press, 1986) p. 191.

56. *Georg Baselitz* (Benedikt Taschen), p. 112.

57. Quoted in Froment and Poinsot, unpaginated.

58. Ibid.

59. Ibid.

60. See Calvocoressi, "Richard Calvocoressi: Georg Baselitz," p. 19.

61. See Froment and Poinsot, unpaginated.

62. Baselitz has noted that the titles of these works, and of the painting *Supper in Dresden*, refer to his most terrifying childhood memory: at the age of seven, he witnessed the saturation bombing of Dresden. See Thomas McEvilley, "The Work of Georg Baselitz" in *Georg Baselitz: The Women of Dresden*, exh. cat. (New York: The Pace Gallery, 1990), p. 10.

63. See Froment and Poinsot, "Georg Baselitz: entretien avec Jean-Louis Froment et Jean-Marc Poinsot," trans. Jacqueline Angot, in *Baselitz: sculpture* (Bordeaux: C.A.P.C. Musée d'Art Contemporain, 1983), p. 19.

64. Quoted in Froment and Poinsot (1988), unpaginated.

65. Heinrich Heil, "Mrs. P. Calls a Spade a Spade," trans. Michael Eldred and David Britt, in *Frau Paganismus*, exh. cat. (London: Anthony d'Offay Gallery, 1994), p. 8.

66. See Froment and Poinsot (1983), p. 17.

67. See Marie-Laure Besnard-Bernadac, Michéle Richet, and Hélène Seckel, *The Picasso Museum, Paris: Paintings, Papier-collés, Picture Reliefs, Sculptures, and Ceramics* (New York: Harry Abrams, 1986), pp. 141–42.

68. See Calvocoressi, "Richard Calvocoressi: Georg Baselitz," p. 18.

69. Quoted in Froment and Poinsot (1988), unpaginated.

70. See Rödiger-Diruf, p. 76.

71. See Nan Rosenthal, "Expanding the Possibilities for Painting: Baselitz, Polke, Kiefer," in *Affinities and Intuitions: The Gerald S. Elliott Collection of Contemporary Art*, exh. cat. (Chicago: Art Institute, 1990), pp. 147–48.

72. Quoted in Georg Baselitz, "Painting: Out of My Head, Head Downward, Out of a Hat," trans. David Britt, in *Georg Baselitz: Gotik—neun monumentale Bilder*, exh. cat. (Cologne: Galerie Michael Werner, 1994), p. 28.

73. Georg Baselitz, "Das Rüstzeug der Maler," trans. Norbert Messler, on liner notes for *Georg Baselitz: Das Rüstzeug der Maler/The Painters' Equipment*, recording (Cologne: Gachnang & Springer, 1987).

WRITINGS BY THE ARTIST

Translated, from the German,
by Joachim Neugroschel

Dear Mr. W.!

I've been ill since your last visit here. Twenty turpentine-soaked cigarettes a day, nitro dilution in my throat, cause headaches and dizziness. The whole bag of tricks in front of and behind the canvas makes me want to puke. I find this material repulsive. Anyone who feels up mastic tears and paint snot has an easier time masturbating. I still have my hand mirror. In any case, I sit on the john with candles on my hat, and G. lies useless on the balcony. I can't say anything about my pictures. I paint, and it's not easy—with that I've done everything. You shouldn't reach too far. Things are dumped on me from dark backgrounds: an astral vault, a blood vessel, a well, a Piranesi urn, the thorn in the ring, the barb—I yearn, black, white, red. The topsy-turvy world upside down. The geniuses won't and can't bear the responsibility anymore.

Everything sub-zero.

That's all.

With that I've depleted myself totally.

I'm left with little. I think it's enough. Why do you ask? I paint female bodies— somewhat below, and the nicest thing is still to squoosh up a face, a head. Maybe something external is involved. Go out in the street and look at the way the people keel over, fall on the sidewalk, suddenly there's nothing left of any flight of fancy, it's so

fantastically simple. *I'm included.* I can only recommend that you masturbate and watch them rubbing their dicks on permanent red, madder lake, and pigeon droppings and reserving their places in the sun. So why do you ask? I'm very friendly, I can't help it.

The cigarettes were good, I'd like to thank you. I've since sewn the little skirt. The lower body remains uncovered. So the sky pounces on you through a pleated funnel. Especially nice for Italians, if only because of the hair. I'd like to ask you to bring me another book—with an inscription. I enjoyed the last one. It was a lovely name. Who wrote it? People have started ringing my bell again and rattling my mailbox. I haven't managed to catch anyone. The sky is lilac.

Best,

G. Baselitz

P.S. B. hasn't brought any money yet.

Berlin, August 8, 1963

First published in German, as "Lieber Herr W.!," *Die Schastrommel* (Bolzano) 6 (March/April 1972), unpaginated. Published in English as "Letter to Herr W.: Berlin/February 1962," trans. David Britt, in *Georg Baselitz: Paintings 1960–83*, exh. cat. (London: Whitechapel Art Gallery, 1983), p. 32.

Why the Painting *The Great Friends* Is a Good Picture!

This picture is an ideal picture, a gift of God, a sine qua non—a revelation. The picture is the *idée fixe* of friendship drawn from pandemoniacal entrenchment and about to sink back in again—according to a biographical decree. It is ambiguous because there's more to the canvas than one might think. The principles of the picture—color, structure, form, etc.—are wild and pure. It's round at all corners. Lime twigs were dispensed with. It's black and white. The ornaments are keys. The painter has peeked into his own pants and painted his economy on the canvas. He's actually managed to get the bunnies to go into the clover and the ducklings to lose their feathers. It's good and it doesn't peel off. It's healthy and cheery because it doesn't contain all the features that contradict this:

Criteria of Form

1. Regressions such as:

 Gingerbread forms, playful tendencies, ideograms

2. Pictorial distortions such as:

Luxuriant rampancy, a confectionery style, shmaltzy grandiloquence, humorous grotesqueness, auricular style

3. Concentrations such as:

Picture salad, millet-pot effect, ornamental padding, written elements, combination of heterogeneous materials

4. Neomorphisms such as:

Deformities, atrophies, grotesqueries, doubled heads, monstrous creations, combinations of humans and animals or humans and landscapes, etc.

5. Stereotypes such as:

Rendering of form details: ornamental, surface-filling reiterations, "hounding to death"

6. Rigidifications such as:

Schematizing, surrounding the picture, absence of shadows, "hard-as-Krupp-steel effect"

7. Decomposition such as:

Disregard of space, loss of composition; linear, flat, fragmentary nonsense, softening of the physiognomy

Criteria of Contents

1. Nonobjective things such as:

Formless scribblings and curlicues, organ forms, geometric-linear depictions, carpet effect

2. Objective things such as:

"Apparatuses," "inventions," maplike things; linearly structured, meticulously executed landscapes, moonlit landscapes, religion, cosmos, magic, allegory, Greek, Oriental, fairy tales, forest or jungle motifs, weapons, battle scenes, filth, obscenities, close-ups (e.g., of a hand), staring eyes, isolated small heads, isolated small eyes, isolated small ears; small hearts, small pricks, small pussies, small birds, small fish, insects, snails, sweethearts, worms, snakes, cobwebs, donkeys or ponies, small horned animals, small predators, bunnies, ducklings, small pigeons, fire, small flames, thunderstorms, sun, moon, and small stars, small mirrors, churches, ruins, crosses, coffins, chimes, pennants, fountains, clocks, musical instruments, ships, planes, etc.

The painting is devoid of all doubts. The painter, in full responsibility, has held a social parade.

Berlin, 1966

First published in German, as "Warum das Bild 'Die großen Freunde' ein gutes Bild ist!," in poster form on the occasion of the exhibition *Baselitz*, Galerie Springer, Berlin, 1966. Published in English as "Why the Picture 'The Great Friends' Is a Good Picture," trans. David Britt, in *Georg Baselitz: Paintings 1960–83*, exh. cat. (London: Whitechapel Art Gallery, 1983), p. 33.

The Upside-Down Object

The sole issue is my possibility of painting a picture. In a nonsupportive culture a destructive activist is capable of analysis.

An object painted upside down is suitable for painting because it is unsuitable as an object. I have no notion about the solidity of the depiction. I don't correct the rightness of the depiction. My relationship to the object is arbitrary. The painting is methodically organized by an aggressive, dissonant reversal of the ornamentation.

Harmony is knocked out of whack, a further limit is reached.

Derneburg, December 12, 1981

First published in English and German, in Stedelijk Museum, Amsterdam, *'60'80—Attitudes/Concepts/Images*, exh. cat. (Amsterdam: Van Gennep, 1982), pp. 88, 234.

What Is a Picture?

I sat on the chair, pulled at my shoe, and my head tumbled to my feet—promptly starting a conversation with me. Sort of like this:

Is this a picture?

He stripped off his shirt and pants. I saw his extremely white but taut skin. The hard muscles made the short, ruddy hair on the back of his neck bristle when he leaned forward.[1]

or this?

The walk along the pond dam is about seven thousand feet long. It is flanked by ancient oaks, also birches, and on the lower edge of the slope a thicket of hazelnuts, honeysuckle, and hogweed. Sunlight is filtered through the canopy of leaves, the end of the dam is bluish but not dark. Meadows spread out to the left of the walk, the branch canal runs through them—draining the large pond through a huge clay pipe under the dam, all the water flows in the nearby river once a year. The meadows are lush, green, and iridescent with flowers. The calm water of the pond lies on the other side of the dam, the bank is wide, edged with reeds, bulrushes, and alder bushes.[2]

or is that a picture?

The scream was still in the air and her eyes were full of tears. Strands of hair stuck chaotically to her forehead. She kept wildly flailing her arms until her hands clawed into her breasts.[3]

I couldn't quite say no to all that.

1. *Orange Eater*
2. *Sand Pond Dam*
3. *Street Picture*

Derneburg, 1982

First published in German and English, in *Documenta 7*, vol. 1, exh. cat. (Kassel: Documenta, 1982), pp. 136, 437.

Sculpture

Sculpture is a thing like a miracle. It is built up, decked out, made arbitrarily not as the sign of thoughts but as a thing within the limits of the shape. Even if a sculpture is hung from the ceiling, it remains a thing, for even blind people can see it.

It is no corpse, it is not the envelope of something, it is more like a dead machine—one can presume the presence of a spirit in it as a partner for a correspondence.

Derneburg, April 18, 1985

First published in German and Italian, as "Die Skulptur ist ein Ding wie ein Wunder," *Lo spazio umano* (Milan) 2 (April–June 1985), pp. 32–36.

Painters' Equipment

A question and its answer. Are the painters still those painters who are painting the great cave? Do they paint the buffalo on the wall as hunger, the eagle as freedom, and the woman with a big bottom as love? Do they paint the buffalo as the table that magically sets itself? Have they meanwhile left the cave, cleared out of the community, and forgotten all those universal, comprehensible agreements, because magic does not still hunger, because flying does not work, and yearning for love does not breed love? Have they traded the cave for some other place? Propagandizing about needs, "What does man need?," feeds upon a yearning for freedom and the fear of death and entices us into taking another way, off the painters' course. The smart ones, hotshots, innovators, activists—in the forefront madmen and hotspurs—have remained within their own skulls. They proclaim plucky mottos: paintings should stick in the throat, eyelids should be nailed down, and hearts grabbed with pliers. Fish bone, air raid, and separation. Well, one still sits together around the fire, warms up the studios, has had enough to eat, and is in love. On battered canvases are those sumptuous ornaments filled with jumbled lines and rich colors; crystalline galleries hang over the frames. All that once stood erect, the still life, has been knocked over, the landscape has been seized and uprooted, the interiors tangled, and the portraits scratched and pierced. Painting became music. Surrealism won. Everything durable has been kicked out of the paintings. Now, the tone goes right through the walls, the line stands upside down. Are the painters now unhappy and freezing? They dance and celebrate with their friends, they invite their fathers and drink Capri with them. A black painting is as white as the sky. The colors in the dark cave are aglow. Light is superfluous. Everything is utterly different, anyway. The paraphernalia of Venus, Zeus, the angels, Picasso were invented by the painters, as were the bull, the roast chicken, and the lovers. The pear-wood palette became a pail, the brush a knife, an ax, and a club. The largest paintings are larger, and the smallest are smaller than ever before. Someone painted a painting weighing five hundred pounds. A Chinese handwalked over the canvas. A Norwegian painted 168 acres of birch wood on one and one-half square inches of canvas. This is not the way I want to continue. Hygiene, I mean religion, is employed. Discipline is one thing, education another, and meditation, too. Intoxication is used to prepare or to stabilize an attitude. Some eat well, others purify themselves through fasting. While I see no point at all in bustling around, in being confused, zap, zap, my friend between New York and Cologne makes the best paintings in his trouser pocket, where his canary sits.

Does one see more of the world by climbing a ladder, does one see still more by lying down flat on the field and by sticking one's nose in the ground? Either way. The difference between a German and an Italian apple tree is enormously large. In Tuscany in the garden I made photos of such trees. Back home in Germany I was terribly excited by these exotic apple trees, these unpaintable fairy-tale-tree-inventions. I realized that I did not want to paint an apple tree at all. I was still under the mother and had stuck out only my nose. The world had not opened up, the secret remained hidden within the object, but now there was confusion. That is an experience, but not of the kind that broadens your mind through shifting horizons. The first la-la sounds and the first dot-dot-comma-dash are indeed vehement creations for the one who makes them. This is not theory. I composed *Fidelio*, I know precisely that as a six-year-old I conducted this very piece; hare and dog I painted when I was eight years old, signing them "AD." One of these watercolors is in Vienna, in the Albertina, the dog is lost. In order to remember, and perhaps also to build up my past, I painted for example, in 1969, the forest, for I am convinced that *The Hunters at Rest in Wermsdorf Forest* was painted by me in my eighth year at school in Saxony. The painting is smaller than the memory. In front of me, on the table, there is a silver thermos-coffeepot with warm coffee. This pot would not mean anything to me were it not that I see myself reflected in it. Thus, I am reminded of my self-portrait with the large hand in the foreground—it hangs in Vienna. There is true surrealism there, but only because I once again know exactly that at that time I had fair short hair and not these dark curls. My long-cherished plan is to paint pictures behind the canvas. I do not want to hide behind the canvas, but want to stand upright before it. The painters' equipment for this act of painting are arms that are too short. Anatomy fails. By 1993, some painters will surely have an arm eighteen inches longer and will make this "behind-the-canvas-picture." That's me. Therefore, I paint today, November 16, 1985, this sort of futurism and sign it with the date 1993. All that which lies behind the painter also lies before him. Ever since I fell on a frozen lake with my head hitting hard on the ice, a singing tone has remained inside my skull. This was a totally unproductive act, which proves the thesis of the unreproductibility of experience. Only recently did this sound vanish from my head; it was erased when I heard the lingering sound after the drum roll in Bruckner's *Second Symphony*. As if by psychic interference, the air rushed out of my ear. Such acts (falling on ice) do not belong to the painters' equipment. Here, nature has different plans. Suppose one paints an apple tree: meanwhile it grows dark, night falls, one stops painting. On the following day, one paints over this apple tree a still life. Is one off target? On the third day, one paints a

portrait over it; one paints like that as long as one wants one thing on top of another. If someone now comes and asks what are you doing, I would immediately answer, a . . . , because that is how I do it. No one forces the painter into a society whose doctrine demands phony paintings, in which the good draws examples of political madness for the picture book of the bad. If I paint the table that magically sets itself, I'll eat it up myself. My wife gently strokes my head. The painting will never be finished, my dear, should the painter fall from the ladder. The white contour ignites a black background. The Spanish painters are good lighting engineers The inventor of the large theater spotlight is Velazquez. I ran away from his lighting rehearsal. Such a focused light makes me feel dizzy. Maybe it was wrong to run away, for now I miss this equipment. I must pull together the mush of paint with a rope. Like snakes, the ends of the rope are lying in the sun, the black adder lies on top, on top of the still life. There, on the painting, drawing is precise where it matters and where it equally matters the line is blurred, it lurches and disappears into darkness. I am not lying—right now, I see Marat in the bathtub, the painting by David. Actually, what I see better is the arm with the pen in the hand, the pendulum arm, the hour has come, the new era. This arm with hand is by Rosso, that painting where in the background Moses rages. It is impossible for Rosso's model to have been still alive at the time of David, but it is the same arm; therefore, Rosso and David are one and the same. This ARM is equipment. Reincarnation is nonsense. Equipment also comprises GREEN and RED DOTS on the garland in the Tomb of Priscilla painted by Renoir. I was standing by and was working on the dance step. Many painters were in that cave. The woman with the tambourine was not yet there. The dead need the best paintings, that is art history, one can add that the paintings are in the darkness. Everything I am saying here is positive, what is bad should be left aside. These are the points to be enumerated: ALL PAINTERS ARE LIVING; PASSION MAY BE THERE; HYGIENE; COLOR, e.g. RED; ALL THINGS IN THE PAINTINGS, e.g. NOTHING IN THEM AT ALL; LINE, it can shoot into the eye from the background, from the bottom of the canvas, or even right through the canvas; ORNAMENT, braided, twisted, wound, even falling, can also be as SNAKE or ROPE; DOT as DOT as SPOT as PILE, like FLAT-CAKE, also flies sometimes across the plane of the canvas; the PLANE itself, impossible to imagine everything, e.g. as HAIR, as BODY, as CHEST of a hero, as GREEN EYE or even as CHRISTMAS TREE, as OCEAN, if possible, not in perspective; NARRATION, here, for instance, the MYTH of the Trojan Horse would be of interest; MUSIC—in Rembrandt's family group in Brunswick a cello is played deep yellow; NUMBERS, MODULE, PROPORTION, not the example with the ladder, but rather Eskimo and iceberg, cyclops behind the rock; of course also everything invented by

painters, such as CHIMNEY, HOUSE, LOCOMOTIVE, PYRAMID, PAVEMENT, WINDOW-CROSS; also THINGS WITHOUT ANGLES, as FIRMAMENT and SEA OF STARS. A better or worse life is not contained here, among the equipment. Illusions belong to the interpreters. The most beautiful of Modigliani's painted nudes has no skin, no flesh, no teeth. One cannot go so far and say that paintings have these things. In this list, as you will have noticed, the motif is missing, it is not included for the following reason: David's painting with the murdered Marat in the bathtub is as obviously just as much a cave painting as is a painted Etruscan tomb. Can paintings actually be seen by others? The great cave is dark, the paintings can hardly be seen. The tombs of the Etruscan or Egyptian are pitch dark, one does not see the paintings at all. Thus, the painter painted paintings that no one can see. Again, Renoir has not bungled in the Tomb of Priscilla, as we now see on close examination, although he could never have assumed that we ever were going to see it. Why did he do it then? The viewer was invented by the public, not by the painters. Only the changed civilization, another cultural imperative, brought this painting to light. All the dead had once been alive. Thus, this painting is an epitaph. The buffalo with the arrowheads is here the dead Marat, and the little ink sponge is, without question, the roll in the still lifes, or else the table that magically sets itself. If we look at the costumes of the people, the rich garments and draped fabrics, the interior of the room, the bathtub, we can say that David had one foot in ancient Rome. This is shifted civilization, not developed toward something better, just shifted. The motif in David's mind is the cave with the cavemen and their still-intact, unabashed agreement that the buffalo and the roll feed both the living and the dead. No painter goes hunting for motifs, that would be paradoxical, because the motif is in the mind of the painter, the mechanism that thinks. Everywhere in every painting the buffalos and rolls are an expression of the motif. Our instincts tell us what to do with them. Our yearning needs pictures. There is a knock on the door. "Come in!" Enter a painter, as I can readily recognize from the stain of paint on his trousers and from his dirty fingernails. "May I sit down?" "Sure." "Want to talk about . . . ?" "Why not." He notices the thermos-coffeepot on the table between us. "Could you give me a cup of coffee?" If he fails to recognize the Parmigianino but thinks only about the coffee in the pot, he is certainly a realist and completely depraved. It might at least occur to him that perhaps the pot is empty. As a matter of fact, it is in the meantime empty. Thus, all I can do is to answer, "I'm afraid not, because this is my self-portrait out of which you want to drink coffee." After all, I do not want to confuse him too much by first complicatedly explaining to him that there is no more coffee in the pot. He answers, quite unexpectedly, "You can't

fool me like that. I see what I know." To which I respond, "You probably want to find the motif in my studio." He is a practical person, he loves beauty, he would like to warm himself up with coffee, then he wants to present his program and fraternize with me. Anyway, he answers totally perplexed, "Oh, there's no nude model here." Now I know he is lying, because for nude drawings he needs a sketch pad, which he has not brought with him. What now? I decide to tell him nothing about the equipment and tersely answer, "No sibyl has stepped between us."

Derneburg, December 12, 1985

Lecture delivered at Rijksakademie van beeldende Kunsten, Amsterdam, October 1, 1987; Royal Academy of Arts, London, December 1, 1987 (organized by Anthony d'Offay Gallery, London); and École Nationale Supérieure des Beaux-Arts, Paris, February 28, 1991. First published in German, as "Das Rüstzeug der Maler," on the accompanying poster. Published in English as liner notes, trans. Norbert Messler, in *Georg Baselitz: Das Rüstzeug der Maler/The Painters' Equipment*, a recording of the lecture at Royal Academy of Arts (Cologne: Gachnang & Springer, 1987). English translation reprinted in *Georg Baselitz* (Cologne: Benedikt Taschen, 1990), pp. 180–81. Original handwritten manuscript published in *Georg Baselitz: Neue Arbeiten*, exh. cat. (Cologne: Galerie Michael Werner, 1987), pp. 1–20.

Woodcut

Alfred Rethel's *Dance of Death* were the first woodcuts I ever saw. The romantic idea and the set of building blocks, cold and confused in double lines and template, plus the children's room.

After that, *The Life of the Virgin Mary*, woodcut as technique, and later, *The Woman on the Abyss*. I had to shake up that order. I introduced the soul.

I used the sentimental pose of the eyes turned inward even though I know, of course, that the splinter lifted with the chisel is first the white drop, then the tear, grief, the sinking form. Sign for woman. Nevertheless soul is necessary against technique. And so along with lots of other things I also made *Richard Wagner as a Woman*.

Derneburg, June 22, 1986

First published in German, as "Holzschnitt," in *Georg Baselitz: Holzschnitte 1984–1986*, exh. cat. (Vienna: Galerie Chobot Wien; Berlin: Galerie Springer, 1986), unpaginated.

Dear Sir!

Many thanks for sending me your schoolwork. I can't correct it. Maybe what I write can help you.

First of all, please read the following in Bavarian.

Imagine the earth so tiny that we can't stand on it and we fall off, the sphere is too small for our feet, we whirl away.

Or imagine the earth as being as big as it really is, so that we can't even be like a sprouting seed on this gigantic surface.

It's easier imagining the former, it's more abstract; imagining it as it really is is no contradiction, but it's a lot harder because of the fact that it's dependent on our spatial behavior, and you can compare it with bees—abstraction has a hard time here.

If you lie flat on the ground, pressing your nose into the grass, and then look across the surface, you probably won't see a surface, you will see a wild scribbling.

Or simply look up at the sky, or peer between your feet when you're standing, etc. So far, Bavarian.

The painter paints pictures according to his knowledge and anyway in front of, not behind, the state of time, of history. These paintings are ruminations on painting.

As you said, he has the prerequisites—that is, the social situation—like anyone else. He wants to have his peace and quiet, he has them, he is not left in peace. He wants to destroy, he wants to construct, he wants to terrify, he wants to be quite peaceable, he's just like anyone else.

Now if you put down a piece of paper, on the table in front of or under you, and draw a tree on it and then claim that this tree is standing just as erect on the paper as in your garden, then you are simply taking over, untested, something that others claim.

In fact, it is not true but merely a convention, like your perspective; even if the deed is a thing or the thing a deed, it does not manifest any fact despite that strong word, it merely manifests an arbitrary act, something thought-up.

Just think as follows: anything can be on a canvas, in a picture, the boundary is drawn through the painter's head; if the boundary is too little then the mind is too small. If the painter has a broad mind, then the pictures are already better, the boundary is shifted. But usually everything comes along so ploddingly.

Best wishes,

Georg Baselitz

Derneburg, 1988

First published in French, trans. Miguel Coutton, in *Georg Baselitz: Dessins 1962–1992*, exh. cat. (Paris: Musée National d'Art Moderne, Centre Georges Pompidou, 1993), pp. 62–63.

Drawing

If you put a piece of paper on the table in front of you and draw a tree on it and then claim that this tree is standing just as erect on the paper as in your garden, then you are simply taking over, untested, something that others claim.

Derneburg, 1988

First published in French, trans. Miguel Coutton, in *Georg Baselitz: Dessins 1962–1992*, exh. cat. (Paris: Musée National d'Art Moderne, Centre Georges Pompidou, 1993), p. 5.

Reading Coffee Grounds

If as a painter, or even a female painter, from Berlin, you launch into a search for pictures, you can start finding some right in your own room, between the stove, window, door, and table; but you can also go farther—for instance, take a wide detour around Berlin, by way of Vitebsk, to China and Japan, now past Clyfford Still on the West Coast of America, to New York, and from there via Paris back to Berlin. That's what Mira did with her finger in the coffee puddle on her wooden table in her studio.

Derneburg, October 4, 1988

Previously unpublished.

Ciao America

Ciao America is a three-color woodcut made from three blocks. The wooden boards are well-planed block boards. The piece was done for the fortieth anniversary of the Galerie

Springer. It starts with the year 1948, when the gallery opened in Berlin: on the first cut the birds are bottom right.

Consistent with the increasing years, more birds join in until finally, in 1988, there are a solid forty birds on the block. Since there were too many numbers, I removed them in the final state of the plate. There are forty birds or more, but because they're upside down and consist purely of lines, spots, and splinters of light colors flashing through the black surface, you can barely tell that they are birds or how many there are.

To make three colorless birds emphatically stand out against the white paper, I cut the appropriate holes into the ground-shade board. Thus, the three birds are singled out, they are something like the handle of a pepper mill or the dinghy tied aft to a trawler and bobbing up and down on the waves.

Nothing should happen in the middle of the plate. If something does happen and is there, like the three birds for instance, then they are to be pulled along the edge, lurching, against the grain, whereby I certainly intend to make a proper board. However, it shouldn't be without the strength of the hand or the warmth of the mind. The short, straight path along the ruler is hindered by interspersed circumstances. The terrain is bumpy.

From the very beginning, no short, direct path was intended, but it was planned as it is actually seen in the first print. Like the fly on the edge of a plate, the first bird was to be cut into the wood anywhere, but not where it had to be, so that the remaining thirty-nine could gather next to it as if aimlessly.

The result was something like a sea shanty with a tipsy singer. That explains the title. It is hard not to repeat yourself and to avoid uniformity in the crazy rocking of a rowboat. I believe that all the plans you work with are good. I mean even such stupid, wrong, chimerical plans that are total crap are good if you work with them. The dull, dismal, smoky plan is the driving idea in a zany mind. The upper body holds up quite well at the table, sitting there and talking, and it *is* someone; the legs under the table have already slid away and through the door.

In the studio I did fourteen prints until the outcome was as it should be.

Derneburg, February 22, 1989

First published in German, in *Hommage à Rudolf Springer*, exh. cat. (Cologne: Galerie Michael Werner, 1989), unpaginated.

Soliloquy

These are thoughts that jump to and fro in the mind and out, thoughts about certain paintings by Hill, Strindberg, Munch, Nolde, Kirchner, Picasso, Larionov, Picabia, Malevich regarding the theme I've been asked about: Expressionism. The reproduced pictures are not the ones occurring in the text, and it wouldn't be so bad if they did occur; after all, they're not just any random pictures.

My thoughts circle around the state of things before a picture is painted: the white canvas, so to speak, and the receptional conditions afterwards.

Painting pictures is an absurd, incomprehensible, and arbitrary enterprise, which grows boring if you take off all the edges only, and multiply them in the Zeitgeist.

Holding the line is retrogressive, the enigmas remain, but the picture behind the canvas is no longer a utopia.

The word "motitif" doesn't sound good, as a concept it's only meant to strengthen, to intensify the concept of "motif." You can't replace it with "metaphor" although a comparable imagehood pictoriality is meant, like a crack in a bowl or rust on the head.

So the things that are still ears and noses on the pictures and perhaps shadowy eyelids and tears are already chimneys there and burst window panes in red houses, and asphalt doesn't come out straight, but as a waterfall and a vein, also ruffled firs and warped pines, glacier mountains and snow fields with dirty spots from the footprints of sedulous people, telegraph poles, sheds and wooden fences, rocks washed around by water. The landscape can be brick-red. Many pictures from north to south, up to the edge of the Alps, but not beyond. In the cities people cluster at the center, thinning out on the edges, northward and southward, in the provinces. Things get quite unruly in the east, where there are Russian blouses. Liquor bottles and boots occur, the ground sways in a wide format. In the west, the car drives and coffee cups steam. Periodicals, even unread, are cut up on the paintings. Chairs dance like tops. *Nature morte* with skull, that is how culture is. The pictures can't be stretched any further, they revolve in a circle, like a map seen from above, the places, the lakes, mountains, cities, hamlets connected by lines, marked by dots, then they hiss like stones in all directions in the kettle when it seethes.

Even though you call, time doesn't advance, the pictures halt quite motionless in the past, they hang on the wall and cover nothing.

You sense and notice that the canvas trembles like a membrane struck by an apple; like a drumskin on which fingers patter; like the net into which a bird flits; and it's a lie

to say that the soul doesn't paint, the mind paints with accessories, not with the ears, and that the point is never the truth, like a foot in the shoe.

Anachronism is quite possible; after all, many people were Gothics. The only question is when and where this anachronism crops up. The thread already breaks on the route from Berlin to Paris and frays apart at the ends, whereas the Paris–Berlin route is not broken. In Moscow the teacups then have the appearance of locomotives. On this journey to Byzantium cubism quickly became an ornament.

Sometimes it's lemon blue, then it's black like a cornfield or green like hair, they say. Or such stories as: the rustling of the forest beats the bass drum; or the rattling of the wheels plays the violin; or the wretched clarinet drinks coffee; or so sugar-sweet the flamingo eats a bunny; as nasty as the marmalade dawn.

A painting is no sock, but the hole in the sock is almost a painting. This is now explained. A painter in Vitebsk sets out in straw shoes and arrives in Paris in patent-leather shoes, another starts out in Oslo, chewing mandrakes, and arrives in Berlin, smoking cigarettes.

Cadmium yellow on cobalt blue, on English red, on Paris green results in crap. An apple on a portrait, on a tree, on a pitcher, on a nude, on a seagull, on a square makes for a picture. More summer resorts have been painted than airplanes, more women than men, more flowers than birds—ah, if you could only paint sex, you wouldn't have to paint a cow green, for it's better for the imagination to look at a whitewashed wall than through a window pane at a meadow. Comparisons of pictures with something else is worthless. If you normally see what is, then you see nothing in nonpainted pictures. Once they're finally painted, you never see what you've already seen. What you see you see only when it's been painted. This will be less striking in a chestnut blossom than in Napoleon's retreat. A cartographer takes only tiny steps of abstraction with a landscape. A painting like *Waterfall by Bomako* is a mind-bending subtlety because it's not a hiking trail for tourists but a carpet ride through dark night. Emil was quite unmotivated drawing a Sepik mask but not with the red cloud. A metaphor would have lighter wings. Who's stupid enough to think that a painter is motivated to paint a naked woman only if the nakedness is motivated? Wearing clothes is motivated by a number of things, that's why the hole in the sock is already a small picture. The motif is the clad food. If the foot belongs to a painter, then the hole in the clothing is the motitif.

Not so fast. A dog gnawing a bone is the motif, the motitif would be the dog in a picture by Abraham Hondius or in Schmeil's biology book, if there were such a dog there. If there is no painted dog, then it's not even a motif; that was why Emil was

unmotivated when drawing the Sepik mask. Dutch bosoms, Nuremberg crones, and a green cow have become pictures, but not a Sepik-mask. No matter how great the geographic distance, the power of the motif does not fade, only error sneaks in, if one thinks like Emil, who thought he'd found a motif without doing what he has to do when painting. If you do it right, then just with a tender touch many things, such as a Dutch bosom, a red cloud, a bottle drier, a shattered guitar, a bronze bottle, a tree on its head become a motitif. If no light shines, then nothing comes of it. Not like that, but like this, so that the painter and the viewer, in front of the painting as voyeurs, reach an agreement over an okay. The argument erupts, they turn into two people, if the hook lies without the fish on dry ground. In the first state, as audience, they are stupid; in the second state, the second one has nothing to say; but the other one inexplicably makes a motitif with his stubbornly crazy zeal. These paintings can move. More directly and more without being asked they show what can occur to just about anybody only if he's not asked what he's actually doing. The burghers no longer had to be bumped off, they had disqualified themselves anyhow through the wrong decision to stop looking at paintings amorously, as at a capricious woman. Thus they had died for the painters. The painters now had to seek their admirers elsewhere. It's too bad that they still haven't found them as yet, there's a lack of educated conversation and the game of arguments. And so you find him, the painter, quite uninhibited as a cutter, smasher, tinker, shredder, and whatever. I'm not interested in groups, not even in Expressionists. What's so great about the enforcement of a style? Someone who's discovered a motitif and is in the process of expanding the hole in the sock is usually surrounded by disorderly idiots singing in the captain's shadow. There are such things as group suction and associations with moronic programs. In the sock metaphor destructive behavior leads to success. The hole got into the sock because of used-up wool, wear and tear, and toe pressure. That's how it began. That's how a lucky painter found his motitif. It would be silly for a whole group to bore holes. The more artistic darning there is, the fewer different textures in the weave; the cruder the darning, the clearer the distinction between the original sock and the patching; this leads to arts and crafts. You also have to consider the thickness of the thread, its color, the darner's skill as factors of the style. An original is an original through its reproducibility, not only, but, but.

To forget about the sock with the hole, here is a different, but analogous example. On a rectangular surface, perhaps twenty inches high and twenty-seven inches wide, a landscape is painted—say, by Ernst Ludwig. This landscape is the motif, or rather it's there as a motif, not as the where, but as the why. Now just what is the motitif?

If a child paints a landscape with a yellow sun in the middle, then that yellow dot in all the surrounding blue is at least so big that the yellow doesn't turn green; so the sun is made fairly large, thereby instantly becoming a motitif, even though the totality has many defects. Put casually, the defects are explained by the child's small circumstances. In the history of painting there are many landscapes with suns—each motivated by a painter. The interdependency of motif and motitif is readable on such pictures. It is made up of various parts located in the landscape. All these things are trees, houses, the horizon, the sea, people, the size of the sun and of the other things from the overall proportion of the picture to the proportion of what is seen and the colors and the chiaroscuro. Kirchner also instantly paints a sun green, if it's a piece of the motif and not the motitif. The surveyor with his theodolites would be in despair over the disproportions. Then that courageous young man tackled it and painted the naked young urban nymphs in the glacier brook. As an exhibitionistic excess it's certainly ridiculous, but it's fun as a painting. After the whistle is blown no one bets on the outcome.

A further example. Her peaky, gaunt nose is more bluish green than reddish yellow, her flaxen hair is not knotted, not braided, barely like this, and why should it be? Her hair is parted as if by a carving knife under the tight traditional coif. Since this is the south of France, flaxen hair is pitch black, more blackish blue than brownish black. In six variations it's as dead as an appliqué and obstinate. No trace of peaches and cream under the skin, nothing points to gossipy neighbors, friends, or indeed to any kind of life or being a woman. Six experiments, each an end, all with big heads, flat, like paper. Not even the dress is changed, only the color. Here it is again, the motitif.

Isn't that, why yes, that's—Madame Ginoux. Like Germany, France also has high, rugged mountains in the south, a narrow passage for wanderers from the north. Carl says that beautiful Germanic women sold their long, blonde braids to Roman women. Now that's a story that provides food for thought. How could the opposite be true? Aren't you naked here without braids or clothes?

Is the fissure in the mountains, like the rip in the curtain, the path of excessive imagination, which pulls the leash and dreams itself into the distance? This would be possible instead of a trip to the South Seas or Tunis, for, after all, flaxen hair turned bluish black and the dappled cow turned green. A further example. Aren't the apple trees along the high road beautiful, still beautiful even if no painter comes by and draws them? Sooner or later one comes by and sees the beautiful trees, he instantly sees the

beautiful drawings done by Feuerbach. Now he can be resourceful and make progress, past the apple trees, if he saws them down; but since painters don't do that sort of thing, he picks up a pencil instead of a saw and with a little luck and slightly squinting eyes that peer into the future, he declares the high road and the apple trees a motitiv in situ, on his drawing pad. You don't need three guesses to figure out what they then look like. This sets aright the whole business of the nature experience. It goes around in a circle, always the same route, always the same things. It would be better to grab the first crosswind in order to fly out of the rotation, otherwise meditation will paint more than the painter does. If there's a beep in your left ear, company is coming; if your fingers itch, then money's in the offing—that's what I've learned. If the swallows soar high, there's going to be fine weather, and when the owl hoots, a neighbor's going to die. That's quite ominous.

Back then, even then, when Karl May was sitting in a snow flurry in Radebeul, writing stories about American Indians, there was a lot of movement among people, and things likewise fled into new arrangements. The Sepik mask found the calla lily, the green cow a blue meadow, the railroad ticket a gear on the eye. Gypsy girls with angular hips leaned against trees made of distemper between broom bushes. Some felt driven to climb high up into the mountains, others toward sailboats and seagulls, and still others pressed their listening ears to the telegraph poles.

Derneburg, July 7, 1989

First published in German, as "Galerie Baselitz: 17 Bilder nebst einem Selbstgespräch," *Du* (Zurich) 7 (July 1989), pp. 42–53.

Ciao America

Behind the lovely photograph of an East Turkish woman carrying water, the ninety-minute folk-dance tape—repeat. The pretty woman is shown as people are shown in photos: she in the middle, behind her and next to her unimportant things, trivia. Once the machine is switched on and plays the first few bars, there is a surging in your body, you straighten, lift your head, grow lighter, almost floating, and now you could begin. But why is it so hard for me, why is it so hard for me? What? How good is your adhesion to the ground? Standing, falling, flying.

What comes with difficulty: to get behind the enigma of pictures by means of understanding, reflection, analysis—central focus or over the edge. A slogan, Ciao, either way, you say it when you come, you say it when you go. Something comes from America. What? According to Dr. Sward, he was wrapped up in financial whims, anti-Semitism, folk dancing, and a diet cult. I think that the influence of Oriental religions—or people believed in these religions. Ford's pictures are mysteriously exotic and beautiful. Beyond the hundredth meridian, it disperses, on this side, it rises up as smoke, dancing smoke. The smoke forms into pictures above the roof. I thought to myself, here as there someone sits in a room and, doing it, presses the key, transmits: yellow, red, red, blue, black, dash, dot, dash.

Derneburg, January 30, 1990

First published in German and English, as "Ciao America/Ciao America," trans. David Britt, in *Recent Paintings by Georg Baselitz*, exh. cat. (London: Anthony d'Offay Gallery, 1990), pp. 5, 35.

The Traveling Painter

From the place where the painter stands he sees someone between the blue sky and the brown earth, someone in a sand-colored cowl, his naked feet in sandals, first very far away, then coming closer, getting bigger and bigger, almost monumental in this treeless region. This place is not quiet, a sawing sound turns into stamping feet. Through the ear into the head, and growing heavier through the body, the sound drops into the feet and the soles. The body rises hopping from the ground. Lacking adhesion to the ground the tension increases. He sees camels flying over the sand and the dance of the beauties in long skirts.

What about the line?

The line continues, say, beyond the outspread arms, the stretching fingers, all the way to the horizon and beyond the silhouette of the mountains to the stroke of the sea, the rays of the sun. The line, knotted up in the body, erupts from the eye, through the window, the door, turns the corner, falls across the street, out to the suburb, to the sand dunes, there it encounters the running camel. It bores as a tree into the earth, shoots up erect, away through the clouds. It loafs idle as a checkered shadow behind the lattice fence. It catches the feet and makes the dancers tumble. The horseman lassos the

leaping calf. The cruiser's cannons far away outside the harbor are aimed at the minaret. Someone stands on the field between below and above as in Turner's Napoleon vision *War, the Exile and the Rock Limpet*, red trousers rise from the boots, up above, the head flickers in front of silvery remoteness. The muezzin neither hears the shot nor sees the ball. Underneath him the minaret collapses into ruins. On the mountain of rubble the dog raises its head, stretches its neck, and howls (also Turner), before a palm tree subsequently strikes roots in the pile of stones and bows in the wind.

Such a tangle of lines, seen and thought, start, finishing line, and everything occurring between them, or the verticals, horizontals, tangents, and all the waves, curves, and arches that he wanders through.

Plus snug, shady places with hot mint tea in metal cups. Once again bony feet in sandals stick out from under the cowls.

Order does not prevail, it exists. It is here as the character of reason. Not even brutal inroads ultimately change anything. What remains are recurring courses—on the one hand, graph-paper geometry; and on the other hand, the chaos between dots and dashes.

He travels in order to find images that he knows. In nontraveled areas he is safe from surprises because he doesn't know the images he doesn't see. A really good recipe for painting is the game with scrap paper and pencil—shooting off ships. Ships lying in bays, hidden behind rocks, or floating on the open sea are hit by a swiftly drawn line, a quick stroke, by those enemy ships that are also hidden or open on the paper. The childlike imagination embellishes the game, the one with the sure stroke wins the battle, not chance, which misses the mark.

Derneburg, April 23, 1990

First published in German, as "Der Maler auf Reisen," in *Malerei: Günter Evertz, Klaus Mertens, Paul Revellio, Wesson Rockwell, Annette Sandforth, Mira Wunderer*, exh. cat. (Berlin: Künstlerwerkstatt im Bahnof Westend, 1990), p. 5.

Drawing

When children draw, they sit hunched over the table, treating the paper by turning it, constantly around, bending and rocking, especially their heads, almost gymnastically. Grown-ups, perhaps just because they have no choice physically, have decided to fix the paper with nails and to peer very earnestly as if disturbing a hare while it eats. No one

understands what they are doing, perhaps they themselves least of all.

Derneburg, March 3, 1992

First published in English, trans. Joachim Neugroschel, in *Georg Baselitz: Pastels, Watercolors, Drawings*, exh. cat. (New York: Matthew Marks Gallery, 1992), unpaginated.

Twice Green

Green as a color: chrome green, chromic oxide green, opaque green, true green, green lake, phthalocyanine green, cadmium green, cobalt green, permanent green, sap green, Verona green, cinnabar green, green earth, Schweinfurth green.

Chromic oxide green and cadmium green are opaque and extremely lightfast. Schweinfurth green is poisonous.

Green as an experience: things get unpleasant when colors are talked about—for instance, red and black, when colors are politically charged—for instance, red and black.

In wrestling, when the good guy enters the ring, he wears white, and the bad guy wears black. This barely moves us. We can let it pass. Green, and I've read this, is Mohammed's color, the color of Islam. That doesn't move me either. I lack a connection. I lack the experience, good or bad. This is the space without images, imagelessness. If the meadow, the fir tree, the mountains, and Islam are green, then nearly everything is green. Normal Sundays are green. Epiphany and Trinity Sunday on workdays too. The Madonna's mantle isn't always green. If something is everywhere, it can't be experienced.

And so consequently a few pictures are green.

Derneburg, September 29, 1992

First published in German, as "Zweimal Grün," in *Georg Baselitz: Radierungen und Holzschnitte 1991/92*, exh. cat. (Munich: Maximilian Verlag/Sabine Knust, 1992), unpaginated.

Somersaults Are Also Movement, and They're Fun Too

Ladies and Gentlemen, good day. In dealing with the topic, "Talking about Germany," I

would like to approach it as a painter. I want to look at the surface, I want to look inside it, into the picture, so to speak, and also behind it, and for the whole thing I need a frame. I do not want to shilly-shally by checking off some things, but rather to follow my inspirations. The surface should not be just superficial, it should, above all, describe something technical-artisanal that hasn't been thought up. It should make the way events function visible and also touch the era. It should show how, when, and with what material I work.

As a frame, I see the talks already given here, especially the talks by artists, and also other things, that I've read and that I think will make a useful guide.

Gottfried Benn, who had just died when I arrived in West Berlin, wrote a series of articles, talks, and essays about the relationship between artists and their time. "Art and the State," "The Problems of the Poetic," "Art and the Third Reich." In "Doric World," he says: "It [art] has its own laws and expresses nothing but itself." Or in his lecture, "Should Poetry Improve Life?": "The bearer of art is statistically asocial, has little notion of anything before him or after him, he lives only for his inner material, for that he gathers and absorbs impressions, draws them inside, so deep inside until it touches his material, makes it restless, drives it to discharge." Or elsewhere: "If a writer's language isn't up to his image of the world, then Germans call him a seer." Those ideas interest me more today than earlier because another turn of events has occurred. Poets, painters, and musicians ought to be aware of their inefficacy. If those sentences had affected them, enough for them to know that they affect nothing, then we wouldn't have to talk about it. But that's not what's happened. I by no means want to polemicize, but when I read the artists' talks, I felt a bit queasy. And so I'm foisting Benn on you, I trust him as my experience, and in agreeing with him, I don't necessarily have to agree with a lot of things that have been said so far. I quite simply make him my authority. So much for the frame.

Now I've set about writing down what I have to say. I haven't written consistently, in one go, but with interruptions, sometimes in Derneburg, sometimes in other places. My talk may be a bit chaotic, but I hope it perhaps produces some good imagery between experience and reflection, something that may be of interest to you too.

In the foreword to the book edition, the speakers are described as German and international thinkers. Thinkers give back some of what they have received and processed. In regard to words, I've always felt more like a receiver than a transmitter. I *have* transmitted images up to now, on the other hand, but nevertheless it makes me uncomfortable as a speaker and, what is more, as a thinker—perhaps only because my

232

history begins later, and I don't have the vast German overview that until now has so tragically dictated the theme.

Now, as I write, I'm in Lower Saxony. I am sitting in my studio. It is Sunday in late September, already rather cold, about twelve degrees, hazy, gloomy weather, bad light. I'm surrounded by my latest paintings, which are so crassly black and white that they remain visible even in this mediocre lighting. Lines are scratched and scraped on the black ground or thick white paint is squeezed out and drawn on them. You can recognize faces, legs, half figures, hares, feet, and so forth. These recognizable things are silhouetted so sharply that the edge of the picture arbitrarily cuts off the very thing that would be necessary for the definition of the totality. Only fragments of these things have emerged through my laying out the canvas on the studio floor or hanging it up on the studio wall. I laid it out in order to track down whatever was under the floor or in the ground or behind the wall. It is not what I see that's beamed out and captured on the canvas; I'm no reflector and I don't return a call like an echo. Fishermen use a bottomless pail to find their catch under the surface of the water. I do more or less the same when I lay out the canvas. That way I can find something that was, until then, hidden in dark spaces. When I find it, all I have to do is draw it on the canvas. For that I don't need any media abilities. If you're in a deep quandary, as in Beckett's barrel, the metal shoe-polish containers that we used for telephoning when we were kids work again. We most certainly heard what we wanted to in those containers. Perhaps it becomes clearer if I compare the laying out of the canvas (which doesn't mean looking past the canvas) with writing music, music that you don't hear.

The interesting thing is that some of the paintings standing around here I made in Italy—and through that very process of laying out the canvas, waiting, tracking down, and fixating things with dots and lines. Now the results were very different from the works done here in Germany. For instance, if I found a girl there in Italy, her face was smaller, her head pressed more strongly on her neck, her forehead was less bulgy than here, her hair is more graceful, but the mental expression is altogether sadder. The hares found in Italy have no heads, but they do have powerful hind legs. The clay vessels are oblong and usually stand on three legs. I also drew things more lightly and casually there than here. The paintings I've done here are more impetuous, the faces I've found are manlier. The necks are thicker, the hair is more tousled, and I've also found hands here that were completely missing in Italy. Likewise, several faces overlap. Scratching or scraping haven't worked here. Here there are thick white lines on a black ground, while red, blue, and green dots are missing; at the same time, there's a lot of yellow here. The

urns are bulging and smaller, perhaps more primitive.

What does that mean? Certainly not that years ago I was afraid of apple trees, which I looked for and also found, but did not recognize, in Italy, or that the houses there resemble faces more than the houses here. Here you find such houses only on old picture postcards. No, I believe that my work consists solely of letting me out of myself so that I can work. So I vanish, stand next to it, and leave the field to the person who has been trained by me to work it. This proceeds smoothly and successfully as long as I focus on filling in and stopping up all untight places, such as rips and holes in my head, making sure that nothing I think gets lost. However, it's more important to keep my head free of those influences, insinuations, ideologies, doctrines, all the crap that people believe is the connection to the world. I'm downright afflicted with a very strong disbelief, I'm not willing to join the chorus. I think that the artist's asocial behavior is the only guarantee that at least paintings will be saved from destruction. The painter shows his paintings like the legendary manna, as the best he has to offer, as a feast for the eyes. Especially where the ground is hard and the hard granite seals the churned-up earth, the old, abandoned debris hides under polished rock, where the facades shine, where we stroll through covered passages, between plants in concrete tubs.

The opposites have concealed themselves. The rotting things have been swept away, are no longer here. Everything now moves only across the surface, horizontally—including reflexes. The amorphous shadows are missing. Chance is virtually excluded. Everything is regular. Orderly. Some people are still afraid of shocks, the majority is completely uninvolved. The wealthy Signor Mobbi in *Miracle in Milan* had a weather slave whom he hung out the window. We have TV. I grub and dig out. It's very much like archeology. You hope you will find proof of life from our past. You find only what you know about. There is a lot of agreement in this archeology. The new formulations are measured by their respective pasts and used by us or by me. Here I can separate myself from the present; that way, I can now feel at home.

I was also born in Germany. From 1938 until the end of the war the village was named Grossbaselitz, then Deutschbaselitz or Němske Pazlicy, and it was located just inside Germany, in the east. The neighboring village was named Wendischbaselitz; it was inhabited by Wends, or rather Sorbs, three miles through the forest toward the east. We had fistfights with the Wendish kids. Not out of exuberance—it was no joke, we never played together. For the grown-ups the Wends were backward because, for instance, the women wore floor-length dresses, unlike the German women. We kids wore short pants and had long hair, the Wendish kids had long pants and bald heads. That made for the

gap between the adults and was reason enough for our brawls. My father was a teacher, we lived in the schoolhouse. There was a teaching-aid room. It contained glass cabinets with stuffed animals, the largest animal being a roebuck, the largest bird a common heron; and there were also boxes of minerals and clay vessels, three thousand years old. The entire building had piles of duckboards holding silkworms. The schoolhouse was surrounded by mulberry bushes, their leaves were fed to the silkworms. The cocoons spun by the worms were packed in sacks and shipped off—a branch of the war industry, parachutes. We collected herbs, chamomile, plantain, myrtle sedge, likewise for the war industry. In front of the school, below the soil, an antiaircraft battery, several antiaircraft guns up to 8.8. In the basement the radio station, lots of soldiers, they played with me. On the highway, day and night over the last years of the war, there was an endless east-to-west trek of thousands of refugees from the Polish territories. Our schoolhouse was packed. We didn't like these people. We heard they were Catholic. In 1945, it came to a horrible end. The schoolhouse was destroyed as we sat in the basement. We then took up the rear of that trek, fleeing west.

Later on, under the new regime, the village castle was destroyed as a monument to feudalism; afterward, the castle's clock was placed on the rebuilt roof of the schoolhouse. Later on, the castle's library, which was being stored in the school, was burned. I am describing these things because I haven't forgotten them and because I believe that these experiences, by arousing my personal fear and causing my predicament, increased my skepticism, my distrust toward events that I couldn't influence. I refused to believe anyone who had good intentions. I mistrusted anyone who devised models for other people to live by. You all must understand how far that can go. I hate ideologies.

I began to dig in the soil with increasing interest. I was less curious about looking at the sky. The earth, the night were more my places of discovery. I was obsessed with the notion of a hole in the earth or a tunnel that would end on the other side, perhaps in southern Africa, if you dug it. This was no yearning to leave my homeland, it was more to penetrate it, its warmth, its darkness, with the adventures I could expect on the other side of the world.

I actually did find clay shards and whole vessels, which our history teacher said were three thousand years old and Slavic. These urns had been buried by the ancestors of those people whom we got along with so badly—that is, we were the foreigners where we were. I can describe those people more effectively because I saw them from a distance: standing, walking, lying, sleeping, and so forth. I know the foreigners better. They, in turn, know me better. Somewhere in between there has to be someone who

knows about us both. That may be the person who stands next to himself—the painter, for instance. Mirrors are inadequate for these measures, but laying out canvases functions quite well.

I certainly can't lay out the canvas on a concept—for instance, the concept of realism, which has more prefixes than substance, just as, for instance, surrealism is the reality of pictures and Socialist or Fascist Realism the surreality of society.

There is loneliness, there is the desire to socialize, you look for company, you look for validation, you try to get there, you need a goal, you join the line. If you're alone, join the line. There are lots of denominational models, there are also quite simply bourgeois ones, from today until tomorrow. These forms of living together are everywhere, they keep order and sometimes cause chaos. I don't believe there are communities that are intrinsically so evil that they are responsible for other people's misery. But there are really nasty creeps who gobble up decent people.

What kind of role do you play, Painter? That's how it's said: playing or taking roles between the spiritual father and the prodigal son. Always a bad thing. The previous speaker listed Kandinsky, Lehmbruck, and Klee; I would also name Schwitters, and I think that was a good start, with Dada, with Merz. It was only later that this utopia became important for me. At that time I felt that they were models, almost pedagogical, those were the extreme positions between a fjord landscape and a streetcar-ticket painting. This was no escape from the petty bourgeoisie, these were no destroyed paintings, no apocalyptic visions. They were simply paintings and also the model. The artist in his shell. Inside his four walls he attacks the furniture, making a mess of it, and his outside experiences increase rankly as gathered evidence. Schwitters drew a narrow circle around himself, he corseted himself in a tight, hard bandage, and, compressed in that way, he primed himself for a loud bang. Very well sealed, hermetic, the studio became an explosive lab. This pressure guaranteed a long flight path. His things likewise flew a long way. By the time the bomb destroyed his home, his mind had long since settled in a different place, where he had been expected. And that was Hannover, that was the street that passed with the people who were going somewhere else. No consensus was found, nor was one sought. The people stretched against the narrow walls until the boiler burst. There was yelling and killing.

The hiking song became a marching song, a pop tearjerker under boots. Books glorified and instigated hostility, as did paintings, between Madonna-like mothers and hand-grenade tossers. Art turned into kitsch. Propaganda was shallow, stupid, and primitive. Talents sobbed sentimentally or punched brutally. Luxury, wealth, and variety

were outlawed, as were fear and aggression, skepticism, pessimism, byroads, experiments. Over there, the other part of the country simply continued in this numbness, supposedly producing better paintings, while in the west the balconies of new buildings had already been painted many different pastel colors. My art teacher in East Berlin recovered from his realistic Bitterfeld friezes of life in Hungary and brought back oils of Gypsy women eating melons. Needless to say, they knew they were lying, but thought it was for a good purpose. Everything would have been all right if they hadn't denounced people, thereby playing Destiny. The goals weren't all that high, the constant compulsion to compromise really turned people into morons.

I want to begin where I myself started out. I don't want to beat around the bush, I can't admonish, nor can I overcome the past. I find that less interesting and besides I question whether it can work. This procedure is too reproductive for me.

I don't think that the hunter and the hare should swap roles. Hares that seek protection with the hunter are also shot if they're fat. The hunter's lovely, solemn uniform is part of the ritual, and if he's a soft-hearted man he'll still use his superior position.

Now artists are not always strong, rather their abilities identify them as jugglers, players, deceivers, magicians—as people who do something that other people would be ashamed of. Sometimes they unbutton their pants too far. Demands are made on them, much more than for mere entertainment, and that's precisely where things get very painful.

To what extent do you go along with political power and believe it makes you stronger? To what extent do you tolerate stupidity if you believe you have something to say? Needless to say, we all know that we have nothing to say, that we artists, especially, are predestined to be asocial. That's our strength, after all. Nevertheless some artists mistake the Party chairman for the Sun King, they mistake a glow for radiance. Nevertheless, conditioning obtains here too—for instance, *Staline, à ta santé* came right after Picasso's peace dove. Here a toast became an icon, a scoundrel became a masterpiece. By contrast, the former West German chancellor does not become a scoundrel if his portrait is painted by a rascal, for the difference between Yosef Visarionovitch and Adolf is Pablo at least. I go along with the Orientals, who outlawed portraiture, so that scoundrels wouldn't survive as national treasures in the museums.

Hence the artist has to be cunning as in the picture books and do the right thing. When the bruin gives up in those stories he waves the white flag. In this case, of course, the polar bear has to wave the red flag.

So what about the artist's role? In everyday life, he is scarcely occupied. He develops a pronounced sense of his own uselessness. Even when playing soccer, he remains anxious and feeble. In sports as a whole, his far-reaching strategic reflections are unsatisfied. Sometimes he has, initially, only his dislikes and instincts; but eventually, and more and more strongly, it is his disquiet, his discord that help him find his material. The initially boundless aggression finds its material.

When I arrived in West Berlin, the American influence, which was so often talked about here, was visible. First and foremost in cars, movies, design—in nearly all things that flew, drove, and stood around. But these were really puny adaptations, almost mistakes, as is the case in all provinces. In fact, it was only the mania for washing and cleansing that Germany took over and then also mastered. Later on, I saw that it was a lot dirtier on the other side than here. There was American painting at the America House, there was music, a record by Ornette Coleman, free jazz with a cover by Pollock. All this was heard and seen.

As I have already said, I read and venerated Gottfried Benn, who, I knew, hadn't left the boat in New York. But ultimately, my strongest influences came from Paris. There the artists were the most radical with books, sounds, and canvases. Their radicalism was greater because it attacked the very core of painting. These, I think, were never demonstrations of freedom, as performed by American painters, but aggressive, existential acts of destruction. For instance, the canvases remained small, they were useless as demonstrative decorations. Beckett, Ionesco, Genet, Jünger. I followed through on all that and wrote ventriloquist pandemoniums. That was how I began stopping up these cracks in my mind. I put myself under steam. I resisted colonization. Internationalism is an attempt to subjugate the provinces. A German can certainly perform like a black dancer. He seriously wants to reach the ultimate roots by way of that exoticism. An American Columbus is not applauded.

First I made things and their interrelations unbelievable and shifted them, not by putting a cap on a bald-headed man, but by painting him as a woman—for instance, *Richard Wagner as a Woman*. That is no humorous drawing, but an assault on convention, and in addition it is topsy-turvy, according to the formula: A tree and a house stand on the ground; but if I paint them in a picture and hang them on the wall, I have to undermine the convention and paint them topsy-turvy. Shifted in that way, they become a potent subject matter and take care of the how, the what, and the why. That's what conventions are for.

Monuments are conventions. Although some are false and some genuine, they are all

protected. Monuments are cared for by a government agency, a restorative group that has acquired almost militant features by having almost no grip on the ground. They tinker with an ensemble that has really always existed only within picture frames. Preservation of monuments is a good example of cultural impotence, and, oddly enough, this is not part of the so-called conservative platform, it's really part of my generation, which raised a ruckus in 1968. Some statues have lost their stature, they were too bilious for some tastes. Others are protected, not because they're necessarily better examples; they have simply become ineffective, they are no longer examples. Regarding the driver's bunker next to the Führer's bunker with those simple-minded frescoes, the locals say that it's a monument and not a creepy devotional object, and here they say that the blue spruce is an alien in these woods. In this case, there's more rubble above the ground than underneath.

Our colleagues, the musicians and the poets, are also in the murky corners of our theaters. Playbills mention them only marginally. We cannot overlook or ignore the fact that there are few new words and sounds or at least that they are not publicly heard. Richard Wagner's era, for instance, can't have been this unproductive. After all, we're long since done with interpreting and processing his music. That's what I mean by "cultural impotence." Performing anything new today is impossible because people are timid. The ever-new interpretations do not bring a greater value.

Today I was on the phone with a friend. He was delighted at the positive outcome of the French referendum, and he's looking forward to an improvement in trade, better sales, and greater turnover because of this decision. Also, the lira and the pound will now be freely traded, which means that both currencies are cheaper for us, and that's good for our commerce. Maybe. All in all, he says, a tremendous number of historic things have taken place during the past two years—for instance, in Russian hostility toward us. Recently, he says, he's had many conversations with a Russian diplomat in Berlin. We used to be enemies, now we've talked, exchanged ideas on history, on the past. The rapprochement, he says, has actually gone so far that this Russian writes love letters to his, my friend's, wife. I find that wonderful too. I don't want to know whether history moves sometimes faster, sometimes slower, but when I read the papers I still find a lot of topics, even horror stories from distant countries. If artists here lose their themes and the motif itself dissolves, then I don't give a damn. I've always regarded themes and motifs as ballast.

Similarly I've never been able to explain or understand myself as someone between east and west or between right and left. However, it has always been unpleasant for me

when colors started getting talked about, when colors became politically charged. Like red and black. In wrestling, it's all right: the good guy wears white and the bad guy black. Even when they climb into the ring, it barely moves us. Green, and I've read this, is Mohammed's color, the color of Islam. But that doesn't move me either, a connection is missing. I lack the experience, good or bad. Green is also the color of space without images, the color of imagelessness, precisely there in Islam, but it is a color all the same. Here it is the color of normal Sundays, the color of Trinity Sunday and Epiphany Sunday even on weekdays, the color of the Madonna's mantle, but not always. The color of compromise and of the median. There are also green firs, green mountains and meadows, green cows by Kirchner, green angels by Piero della Francesca, green noses by Picasso, but there is not a single green square by Mondrian. And that omission is precisely what makes it so interesting, so that I can keep on using that green.

I want to start again with laying out the canvas. Anyone can determine that today there are very different paintings, distinct in form, and when this form is distinct, then that which is formed is also distinct. Groups and followings form here as in all times, and they argue over whose form is the right one, who does the right or wrong paintings, or whether paintings can even be done today. Accordingly, there is progression in painting too, and with progressive output the contemporary validity of the work adapts. One person is right, the other lies at his side. That, in short, is roughly the tenor that critically accompanies the making of paintings. If I want to pick apart whatever is behind this idea of progress, then it's only because I don't believe in it and because I don't fit into this pattern. I have always followed a thought that ended in a different way.

There are old and young living artists, there are German and foreign artists. There are centers or metropoles that are potent, that cast long shadows across the provinces. Postwar Germany was such a province. The previously established hierarchies were destroyed. We were impoverished. But we had been poor since 1933, and after 1945 our poverty was joined by shame. The opposites balanced out. Never again was there any compression for a flight of fancy. The best artists and intellectuals were ignored, wiped out, or exiled. There were only survivors and newborns. If you wanted to, you could find, you could rediscover the Bauhaus, Dada, Expressionism, and so on. But that came about in the usual way of art-historical addition, and there was none of the live conflict that denounced the elders. When I studied in West Berlin, Schmidt-Rottluff, for instance, was still alive, he was a teacher at my school. Neither I nor my fellow students would have dreamt of demanding from him what he had established as a Brücke

painter. I looked, as I have said, toward Paris, and Pollock, who was already dead by that time, was the higher church spire in our backwater Berlin. But in those days, when I was still a student, something prodded me, like a freedom that I had won but did not deserve. It was then lost. Whether or not freedom was deserved didn't matter. At least you felt free and used this aimless motion. Everyone breathed deeply. Dissolute, restless, unguided, you stood on your own two feet at first. It was only when order—this time democratic—was urged that you got only smaller pieces of the freedom pie. And this was generally accepted, because it brought more security and was supposed to bring more equality. Now we have quite a lot of everything, but our motion has been limited more and more, so that we have less desire. The courage to take risks has been lost. Pessimistically we now see things from the other side. I remember that Sartre once destined us for Existentialism, but we still had fun. Now it's not so much a pessimistic philosophy as a mood, and it's no longer fun. So, something has been lost since then. Laying out canvases came later.

At first I looked for a different way. I found outsiders, and so I said goodbye and no longer ran with the pack. After all, this possibility did exist in Germany. Meanwhile I'm convinced that this is really the only possibility. The greatest opportunity—and this is an alternative—comes by making no social demands. I am responsible to no one for my work. I am not a member. No matter how ugly my work may be, no one will bang on my head and blame me for the misery. Isn't it wonderful, such an artist's life? I'll be damned if I say it in another way.

Today a young artist says he paints conservative pictures. I sense what he means. All he'd have to do is say: I paint. That way, a difficult part is still reserved for him. It means not participating in the conversation. He shifts into reverse to go forward; that's subversive, and he actually does go forward so long as he shoves others off the running board. They will try to jump back on, for there are still curious people left among the artists, at least among the painters, and besides, it's easier to crawl up mountains together. Or else say right off that he's finished himself off. Provide something new for lending rather than constantly dealing yet another blow to paintings that have already been thoroughly squeezed out. We can see that the avant-garde can change directions, it can move both forward and backward. Today it's moving in the opposite direction. My friend says that progress today is reproductive invariance or reproductive inversion or reproductive innovation. However, the avant-garde should not remain stock-still and immobile. Progressiveness has become a strategic toy. On the other hand, the reanimation efforts are like the many lunatics who think they're Napoleon. Something

that takes place in my mind may resemble something taking place in someone else's mind. So, conservative paintings, please, but please, no patterns that are already labeled. Somersaults are also movement, and they're fun too.

The minor differences that simultaneously, yet so differently, constitute German and other European or even other paintings are, I feel, very important. We should absolutely leave it that way, on no account should we open up and conform. How should that work and, above all, why? Something would be lost—at least, someone would perish. For instance, I find Czech Cubism very remote from the original, even when it's well-meant. But it's different when those small German landscapes invented by Dürer often crop up in the background of Italian Renaissance paintings, in portraits, and also in Madonnas. That's really conspicuous, without splitting hairs. These certainly aren't coincidences, for it takes a lot of time and skill to paint such landscapes. The portrait shows an Italian woman, the Madonna comes from further south. Raphael, Pontormo, Parmigianino as cosmopolites—they solved riddles and, like many of their contemporaries, they tried to find the philosopher's stone as alchemists. After all, the Italian landscape had already been invented, and the Oriental one too, but the north, behind the Alps, was still exotic. The exchange of landscapes functioned as nicely as the trading of goods. Dürer's graphics sold well in Italy. Although the painters knew better, they enriched themselves with it. It wasn't yet the wanderlust that later drove the German painters to Italy. Nor was it visions of something that they themselves didn't have. People want to see what they want to see. The rich painter doesn't paint the gnawed-up fish. The poor painter doesn't paint the fat ham. Nor vice versa. However, the turbulent processes in the mind shake up the pictures. It comes from deep inside, you expect it, and it shakes up what you know. I lack what's needed for a large overview and so I have the problem bare-naked.

When I lay out a canvas I stand next to myself—that is, I let it work, which also means that the mechanism that thinks is the motif. Another example of that, which again could be so embarrassing for a German painter if the results hadn't been different. One day, this mechanism was drawing lots of swastikas. I, the painter standing at the side, was startled. The next day, I went to Munich and in a gallery I stumbled upon an African death-cult mask covered with hundreds of swastikas. It can or could go on like that, undisturbed, if the problem weren't so exposed. For here it can catch fire very quickly and become a trauma. Am I afraid of the scarecrow painter about whom Immendorff says: "The painter-enemy in the painter is his best friend"?

Once again the question of social commitment. I believe that this is the key to the

artist's role. All societal relationships are univocal when fundamental issues are touched on. At first unpolitical movements, protest demonstrations, civic initiatives have become parties since, after all, they are dependent on the possibilities of everyone having a say. What artists do doesn't touch on anything fundamental even if they wish it did. Their activities only accompany, and the more they participate because they can't help themselves, the more harmoniously they will illustrate—because they are asked—whatever people need. It's good to be a pacifist, you can be that, but I know that programmatic organizations, like the churches, are no longer peace-loving. Were they ever?

The faith in fairness, the idea of social justice have once again gone awry. The poor want to climb up and the rich don't want to climb down, and so there's always resistance. Hope constantly fed anew—who stuffs it with food? The ideologists have seductive platforms and usually start way up high in improving the world. Down below, more in bars and at the family table, I much prefer the know-it-alls—in fact, that's where folk music is at home. The tone is cruder and the living is freer. But the sacks they carry are empty. It's better than carrying ideologies, though. I say that these are the enemies. The carriers of ideologies can, like Benn's art carriers, also be people of whose claptrap about the eastern paradise nothing is left but a broken shell with burned-out tenants. Do we have to rummage through archives again to remember what's going on everywhere? The enemies are hiding. Now the archives are beaten like the bushes where thieves hide. People knew they were or had been right—at the very latest by the time they came up against those carriers of ideology. People had to yield to pressure and vanish simply because they were stronger—asocial, not the crowd, or even representatives, but were opposed. If you now leaf through these statistical lists and then raise a hue and cry, you impress others as having gotten the short end of the stick and suffering from deprivation of love. If someone made his career in the system, he was the bard of the system. Thus I found it very funny when the chairman of the state council made an official visit to Saarbrücken, and several major West German writers and artists were sitting at his banquet table as media toadies. Should they now be beaten out of the bushes?

I said that laying out a canvas on concepts doesn't work—words would come out, but no pictures. Germany and homeland are concepts—also more than that. It's the place I didn't have to decide on, I didn't choose it. Whether the prevailing circumstances are good or bad, I can adjust. I can butt in, and then I'll find myself in counted majorities or not. But I have to do my work, and that's something I began several years ago.

Something is always happening outside. I had already hung out my program on the door in time and I was waiting for someone to buy a ticket and watch my performance. But nobody wanted to. However, my performance is still running all the same. And when I talk about laying out a canvas, it's something I've been doing all these years—you can see that now. That's what I'm talking about, but this talk is more of a voice in front of the curtain.

Does laying out a canvas, such as I describe it and do it, block the forward view? No. If a profession of faith is lacking, then so is good will. The profession of faith is not a commentary on something on or—for all I care—behind the canvas, like a painter's murmuring. I believe that the profession of faith is the stance one takes, and I imagine this stance as a flagpole without a flag being run up. Founding utopias. I can certainly see myself as an antenna, ready for reception, grounded, and with my head in the clouds, in between there is a spool with tight windings. I have a better view of what's behind me, what I'm leaving, where I come from, what I've heard and seen—all fairly stuffed with pictures. Utopia, the Nowhere-Land, is to be discovered by the imagination. Where you get it from is one thing, what you do with it is another. I do it archeologically and I test the sediment.

Every door has two sides, an inside and an outside. If I peer through the keyhole I can look inside, but also outside. I can't pick the location, I'm there, inside or outside. I condition myself to peer through the keyhole—that is, I have to squeeze my nose very flat against the surface of the door to get as big a view as possible, and I can only hope that the light's on. If the country is dark, then you quickly become a visionary.

Derneburg, October 1992

Lecture delivered at *Münchner Podium in den Kammerspielen* '92, Munich, November 8, 1992. First published in German, as "Georg Baselitz: Purzelbäume sind auch Bewegung, und noch dazu macht es Spaß," in *Reden über Deutschland 3: Hans-Dietrich Genscher, Georg Baselitz, Günter Grass, Jiří Gruša, Péter Nádas, Wolfgang Schäuble* (Munich: Bertelsmann, 1992), pp. 35–51.

Music

I repeatedly did Richard Wagner as a woman. Slowly I found that it helped me to listen to music. Actually, because I see better than I hear, I also see music better. On the other hand, an opera may leave less room for the imagination, unless it plays in the realm of

the imagination. If it does, then one can do more if one helps to move music and playing further away from knowledge and experience. Quite incredible things have to occur. There are no limits for eyes and ears.

Derneburg, November 19, 1992

First published in German and Dutch, trans. Janneke van der Meulen, in *Harrison Birtwistle 1934: Punch and Judy, A Tragical Comedy or a Comical Tragedy Opera in One Act* (Amsterdam: De Nederlandse Opera Stichting, 1992), p. 33.

not nope nope nope not nein

not object nein, no thing nein, not matter nein, not stone nein, not fragment nein, not head nein, not at all not nein, no nothing not not nein, not nature nein, not semblance nein, not seems nothing nein, not not at all nein, not nothing at all not nein, not inside outside not nein, not above below not nein, not back front side not nein, not for not against not nein, not sex nein, not between here not nein, not here not there not nein, not being nein, not then not now nein, not at all being nothing nein, not on and so on not nein, not despair not nein, not past not nein, not nope not nein, not nope not but not nein, not nope nope nope not nein

Derneburg, February 24, 1993

First published in German, in *Georg Baselitz: nicht nee nee nee nicht no*, exh. cat. (Stommeln, Germany: Synagoge Stommeln, 1993), unpaginated.

Questioning Myself

Drawings are like caprioles, they amaze you and scare you and terrify you. If I didn't draw, my mind would feel numb, like in a mine. Not that drawing is fun, it's no fun at all. But then again it's not annoying. It's like a language without understanding, and it makes sense only when I've learned some vocabulary—that takes a long time. At first I don't know what I'm doing, then I think I do know. Ultimately I use it in a hygienic way—that is, it really uses me more. Since by now I know what happens if I don't do it,

it controls me more than I could ever control it. You can't offer it just one finger, it'll take the whole hand. It installs a cipher of something that was not on the paper. More cipher than thing. A picture has actually become a thing, just like Cézanne's still apples. A drawing is the synthesis—that is, when you go to bed with Cézanne's apples and then dream about Provence at night. I smoke more cigars when I draw than when I paint. I can't draw while eating, telephoning, listening to music, or conversing. I can, but the drawing turns into unbelievable crap. I find so-called telephone doodling repulsive. I don't think one should place a compass on a drawing, you can draw better with a pendulum, similar to the one that dousers use. A drawing is always naked. Everyone instantly sees the lovely, pleasant sides, which are so boring; but not everyone sees an ugly, unpleasant side because he simply doesn't want to see it. A person doesn't want to see certain meals. Is someone who forges drawings less dishonorable than someone who forges paintings? Today almost everyone draws like Beuys. Drawings always contain something of an acquired talent. Even the stupidest person can draw like Raphael; but doing really miserable drawings is very hard because it takes a lot of intelligence. I'm terrified when I see a drawing of mine done by someone else. I sign and date my drawings myself.

Imperia, Italy, July 1993

Previously unpublished.

The Red Garland

The great designs, such as paintings and stuccos, have mostly vanished under a patina applied by time. It's no different for old drawings. The delicate, brittle, sensitive qualities by which they're distinguished today are often nothing but the decay brought on by aging. It leaves no extinguishable traces—which quickly leads to misunderstandings that warp the artist's intention. The original clear and simple idea of a drawing is thus often concealed.

If you're looking for an immediate image, then there's a lot to be said for prints. This is more obvious in the prints of, say, the Fontainebleau school than in other prints. Beyond their reproductive contents, the Fontainebleau prints are marked by the highly personal manner of each artist. The approaches in the drawings of Rosso and others are

clearly recognizable, but their graphic translations, as, say, by L.D., are unique. On the one hand, this makes these works interesting in terms of reconstructing the style and the specific quality of the images invented in Fontainebleau; and on the other hand, these works are more authentic in documenting the new form that was found here. I was very surprised when I first discovered these prints for myself. I had never seen such liberal, experimental, and arbitrary prints. Some of them are hard, with an almost stenciled effect, they follow the unusual ornaments of a Mannerist drawing, as in Mignon. Or else, they have totally crazy, twisted, obsessed figurations as in Juste de Juste. These prints are all very remote from the previous craftsmanship of engravings, they go against the old manner—for instance, Raimondi's: they are incredibly bizarre and unserious. Drawings turned into ciphers by means of dots and lines scratched or even etched into the plate, usually printed black, but also red and lilac. The art manifested in the Italian Renaissance with Raphael was put in an extremely unstable situation by these unusual prints. I'm interested in such borderline cases in art, where the acquired terrain has became unsafe and the classical picture crumbles. From here, art carries on more blithely. Whenever the issue of the relationship between image and reproduction remains blurry and artists experiment with pictures that disregard conventional form and escape its stranglehold, then something valuable is always gained. The imagination is vaster than a surveyor's staff can measure.

Derneburg, September 20, 1993

First published in English, as "Reflections on the School of Fountainebleau," trans. Henri Zerner, in Karen Jacobson, ed., *The French Renaissance in Prints from the Bibliothèque Nationale de France*, exh. cat. (Los Angeles: Grunwald Center for the Graphic Arts, University of California, 1994), p. 13.

Painting Out of My Head, Upside Down, Out of a Hat

These paintings are painted—sort of painted. They are painted, but then again they are not. They are painted somewhat differently than the way I used to paint. The pigments are put on the canvas, and the canvas is stretched on a stretcher. By the time I stretch the canvas, I've already done the painting and completed it on the floor. The canvas lay on the floor, and I applied the pigments. It's precisely this painting technique that separates these from the previous paintings. One reason, for instance, is that I don't have a wide or full view of what I've done while painting. In order to get an overview I would

have had to climb up a high ladder. But I didn't want to. So I can only see the little bit that I'm doing on the large surface—I stand, walk, and kneel on the canvas while I squeeze out my colors. The ground, which is white or, most often, black, was done at the very start. If anything—say, the drawing—doesn't work, work out as it should, then I cover the entire canvas with black and start the drawing all over again.

If I have to say now—that is, after the fact—what it is that I'm drawing, I'm tongue-tied. For when I crawl around the canvas and squeeze out the pigments, I know what I'm doing but not what it is that I'm doing. I once thought of describing it as painting or drawing something that's under, somehow under, underneath, under the canvas. And it's certainly not wrong to say that these are—perhaps to a very essential extent—my own old drafts, drawings, paintings, and so on. Anyone can see it, after all. The old heroes, lumberjacks, and friends can be seen, and also hares, dogs, pigs, trees, and lakes—although more linear, more ornamental than in the past. I've now done a better job of getting them to the surface, I've put them down, sort of like painting vases, like painting ceramic tiles. Then again, these things that are made today are no knock-offs or projections of old things, they can't be, for nothing was lying under the canvas, nothing that could be physically felt or that could fall from the head as a cipher that was stamped on the mind.

During the past few years my attitude toward painting and my observation of painting have changed profoundly—in such a way that I can't explain what is really happening on the canvas, because it's important and it has to happen, and because most of what other people call paintings cannot be compared with what I'm trying to do in paintings. Previously there was more consensus. There was more security in the company of painters. I often do like other artists' paintings, but I find less and less to relate to in them. I don't mean a comparison of quality or whatnot. What I mean is that the things I make are not paintings. Nor do I know what else they may be. I don't mean that they're better or worse or different, I just mean that they're totally different. Be that as it may, now that I've already started to interpret them, I really want to take a stab at it.

It could be possible that there is a congruence, an overlapping between, on the one hand, what I've been thinking for years and what I've accordingly drawn and painted and, on the other hand, my current activity as a painter—whereby this painter won't let in something that wants to come through the door. That is, I don't want to use any new material, I want to use only what's been here for years—something that's so restless that it constantly keeps turning more and more into lines and colors in its own circulatory

system. We shouldn't picture that as a nice person without curiosity. No, it isn't like that. What I see instantly arouses a memory of something I once saw, and it has turned into pictures, and meanwhile I see the pictures more and more sharply as models for pictures. The colored strokes and splotches and dots are already filled, occupied by the appropriate pictures, they are no longer free, can no longer be used in any other way, can no longer be formed anew. My entire kaleidoscopic system is gathered in a cardboard tube that I don't want to give away. I myself threw in all the multicolored glass shards at some point. Earlier I broke open this cardboard tube and tried to fill in new and different variants. Then everything fell apart, and so the system has to be kept shut. The gathered stuff is seething and simmering and trying to get out. The mind, as a catalyst, can process things that come from outside. You look into the landscape and make it into a picture. But the reverse can also happen. The catalyst with a vent is the untight place on the vessel, on me, and it lets the squeezed things fly out. The imagination spreads like the spores of the trodden puffball. This concept of painting is not unpleasant. I think that's how it is.

A child has no biography, has gathered nothing, but his imagination already spread inside him before he was born, and when he draws he tries to harmonize his imagination with whatever he sees and experiences. But sooner or later you're no longer a child, then you've done enough comparing and measuring and drawing; and at that point, when every stroke, dot, or splotch is no longer used to compare with a thing, to approach it, then that's enough. Now you only need to talk to yourself and you've got a lot to say— and so much for that.

Derneburg, November 25, 1993

First published in German and English, as "Malen aus dem Kopf, auf dem Kopf oder aus dem Topf/Painting: Out of My Head, Head Downward, Out of a Hat," trans. David Britt, in *Georg Baselitz: Gotik—neun monumentale Bilder*, exh. cat. (Cologne: Galerie Michael Werner, 1994), pp. 24–25, 28–29.

Angels and Gnomes—German Tribal Art

In looking for my elders I'm somewhat at a loss. I can't deal with the well-known tradition. The comparison between an angel and a garden gnome occurred to me: the gnome as a sculpture with a pointed cap and a friendly face, and the angel sculpture as a woman with wings. I don't care if angels are male or not—for me they're female.

History moves forward, but also backward, or it doesn't move at all. I think I can do something with a memory. I can also call it utopian. I wander off into the wild blue yonder when I make sculptures. I move, perhaps I merely turn. An arrow is shot and flies away, but also flies this way. It doesn't fly like this: ———>, but like this: <———>. A memory doesn't begin, not yesterday nor further back. A sculpture doesn't start, it's not an object for a program.

What's obvious right off is that the gnome is ugly-beautiful, the angel is beautiful-beautiful. That's simply always true. The ugliest angel is still beautiful, and the most beautiful garden gnome is still ugly. When I assume that both the angel and the gnome have to be beautiful or are meant to be beautiful by the sculptor, I have to ask: Why is the gnome nevertheless ugly? One reason: the angel stands for heaven, the place where the gods or the Good Lord live. The angel is the messenger. Envoys with good tidings are seductively beautiful. Another reason: painters and sculptors always, simply always, for millennia now, have worked on the idealization, on the image of this winged woman. There are wonderful angels in art history, not only Christian angels, but also older ones, on vases, mosaics, sculptures, and even in modern movies. Another reason: angels are mostly girls or women. But the truly important reason is that so many artists in all times all around the Mediterranean have worked on angels. Angels are part of our basic resources. An unbelievable number of angels have been and are being made ever since art moved from its reserved location and mingled with the common folk; and that is a point of contact with the garden gnome—except that this gnome has no privileges, he has no place in art history. He comes from the earth, the forest, the mountain, the cave, the lake. He has no contact with the upper world. He is the counter-world, especially in the Christian sense. He is pagan, he represents the underworld and was sacrificed for the church. The ideology of society—Christian, that is—is also its culture: it paints the paintings and makes the sculptures. When this kind of societal life took root, the old paintings and sculptures disappeared, but they *had* existed, for we can find them in the ground. If we dig north of the Alps, we never find women with wings, but we do find something like gnomes. But in the places where the Christians come from people have found a lot of angels from an era before the Christians—pictures of people who dwell somewhere in the supernatural. That pictorial idea has survived even today, even among us. The other pictorial idea has vanished.

We find the very same thing in photographs of Africa, where whole cartloads of sculptures, which had been declared idols, were burned. Nevertheless, stubbornly enough, angels have never gotten established in Africa.

1959 Baselitz hitchhikes to Amsterdam, where he sees a painting that has a lasting influence on his work: Chaim Soutine's *Le Boeuf écorché* (*The Skinned Ox*, 1926) at the Stedelijk Museum. On his return journey, he stops in Kassel to visit *Documenta 2*, where he sees works by Kandinsky, Malevich, and Nolde, as well as more contemporary works by American abstractionists. He gives up his studio in the academy and works exclusively at home.

1960 He devotes his attention to the subject of anamorphosis. Baselitz becomes interested in the art of the mentally ill, which he sees reproduced in Hans Prinzhorn's seminal study, *Bildnerei der Geisteskranken* (1922). He paints *G. – Kopf* (*G. – Head*), based on an illustration in Prinzhorn's book.

1961 He adopts the surname Baselitz, which is taken from the name of his birthplace. During his first trip to Paris, he sees works by Gustav Moreau at the Musée Moreau; he also sees works by Hans Fautrier and Henri Michaux. In Berlin, Baselitz and Schönebeck stage an exhibition of their work in an abandoned house. They write an accompanying manifesto, later called "Pandämonisches Manifest I, 1. Version, 1961," which is followed by an abridged, second version; both are published as posters announcing the exhibition. At the academy, he attends Trier's master class.

1962 Baselitz and Schönebeck write "Pandämonisches Manifest II, 1962." He marries Kretzschmar. Their first son, Daniel, is born. He becomes friends with Michael Werner. He completes his studies at the academy.

1963 His first solo exhibition inaugurates Galerie Werner & Katz in Berlin. *Die grosse Nacht im Eimer* (*The Big Night Down the Drain*, 1962–63) and *Der nackte Mann* (*The Naked Man*, 1962) are confiscated from the exhibition by the district attorney on charges of public indecency, and the artist and his dealers are fined. The court case lasts until 1965 and results in the return of the paintings to Baselitz. He writes as a manifesto the letter "Lieber Herr W.!" He completes a series of eleven paintings entitled *P.D. – Füße* (*P.D. – Feet*), a few of which were begun in 1960.

1964 Baselitz paints two related groups, the *Idol* and *Oberon* pictures, which are shown at the 1. Orthodoxer Salon, Galerie Michael Werner in Berlin. He sees the late, figurative works of Francis Picabia at Place Furstenberg in Paris. He spends the spring in Schloß Wolfsburg and produces his first etchings in its printing house; in autumn, they are exhibited at Galerie Michael Werner in Berlin. He begins friendship with Johannes Gachnang.

1965 Making the first of yearly visits to Italy, Baselitz spends six months at the Villa Romana in Florence on a scholarship. He studies Italian Mannerist prints, seeking out the work of Amico Aspertini, Bronzino, Parmigianino, Pontormo, and Rosso. His *Tierstück* (*Animal Piece*) pictures are made in Florence. He has his first exhibition at Galerie Friedrich & Dahlem in Munich; it initiates his associations with Franz Dahlem and Heiner Friedrich. In Berlin, he works on the *Helden* (*Heroes*) pictures until the middle of 1966. He paints *Die grossen Freunde* (*The Great Friends*).

1966 *The Great Friends* is shown at Galerie Springer in Berlin, accompanied by his manifesto "Warum das Bild 'Die großen Freunde' ein gutes Bild ist." His son Anton is born. Baselitz moves to Osthofen near Worms, Rheinland-Pfalz. He paints works with rural themes: cows, dogs, woodsmen, hunters. He makes his first woodcuts. He works on the *Fraktur Bilder* (*Fracture Paintings*) until 1969.

1967 Baselitz paints *B. für Larry* (*B. for Larry*).

1968 He produces *Waldarbeiter* (*Woodsmen*) pictures into 1969. His work is actively promoted by the Munich dealers Dahlem, who represents the paintings, and Fred Jahn, who represents the graphic works. Baselitz receives grant from the cultural section of the German Industrial Association.

1969 He paints first picture in which the entire composition is upside down: *Der Wald auf dem Kopf* (*The Wood on Its Head*). A group of upside-down portraits of friends and family follows. The upside-down subject becomes his signature practice.

1970 Baselitz renews association with Friedrich and will exhibit regularly in his Munich gallery. He begins to use device of picture within a picture, painting mostly landscapes. The first retrospective of graphic works is organized by Dieter Koepplin for the Kunstmuseum Basel. Dahlem shows the first exhibition of upside-down paintings in Cologne.

1971 He moves to Forst on the Weinstrasse and uses the old local school as his studio. Baselitz starts to paint pictures of birds, some based on photographs by Drechsler and other naturalists. An exhibition of work from 1962–70 is held at Galerie Tobiès & Silex in Cologne. He begins finger painting, a technique he concentrates on in 1972.

1972 Kunstverein Hamburg exhibits works from 1962–72. Baselitz participates in *Documenta 5* in Kassel. He rents a factory space in Musbach to use as a studio. An exhibition of the 1969 portraits, *Freunde* (*Friends*), is organized by Gachnang for the Goethe-Institut/Provisorium in Amsterdam.

1973 Hans Neuendorf shows the 1965–66 *Heroes* pictures in his Hamburg gallery. Baselitz paints the so-called *Fahnen* (*Flags*), strips of canvas pinned to the wall.

1974 Friedrich begins to exhibit Baselitz's work in his Cologne gallery. A retrospective of graphic works is organized by Rolf Wedewer for the Städtisches Museum Leverkusen, Schloß Morsbroich; it includes etchings from 1963–74 and woodcuts from 1966–67 and is accompanied by the first catalogue of the graphic work. Most of the paintings Baselitz creates up to the end of 1975 are landscapes with subjects related to childhood memories of his birthplace. He paints *Akt Elke* (*Nude Elke*) pictures.

1975	Baselitz moves to Derneburg near Hildesheim; his studio is part of his home. He makes his first trip to New York, where he works in a studio for about two weeks, making two Saxon landscapes and drawings of eagles. In New York, he sees an exhibition of Jean Dubuffet at Robert Elkon Gallery. Before going home, he travels to Brazil to participate in the *Bienal* in São Paulo. In Germany, he completes the two *Schlafzimmer* (*Bedroom*) paintings.
1976	An exhibition of paintings, graphic works, and *Pandämonisches* manifestos is organized by Gachnang for the Kunsthalle Bern. In Munich, a retrospective held at the Galerieverein München and the Staatsgalerie Moderner Kunst is organized by Carla Schulz-Hoffmann, Wolf-Dieter Dube, and Jahn. An exhibition of paintings, prints, and watercolors is organized by Siegfried Gohr for the Kunsthalle Köln in Cologne. Baselitz paints another group of *Nude Elke* pictures. Baselitz creates twenty gouaches to illustrate an edition of Comte de Lautrèamont's *Die Gesänge des Maldoror* published by Rogner & Bernhard in Munich. He establishes a studio in Florence, which he uses until 1981.
1977	He works on large-format linoleum cuts until 1979. He is appointed instructor at the Staatliche Akademie der Bildenden Künste in Karlsruhe; he is given a professorship in 1978. Baselitz withdraws participation in *Documenta 6*, due to participation by official representatives of East German painters. He begins painting diptychs on plywood.
1978	Up to the end of 1980, he paints pictures that have two or more panels, as well as large-format, single-panel works such as *Die Ährenleserin* (*The Gleaner*), *Trümmerfrau* (*Bomb-Site Woman*), and *Adler* (*Eagle*). Baselitz's painting becomes more abstract. Recent paintings and drawings are exhibited at Helen van der Meij Gallery in Amsterdam.
1979	An exhibition of the work of 1977–78 is organized by Rudi Fuchs for the Van Abbemuseum in Eindhoven. Baselitz works on the eighteen-part *Straßenbild* (*Street Picture*) from March 1979 until February 1980. He delivers the manifesto "Vier Wände und Oberlicht" as a lecture on the occasion of the Dortmunder Architekturtage (architecture convention); the convention theme is museum buildings. He begins making wood sculpture. An exhibition of linoleum cuts from 1976–79 is organized by Gohr and Jahn for the Josef-Haubrch-Kunsthalle in Cologne.
1980	The sculpture *Modell für eine Skulptur* (*Model for a Sculpture*, 1979–80) is shown in the West German Pavilion at the Venice *Biennale*. Baselitz paints three diptychs: *Deutsche Schule* (*German School*), *Das Atelier* (*The Studio*), and *Die Familie* (*The Family*). He works on the *Strandbild* (*Beach Scene*) series until 1981. An exhibition of *Model for a Sculpture* and a group of linoleum cuts is organized by Nicholas Serota for the Whitechapel Art Gallery in London.
1981	Bazelitz participates in *A New Spirit in Painting*, which is organized by Norman Rosenthal for the Royal Academy of Arts in London. *Street Picture* is exhibited at Galerie Michael Werner in Cologne. During the 1980s and into the 1990s, his work is frequently exhibited by Werner. He paints the *Orangenessers* (*Orange Eaters*) and *Trinkers* (*Drinkers*) series. *Street Picture* is shown in an exhibition organized by Alexander van Grevenstein for the Stedelijk Museum in Amsterdam. He maintains a studio in Castiglione Fiorentano near Arezzo until 1987. A group of *Die Mädchen von Olmo* (*The Girls of Olmo*) and *Drinkers* paintings, all painted in 1981, is exhibited at Galerie Michael Werner in Cologne. His first exhibitions are held in New York at Xavier Fourcade Gallery and Brooke Alexander, Inc.
1982	Exhibitions are held at Sonnabend Gallery in New York, Young Hoffman Gallery in Chicago, and Waddington Galleries and Anthony d'Offay Gallery in London. In Kassel, Baselitz participates in *Documenta 7*, which is organized by Fuchs with the assistance of Gachnang. Eight paintings from the concurrent series *Mann im Bett* (*Man in Bed*) are exhibited in *Zeitgeist: Internationale Kunstausstellung Berlin 1982*, which is organized by Christos Joachimides and Rosenthal for the Martin-Gropius-Bau in Berlin. The first issue of the magazine *Krater und Wolke* is devoted to Baselitz; it is edited by Penck and published by Galerie Michael Werner in Cologne. Baselitz returns to intensive work on sculptures of figures and heads.
1983	He paints *Nachtessen in Dresden* (*Supper in Dresden*), which portrays Die Brücke artists. He works on Christian subjects until the end of 1984. An exhibition of sculpture is held at Galerie Michael Werner in Cologne. The first overview of the sculptural work is organized by Jean-Louis Froment for the Musée d'Art Contemporain Bordeaux. Baselitz participates in *Expressions: New Art from Germany*, which is organized by Jack Cowart; it opens at the Saint Louis Art Museum and travels throughout the United States. Detlev Gretenkort begins working with the artist as secretary and archivist. Baselitz produces *Der Brückechor* (*The Brücke Choir*), a companion to *Supper in Dresden*. He leaves the academy in Karlsruhe to assume a professorship at the Hochschule der Künste Berlin. An exhibition of paintings from 1976–83 is organized by I. Michael Danoff for the Akron Art Museum. Jahn publishes the first volume of the catalogue raisonné of graphic works. A sculpture exhibition, organized by Stephanie Barron, opens at the Los Angeles County Museum of Art and travels to the University Art Museum, University of California, Berkeley.
1984	He paints *Das Abgarbild* (*The Abgar Picture*) series. A retrospective of drawings from 1958–83, organized by Koepplin, opens at the Kunstmuseum Basel and travels to cities in the Netherlands, Switzerland, and Germany. Baselitz has his first exhibition at Mary Boone Gallery in New York in association with Michael Werner. The Munich dealer Sabine Knust begins to represent the graphic works. A retrospective of graphic work, organized by Rainer Michael Mason, opens at the Staatliche Graphische Sammlung, Neue Pinakothek, in Munich and travels to the Cabinet des Estampes, Musée d'Art et d'Histoire, in Geneva and Bibliothèque Nationale in Paris. His first exhibition of prints at the Museum of Modern Art in New York is organized by Audrey Isselbacher. An exhibition of paintings from 1966–84 is organized by Jo-Anne Birnie Danzker for the Vancouver Art Gallery.
1985	Baselitz completes the painting *Die Nacht* (*The Night*, 1984–85). When Mason's 1984 retrospective of graphic works travels to the Bibliothèque Nationale in Paris, it is shown together with a selection of sculpture. He paints *Mutter und Kind* (*Mother and Child*) series of pictures into 1986. An exhibition, organized by Ulrich Weisner, shows works by the

artist together with his collection of Mannerist prints and African art; after opening at the Kunsthalle Bielefeld, it travels to the Kunstmuseum Winterthur. Baselitz writes the manifesto "Das Rüstzeug der Maler."

1986 He paints the two *Pastorale (Pastoral)* pictures as well as a group of *Kampfmotive (Fight Motifs)* pictures. A retrospective is held at Galerie Beyeler in Basel. In honor of his artistic career, he is given the Kaiserring Prize by the town of Goslar. He makes the sculpture *Gruß aus Oslo (Greetings from Oslo)*.

1987 A show of the sculptures is organized by Carl Haenlein for the Kestner-Gesellschaft Hannover. Baselitz spends three months working on the appliqué *Anna selbdritt (Virgin and Child with St. Anne)*. He establishes a studio in Imperia on the Italian Riviera. He begins *Malerbilder (Painter's Pictures)* series, which he works on into 1988. He delivers lectures of "Das Rüstzeug der Maler" in Amsterdam and London. An exhibition of the *Pastoral* paintings and related drawings is organized by Gohr and A. M. Fischer for the Museum Ludwig in Cologne. Baselitz participates in *1961Berlinart1987*, which is organized by Kynaston McShine for the Museum of Modern Art in New York.

1988 The artist makes the *Tragischer Kopf (Tragic Head)* sculpture and *Das Motiv (The Motif)* paintings. A retrospective of work from 1965–87, organized by Joachimides, opens at the Sala d'Arme di Palazzo Vecchio in Florence and travels to the Hamburger Kunsthalle in Hamburg. Baselitz finishes *Das Malerbild (The Painter's Picture*, 1987–88). He gives up his professorship at the Hochschule der Künste Berlin. Until the middle of 1989, he works on the *Volkstanz (Folk Dance)* pictures. Compiled by Edward Quinn with a text by Andreas Franzke, the first monograph on Baselitz's painting and sculpture is published. An exhibition containing early works from 1964 and sculpture from the 1980s is organized by Klaus Gallwitz for the Städtische Galerie im Städelschen Kunstinstitut in Frankfurt.

1989 The French Arts Minister Jack Lang confers upon him the medal of Chevalier dans l'Ordre des Arts et des Lettres. He participates in *Bilderstreit: Widerspruch, Einheit und Fragment in der Kunst seit 1960*, which is organized by Gohr and Gachnang for the Museum Ludwig in Cologne. Baselitz makes the twenty-part painting *45*. He spends a year, working into 1990, on the group of sculptures *Dresdner Frauen (Women of Dresden)*. He participates in *Refigured Painting: The German Image 1960-88*, which is organized by Thomas Krens, Joseph Thompson, and Michael Govan for the Solomon R. Guggenheim Museum in New York and the Williams College Museum of Art in Williamstown; it travels to the Kunstmuseum Düsseldorf and the Schirn Kunsthalle Frankfurt.

1990 The first showing of *45* takes place at Galerie Michael Werner in Cologne. The first large-scale exhibition of Baselitz's work is held in East Germany at the Staatliche Museen zu Berlin, Nationalgalerie Altes Museum. A retrospective of painting and sculpture from 1963–89, organized by Harald Szeemann, opens at the Kunsthaus Zürich and travels to the Städtische Kunsthalle Düsseldorf. On October 3, Germany is reunified. Arne Glimcher exhibits the *Women of Dresden* and *45* at Pace Gallery in New York. Baselitz edits an issue of *Krater und Wolke* devoted to Penck. Werner publishes Baselitz's artist book *Malelade (Paintfool)*, which contains forty-one etchings.

1991 An exhibition of the *Paintfool* etchings is organized by Riva Castleman for the Museum of Modern Art in New York. In Paris, he delivers lecture of "Das Rüstzeug der Maler," on the occasion of Lucio Amelio's showing of the sculpture *Frau aus dem Süden (Woman from the South*, 1990) at Piece Unique. Baselitz participates in *Metropolis: International Kunstausstellung Berlin 1991*, which is organized by Joachimides and Rosenthal for the Martin-Gropius-Bau in Berlin. He begins the *Bildübereins (Picture Once Over)* series of paintings. A retrospective of Baselitz's graphic work from the collection of the Cabinet des Estampes, Musée d'Art et Histoire, in Geneva is organized by Mason; it opens in Geneva and travels to the IVAM Centre Julio González in Valencia and the Tate Gallery in London.

1992 A retrospective of work from 1964–91, organized by Gohr and Peter A. Ade, opens at the Kunsthalle der Hypo-Kulturstiftung in Munich and travels to the Scottish National Gallery of Modern Art in Edinburgh and the Museum Moderner Kunst Stiftung Ludwig Wien in Vienna. He rejoins faculty at the Hochschule der Künste Berlin. He delivers "Purzelbäume sind auch Bewegung, und noch dazu macht es Spaß" as speech at the Munich Kammerspielen.

1993 Baselitz creates scenic concept for Harrison Birtwistle's opera *Punch and Judy*, directed by Pierre Audi at the Deneder Landse Opera in Amsterdam. He makes more sculptures, including *Das Bein (The Leg)* and *Weiblicher Torso (Female Torso)*. An exhibition of work from 1990–93 is organized by Steingrim Laursen and Heinrich Heil for the Louisiana Museum of Modern Art in Humlebaek, Denmark. An exhibition of *Virgin and Child with St. Anne* and related drawings is organized by Koepplin for the Kunstmuseum Basel. An exhibition of drawings from 1962–92 is organized by Fabrice Hergott and Marie-Laure Bernadac for the Musée National d'Art Moderne, Centre Georges Pompidou, in Paris. He participates in the Venice *Biennale*, in the International Pavilion organized by Achille Bonito Oliva.

1994 An exhibition of works from 1981–93, organized by Ernest-Gerhard Güse and Ernest W. Uthemann, opens at the Saarland Museum in Saarbrücken, concurrently with an exhibition of sculpture from 1979–93, organized by Uwe M. Schneede, at the Hamburger Kunsthalle in Hamburg. Baselitz continues *Picture Once Over* series. The sculptures *Frau Paganismus, Ding mit Arm (Thing with Arm)*, and *Gandhara Kopf (Gandhara Head)* are exhibited at Anthony d'Offay Gallery in London. *Ding Kariert (Thing Checkered)* is the first sculpture he covers with fabric. He writes the manifesto "Malen aus dem Kopf, auf dem Kopf, oder aus dem Topf." He participates in *The Romantic Spirit in German Art 1790-1990*, which is held at the Royal Scottish Academy and the FruitMarket Gallery in Edinburgh, the Hayward Gallery in London, and the Haus der Kunst in Munich.

1995 Baselitz's first retrospective at an American museum is organized by Diane Waldman for the Solomon R. Guggenheim Museum in New York. The exhibition will travel to Los Angeles, Washington, D.C., and Berlin. The artist continues to live and work in Derneburg and Imperia.

SELECTED BIBLIOGRAPHY

Entries in this bibliography give original sources, unless otherwise indicated. For publications accompanying exhibitions, see Selected Exhibition History. The Artist's Illustrated Books and Artist's Writings sections are arranged chronologically; all other sections follow alphabetical order.

Artist's Illustrated Books

Comte de Lautréamont [Isidore Ducasse]. *Die Gesänge des Maldoror*. Trans. Ré Soupault. Munich: Rogner & Bernhard, 1976. Supplement includes twenty gouaches and reprinted texts by Baselitz.

Baselitz, Georg. *Georg Baselitz: Zeichnungen zum Staßenbild* [sic, Strandbild] (exh. cat.). Cologne: Galerie Michael Werner, 1982. Text by Heribert Heere.

———. *Sächsische Motive* (exh. cat.). Berlin: Rainer Verlag; Berlin: Daadgalerie, 1985.

———. *Le sedia di Paolo* (exh. cat.). Florence: Salone Villa Romana, 1988.

———. *Georg Baselitz: Malelade*. Cologne: Michael Werner, 1990. Includes forty-one etchings and original text by Baselitz. In German.

Beckett, Samuel. *Bing*. Trans. Elmar Tophoven. Cologne: Galerie Michael Werner, 1991. Includes twenty-four etchings and one woodcut by Baselitz. In German.

Baselitz, Georg. *Winter*. San Francisco: Hine, 1993. Includes reprinted text by Joseph Brodsky and fourteen etchings and one woodcut by Baselitz.

Artist's Writings

with Schönebeck, Eugen. "Baselitz/Eugen Schönebeck" ["Pandämonisches Manifest I, 1. Version, 1961"] (Berlin, Oct. 1961). Poster published on the occasion of *Baselitz/Eugen Schönebeck: Bilder, Zeichnungen*, Schaperstrasse 22, am Fasanenplatz, Berlin, 1961. Revised poster published during the same event as "Baselitz/Sohoeneback [sic]" ["Pandämonisches Manifest I, 2. Version, 1961"] (Berlin, Nov. 1961). First version published in English as "Pandemonium 1: Berlin/November 1961," trans. David Britt. In *Georg Baselitz: Paintings 1960–83* (exh. cat.). London: Whitechapel Art Gallery, 1983, pp. 23–24.

with Schönebeck, [Eugen]. ["Pandämonisches Manifest II, 1962"] (Berlin, Feb. 1962). Poster. Published in English as "Pandemonium 2: Berlin/February 1962," trans. David Britt. In *Georg Baselitz: Paintings 1960–83* (exh. cat.). London: Whitechapel Art Gallery, 1983, pp. 24–25, 29.

"Lieber Herr W.!" (Berlin, Aug. 8, 1963). *Die Schastrommel* (Bolzano) 6 (March/April 1972), unpaginated. Published in English as "Letter to Herr W.: Berlin/8 August 1963," trans. David Britt. In *Georg Baselitz: Paintings 1960–83* (exh. cat.). London: Whitechapel Art Gallery, 1983, p. 32.

"Warum das Bild 'Die großen Freunde' ein gutes Bild ist!" (Berlin, 1965). Poster published on the occasion of *Baselitz*, Galerie Springer, Berlin, 1966. Published in English as "Why the Picture 'The Great Friends' is a Good Picture," trans. David Britt. In *Georg Baselitz: Paintings 1960–83* (exh. cat.). London: Whitechapel Art Gallery, 1983, p. 33.

"Vier Wände und Oberlicht" (lecture delivered on the occasion of Dortmunder Architekturtage zum Thema 'Museumsbauten,' Dortmund, April 26, 1979). *Neue Heimat-Monatshefte für neuzeitlichen Wohnungs- und Städtebau* (Hamburg) 26, no. 8 (1979), pp. 30–31. Published in English as "Four Walls and Skylight

or Rather No Picture on the Wall at All." In *Georg Baselitz: Works of the Seventies* (exh. cat.). New York: Michael Werner Gallery, 1992, unpaginated.

["Der Gegenstand auf dem Kopf"] (Derneburg, Dec. 12, 1981). In Stedelijk Museum, Amsterdam, *'60'80– Attitudes/Concepts/Images* (exh. cat.). Amsterdam: Van Gennep, 1982, pp. 88, 234. In English and German.

["Ich saß auf dem Stuhl . . ."] In *Documenta 7*, vol. 1 (exh. cat.). Kassel: Documenta, 1982, pp. 136, 437. In German and English.

"Die Skulptur ist ein Ding wie ein Wunder" (Derneburg, April 18, 1985). *Lo spazio umano* (Milan) 2 (April–June 1985), pp. 32–36. In German and Italian.

"Das Rüstzeug der Maler" (Derneburg, Dec. 12, 1985; lecture delivered at Rijksakademie van beeldende Kunsten, Amsterdam, Oct. 1, 1987; Royal Academy of Arts, London, Dec. 1, 1987 [organized by Anthony d'Offay Gallery, London]; École Nationale Supérieure des Beaux-Arts, Paris, Feb. 28, 1991; and Kunstmuseum Bonn, Sept. 22, 1992). Poster published on the occasion of each lecture, except Kunstmuseum Bonn. Published in English as liner notes, trans. Norbert Messler, in *Georg Baselitz: Das Rüstzeug der Maler/The Painters' Equipment* (recording of the lecture at Royal Academy of Arts). Cologne: Gachnang & Springer, 1987. Original handwritten German manuscript published in *Georg Baselitz: Neue Arbeiten* (exh. cat.). Cologne: Galerie Michael Werner, 1987, pp. 1–20. Reprinted in English in *Georg Baselitz*. Cologne: Benedikt Taschen, 1990, pp. 180–81.

"Holzschnitt" (Derneburg, June 22, 1986). In *Georg Baselitz: Hotzschnitte 1984–1986* (exh. cat.). Berlin: Galerie Springer; Vienna: Galerie Chobot Wien, 1986, unpaginated.

"Die gemalten Bilder wiegen mehr alls die fotografierten Fotos!" (Derneburg, March 6, 1987). *Das Magazin* (Zurich) 23 (June 11, 1994), p. 39.

["Lieber Herr!"] (Derneburg, March 21, 1988). In *Georg Baselitz: Dessins 1962–1992* (exh. cat.). Trans. Miguel Coutton. Paris: Musée National d'Art Moderne, Centre Georges Pompidou, 1993, pp. 62–63. In French.

["Wenn Sie sich ein Stück Papier auf dem Tisch vorlegen . . ."] (Derneburg, March 21, 1988). In *Georg Baselitz: Dessins 1962–1992* (exh. cat.). Trans. Miguel Coutton. Paris: Musée National d'Art Moderne, Centre Georges Pompidou, 1993, p. 5. In French.

"Wenn man sich als Maler . . ." (Derneburg, Oct. 4, 1988). Previously unpublished manuscript.

["Ciao America"] (Derneburg, Feb. 22, 1989). In *Hommage à Rudolf Springer* (exh. cat.). Cologne: Galerie Michael Werner, 1989, unpaginated. In German.

"Malelade" (Derneburg, May–June 1989). In *Malelade*. Cologne and New York: Michael Werner, 1990, unpaginated. In German. Published in English in *Georg Baselitz: Malelade* (exh. cat.). Trans. Joachim Neugroschel. Cologne: Galerie Michael Werner, 1990, unpaginated.

"Galerie Baselitz: 17 Bilder nebst einem Selbstgespräch" (Derneburg, July 7, 1989). *Du* (Zurich) 7 (July 1989), pp. 42–53.

"Ciao America/Ciao America" (Derneburg, Jan. 30, 1990), trans. David Britt. In *Recent Paintings by Georg Baselitz* (exh. cat.). London: Anthony d'Offay Gallery, 1990, pp. 5, 35. In English and German.

"Der Maler auf Reisen" (Derneburg, June 23, 1990). In *Malerei: Günter Evertz, Klaus Mertens, Paul Revellio, Wesson Rockwell, Annette Sandforth, Mira Wunderer* (exh. cat.). Berlin: Künstlerwerkstatt im Bahnof Westend, 1990, p. 5.

["Wenn Kinder zeichnen . . ."] (Derneburg, March 3, 1992), trans. Joachim Neugroschel. In *Georg Baselitz: Pastels, Watercolors, Drawings* (exh. cat.). New York: Matthew Marks Gallery, 1992, unpaginated.

"Ballsaison in Schweden" (Derneburg, Aug. 1992), trans. Joachim Neugroschel. In *Carl Frederick Hill: Ballsaison in Schweden/Carl Fredrik Hill: Ball Season in Sweden*. Format, vol. 14. Hellerup, Denmark: Edition Bløndal, 1994, pp. 6–10, 12–16, 18–21. Imaginary correspondence between C[arl] F[redrik] H[ill] and August [Strindberg] written by Baselitz.

"Zweimal Grün" (Derneburg, Sept. 29, 1992). In *Georg Baselitz: Radierungen und Holzschnitte 1991/92* (exh. cat.). Munich: Maximilian Verlag/Sabine Knust, 1992, unpaginated.

["Purzelbäume sind auch Bewegung, und noch dazu macht es Spaß"] (Derneburg, Oct. 1992; lecture delivered at *Münchner Podium in den Kammerspielen '92*, Munich, Nov. 8, 1992). Published as "Georg Baselitz: Purzelbäume sind auch Bewegung, und noch dazu macht es Spaß." In *Reden über Deutschland 3: Hans-Dietrich Genscher, Georg Baselitz, Günter Grass, Jiří Gruša, Péter Nádas, Wolfgang Schäuble*. Munich: Bertelsmann, 1992, pp. 35–51. (Publication also includes "Georg Baselitz," Norman Rosenthal's introductory remarks at *Münchner Podium in den Kammerspielen '92*, pp. 31–33.) Published in English as "Somersaults Are Also Movement—and They Are Fun as Well," trans. Paulette Møller. English supplement to *Baselitz Værker fra 1990–93*, a special issue of *Louisiana Revy* (Denmark) 33, no. 3 (May 1993), pp. 3–8.

["Mehrfach habe ich Richard Wagner als Frau gemacht . . ."] (Derneburg, Nov. 19, 1992), trans. Janneke van der Meulen. In *Harrison Birtwistle 1934: Punch and Judy, A Tragical Comedy or a Comical Tragedy Opera in One Act*. Amsterdam: De Nederlandse Opera Stichting, 1992, p. 33. Includes handwritten German manuscript. In Dutch.

["nicht Objekt no, . . ."] (Derneburg, Feb. 24, 1993). In *Georg Baselitz: nicht nee nee nee nicht no* (exh. cat.). Stommeln, Germany: Synagoge Stommeln, 1993, unpaginated.

["1965 war ich für halbes Jahr in Florenz"] (Derneburg, June 21, 1993). Published in French as "La genèse d'une collection d'estampes maniéristes italiennes," trans. H. Prouté. *Nouvelle de l'estampe* (Paris) 133 (March 1994), pp. 31–32.

"Fragen an mich" (Imperia, Italy, July 1993). Previously unpublished manuscript.

["Die groffen Entwistaas"] (Derneburg, Sept. 20, 1993). Published in English as "Reflections on the School of Fountainebleau," trans. Henri Zerner. In *The French Renaissance in Prints from the Bibliothèque Nationale de France* (exh. cat.). Los Angeles: Grunwald Center for the Graphic Arts, University of California, 1994, p. 13. Published in French as "Sur la Gravure et Fontainebleau," trans. Rainer Michael Mason. In *La Gravure Française à la Renaissance à la Bibliothèque nationale de France*. Los Angeles: Grunwald Center for the Graphic Arts, University of California, 1995, p. 13.

"Malen aus dem Kopf, auf dem Kopf oder aus dem Topf" (Derneburg, Nov. 25, 1993). Published in English and German as "Malen aus dem Kopf, auf dem Kopf oder aus dem Topf/Painting: Out of My Head, Head Downward, Out of a Hat," trans. David Britt. In *Georg Baselitz: Gotik—neun monumentale Bilder* (exh. cat.). Cologne: Galerie Michael Werner, 1994, pp. 24–25, 28–29.

"Angels and Gnomes—German Tribal Art/Engel und Zwerge—German Tribal Art" (Derneburg, June 17, 1994), trans. David Britt. In *Frau Paganismus: Georg Baselitz* (exh. cat.). London: Anthony d'Offay Gallery, 1994, pp. 11–13, 35–37.

Interviews and Statements

Dahlem, Franz. "Ein imaginäres Gespräch zwischen Baselitz, Dahlem und Pickshaus/An Imaginary Conversation between Baselitz, Dahlem and Pickshaus/Un entretien imaginaire entre Baselitz, Dahlem et Pickshaus," trans. Bernadette Martial, Norbert Messler, John Ormond, and Anne Trémeau-Böhm. In *Georg Baselitz*. Cologne: Benedikt Taschen, 1990, pp. 6–53.

Davvetas, Demosthène. "Tenir la mémoire à distance: interview de Georg Baselitz par Demosthène Davvetas." *Art Press* (Paris) 123 (March 1988), pp. 11–12.

———. "Georg Baselitz." *New Art* (Seaforth, Australia) 1/2 (May–June 1988), pp. 35–38.

Froment, Jean-Louis and Jean-Marc Poinsot. "Georg Baselitz: entretien avec Jean-Louis Froment et Jean-Marc Poinsot," trans. Jacqueline Angot. In *Baselitz: sculpture* (exh. cat.). Bordeaux: C.A.P.C. Musée d'Art Contemporain, 1983, pp. 9–22. Published in English as "An Interview with Georg Baselitz by Jean-Louis Froment and Jean-Marc Poinsot," trans. David Britt. In *Georg Baselitz: Sculpture and Early Woodcuts* (exh. cat.). London: Anthony d'Offay Gallery, 1988, unpaginated.

Gachnang, Johannes. "Johannes Gachnang: Een Gesprek Met Georg Baselitz/Johannes Gachnang: Ein Gespräch mit Georg Baselitz" (interview, Nov. 6, 1975), trans. Lieneke Leeman. In *Georg Baselitz: Tekeningen/Zeichnungen* (exh. cat.). Groningen: Groninger Museum, 1979, pp. 3–13.

Geldzahler, Henry. "Georg Baselitz" (interview, Derneburg, Oct. 19–20, 1983). *Interview* (New York) 14, no. 4 (April 1984), pp. 82–84. Reprinted as "Georg Baselitz." In Jeanne Siegel, ed. *Artword 2: Discourse on the Early 80s*. Ann Arbor, Mich.: UMI Press, 1988, pp. 93–103.

Gorella, Arwed D. "Der Fall Baselitz und das Gespräch von Arwed D. Gorella, Berlin." *Tendenzen* (Munich) 30 (Dec. 1964), unpaginated.

Grasskamp, Walter. "Converses amb els artistes: Georg Baselitz." In *Origen i visió: nova pintura alemanya* (exh. cat.). Barcelona: Fundació Caixa de Pensions, 1984, pp. 9–13.

Graw, Isabelle. "Malerbilder Ein Gespräch mit Georg Baselitz – von Isabelle Graw." *Artis* (Stuttgart) 42 (June 1990), pp. 30–35.

Hecht, Axel and Alfred Welti. "Ein Meister, der Talent verschmäht/Georg Baselitz: 'Avoid Harmony at All Costs.'" *Art* (Hamburg) 6 (June 1990), pp. 54–66, 70, 72; supplement, pp. 1–4.

Hunov, John. "Interview med Georg Baselitz." In *Georg Baselitz: grafik og malerier* (exh. cat.). Kastrup, Denmark: Tårnby Kommune Kastrupgårdsamlingen, 1981, pp. 4–5.

Kerchache, Jacques. "Entretien: Jacques Kerchache/Georg Baselitz." In *L'Art africain dans la collection de Baselitz* (exh. cat.). Paris: 4ème Salon International des Musées et des Expositions, 1994, pp. 5–32.

Koepplin, Dieter. "Georg Baselitz Über Die Nacht: Gespräch mit Dieter Koepplin/Georg Baselitz on 'Die Nacht': In Conversation with Dieter Koepplin," trans. Catherine Schelbert. *Parkett* (Zurich) 11 (1986), pp. 34–51.

———. "Georg Baselitz: 'Da Ich Kein Historienmaler Bin' Gespräch über '45' mit Dieter Koepplin." In *Georg Baselitz: 45*. Stuttgart: Cantz, 1991, pp. 9–33.

———. "Eine thematische 'Begründund' für das Bild, das ohnehim getan sein will—Bild, oder ist es 'Kunstgewerbe,' wie war das bei Matisse?: Georg Baselitz über seinen 'Vorhang Anna selbdritt' befragt in Derneburg am 6 February 1993" (interview, Derneburg, Feb. 6, 1993). In *Georg Baselitz: Der Vorhang "Anna selbdritt" von 1987, und die dazugehörigen Zeichnungen* (exh. cat.). Stuttgart: Cantz, 1993, pp. 45–51.

———. "Georg Baselitz: 'puisque je ne suis pas un peintre historique . . . ,'" trans. Jeanne Etoré. *Art Press* (Paris) 159 (June 1991), pp. 14–22.

———. "Erfunndere Bilder" (conversation with Baselitz on Munch). In *Edvard Munch: Sein Werk in Schweizer Sammlungen* (exh. cat.). Basel: Kunstmuseum Basel, 1985, pp. 145–70.

Krüger, Werner and Wolfgang Pehnt, eds. *Künstler im Gespräch*. Cologne: Artemedia Buch & Film, 1984, pp. 12–14.

Mason, Rainer Michael. "Une Analyse complémentaire." In *Georg Baselitz: Gravures 1963–1983* (exh. cat.). Geneva: Cabinet des Estampes, 1984, pp. 25–29. Includes statements by Baselitz from interview, Derneburg, May 19–20, 1984. Published in Spanish, French, and English as "Un Análsis Complementario/Une Analyse complémentaire/A Complementary Analysis," trans. Jean-Marie Clark, Anacleto Ferrer, Anna Montero, Carol Rankin, Françoise Senger, and Harry Smith. In *Georg Baselitz: Grabados/Gravures/Prints 1964–1990* (exh. cat.). Valencía: Institut Valencía d'Art Modern; Geneva: Cabinet des Estampes; London: Tate Gallery, 1991, pp. 9–13, 27–32, 45–50.

———. "La disciplina y el distanciamiento/La discipline et l'écart/Discipline and Divergence," trans. Jean-Marie Clark, Anacleto Ferrer, Anna Montero, Carol Rankin, Françoise Senger, and Harry Smith. In *Georg Baselitz: Grabados/Gravures/Prints 1964–1990* (exh. cat.). Valencía: Institut Valencía d'Art Modern; Geneva: Cabinet des Estampes; London: Tate Gallery, 1991, pp. 15–25, 33–43, 51–60. Includes statements by Baselitz from interview, Derneburg, Dec. 13, 1990 and Jan. 9–11, 1991.

Pillar, Micky. "Schilder Georg Baselitz: Talent is zeer hinderlijk." *Haagse Post* (The Hague) 66, no. 8 (Feb. 24, 1979), pp. 58–61.

Renard, Delphine. "Entretien: Georg Baselitz." *Beaux Arts* (Paris) 23 (April 1985), pp. 36–41.

Schwerfel, Heinz Peter. *Georg Baselitz im Gespräch mit Heinz Peter Schwerfel* (interview, Dec. 1988). Kunst Heute 2. Cologne: Kiepenheuer & Witsch, 1989.

Weisner, Ulrich. "Wechselbeziehungen im Prozess der Kunst: Nach Einem Gespräch mit Georg Baselitz." In *Georg Baselitz: Vier Wände* (exh. cat.). Bielefeld: Kunsthalle Bielefeld, 1985, pp. 7–32, 36. Essay based on interview

with Baselitz. Derneburg. May 8. 1985.

Weiss, Evelyn. "Evelyn Weiss: Gespräch mit Georg Baselitz im Schloß Derneburg am 22.6.75." In *XIII. Bienal de São Paulo 1975 República Federai da Alemanha: Georg Baselitz* (exh. cat.). Brazil: Bienal de São Paulo, 1975, unpaginated.

Articles and Essays

Ahrens, Klaus. "Bilder machen Bilder Kaputt." *Süddeutsche Zeitung Magazin* (Frankfurt) 12 (March 20, 1992), pp. 10–14, 16, 18.

Buttig. Martin G. "Der Fall Baselitz." *Der Monat* (Berlin) 17, no. 203 (Aug. 1965), pp. 90–95.

———. "Baselitz Case." *Censorship* (London), vol. 2, no. 1 (winter 1966), pp. 35–41.

Caldwell, John. "Baselitz in the Seventies: Representation and Abstraction/Baselitz in den siebziger Jahren: Gegenstand – Lichkeit und Abstraktion," trans. Elisabeth Brockmann. *Parkett* (Zurich) 11 (1986), pp. 84–97.

Calvocoressi, Richard. "A Source for the Inverted Imagery in Georg Baselitz's Painting." *The Burlington Magazine* (London) 127, no. 993 (Dec. 1985), pp. 894–99.

Collins, Matthew. "Georg Baselitz: Effluents and Inventions." *Artscribe* (London) 43 (Oct. 1983), pp. 20–25.

Darragon, Eric. "Opinione Contraria: Im Auge des Malers, Der Kopf Des Bildhauers/Opinione Contraria: In the Painter's Eyes the Sculptor's Head," trans. Mariette Müller and Catherine Schelbert. *Parkett* (Zurich) 11 (1986), pp. 52–59.

———. "Georg Baselitz," trans. Brian Holmes and Isabelle Kross. *Galeries Magazine* (Paris) 58 (Feb.–March 1994), pp. 68–77, 114. Photographs by Yves J. Hayat. In French and English.

De Ferrari, Gabriella. "The Art of Discord." *Mirabella* (New York), May 1992, pp. 56–61.

Dietrich-Boorsch, Dorothea. "The Prints of Georg Baselitz: An Introduction." *The Print Collector's Newsletter* (New York) 7, no. 6 (Jan.–Feb. 1982), pp. 165–67.

Dornberg, John. "The Artist Who Came in from the Cold." *ARTnews* (New York) 91, no. 8 (Oct. 1992), pp. 102–07.

Fuchs, Rudi. "Georg Baselitz." In *The Saatchi Collection Art of Our Time*, vol. 3. London: Lund Humphries, 1984, pp. 9–11.

———. "Baselitz: peintures." *Artstudio* (Paris) 2 (autumn 1986), pp. 34–47.

Gohr, Siegfried. "In the Absence of Heroes: The Early Work of Georg Baselitz," trans. Frederic J. Hosenkiel. *Artforum* (New York) 20, no. 10 (summer 1982), pp. 67–69.

———. "Georg Baselitz: Paintings Don't Come with Guarantees." *Flash Art* (Milan) 26, no. 171 (summer 1993), pp. 67–72.

Guidieri, Remo. "Georg Baselitz's Pastorale." *Arts Magazine* (New York) 60, no. 10 (summer 1986), pp. 35–37.

———. "Zwei horizontale Hälften nebenenander/Two Close Horizontal Moieties," trans. Martine Karnoouh-Vertalier and Elfriede Riegler. *Parkett* (Zurich) 11 (1986), pp. 28–33.

Heymer, Kay. "Georg Baselitz: Images Find New Nourishment in Complex Interferences," trans. Henry Martin. *Flash Art* (Milan) 152 (May–June 1990), p. 149.

"Klage und Qual: Baselitz-Prozess." *Der Spiegel* (Hamburg) 18, no. 26 (June 24, 1964), pp. 82–84.

Kosegarten, Antje. "Georg Baselitz: Visionen oder Provokationen eines Berliner Malers?" *Die Grünenthal Waage* (Stolberg) 5, nos. 4–5 (1966), pp. 180–85.

Kuspit, Donald B. "The Archaic Self of Georg Baselitz." *Arts Magazine* (New York) 58, no. 4 (Dec. 1983), pp. 76–77. Reprinted in Kuspit. *The New Subjectivism: Art in the 1980s.* Ann Arbor, Mich.: UMI Press, 1988, pp. 117–23.

———. "Pandemonium: The Root of Georg Baselitz's Imagery." *Arts Magazine* (New York) 60, no. 10 (summer 1986), pp. 24–29. Reprinted in Kuspit. *The New Subjectivism: Art in the 1980s.* Ann Arbor, Mich.: UMI Press, 1988, pp. 125–35.

Lloyd, Jill. "Georg Baselitz Comes Full Circle: The Art of Transgression and Restraint." *Art International* (Lugano) 5 (winter 1988), pp. 86–96.

Mason, Rainer Michael. "Zu Einem Frontispiz von Georg Baselitz/Notes on an Engraved Frontispiece by Georg Baselitz," trans. Elfriede Riegler and Peter Simmons. *Parkett* (Zurich) 11 (1986), pp. 60–68.

McEwen, John. "The Castle Where Art's About Face." *The Sunday Times Magazine* (London), March 17, 1985, pp. 44–52. Photographs by Snowdon.

Meyer, Franz. "Kampfmotive/Fight Motifs," trans. Peter Pasquill. *Parkett* (Zurich) 11 (1986), pp. 69–82.

Pincus-Witten, Robert. "Georg Baselitz: From Nolde to Kandinsky to Matisse. A Speculative History of Recent German Painting." *Arts Magazine* (New York) 60, no. 10 (summer 1986), pp. 30–34.

Saatchi, Doris. "The Painter and His Castle: The Surprising Surroundings Where Georg Baselitz Lives and Works." *House and Garden* (Los Angeles) 155, no. 12 (Dec. 1983), pp. 180–91. Photographs by Evelyn Hofer.

Winkler, Ralf. "Begegnungen mit Georg Baselitz." In *Krater und Wolke*, vol. 1. Cologne: Galerie Michael Werner, 1982, unpaginated.

Winter, Peter. "Georg Baselitz Comes Full Circle: The Painter-Prince's New Clothes." *Art International* (Lugano) 5 (winter 1988), pp. 97–100.

Woimant, Françoise. "Georg Baselitz: Gravures et sculptures." *Nouvelles de l'estampe* (Paris) 79 (March 1985), p. 5.

Monographs

Franzke, Andreas. *Georg Baselitz.* Trans. Ramón Ibero. Exhibition history compiled by Detlev Gretenkort. Barcelona: Ediciones Polígrafa, 1988. German edition. Munich: Prestel, 1988. French edition. Trans. Jeanne Etoré. Paris: Editions Cercle d'Art, 1988. English edition. Trans. David Britt. Munich: Prestel, 1989.

Georg Baselitz. Trans. Bernadette Martial, Norbert Messler, John Ormond, and Anne Trémeau-Böhm. Cologne: Benedikt Taschen, 1990. Text by Franz Dahlem and reprinted texts by Baselitz. In German, English, and French.

Georg Baselitz: Pastelle 1985–1990. Trans. Barbara Honrath and Catherine Schelbert. Bern-Berlin: Gachnang & Springer, 1990. Texts by Siegfried Gohr, Emil Maurer, and Diane Waldman. In German and English.

Koepplin, Dieter. *Georg Baselitz: 45.* Stuttgart: Cantz, 1991. Texts by Felix Baumann, Siegfried Gohr, Franz Meyer,

and interview by Koepplin. In German.

Hofmann, Werner. *La Bella Maniera: Druckgraphik des Manierismus aus der Sammlung Georg Baselitz*. Bern-Berlin: Gachnang & Springer, 1994. Texts by Werner Hofmann, Karin Orchard, Thomas Röske.

Jahn, Fred (in collaboration with Johannes Gachnang). *Baselitz: Peintre-Graveur: Werkverzeichnis der Druckgrafik*, vol. 1: *1963–1974*; vol. 2: *1974–1982*. Bern-Berlin: Gachnang & Springer, 1983; 1987.

Quinn, Edward. *Georg Baselitz: Eine fotografische Studie von Edward Quinn*. Trans. Ursula Rohrer and Hubertus von Gemmingen. Bern: Benteli, 1993.

Schulz-Hoffmann, Carla. *Georg Baselitz: Staatsgalerie moderner Kunst*. Stuttgart: Gerd Hatje, 1993.

Schwerfel, Heinz Peter. *Georg Baselitz im Gespräch mit Heinz Peter Schwerfel*. Kunst Heute 2. Cologne: Kiepenheuer & Witsch, 1989.

General Essays, Articles, and Books

Brock, Bazon. "The End of the Avant-garde? And So the End of Tradition: Notes on the Present 'Kulturkamp' in West Germany," trans. Frederick J. Hosenkiel. *Artforum* (New York) 19, no. 10 (June 1981), pp. 62–67.

Buchloch, Benjamin H. D. "Figures of Authority, Ciphers of Regression: Notes on the Return of Representation in European Painting." *October* (New York) 16 (spring 1981), pp. 39–68. Reprinted in Brian Wallis, ed. *Art After Modernism: Rethinking Representation*. Boston: David R. Godine, 1991, pp. 107–34.

Fuchs, R. H. "Chicago Lecture" (lecture, Chicago, March 13, 1984). *Tema Celeste* (Siracusa)19 (Jan.–March 1989), pp. 49–59.

Genscher, Hans-Dietrich, Georg Baselitz, et al. *Reden über Deutschland 3*. Munich: Bertelsmann, 1992.

Gohr, Siegfried. "The Situation and the Artists." *Flash Art* (Milan) 106 (Feb.–March 1982), pp. 38–46.

Kuspit, Donald B. "Acts of Aggression: German Painting Today, Part II." *Art in America* (New York) 71, no. 1 (Jan. 1983), pp. 90–101, 131–35.

———. "Sincere Cynicism: The Decadence of the 1980s." *Arts Magazine* (New York) 65, no. 3 (Nov. 1990), pp. 60–65.

———. "Mourning and Melancholia in German Neo-Expressionism: The Representation of German Subjectivity." In Ingebort Hoesterey and Ulrich Weisstein, eds. *Intertextuality: German Literature and Visual Art from the Renaissance to the Twentieth Century*. Columbia, S.C.: Camden House, 1993, pp. 81–99.

Marcellis, Bernard. "German Painters." *Domus* (Milan) 616 (April 1981), pp. 54–55. In English and Italian.

Pohlen, Annelie. "Irony, Rejection and Concealed Dreams: Some Aspects of 'Painting' in Germany." *Flash Art* (Milan) 94–95 (Jan.–Feb. 1980), pp. 17–18.

Roditi, Edouard. "Germany: The New 'Ecole de Berlin.'" *Arts Magazine* (New York) 39, no. 10 (Sept.–Oct. 1965), pp. 45–47.

Russell, John. "The New European Painters." *The New York Times Magazine* (New York), April 24, 1983, pp. 28–33, 36–40, 42, 71–72, 74–75.

SELECTED EXHIBITION HISTORY

Exhibition reviews are listed under the exhibition to which they refer.

Solo and Two-Person Exhibitions

Berlin, Schaperstrasse 22 (organized by Baselitz and Eugen Schönebeck), *Baselitz/Eugen Schönebeck: Bilder, Zeichnungen.* Nov. 10–30, 1961. Two versions of a printed manifesto, with texts by Baselitz and Schönebeck.

Berlin, Galerie Werner & Katz. *Baselitz.* Oct. 1–25, 1963. Exhibition catalogue, with foreword by Herbert Read and essays by Martin G. Buttig and Edouard Roditi. In German.

—"Keine gerichtlichen Schritte gegen Baselitz-Bilder." *Der Tagesspiegel* (Berlin), Oct. 5, 1963, p. 1.

—Ohff, Heinz. "Beim Namen genannt: Georg Baselitz zur Eröffnung der Galerie Werner und Katz." *Der Tagesspiegel* (Berlin), Oct. 3, 1963, p. 4.

—O[hff], H[einz]. "Eine Frage für den Staatsanwalt: Zur Auseinandersetzung über die Ausstellung Georg Baselitz in der Galerie Werner & Katz." *Der Tagesspiegel* (Berlin), Oct. 4, 1963, p. 4.

Berlin, Freie Galerie. *G. Baselitz: Ölbilder, Gouacher, Zeichnungen 1959–64.* Sept. 12–Oct. 8, 1964.

Berlin, 1. Orthodoxer Salon, Galerie Michael Werner. *G. Baselitz: Oberon.* opened June 27, 1964.

Berlin, Galerie Michael Werner. *Georg Baselitz: Radierungen 1964.* opened Sept. 13, 1964.

Berlin, Galerie Michael Werner. 1965.

Munich, Galerie Friedrich & Dahlem. *Baselitz: Oelbilder und Zeichnungen.* June 25–Aug. 4, 1965. Exhibition catalogue.

Berlin, Galerie Springer. *Baselitz.* Jan. 29–Feb. 12, 1966. Exhibition flyer, with text by Baselitz. In German.

Badenweiler, Germany, Wandelhalle des Markgrafenbades, Kurbuchhandlung Krohn. *Georg Baselitz: Aquarelle, Zeichnungen, Graphik.* Sept. 17–Oct. 20, 1966.

Baden-Baden, Staatliche Kunsthalle Baden-Baden. *14 mal 14. Junge deutsche Künstler* (with Dieter Haack), May 17–May 26, 1968. Exhibition catalogue, with essay by Klaus Gallwitz.

Zurich, Galerie Obere Zäune. *Georg Baselitz: Gemäldeausstellung.* May 21–June 11, 1968.

Erlangen, Galerie Beck. *Georg Baselitz: Bilder, Zeichnung, Grafik.* Oct. 29–Nov. 29, 1969.

Berlin, Galerie Gerda Bassenge. *Zeichnungen der Künstler: Georg Baselitz, Osthofen.* Nov. 21–30, 1969.

Munich, Galerie Heiner Friedrich. *Georg Baselitz.* opened Jan. 13, 1970.

Basel, Kunstmuseum Basel. *Georg Baselitz: Zeichnungen.* April 11–May 19, 1970. Exhibition catalogue, with foreword by Dieter Koepplin and reprinted text by Baselitz.

Stuttgart, Galerie Berner. *Georg Baselitz.* opened Oct. 10, 1970.

Cologne, Franz Dahlem. *Georg Baselitz.* Oct. 12–20, 1970.

Antwerp, Wide White Space Gallery. *Georg Baselitz: Tekeningen en Schilderijen.* Nov. 7–Dec. 3, 1970. Exhibition catalogue, with reprinted foreword by Dieter Koepplin.

Heidelberg, Galerie Rothe. *Georg Baselitz: Aquarelle, Zeichnungen, Radierungen 1961–1971.* March 12–April 18, 1971.

Cologne, Galerie Thomas Borgmann. *Zeichnungen.* Nov. 15–Dec. 8, 1971.

Cologne, Galerie Tobiès & Silex. *Georg Baselitz: Bilder 1962–1970.* Dec. 22, 1971–Feb. 28, 1972. Exhibition catalogue.

—Thwaites, John Anthony. "Cologne." *Art + Artists* (London) 7, no. 2 (May 1972), pp. 52–53.

Karlsruhe, Galerie Grafikmeyer, *Georg Baselitz: Zeichnungen*, Feb. 18–March 30, 1972.

Mannheim, Städtische Kunsthalle Mannheim, *Georg Baselitz: Gemälde und Zeichnungen*, March 17–April 16, 1972. Exhibition catalogue, with foreword by Heinz Fuchs.

Hamburg, Kunstverein Hamburg, *Georg Baselitz*, April 22–May 14, 1972. Exhibition catalogue, with essay by Günther Gercken. In German.

Munich, Galerie Heiner Friedrich, *Georg Baselitz*, June–July 1972.

Cologne, Galerie Rudolf Zwirner, *Georg Baselitz: Bilder 1964–72*, Sept. 9–30, 1972.

Munich, Staatliche Graphische Sammlung, *Georg Baselitz: Zeichnungen und Radierungen 1960–1970*, Oct. 5–Nov. 5, 1972. Exhibition catalogue, with essay by H. P[ée].

Frankfurt, Galerie Loehr (Alt Niederursel), *Georg Baselitz: Bilder 1959–1969*, Oct. 18–Nov. 25, 1972; Galerie Loehr (Goethestraße), *Georg Baselitz: Radierungen 1964–1972*, Oct. 25–Nov. 25, 1972.

Amsterdam, Galerie im Goethe–Institut/Provisorium, *Baselitz (Portretten)*, Nov. 20–Dec. 22, 1972.

Frankfurt, Galerie Loehr, *Georg Baselitz: Bilder, Zeichnungen, Graphik 1959–1969*, opened April 29, 1973.

Hamburg, Galerie Neuendorf, *Georg Baselitz: Ein neuer Typ, Bilder 1965/66*, May–June 1973. Exhibition catalogue, with essay by Günther Gercken and reprinted excerpts from text by Baselitz.

Munich, Verlagsräume Mosel, *Georg Baselitz: Arbeiten auf Papier, 1964–1973*, July 17–Aug. 24, 1973.

Vienna, Galerie Grünangergasse 12, *Georg Baselitz: Zeichnungen*, Nov. 6–25, 1973.

Cologne, Heiner Friedrich, *Georg Baselitz*, March 8–30, 1974.

Ravensburg, Städtische Galerie Altes Theater, *Georg Baselitz: Bilder und Zeichnungen*, May 10–June 3, 1974.

Leverkusen, Schloß Morsbroich, Städtisches Museum, *Georg Baselitz: Radierungen 1963–1974, Holzschnitte 1966–1967*, July 19–Sept. 1, 1974. Exhibition catalogue, with foreword by Rolf Wedewer, essay by Fred Jahn, and reprinted essay by Mircea Eliade.

Munich, Galerie Heiner Friedrich, *Georg Baselitz: Adler, Mappe mit 11 Radierungen, Holzschnitten und Holzstichen*, opened Feb. 6, 1975. Exhibition catalogue.

Cologne, Galerie Michael Werner, *Georg Baselitz: Zeichnungen 1960–1974*, Feb. 19–March 20, 1975. Exhibition catalogue.

Frankfurt, Galerie Loehr, *Baselitz: Neue Zeichnungen – Neue Radierungen*, Sept. 10–Oct. 11, 1975.

Karlsruhe, Galerie Grafikmeyer, *Georg Baselitz: Radierungen 1964–1966*, opened Dec. 5, 1975.

Bern, Kunsthalle Bern, *Georg Baselitz: Malerei, Handzeichnungen, Druckgraphik*, Jan. 24–March 7, 1976. Exhibition catalogue, with foreword by Johannes Gachnang and essay by Theo Kneubühler.

Munich, Galerieverein München and Staatsgalerie Moderner Kunst, *Georg Baselitz*, April 1–May 9, 1976. Exhibition catalogue, with essays by Carla Schulz-Hoffmann, Günther Gerken, and Johannes Gachnang. In German.

Cologne, Galerie Heiner Friedrich, *Georg Baselitz: Bilder und Zeichnungen*, June 24–Aug. 1, 1976.

Cologne, Kunsthalle Köln, *Georg Baselitz: Gemälde, Handzeichnungen, Druckgraphik*, June 25–Aug. 8, 1976. Exhibition catalogue, with foreword by Horst Keller and essays by Franz Dahlem, Siegfried Gohr, and Dieter Koepplin.

Hamburg, Kunstverein Hamburg, *Georg Baselitz: Adler–Grafiken, Probedrucke, Zeichnungen*, June 26–July 25, 1976.

Vienna, Galerie Heike Curtze, *Georg Baselitz*, March 2–July 15, 1977.

Munich, Galerie Heiner Friedrich, *Georg Baselitz: Druckgraphik 1976/77*, April 1977.

Basel, Galerie Elisabeth Kaufmann, *Baselitz: Der neue Typ*, Aug. 20–Sept. 17, 1977.

Cologne, Galerie Heiner Friedrich, *Georg Baselitz*, Sept. 9–Oct. 11, 1977.

Amsterdam, Galerie Helen van der Meij, *Georg Baselitz: Schilderijen/Tekeningen*, May 27–June 30, 1978.

Cologne, Galerie Heiner Friedrich, *Georg Baselitz: Neue Arbeiten*, Sept. 23–Oct. 21, 1978.

Eindhoven, Van Abbemuseum, *Georg Baselitz: Bilder, 1977–1978*, Feb. 23–April 2, 1979. Exhibition catalogue, with essay by R. H. Fuchs. In German and English.

Groningen, Groninger Museum, *Georg Baselitz: Tekeningen/Zeichnungen*, Feb. 24–March 18, 1979. Exhibition catalogue, with foreword by Frans Haks and interview by Johannes Gachnang. In Dutch and German, trans. Lieneke Leeman.

Paris, Galerie Nancy Gillespie–Elisabeth de Laage, *Georg Baselitz*, March 17–April 20, 1979.

Munich, Galerie Heiner Friedrich, *Georg Baselitz: Neue Zeichnungen*, May 3–June 2, 1979.

Cologne, Josef-Haubrich-Kunsthalle, *Georg Baselitz: 32 Linolschnitte aus den Jahren 1976 bis 1979*, July 7–Aug. 12, 1979. Traveled to Eindhoven, Van Abbemuseum, Feb. 20–April 5, 1981. Exhibition catalogue, with essays by Siegfried Gohr and Fred Jahn.

Amsterdam, Galerie Helen van der Meij, *Georg Baselitz: Linoleumsneden*, Oct. 9–Nov. 7, 1979.

Munich, Galerie Heiner Friedrich, *Georg Baselitz: Linolschnitte aus den Jahren 1976 bis 1979*, Nov. 2, 1979–Jan. 12, 1980.

Cologne, Galerie Heiner Friedrich, *Georg Baselitz*, March–April 1980.

Berlin, Galerie Springer, *Georg Baselitz: Monumentale Linolschnitte 1976–1979*, April 9–17, 1980.

London, The Whitechapel Art Gallery, *Georg Baselitz: Model for a Sculpture (with M. Beckmann)*, Nov. 13, 1980–Jan. 11, 1981.
 —Feaver, William. "The World: London, Pointillism, Plein Air and Piggybacks." *ARTnews* (New York) 80, no. 2 (Feb. 1981), pp. 201, 203.

Paris, Gillespie-Laage-Salomon, *Georg Baselitz*, Nov. 22, 1980–Jan. 7, 1981.

Kastrup, Tårnby Kommune Kastrupgårdsamlingen, *Georg Baselitz: Grafik og malerier*, Jan. 17–March 1, 1981. Exhibition catalogue, with interview by John Hunov and reprinted essay by Per Kirkeby.

Cologne, Galerie Michael Werner, *Georg Baselitz: Straßenbild 1979/80*, Feb. 2–28, 1981.

Düsseldorf, Galerie Heike Curtze, *Georg Baselitz: Druckgraphik von 1972–1981*, May 29–June 14, 1981.

Düsseldorf, Städtische Kunsthalle Düsseldorf, *Georg Baselitz/Gerhard Richter*, May 30–July 5, 1981. Exhibition catalogue, with essay by Jürgen Harten.

Munich, Fred Jahn, *Georg Baselitz: Malerei auf Papier, 1977*, Oct. 1–15, 1981.

Braunschweig. Kunstverein Braunschweig. *Baselitz*. Oct. 3–Nov. 29, 1981. Exhibition catalogue, with foreword by Jürgen Schilling, reprinted essays by Martin G. Buttig, Franz Dahlem, Heinz Fuchs, Rudi H. Fuchs, Johannes Gachnang, Theo Gachnang, Klaus Gallwitz, Günther Gercken, Siegfried Gohr, Per Kirkeby, Dieter Koepplin, Antje Kosegarten, Herbert Pée, A. R. Penck, Carla Schulz-Hoffmann, and Evelyn Weiss, and reprinted text by Baselitz. In German.

Munich. Galerie Biedermann/Fred Jahn. *Georg Baselitz: Probedrucke und Zustandsfolgen zur Bäumemappe 1974 und zur Adlermappe 1974*, opened Oct. 13, 1981.

Zurich. Annemarie Verna. *Georg Baselitz: Linolschnitte 1977–1979*, Oct. 13–Nov. 14, 1981.

Amsterdam. Stedelijk Museum. *Georg Baselitz: Das Straßenbild*, Oct. 24, 1981–Jan. 10, 1982. Exhibition catalogue, with essay by Alexander van Grevenstein. In Dutch and English, trans. Patricia Wardle.

Cologne. Galerie Michael Werner. *Georg Baselitz: Neue Bilder*, Nov. 10–Dec. 20, 1981.
—Pohlen, Annelie. "Georg Baselitz, Michael Werner/Cologne," trans. John Garrett. *Flash Art* (Milan) 105 (Dec. 1981–Jan. 1982), pp. 58–59.

New York. Brooke Alexander. *Georg Baselitz: Selected Woodcuts, Etchings and Linoleum Cuts, 1976–1981*, Dec. 1–31, 1981.
—Blau, Douglas. "Georg Baselitz, Brooke Alexander." *Flash Art* (Milan) 106 (Feb.–March 1982), p. 56.

New York. Xavier Fourcade. *Georg Baselitz: New Paintings and Drawings 1979–1981*, Dec. 2, 1981–Jan. 9, 1982.
—Liebmann, Lisa. "Georg Baselitz." *Artforum* (New York) 20, no. 7 (March 1982), pp. 69–70.
—Kuspit, Donald B. "Georg Baselitz at Fourcade." *Art in America* (New York) 70, no. 2 (Feb. 1982), pp. 139–40.
—Russell, John. "The News Is All from West Germany." *The New York Times*, Dec. 11, 1981, section C, p. 26.

Amsterdam. Galerie Helen van der Meij. *Georg Baselitz: Schilderijen, Grafiek*, Jan. 12–Feb. 13, 1982.

New York. Sonnabend Gallery. *Georg Baselitz: Paintings*, March 6–27, 1982.
—Kramer, Hilton. "Neo-Expressionism of Georg Baselitz." *The New York Times*, March 26, 1982, p. 23.
—Kuspit, Donald. "Georg Baselitz." *Artforum* (New York) 22, no. 2 (Oct. 1983), pp. 75–76.

Cologne. Galerie Michael Werner. *Georg Baselitz: Zeichnungen zum Straßenbild* [sic, Strandbild], May 3–June 3, 1982. Exhibition catalogue, with essay by Heribert Heere.

Vienna. Galerie Nächst St. Stephan. *Georg Baselitz: Zeichnungen 1976–1981, Druckgraphik 1964–1981*, May 6–June 1, 1982.

Chicago. Chicago International Art Exposition (organized by Roger Ramsay Gallery, Chicago). *Georg Baselitz: Works on Paper 1962–1982*, May 9–13, 1982.

Chicago. Young Hoffman Gallery. *Georg Baselitz Paintings*, May 11–22, 1982.

London. Waddington Galleries. *Georg Baselitz*, Oct. 27–Nov. 20, 1982. Exhibition catalogue, with essay by Richard Calvocoressi.
—Collier, Caroline. "Georg Baselitz: Waddington Galleries." *Flash Art* (Milan) 110 (Jan. 1983), p. 66.
—Januszczak, Waldemar. "Two Exhibitions of Works by Georg Baselitz." *Studio International* (London) 196, no. 998 (Jan.–Feb. 1983), pp. 52–53.
—Morgan, Stuart. "Georg Baselitz, Paintings 1966–69 at Anthony d'Offay Gallery and Recent Paintings and Drawings at Waddington Gallery [sic]." *Artforum* (New York) 21, no. 6 (Feb. 1983), pp. 86–87.

Munich. Fred Jahn. *Georg Baselitz: 16 Holzschnitte, rot und schwarz, 1981/82*, Nov. 1982. Traveled to Cologne, Galerie Rudolf Zwirner, Dec. 1982. Exhibition catalogue, with essay by Per Kirkeby.

London. Anthony d'Offay Gallery. *Ruins, Strategies of Destruction in the Fracture Paintings of Georg Baselitz, 1966–1969*, Nov. 9–Dec. 3, 1982. Exhibition catalogue, with essay by Rafael Jablonka, trans. David Britt and Anne Seymour.
—Collier, Caroline. "Georg Baselitz: Waddington Galleries." *Flash Art* (Milan) 110 (Jan. 1983), p. 66.
—Januszczak, Waldemar. "Two Exhibitions of Works by Georg Baselitz." *Studio International* (London) 196, no. 998 (Jan.–Feb. 1983), pp. 52–53.
—Morgan, Stuart. "Georg Baselitz, Paintings 1966–69 at Anthony d'Offay Gallery and Recent Paintings and Drawings at Waddington Gallery [sic]." *Artforum* (New York) 21, no. 6 (Feb. 1983), pp. 86–87.

Berlin. Galerie Springer. *Georg Baselitz: Das Bild "Weiße Frau" 1989 und ausgewählte Graphiken 1963–1982*, Jan. 14–Feb. 1983.

Krefeld. Museum Haus Esters. *Georg Baselitz / A. R. Penck: Druckgraphik*, Jan. 16–Feb. 27, 1983. Exhibition catalogue, with essay by Gerhard Storck.

Cologne. Galerie Michael Werner. *Georg Baselitz: Holzplastiken*, Feb. 16–March 12, 1983. Exhibition catalogue, with essays by Andreas Franzke, R. H. Fuchs, and Siegfried Gohr.

Paris. Gillespie-Laage-Salomon. *Georg Baselitz: Tableaux Récents, Dessins et Linogravures*, Feb. 26–April 2, 1983.

Bordeaux. C.A.P.C. Musée d'Art Contemporain de Bordeaux. *Baselitz, Sculptures*, March 18–April 23, 1983. Exhibition catalogue, with essays by Jean-Louis Froment and interview by Froment and Jean-Marc Poinsot. In French, trans. Jacqueline Angot.

New York. Xavier Fourcade. *Georg Baselitz: Six Paintings 1965–1969, Four Paintings 1982–1983*, March 31–May 7, 1983. Exhibition catalogue, with acknowledgments by Xavier Fourcade.
—Bass, Ruth. "Georg Baselitz: Xavier Fourcade." *ARTnews* (New York) 82, no. 6 (summer 1983), p. 189.
—Russell, John. "Georg Baselitz and His Upside-Downs." *The New York Times*, April 8, 1983, section C, p. 23.

New York. Sonnabend Gallery. *Georg Baselitz*, May 19–June 18, 1983.
—Smith, Roberta. "Germanations." *The Village Voice* (New York), June 28, 1983, p. 97.

Akron. Akron Art Museum. *Georg Baselitz*, June 18–Aug. 28, 1983. Exhibition brochure, with essay by I. Michael Danoff.

London. Whitechapel Art Gallery. *Georg Baselitz: Paintings 1960–83*, Sept. 7–Oct. 30, 1983. Traveled to Amsterdam, Stedelijk Museum, Jan. 13–March 4, 1984; and Basel, Kunsthalle Basel, March 17–April 23, 1984. Exhibition catalogue, with foreword by Nicholas Serota, essay by Richard Calvocoressi, and reprinted texts by Baselitz, trans. David Britt. German edition, with additional foreword by Jean-Christoph Ammann, published by Kunsthalle

Basel. Dutch edition, with additional foreword by Edy de Wilde, published by Stedelijk Museum; in Dutch and English, trans. David Britt and Patricia Wardle.

Hamburg, Galerie Neuendorf Hamburg. *Georg Baselitz: Zeichnungen 1961–1983*, Sept. 12–Oct. 31, 1983. Exhibition catalogue, with essay by Günther Gercken and text by Franz Dahlem. In German and English; trans. David Britt.

New York, The Museum of Modern Art, *Monumental Prints by Georg Baselitz and Rolf Iseli*, Oct. 11, 1983–Jan. 3, 1984. Exhibition brochure, with essays by Audrey Isselbacher.
—Cohen, Ronny H. "'Monumental Prints.'" *Artforum* (New York) 22, no. 6 (Feb. 1984), p. 83.

Los Angeles, Los Angeles County Museum of Art. *Gallery 6: Georg Baselitz*, Nov. 10, 1983–Jan. 1, 1984. Traveled to Berkeley, University of California, University Art Museum, Jan. 21–March 3, 1984. Exhibition brochure, with preface by Stephanie Barron and essay by Andreas Franzke.
—Gardner, Colin. "An Obsession with Process." *Artweek* (San Jose) 14, no. 44 (Dec. 24, 1983), p. 16.

Munich, Fred Jahn, *Neue Druckgrafik von Georg Baselitz*, Nov. 25–Dec. 23, 1983.

Eindhoven, Van Abbemuseum (organized with Kunstmuseum Basel), *Georg Baselitz: Zeichnungen 1958–1983*, Jan. 28–Feb. 26, 1984. Traveled to Kunstmuseum Basel, March 20–May 6, 1984; Bonn, Städtisches Kunstmuseum, June 13–Aug. 26, 1984; Nürnberg, Norishalle, Kunsthalle Nürnberg, Sept.14–Nov. 4, 1984; Hannover, Kunstverein Hannover, Feb. 2–March 17, 1985; Karlsruhe, Badischer Kunstverein, May 16–June 23, 1985; and Berlin, Haus am Waldsee, July 6–Aug. 18, 1985. Exhibition catalogue, with essays by R. H. Fuchs and Dieter Koepplin.

Cologne, Galerie Michael Werner, *Georg Baselitz: Acht Bilder*, Feb. 6–March 3, 1984. Exhibition catalogue, with essay by Rafael Jablonka.

Paris, Gillespie-Laage-Salomon, *Georg Baselitz: Gravures 1964–1983*, March 17–April 25, 1984.

Munich, Galerie Fred Jahn, *Zeichnungen März 1984/Drawings March 1984: Georg Baselitz*, March 19–31, 1984.

New York, Mary Boone Gallery, *Georg Baselitz*, April 7–28, 1984. Exhibition catalogue, with essays by Klaus Kertess and Norman Rosenthal, co-published with Michael Werner.

Munich, Staatliche Graphische Sammlung, Neue Pinakothek, *Georg Baselitz: Druckgraphik/Prints/Estampes*, April 11–June 3, 1984. Traveled to Geneva, Cabinet des Estampes, Musée d'Art et Histoire, June 21–Sept. 2, 1984; Trier, Städtisches Museum Simeonstift, Jan. 18–Feb. 28, 1985; and Paris, Bibliothèque Nationale, in association with Galerie Mansart et Galerie Mazarine, Paris, March 22–May 12, 1985. Exhibition catalogue, with texts by Siegfried Gohr. In Dutch, French, German, and English editions, trans. Reinhard Rudolph and Odile Desmanges. French edition, *Georg Baselitz: Sculptures et gravures monumentales*, published by Bibliothèque Nationale, in association with Galerie Mansart et Galerie Mazarine, with essays by Marie-Cécile Miessner and Françoise Woimant and excerpts from texts by and interviews of Baselitz.

Cologne, Galerie Thomas Borgmann, *Georg Baselitz: Retrospektive 1960–1983, 40 Aquarelle, Gouachen, Zeichnungen*, May 3–June 30, 1984.

Freiburg, Kunstverein Freiburg, *Georg Baselitz: Druckgraphik*, Sept. 3–30, 1984.

Frankfurt, Galerie Herbert Meyer-Ellinger, *Georg Baselitz: Arbeiten auf Papier*, Sept. 13–Oct. 27, 1984.

Lyon, Artothèque, *Georg Baselitz (Xylographie 1974–1983, provenant des collections du Cabinet des Estampes, Genéve)*, Oct. 5–27, 1984. Exhibition catalogue, with reprinted essay by Rainer Michael Mason. In French and German.

London, Waddington Galleries, *Georg Baselitz*, Oct. 31–Nov. 24, 1984. Exhibition catalogue, with essay by Norman Rosenthal.

Vancouver, Vancouver Art Gallery, *Georg Baselitz*, Nov. 2, 1984–Jan. 2, 1985. Exhibition catalogue, with essay by Jo-Anne Birnie Danzker and reprinted texts by Baselitz, trans. Danzker.

Zwevegem-Otegem, Belgium, Deweer Art Gallery, *G. Baselitz: Werken op papier/Oeuvres sur papier/Works on Paper*, Nov. 17–Dec. 17, 1984. Exhibition catalogue, with essay by Jo Coucke. In Dutch and French.

Cologne, Galerie Michael Werner, *Georg Baselitz: Zehn Bilder*, Nov. 19–Dec. 22, 1984. Exhibition catalogue, with essay by Hilde Zaloscer.

Berlin, Daadgalerie, *Georg Baselitz: "Sächsische Motive", 54 Aquarelle (1971/75), Faksimiledruck im Originalformat*, Jan. 27–March 8, 1985. Traveled to Eindhoven, Van Abbemuseum, July 6–Aug. 25, 1985. Book illustrated by Baselitz published on the occasion of the exhibition.

Pittsburgh, Carnegie-Mellon University, College of Fine Arts, Hewlett Gallery, *Georg Baselitz: Selected Drawings 1978–1984*, Feb. 3–28, 1985.

Paris, Gillespie-Laage-Salomon, *Georg Baselitz: Peintures et Aquarelles*, March 20–April 20, 1985.

London, Anthony d'Offay Gallery, *Georg Baselitz: Paintings 1964–1967*, May 1–31, 1985. Exhibition catalogue, with foreword by Anthony d'Offay.

Munich, Maximilian Verlag/Sabine Knust, *Georg Baselitz: Holz- und Linolschnitte 1984/85*, July 4–Aug. 18, 1985.

Bielefeld, Kunsthalle Bielefeld, *Georg Baselitz: Vier Wände*, Sept. 1–Oct. 27, 1985. Traveled to Winterthur, Kunstmuseum Winterthur, Jan. 19–March 16, 1986. Exhibition catalogue, with interview by Ulrich Weisner.

Cologne, Galerie Thomas Borgmann, *Georg Baselitz: Arbeiten auf Papier 1961–1968*, Sept. 12–Nov. 2, 1985. Exhibition catalogue.

Boston, The Alpha Gallery, *Georg Baselitz: Selected Prints 1963–1985*, Nov. 9–Dec. 4, 1985. Exhibition catalogue, with essay by Joanna E. Fink.

Oldenburg, Oldenburger Kunstverein, *Baselitz: Graphik 1964–1985*, Dec. 8, 1985–Jan. 19, 1986.

New York, Mary Boone Gallery, *Georg Baselitz*, April 5–26, 1986.

Basel, Galerie Beyeler, *Georg Baselitz*, April 26–June 21, 1986. Exhibition catalogue, with essay by Franz Meyer. In German.

Belgrad, Muzej Savremene Umetnosti (organized with Obalne Galerije Piran and Galerija Loza Koper, Belgrad; Cankarjev Dom, Ljubljana; Galerije Grada, Zagreb; and Galerija Suvremene Umjetnosti, Yugoslavia), *Georg Baselitz, Slike & Akvareli 78–85*, May 8–June 22, 1986. Traveled to Galerije Grada, Sept. 11–Oct. 5, 1986; and Cankarjev Dom, June 26–Aug. 20, 1986. Exhibition catalogue, with essays by Zoran Gavric, Günther Gercken,

Andrej Medved, and Hilde Zaloscer, and reprinted texts by Baselitz. In Serbo-Croatian.

Salzburg. Galerie Thaddaeus Ropac. *Georg Baselitz: Zeichnungen, 1977–84*. July 24–Aug. 31, 1986. Exhibition catalogue.

Hovikodden. Henie-Onstad Kunstsenter. *Georg Baselitz: Kamp-Motiver*. Sept.–Oct. 1986. Exhibition catalogue, with essays by Per Hordenakk and Per Kirkeby. In Norwegian and German; trans. Peter Shield.

Vienna. Galerie Chobot. *Georg Baselitz: Holzschnitte 1984–1986*. Sept. 3–27, 1986. Exhibition catalogue, with text by Baselitz.

Goslar. Mönchehaus Museum für Moderne Kunst (organized with Van Abbemuseum, Eindhoven). *Georg Baselitz (Druckgraphik)*. Sept. 27–Dec. 7, 1986; Vienna. Galerie Heike Curtze. Oct. 15–Nov. 15, 1986; and Munich. Maximilian Verlag/Galerie Sabine Knust. Feb. 12–March 31, 1987. Exhibition catalogue, with essays by R. H. Fuchs and reprinted text by Baselitz, published by Van Abbemuseum.

Vienna. Wiener Secession. *Georg Baselitz: Bäume*. Oct. 15–Nov. 23, 1986. Exhibition catalogue, with essays by Herbert Hrachovec and Otmar Rychlk, and reprinted interview by Henry Geldzahler.

New York. Brooke Alexander. *Georg Baselitz: Early Prints and Drawings*. April 18–May 30, 1987.

Milan. Christian Stein. *Baselitz*. April 29–May 30, 1987.
 —de Sanna, Jole. "Georg Baselitz. Galleria Christian Stein." trans. Meg Shore. *Artforum* (New York) 26, no. 1 (Sept. 1987), pp. 139–40.

Minneapolis. First Bank Skyway Gallery. *Georg Baselitz: Paintings, Drawings, Prints, 1966–86 from the First Banks Collection*. May 1–Sept. 8, 1987.

Hannover. Kestner-Gesellschaft Hannover. *Georg Baselitz: Skulpturen und Zeichnungen 1985–1986*, May 15–June 28, 1987. Exhibition catalogue, with essays by Stephanie Barron, Eric Darragon, Andreas Franzke, Carl Haenlein, and A. M. Hammacher, and reprinted interview by Jean-Louis Froment and Jean-Marc Poinsot, trans. Henriette Beese and Eva Karcher.

Basel. Galerie Buchmann (organized by Galerie Neuendorf, Frankfurt). *Georg Baselitz: Adler*. June 2–Aug. 1, 1987. Traveled to Galerie Neuendorf. Sept. 10–Oct. 30, 1987. Exhibition catalogue, with essay by Günther Gercken. In German and English; trans. Eileen Martin.

Cologne. Museum Ludwig. *Georg Baselitz. Pastorale*. July 4–Aug. 16, 1987. Exhibition catalogue, with essays by R. H. Fuchs and Siegfried Gohr, and reprinted essays by A. M. Fischer and Remo Guidier. In German, trans. Norbert Messler.

Caen. Abbaye aux Dames. *Georg Baselitz: Estampes*. Sept. 18–Oct. 23, 1987. Exhibition catalogue, with essays by Patrick Krebs and Sylvie Zavatta, and reprinted text by Baselitz.

Karlsruhe. Galerie Meyer-Hohmeister. *Georg Baselitz: Fünf farbige Arbeiten auf Canson*. Oct. 17–Nov. 28, 1987. Exhibition catalogue, with essay by Andreas Franzke.

Cologne. Galerie Michael Werner. *Neue Arbeiten*. Nov. 13, 1987–Jan. 6, 1988. Exhibition catalogue, *Georg Baselitz*, with text by Baselitz. In German.

New York. Mary Boone Gallery. *Georg Baselitz*. Nov. 21–Dec. 23, 1987. Exhibition catalogue, with essay by Trevor Fairbrother, co-published with Michael Werner, 1987.
 —Heartney, Eleanor. "Georg Baselitz at Mary Boone Gallery." *Art in America* (New York) 76, no. 7 (July 1988), p. 134.
 —Kandel, Susan and Elizabeth Hayt-Atkins. "Georg Baselitz. Mary Boone." *ARTnews* (New York) 87, no. 3 (March 1988), p. 189.
 —K[uspit], D[onald]. "Georg Baselitz: Mary Boone Gallery." *Artforum* (New York) 26, no. 7 (March 1988), p. 134.
 —Russell, John. "Georg Baselitz." *The New York Times*, Dec. 4, 1987, section C, p. 28.

London. Anthony d'Offay Gallery. *Georg Baselitz: Sculpture and Early Woodcuts*, Dec. 2, 1987–Jan. 16, 1988. Exhibition catalogue, with foreword by Anthony d'Offay and reprinted interview by Jean-Louis Froment and Jean-Marc Poinsot, trans. David Britt.
 —Beaumont, Mary Rose. "Georg Baselitz. Anthony d'Offay Gallery." *Arts Review* (London) 39, no. 25 (Dec. 18, 1987), p. 886.
 —Ilse, Chrissie. "Georg Baselitz. Anthony d'Offay. London." *Flash Art* (Milan) 139 (March–April 1988), p. 120.

Tokyo. Akira Ikeda Gallery. *Georg Baselitz: Paintings*. Feb. 8–27, 1988. Exhibition catalogue, with reprinted essay by John Caldwell. In English and Japanese.

Madrid. Instituto Alemán de Madrid. *Georg Baselitz: Dibujos, grabados en metal y xilografías (1963–1982)*, Feb. 12–March 11, 1988. Traveled to Zamora. Casa de Cultura de Zamora. April 22–May 10, 1988; Leon, Sala de Exposiciones de la Obra Cultural. May 19–June 10, 1988; Brussels. Atelier Ste Anne, Nov. 15–Dec. 10, 1988; Milan. Goethe-Institute. Studio d'Arte Cannaviello. Feb. 23–April 2, 1989; Leverkusen. Museum Morsbroich Leverkusen. Sept. 6, 1989–Jan. 21, 1990; Salzburg. Rupertinum, Sept. 6–21, 1990; and Graz. Kulturhaus Graz, March 5–April 7, 1991. Exhibition catalogue, with essays by Georg Reinhardt and reprinted text by Baselitz. In German.

Florence. Salone Villa Romana. *La Sedia di Paolo*. April 28–June 10, 1988. Book illustrated by Baselitz published on the occasion of the exhibition.

Florence. Sala d'Arme di Palazzo Vecchio. *Georg Baselitz: Dipinti 1965–1987*, April 29–June 28, 1988. Traveled to Hamburg. Hamburger Kunsthalle. July 22–Sept. 4, 1988; and Ljubljana, Cankarjev Dom, June 16–Aug. 13, 1989. Exhibition catalogue, with essays by Demosthène Davvetas, Christos M. Joachimides, and Wieland Schmied, published by Electa, Milan, 1988. German edition includes additional essay by Werner Hofmann; in Italian and German.

Frankfurt am Main. Städtische Galerie im Städelschen Kunstinstitut Frankfurt am Main, *Georg Baselitz: Der Weg der Erfindung—Zeichnungen, Bilder, Skulpturen*. May 5–Aug. 14, 1988. Exhibition catalogue, with essay by Klaus Gallwitz, Ursula Grzechca-Mohr, and Kay Heymer, and reprinted texts by Baselitz.

Antibes. Château Grimaldi. Musée Picasso. *Georg Baselitz (Gravures)*. June 7–30, 1988.

Toledo, Ohio, The Toledo Museum of Art, *Georg Baselitz: Prints and Drawings from the Bareiss Collection*, Sept. 3–Dec. 31, 1988.
 —Kuspit, Donald. "Georg Baselitz: Toledo Museum of Art." *Artforum* (New York) 27, no. 8 (April 1989), pp. 169–70.
Bremen, Kunsthalle Bremen, *Georg Baselitz: Das Motiv, Bilder und Zeichnungen 1987–1988*, Sept. 18–Oct. 30, 1988. Exhibition catalogue, with essays by Annette Meyer Zu Eissen and Siegfried Salzmann, and reprinted text by Baselitz.
Paris, Galerie Laage-Salomon, *Georg Baselitz: Peintures récentes*, Oct. 15–Nov. 19, 1988.
Munich, Maximilian Verlag/Sabine Knust, *Georg Baselitz: Graphik 1988*, Dec. 1, 1988–Jan. 20, 1989. Exhibition catalogue.
Cologne, Galerie Michael Werner, *Hommage à Rudolf Springer*, April 3–9, 1989. Exhibition catalogue, with reprinted text by Baselitz. In German.
Basel, Kunstmuseum Basel, *Georg Baselitz: Zeichnungen und druckgraphische Werke aus dem Kupferstichkabinett Basel*, May 27–July 23, 1989. Traveled to Berlin, Staatliche Museen zu Berlin, Nationalgalerie Altes Museum, April 4–June 4, 1990; and Vienna, Graphische Sammlung Albertina, Feb. 21–April 20, 1992. Exhibition catalogue, with reprinted essays by Martin G. Buttig, R. H. Fuchs, Per Kirkeby, A. R. Penck, Wieland Schmied, and Carla Schulz-Hoffmann, and reprinted text by Baselitz.
Venice, California, L.A. Louver Gallery, *Georg Baselitz: Graphic Works 1966–1989*, Sept. 23–Oct. 21, 1989.
Boston, Mario Diacono, *Georg Baselitz*, Dec. 2–23, 1989. Exhibition brochure, with essay by Mario Diacono, trans. Marguerite Shore.
Bielefeld, Kunsthalle Bielefeld, *Georg Baselitz: Holzschnitt 1966–1989*, Dec. 3, 1989–Feb. 4, 1990. Traveled to Braunschweig, Herzog Anton Ulrich-Museum, May 17–July 1, 1990; and Ulm, Ulmer Museum, Sept. 22–Nov. 11, 1990. Exhibition catalogue, with essay by Ulrich Weisner and reprinted text by Baselitz, published by Cantz, Stuttgart, 1989.
Zurich, Galerie Kornfeld, *Georg Baselitz: Graphik der Jahre 1981–1989*, Dec. 6, 1989–Feb. 9, 1990.
Cologne, Galerie Michael Werner, *Georg Baselitz: 45*, Feb. 3–March 7, 1990. Exhibition catalogue, with essay by Siegfried Gohr. In German.
 —K[oether], J[utta]. "Georg Baselitz, Galerie Michael Werner." trans. Joachim Neugroschel. *Artforum* (New York) 28, no. 9 (May 1990), pp. 203–04.
Barcelona, Centre Cultura de la Fundació Caixa de Pensions (organized by Fundacíon Caja de Pensiones, Madrid), *Georg Baselitz*, Feb. 27–April 22, 1990; Madrid, Sala de Exposiciones de la Fundacíon Caja de Pensiones, May 17–July 15, 1990. Exhibition catalogue, with essays by Kay Heymer, Antoni Marí, and Kevin Power, reprinted essay by Rudi Fuchs, and bibliography by Detlev Gretenkort. In English and Spanish, trans. James Eddy, Victor Girona, Elena Heidepriem, Antoni Marí, Joana Martínez, Joan Olivar, and África Vidal.
New York, Michael Werner Gallery, *Georg Baselitz: "Hero Paintings."* March 2–April 14, 1990. Exhibition catalogue, with reprinted essay by Günther Gercken, trans. David Britt.
 —Mantegna, Gianfranco. "Georg Baselitz, Michael Werner." *ARTnews* (New York) 89, no. 7 (Sept. 1990), p. 153.
 —Smith, Roberta. "The Burden of Isolation, In Baselitz 'Hero' Paintings." *The New York Times*, March 30, 1990, section C, p. 24.
Berlin, Staatliche Museen zu Berlin, Nationalgalerie Altes Museum, *Georg Baselitz: Bilder aus Berliner Privatbesitz*, April 4–June 4, 1990. Exhibition catalogue, with essay by Dieter Koepplin.
New York, Hirschl & Adler Modern, *Georg Baselitz: Selected Drawings 1966–1984*, April 5–28, 1990.
London, Anthony d'Offay Gallery, *Recent Paintings by Georg Baselitz*, April 12–May 15, 1990. Exhibition catalogue, with essay by Norman Rosenthal and texts by Baselitz, trans. David Britt.
 —Hall, James. "Madonnas of the Machine Age." *Art International* (Paris) 12 (autumn 1990), pp. 63–66.
Zurich, Kunsthaus Zürich, *Georg Baselitz*, May 23–July 8, 1990. Traveled to Düsseldorf, Städtische Kunsthalle Düsseldorf, July 28–Sept. 9, 1990. Exhibition catalogue, with essays by Mario Diacono, Rudi Fuchs, Kevin Power, Harald Szeemann, and Michel Tournier, and reprinted essay by John Caldwell. In German, trans. Rut Blümel, Elisabeth Brockmann, Franz Kaiser, Dom-Schule, and Hellmut Waller.
 —Keyes, Norman Jr. "Georg Baselitz at the Kunsthaus." *Art In America* (New York) 79, no. 1 (Jan. 1991), pp. 145, 147.
New York, David Nolan Gallery, *Georg Baselitz: Prints 1964 to 1985*, June 2–July 25, 1990. Exhibition catalogue, with reprinted excerpts from a text by Baselitz, trans. David Britt.
Vendée, Les Sables–d'Olonne, Musée de l'Abbaye Sainte-Croix, *Georg Baselitz: Image*, June 16–Sept. 16, 1990. Exhibition catalogue, with essays by Eric Darragon, Yves Kobry, and Didier Ottinger, and reprinted texts by Baselitz. In French.
 —Ernould-Gandouet, Marielle. "Les Sables–d'Olonne: Georg Baselitz." *L'Oeil* (Lausanne) 420–21 (July–Aug. 1990), p. 113.
Munich, Maximilian Verlag/Sabine Knust, *Georg Baselitz: 18 Radierungen, 1989*, July 5–31, 1990. Exhibition catalogue, with reprinted essay by Joseph Brodsky.
London, Runkel-Hue-Williams and Grob Gallery, *Paintings/Bilder 1962–1988*, Sept. 19–Nov. 2, 1990. Exhibition catalogue, with essay by Barry Barker. In English and German, trans. Claus Runkel.
New York, The Pace Gallery (57th Street), *Georg Baselitz: Sculpture*, Oct. 19–Nov. 24, 1990; The Pace Gallery (Greene Street), *Forty Five*, Oct. 19–Dec. 1, 1990. Exhibition catalogue in two parts, *Georg Baselitz: The Women of Dresden*, with essay by Thomas McEvilley, and *Georg Baselitz: Forty Five*.
 —Balken, Deborah. "Georg Baselitz: Pace Uptown, Pace Greene Street." *ARTnews* (New York) 90, no. 1 (Jan. 1991), p. 144.
 —Hirsch, Faye. "Georg Baselitz." *Arts Magazine* (New York) 65, no. 5 (Jan. 1991), p. 85.
 —Ottmann, Klaus. "Georg Baselitz: Head of the German State." *Flash Art* (Milan) 156 (Jan.–Feb. 1991), p. 122.
 —Smith, Roberta. "Baselitz and the Aftermath of War." *The New York Times*, Oct. 26, 1990, section C, p. 30.

Salzburg, Rupertinum. *Georg Baselitz: Druckgraphik 1963 bis 1988*. Dec. 5, 1990–Feb. 24, 1991.

Parma, La Sanseverina, Galleria - Edizioni d'Arte. *Georg Baselitz: Opere recenti*, March 9–May 15, 1991. Exhibition catalogue, with essays by Mario Diacono and Elena Pontiggia.

Munich, Maximilian Verlag/Sabine Knust. *Georg Baselitz: Holzschnitte 1990*, Jan. 31–March 28, 1991. Exhibition catalogue, with essay by A. R. Penck.

Munich, Bayerische Vereinsbank, Palais Preysing. *Georg Baselitz: Druckgraphik 1985–1990*, March 12–April 14, 1991. Exhibition catalogue, with essay by Rainer Michael Mason.

Amsterdam, Stedelijk Museum. *Georg Baselitz: Zeichnungen und druckgraphische Werke aus dem Kuperstichkabinett Basel*, March 16–May 5, 1991. Exhibition catalogue, with reprinted essay by Dieter Koepplin.

New York, Brooke Alexander Editions. *Georg Baselitz: New Woodcuts and Lithographs*, April 3–May 25, 1991.

New York, The Museum of Modern Art. *Malelade by Georg Baselitz*, April 11–July 23, 1991. Exhibition brochure, with essay by Riva Castleman.

The Hague, Haags Gemeentemuseum. *Georg Baselitz: Malelade, 1990*, April 27–June 3, 1991.

Milan, Galleria del Credito Valtellinese. *Baselitz: Opere dalla collezione Ackermeier – Berlino*, May 8–July 20, 1991. Exhibition catalogue, with essays by Hartmut Ackermeier, Achille Bonito Oliva, Norman Rosenthal, and Harald Szeeman, published by Edizioni Bolis, Bergamo, 1991. In German, English, and Italian.

Basel, Galerie Buchmann. Art 22'91. *One Man Show – Georg Baselitz: Frühe Zeichnungen & Druckgraphik*, June 12–17, 1991.

Copenhagen, Statens Museum for Kunst. *Tema Baselitz*, June 27–Sept. 8, 1991. Exhibition catalogue, with essays by Villads Villadsen.

Hildesheim, Roemer & Pelizaeus-Museum. *Georg Baselitz: Malelade 1990*, Sept. 8–Oct. 20, 1991.

Geneva, Cabinet des Estampes, Musée d'Art et Histoire (organized with IVAM Centre Julio González, Valencia and Tate Gallery, London). *Georg Baselitz: Grabados/Gravures/Prints 1964–1990*, Sept. 12–Nov. 3, 1991. Traveled to IVAM Centre Julio González, Nov. 21, 1991–Jan. 19, 1992; Tate Gallery, July 15–Nov. 1, 1992. Exhibition catalogue, with essays by Jeremy Lewison and Rainer Michael Mason. In Spanish, French, and English, trans. Jean-Marie Clarke, Anacleto Ferrer, Anna Montero, Carol Rankin, Francoise Senger, and Harry Smith.
—Barter, Ruth. "England in Review." *Arts Magazine* (New York) 66, no. 5 (Jan. 1992), pp. 92–93.
—Burn, Guy. "Report: Prints." *Arts Review* (London) 44 (Aug. 1992), p. 348.

Gladbeck, Thomas-Morus-Akademie Bensberg, Bergisch Gladbach. *Auf der Suche nach dem Unverbrauchten: Georg Baselitz als Graphiker*, Oct. 10–Nov. 24, 1991. Exhibition catalogue, with essay by Georg Reinhardt.

London, Anthony d'Offay Gallery. *Hammergreen: New Paintings by Georg Baselitz*, Oct. 15–Nov. 23, 1991. Exhibition catalogue, with essay by Kevin Power.

Herford, Herforder Kunstverein, Pöppelmann-Gesellschaft (organized with Kunstverein Bremerhaven). *Georg Baselitz: Zeichnungen, Aquareile, Druckgraphik*, Oct. 19–Nov. 17, 1991. Traveled to Kunstverein Bremerhaven, Jan. 5–Feb. 2, 1992. Exhibition catalogue, with essay by Günther Gerken, published by Cantz, Stuttgart, 1991.

Hannover, Galerie Borkowski. *Baselitz: Holzschnitte/Radierungen*, Oct. 27–Dec. 14, 1991.

Cologne, Galerie Michael Werner. *Georg Baselitz: Neue Arbeiten*, Nov. 15–Dec. 31, 1991. Exhibition catalogue, with essay by Rudi Fuchs and text by Baselitz. In German and English.
—Koether, Jutta. "Georg Baselitz. Michael Werner." trans. Joachim Neugroschel. *Artforum* (New York) 30, no. 6 (Feb. 1992), pp. 130–31.

New York, Mary Boone Gallery. *Georg Baselitz: "The Zeitgeist Paintings."* Nov. 16–Dec. 21, 1991.

Cologne, Galerie Michael Werner. *Georg Baselitz: Malelade*, Jan. 7–31, 1992. Exhibition catalogue, with essay by Joachim Blüher and reprinted text by Baselitz. In German and English, trans. David Britt and Joachim Neugroschel.

Munich, Galerie Fred Jahn/Galerie Fred Jahn Studio. *Baselitz: Zeichnungen, Aquarelle, und Pastelle, 1983–1991*, Jan. 23–Feb. 29, 1992.

Naples, Lucio Amelio. *La Commedia dell'Arte: Georg Baselitz*, opened Feb. 28, 1992.

Paris, Ameliobrachot – Piece Unique. *Frau Aus dem Süden*, Feb. 28–April 28, 1992.

Basel, Museum für Gegenwartkunst. Öffentliche Kunstsammlung Basel, *Georg Baselitz: Probedrucke zweier Riesenholzschnitte*, March 12–April 20, 1992.

New York, The Pace Gallery. *Georg Baselitz: Recent Paintings*, March 20–April 18, 1992. Exhibition catalogue, with essay by Michael Brenson.
—Grimes, Nancy. "Georg Baselitz, Pace." *ARTnews* (New York) 91, no. 6 (summer 1992), p. 121.
—Kuspit, Donald. "Georg Baselitz. Matthew Marks, The Pace Gallery, Michael Werner." *Artforum* (New York) 31, no. 1 (Sept. 1992), pp. 93–94.

Munich, Kunsthalle der Hypo-Kulturstiftung. *Georg Baselitz: Retrospektive 1964–1991*, March 20–May 17, 1992. Traveled to Edinburgh, Scottish National Gallery of Modern Art, May 30–July 12, 1992; and Vienna, Museum Moderner Kunst Stiftung Ludwig Wien, July 23–Sept. 13, 1992. Exhibition catalogue, with essays by Siegfried Gohr, Lóránd Hegyi, and Carla Schulz–Hoffmann.
—Henry, Clare. "Scotland." *Arts Review* (London) 44 (July 1992), p. 273.

New York, Michael Werner Gallery. *Georg Baselitz: Works of the Seventies*, April 25–June 12, 1992. Exhibition catalogue, with reprinted text by Baselitz, trans. Joy Fischer.
—Mahler, Bettina. "Germany in Review." *Arts Magazine* (New York) 66, no. 7 (March 1992), pp. 93–94.

New York, Matthew Marks Gallery. *Georg Baselitz: Pastels, Watercolors, Drawings*, May 2–June 26, 1992. Exhibition catalogue, with essay by Franz Dahlem and reprinted text by Baselitz, trans. Joachim Neugroschel.
—Kuspit, Donald. "Georg Baselitz, Matthew Marks, The Pace Gallery, Michael Werner." *Artforum* (New York) 31, no. 1 (Sept. 1992), pp. 93–94.

Passau, Museum Moderner Kunst. *Georg Baselitz: Druckgraphik 1963–1991*, June 14–Sept. 20, 1992.

Basel, Galerie Beyeler. *Georg Baselitz*, June 17–22, 1992. Exhibition catalogue, with essay by Werner Schmalenbach.

In German and English, trans. Isabel Feder.

Aachen, Ludwig Forum für International Kunst. *Georg Baselitz: Die Aachener Zeichnungen, 1958–1976/Das Pandömonische Manifest 1961/1962*. June 18–Aug. 30, 1992. Traveled to Lisbon, Centro de Arte Moderna da Fundação Calouste Gulbenkian, April 15–June 27, 1993. Exhibition catalogue, with essay by Wolfgang Becker and reprinted texts by Baselitz. In German and Portugese.

Hannover, Galerie Borkowski. *Art actuell 1 – George Baselitz: Aquatinten und Holzschnitte*, Aug. 18–26, 1992.

Frankfurt am Main, Galerie Springer & Winckler. *Georg Baselitz: Arbeiten auf Papier 1964–1988*, Sept. 1–Oct. 10, 1992.

Paris, Galerie Laage-Salomon. *Georg Baselitz: Malelade, 1990*, Feb. 22–March 14, 1992.

Kaiserslautern, Pfalzgalerie Kaiserslautern. *Georg Baselitz: Malelade, 1990*, March 10–April 20, 1992.

Basel, Galerie Beyeler. *Georg Baselitz*, Oct. 17–Dec. 31, 1992. Exhibition catalogue, with essay by Werner Schmalenbach. In German.

Munich, Maximilian Verlag/Sabine Knust. *Baselitz: Winter – Ein Buch mit 14 Aquatinten und einem Gedicht von Joseph Brodsky*, Oct. 22–Nov. 10, 1992.

Malmö, Malmö Konsthall. *Georg Baselitz: Grafik och Skulpture*, Feb. 13–March 21, 1993. Exhibition catalogue, with essays by Jeremy Lewison and Rainer Michael Mason.

Tel Aviv, Tel Aviv Museum of Art. *Georg Baselitz: Malelade, A Book of Etchings*, Feb. 23–April 13, 1993.

Munich, Galerie Fred Jahn. *Baselitz: Anna, Jutta, Wanda, Bruna, Martha, Olga, Lena, Hanna – acht Bilder von 1992*, March 11–31, 1993.

Stommeln, Synagoge Stommeln. *Georg Baselitz: nicht nee nee nee nicht no*, March 21–July 31, 1993. Exhibition catalogue, with essay by Siegfried Gohr and text by Baselitz.

Humlebaek, Denmark, Louisiana Museum of Modern Art. *Baselitz Værker fra 1990–93*, May 20–Aug. 29, 1993. *Louisiana Revy* (Denmark) 33, no. 3 (May 1993) published on the occasion of the exhibition, with texts by Baselitz, essays by Eric Darragon and Heinrich Heil, and English summary of texts by Uffe Harder. In Swedish and English; trans. Hans Christian Fink, Frants Iver Gundelach, Paulette Møller, and Herbert Zeichner.

Sundern, Kulturring Sundern. *Georg Baselitz: Druckgraphik 1989–1992*, May 26–July 17, 1993.

Basel, Kunstmuseum Basel. *Der Vorhang "Anna selbdritt" von 1987 und die dazugehörigen Zeichnungen*, June 5–Aug. 29, 1993. Exhibition catalogue, with essay and interview by Dieter Koepplin, published by Cantz, Stuttgart, 1993.

Karlsruhe, Städtische Galerie im PrinzMaxPalais Karlsruhe. *Georg Baselitz: Gemälde, Schöne und häßliche Porträts*, June 12–Sept. 26, 1993. Traveled to Linz, Neue Galerie der Stadt Linz, Oct. 1–Dec. 12, 1993. Exhibition catalogue, with essays by Eric Darragon, Andreas Franzke, Peter Gorsen, Alexander Jakimovic, Didier Ottinger, Kevin Power, Sean Rainbird, Erika Rödiger-Diruf, and Ulrich Weisner, trans. Klaus Englert and Andrew Jenkins.

Paris, Galerie Montenay. *Georg Baselitz*, Sept. 30–Oct. 30, 1993.
—Vedrenne, Elisabeth. "Baselitz: Sens dessus dessous." *Beaux Arts* (Paris) 116 (Oct. 1993), pp. 52–57.

Paris, Galerie Daniel Templon. *Hommage à Georg Baselitz*, Oct.12–Nov. 20, 1993. Exhibition catalogue.

Paris, Musée National d'Art Moderne, Centre Georges Pompidou. *Georg Baselitz: Dessins 1962–1992*, Oct. 12, 1993–Jan. 2, 1994.
—Vedrenne, Elisabeth. "Baselitz: Sens dessus dessous." *Beaux Arts* (Paris) 116 (Oct. 1993), pp. 52–57.

New York, The Pace Gallery. *Georg Baselitz: Paintings and Sculpture*, Dec. 3, 1993–Jan. 8, 1994. Exhibition catalogue. Traveled to Saarbrücken, Saarland Museum, as *Georg Baselitz: Werke von 1981–1993*, Feb. 13–April 4, 1994. Exhibition catalogue, with essays by Heinrich Heil and Ernest W. Uthemann, and reprinted text by Baselitz.

Seoul, Korea, Gana Art Gallery. *Georg Baselitz*, Dec. 4–18, 1993. Exhibition catalogue, with essay by Franz Meyer and reprinted text by Baselitz. In Korean.

Barcelona, Edicions T Galeria d'Art. *Georg Baselitz: Aiguatintes i xilografies*, Dec. 15, 1993–Feb. 1994.

Hamburg, Hamburger Kunsthalle. *Georg Baselitz: Skulpturen*, Feb. 17–April 17, 1994. Exhibition catalogue, with essay by Uwe M. Schneede, published by Cantz, Stuttgart, 1994.

Hannover, Galerie Borkowski. *Georg Baselitz: Zeichnungen, Graphiken*, March 6–April 23, 1994.

Cologne, Galerie Michael Werner. "*Gotik – neun monumentale Bilder*," March 19–April 23, 1994. Exhibition catalogue, with text by Baselitz.

London, Anthony d'Offay Gallery. *Frau Paganismus*, June 2–July 30, 1994. Exhibition catalogue, with essay by Heinrich Heil and text by Baselitz. In English, trans. David Britt.

Mosigkau, Museum Schloß Mosigkau. *Georg Baselitz: Frühe und neuere graphische Arbeiten*, June 24–July 24, 1994.

Tampere, Sara Hildénin Taidemuseo. *Georg Baselitz: Grafiikkaa vuosilta 1965–1992*, Sept. 9–Oct. 30, 1994. Exhibition catalogue, with essay by Götz Adriani.

New York, Michael Werner Gallery. *Works on Paper from the 1960's by Georg Baselitz*, Sept. 14–Nov. 5, 1994.

Emden, Kunsthalle im Emden/Stiftung Henri Nannen. *Georg Baselitz: Holzschnitte 1966–1991*, Oct. 1–Nov. 20, 1994. Traveled to Zwickau, Städtisches Museum Zwickau, Dec. 4, 1994–Jan. 29, 1995; and Reutlingen, Städtisches Kunstmuseum Spendhaus Reutlingen, Feb. 10–April 2, 1995. Exhibition catalogue, with essays by Karin Adelsbach, Andrea Firmenisch, and Siegfried Gohr.

Amsterdam, Stedelijk Museum. *Couplet III: Georg Baselitz, Recente schilderijen/Recent Paintings* (part of the exhibition "*Couplet III, Georg Baselitz, Eugène Leroy, Giudo Lippen, Jos van Merendonk, Moniek Toebosch, David Bade, Ruud Bloemheuvel*"), Oct. 15, 1994–Jan. 1, 1995.

Leipzig, Dogenhaus Galerie. *Georg Baselitz: Radierungen 1991–1994*, Dec. 9, 1994–Feb. 11, 1995.

Nantes, Galerie des Beaux-Arts. *Georg Baselitz: Gravures sur bois et linoleum*, Jan. 11–Feb. 21, 1995. Exhibition catalogue, with essay by Fabrice Hergott.

Dresden, Galerie Hübner & Thiel. *Georg Baselitz: Druckgraphik*, Jan. 28–March 4, 1995.

Zurich, Galerie Jamileh Weber. *Georg Baselitz bei Jamileh Weber*, April 1–May 13, 1995.

Heidelberg, Michael Kunsthandel und Galerie. *Georg Baselitz: Gouachen und Zeichnungen von 1974–1983*, April 3–May 5, 1995.

Group Exhibitions

Berlin. Akademie der Künste (organized by Deutscher Künstlerbund). *13. Ausstellung Berlin*, March 22–April 26, 1964. Exhibition catalogue.

Berlin. Akademie der Künste. *Junge Generation: Maler und Bildhauer in Deutschland*, June 5–July 10, 1966. Exhibition catalogue. with essays by Will Grohmann and Hans Scharoun.

Berlin. Deutsche Gesellschaft für Bildende Kunst (Kunstverein Berlin) and Akademie der Künste. *Labyrinthe: Phantastische Kunst vom 16. Jahrundert bis zur Gegenwart*. Oct.–Nov. 1966. Exhibition catalogue. with essays by Heinz Ladendorf and Eberhard Roters. Traveled to Baden-Baden. Staatliche Kunsthalle, Dec. 28, 1966–Feb. 12, 1967; and Nürnberg. Kunsthalle Nürnberg, March. 1967.
 —Piene. Nan R. "Report from Berlin." *Art in America* (New York) 55, no. 1 (Jan.–Feb. 1967). pp. 106–11.

Baden-Baden. Staatliche Kunsthalle. *Deutscher Kunstpreis der Jugend 1966 Malerei*. Oct. 1–Nov. 6, 1966. Exhibition catalogue. with essay by Heinz Olff.

Berlin. Athens Zapeion (organized by Deutsche Gesellschaft für Bildende Kunst [Kunstverein Berlin] in collaboration with Goethe-Institut. Athens. Germany). *Berlin Berlin: Junge Berliner Maler und Bildhauer*, Feb. 24–March 19, 1967. Exhibition catalogue. with essay by Christos M. Joachimides.

Stuttgart, Württembergischer Kunstverein. *Figurationen*. July 29–Sept. 10, 1967. Exhibition catalogue. with essay by Dieter Honisch.

Berlin. Nationalgalerie Berlin, *Sammlung 1968 Karl Ströher*. March 1–April 14, 1969. Traveled to Düsseldorf, Städtische Kunsthalle. April 25–June 17, 1969. Exhibition catalogue. with essays by Hans Strelow and Jürgen Wissmann.

Berlin. Orangerie des Schloßes Berlin-Charlottenburg (organized with Erholungshaus der Farbenfabriken Bayer, Leverkusen). *Ars Viva 69*. Oct. 10–Nov. 9, 1969. Traveled to Erholungshaus der Farbenfabriken Bayer, Nov. 25–Dec. 19, 1969. Exhibition catalogue. with essays by Horst Richter, Dirk Schwarze, and Günther Wirth, and reprinted essay by Martin G. Buttig. In German.

Hamburg. Kunsthaus Hamburg (organized by Schloß Morsbroch. Städtisches Museum Leverkusen). *Zeichnungen: Baselitz, Beuys, Buthe, Darboven, Erber, Palermo. Polke, Richter, Rot*. July 17–Aug. 9, 1970. Traveled to Munich. Kunstverein München, Aug. 21–Sept. 13, 1970. Exhibition catalogue. with essay by Rolf Wedewer.

Kassel. Neue Galerie and Museum Fridericianum. *Documenta 5: Befragung der Realität Bildweltenheute*. June 30–Oct. 8, 1972. Binder. with numerous essays. published by Documenta and Bertelsmann, Kassel, 1972.

Vienna. Galerie Nächst St. Stephan. *Zeichnungen der deutschen avantgarde*. Oct. 4–31, 1972. Traveled to Innsbruck. Galerie im Taxipalais, June 6–July 2, 1972. Exhibition catalogue. with essay by Peter Weiermair.

São Paulo. Parque Ibirapuera. Pavilhao Armando de Arruda Pereira (organized by Wallraf-Richartz Museum, Cologne). *XIII Bienal de São Paulo: Georg Baselitz, Palermo und Sigmar Polke*. Oct. 17–Dec. 15, 1975. Separate exhibition catalogue. *XIII Bienal de São Paulo 1975 República Federal da Alemanha: Georg Baselitz*. with interview by Evelyn Weiss.

Kassel. Museum Fridericianum. *Documenta 6: Malerei, plastik, performance*. June 24–Oct. 2, 1977. [Baselitz withdrew his paintings due to the inclusion of works by East German artists.] Exhibition catalogue, vol. 1 of 3, with essays by Karl Oskar Blase. Bazon Brock. Lothar Romain, et al., published by Paul Dierichs, Kassel, 1977.

Humlebaek. Denmark. Louisiana Museum (organized by Ink. Halle für Internationale Neue Kunst, Zurich), *Works from the Crex Collection, Zurich/Werke aus der Sammlung Crex, Zürich*. Dec. 9, 1978–Jan. 28, 1979. Traveled to Halle für Internationale Neue Kunst, Jan. 22–Feb. 18, 1979; and Munich. Städtische Galerie im Lenbachhaus [dates unavailable]. Exhibition catalogue. vol. 2 of 3, with essay by Christel Sauer. In German and English, trans. Peter Pasquill.

Munich. Städtische Galerie im Lenbachhaus. *Bilder, Objekte, Filme, Konzept*. April 3–May 13, 1979. Exhibition catalogue. with essays by Jost Herbig and Barbara Herbigand.

Karlsruhe. Badischer Kunstverein, *Malerei auf Papier: Georg Baselitz, Jörg Immendorf, Anselm Kiefer, Markus Lüpertz, A. R. Penck, Arnulf Rainer*. July 24–Sept. 16, 1979. Exhibition catalogue. with essay by Michael Schwarz. trans. Christopher Normington.

Venice. La Biennale di Venezia. West German Pavilion. *XXXIX Esposizione Internazionale d'Arte Venezia: Settor Arti Visive* [Baselitz with Anselm Kiefer]. June 1–Sept. 28, 1980. Separate exhibition catalogue. *Georg Baselitz*. with essays by Johannes Gachnang. Klaus Gallwitz. and Theo Kneubühler. In German and English, trans. Moishe Postpone and Catherine Schelbert.

Vancouver. Vancouver Art Gallery. *Forms of Realism Today/Formes du réalisme aujourd'hui*. June 7–July 20, 1980. Exhibition catalogue. with essay by Thomas Grochowlak and reprinted text by Baselitz, trans. J. Paul Brack and John Anthony Thwaites.

London. Royal Academy of Art. *A New Spirit in Painting*, Jan. 15–March 18, 1981. Exhibition catalogue, with preface by Christos M. Joachimides. Norman Rosenthal. and Nicholas Serota. and text by Christos M. Joachimides.

Amsterdam. Stedelijk Museum Amsterdam. *'60`80–Attitudes/Concepts/Images*. June 6–July 11, 1982. Exhibition catalogue. with introduction by Ad Petersen and essays by Wim Beeren. Cor Blok. Antje von Graevenitz. Gijs van Tuyl. and Edy de Wilde. and statements by the artists. published by Van Gennep. In German and English, trans. Patty Krone. Yvonne Limburg. M. E. Munz. Arent Noordam. Phil Sutton. A. J. de Swarte. Marijke van der Glas. J. J. van der Maas. and Patricia Wardle.

Kassel. Museum Fridericianum. *Documenta 7*. June 19–Sept. 28, 1982. Exhibition catalogue. vol. 2 of 2, with essays by Germano Celant. R. H. Fuchs. Johannes Gachnang. Walter Nikkels. Gerhard Storck. and Coosje van Bruggen, and statements and other texts by the artists. published by Documenta. Kassel. 1982. In German and English, trans. Annette Allwardt. Roderick Fletcher. John Gabriel. Stephen Locke. Alberto Noceti. Maja Oeri. Ariane Rüdiger Schuldt. Meg Shore. and Marianne Wienert.

Berlin. Martin-Gropius-Bau. *Zeitgeist: Internationale Kunstausstellung Berlin 1982*. Oct. 16, 1982–Jan. 16, 1983. Exhibition catalogue. with essays by Walter Bachauer. Thomas Bernhard. Karl-Heinz Bohrer. Paul Feyerabend. Christos M. Joachimides. Hilton Kramer. Vittorio Magnango Lampugnani. Robert Rosenblum. and Norman Rosenthal.

—Faust, Wolfgang Max. "The Appearance of the Zeitgeist," trans. Martha Humphreys. *Artforum* (New York) 21, no. 5 (Jan. 1983), pp. 86–93.

Saint Louis, The Saint Louis Art Museum. *Expressions: New Art from Germany*, June 24–Aug. 21, 1983. Traveled to Long Island City, P. S. 1, The Institute for Art and Urban Resources, Sept. 25–Nov. 10, 1983; Cincinnati, The Contemporary Arts Center, Dec. 1983–Jan. 1984; Chicago, Museum of Contemporary Art, Feb. 3–April 1, 1984; Newport Beach, Newport Harbor Art Museum, April 18–June 10, 1984; and Washington, D.C., Corcoran Gallery of Art, June 30–Aug. 26, 1984. Exhibition catalogue, with essays by Jack Cowart, Siegfried Gohr, Donald B. Kuspit, and bibliography by Renate Winkler, published by The Saint Louis Art Museum and Prestel, Munich, 1983.

—Bell, Jane. "What Is German about the New German Art?" *ARTnews* (New York) 83, no. 3 (March 1984), pp. 96–101.

—Lawson, Thomas. "'New Expressions.' P. S. 1; Kiely Jenkins, Fun Gallery." *Artforum* (New York) 22, no. 5 (Jan. 1984), p. 76.

—Relyea, Lane. "Attempting to Elude History." *Artweek* (San Jose) 15, no. 23 (June 9, 1984), p. 1.

Barcelona, Centre Cultural de la Fundació Caixa de Pensions. *Origen i visió: nova pintura alemanya*, April 5–May 6, 1984. Traveled to Madrid, Palacio Velázquez, Parque del Retiro, May 21–July 29, 1984; and Mexico City, Museo de Arte Moderne, Dec. 13, 1984. Exhibition catalogue, with essays by Christos M. Joachimides and conversations with the artists by Walter Grasskamp.

Düsseldorf, Städtische Kunsthalle. *Upheavals/Aufbrüche*, Oct. 12–Nov. 25, 1984. Exhibition catalogue, *Upheavals: Manifestos, Manifestations—Conceptions in the Arts at the Beginning of the Sixties, Berlin, Düsseldorf, Munich/Aufbrüche: Manifeste, Manifestationen—Positionen in der bildenden Kunst zu Beginn der 60er Jahre in Berlin, Düsseldorf und München*, ed. Klaus Schrenk, with essays by Hans M. Bachmayer, Lore Ditzen, Juliane Roh, Karl Ruhrberg, Klaus Schren, and Emmett Williams, and reprinted text by Baselitz and other manifestos, published by Dumont, Cologne, 1984. In German and English, trans. David Britt, Elisabeth Brockmann, Eileen Martin, Stephen Reader, and Elizabeth Volk.

—Galloway, David. "Report from Germany." *Art in America* (New York) 73, no. 3 (March 1985), pp. 23–29.

Toronto, Art Gallery of Ontario. *The European Iceberg: Creativity in Germany and Italy Today*, Feb. 8–April 7, 1985. Exhibition catalogue, with essay by Germano Celant, et al., and statements by architects and designers, trans. Joachim Neugroschel and Leslie Strickland, co-published with Gabriele Mazzotta, Milan, 1985.

Berlin, Nationalgalerie Berlin, Staatliche Museen Preußischer Kulturbesitz. *Kunst in der Bundesrepublik Deutschland 1945–1985*, Sept. 27, 1985–Jan. 21, 1986. Exhibition catalogue, with essays by Lucius Grisebach, Angela Schneider, Eduard Trier, et al.

London, Royal Academy of Arts. *German Art in the Twentieth Century: Painting and Sculpture, 1905–1985*, Oct. 11–Dec. 22, 1985. Traveled to Stuttgart, Staatsgalerie Stuttgart, Feb. 8–April 27, 1986. Exhibition catalogue, with essays by Werner Becker, Hanne Bergius, Georg Bussmann, Matthias Eberle, Ivo Frenzel, Günther Gerken, Siegfried Gohr, Walter Grasskamp, Wulf Herzogenrath, Reinhold Hohl, Christos M. Joachimides, Jill Lloyd, Franz Meyer, Harry Pross, Sixten Ringbom, Irit Rogoff, Norman Rosenthal, Wolfgang Rothe, Wieland Schmied, Uwe M. Schneede, Carla Schulz-Hoffmann, Peter-Klaus Schuster, Sarah O'Brien Twohig, Richard Verdi, Stephan von Wiese, and Thomas Zaunschrim, and biographies of the artists by Walter Grasskamp.

Pittsburgh, Carnegie Museum of Art. *1985 Carnegie International*, Nov. 9, 1985–Jan. 5, 1986. Exhibition catalogue, with introduction by John Caldwell and anthology of reprinted essays by Germano Celant, Rudi H. Fuchs, Johannes Gachnang, Jannis Kounellis, et al.

New York, The Museum of Modern Art. *1961Berlinart1987*, June 4–Sept. 8, 1987. Traveled to San Francisco, San Franciso Museum of Modern Art, Oct. 22, 1987–Jan. 3, 1988. Exhibition catalogue, with essays by René Block, Laurence Kardish, Kynaston McShine, Karl Ruhrberg, Wieland Schmied, Michael Schwarz, and John Willett; reprinted essays by Baselitz, excerpted from *Georg Baselitz: Schilderijen/Paintings 1960–83* (Whitechapel Art Gallery, London, 1983); and chronology by Thomas Schulte, biographies of the artists by Marjorie Frankel Nathanson, and bibliography by Daniel A. Starr; trans. John William Gabriel.

—Brenson, Michael. "A New Show Chronicles Resurgence of Berlin Art." *The New York Times*, June 5, 1987, section C, pp. 1, 22.

—Cotter, H[olland]. "Art from the Exiled City." *Art in America* (New York) 75 (Oct. 1987), pp. 43–51.

—Rogoff, Irit. *Burlington Magazine* (London) 129, no. 1,014 (Sept. 1987), pp. 623–25.

Toledo, Ohio, The Toledo Museum of Art (organized by Solomon R. Guggenheim Museum, New York). *Refigured Painting: The German Image 1960–88*, Oct. 30, 1988–Jan. 8, 1989. Traveled to Solomon R. Guggenheim Museum, Feb. 10–April 23, 1989; a selection shown at Williamstown, Mass., Williams College Museum of Art, Feb. 10–March 26, 1989; Düsseldorf, Kunstmuseum Düsseldorf, May 20–July 30, 1989; and Frankfurt, Schirn Kunsthalle Frankfurt, Sept. 12–Nov. 12, 1989. Exhibition catalogue, with essays by Michael Govan, Heinrich Klotz, Thomas Krens, Hans Albert Peters, Jürgen Schilling, and Joseph Thompson; biographies, exhibition history, and bibiliography by Kathryn Potts and Sally Shafto; trans. John William Gabriel and Stephen Reader.

Cologne, Museums Ludwig in den Rheinhallen der Kölner Messe. *Bilderstreit: Widerspruch, Einheit und Fragment in der Kunstseit 1960*, April 8–June 28, 1989. Exhibition catalogue, with texts by Johannes Gachnang, et al., published by Dumont, Cologne, 1989.

Atlanta, High Museum of Art. *Art in Berlin: 1815–1989*, Nov. 14, 1989–Jan. 14, 1990. Exhibition catalogue, with foreword by Gudmund Vigtel and essays by Françoise Forster-Hahn and Kurt W. Forster, Charles W. Haxthausen, Peter Jelavich, Clark V. Poling, Eberhard Roters, and Gudmund Vigtel.

Berlin, Martin-Gropius-Bau. *Metropolis: International Kunstausstellung Berlin 1991*, April 20–July 21, 1991. Essays by Achille Bonito Oliva, Wolfgang Max Faust, Christos M. Joachimides, Norman Rosenthal, et al., published by Cantz, Stuttgart, 1991.

Cologne, Galerie Michael Werner. *Korrespondenzen*, April 10–May 20, 1992. Exhibition catalogue, with essay by Siegfried Gohr. In German and English, trans. John Gabriel.

Los Angeles, Los Angeles County Museum of Art. *Parallel Visions: Modern Artists and Outsider Art*, Nov. 18, 1992–Jan. 3, 1993. Traveled to Madrid, Museo Nacional Reina Sofía, Feb. 11–May 9, 1993; Basel, Kunsthalle Basel, July 4–Aug. 29, 1993; and Tokyo, Setagaya Art Museum, Sept. 30–Dec. 12, 1993. Exhibition catalogue, with introduction by Maurice Tuchman and essays by Russell Bowman, Roger Cardinal, Carol S. Eliel, Carol S. Eliel and Barbara Freeman, Sander L. Gilman, Mark Gisbourne, Reinhold Heller, John M. MacGregor, Donald Preziosi, Maurice Tuchman, Allen S. Weiss, Jonathan Williams, and Sarah Wilson; and biographies of the artists by Barbara Freeman; co-published with Princeton University Press, Princeton, 1992.

Edinburgh, Royal Scottish Academy and the FruitMarket Gallery (organized by Scottish National Gallery of Modern Art; Hayward Gallery, London; and Nationalgalerie Berlin). *The Romantic Spirit in German Art 1790–1990*, July 28–Sept. 7, 1994. Traveled to Hayward Gallery, Sept. 29, 1994–Jan. 8, 1995; and Munich, Haus der Kunst, Feb. 2–May 1, 1995. Exhibition catalogue, ed. Keith Hartley, Henry Meyric Hughes, and William Vaughan, with introduction by Keith Hartley and essays by Richard Calvocoressi, et al.

INDEX OF REPRODUCTIONS